COMIC ABSTRACTION

ABSTR

COMIC ACTION

IMAGE-BREAKING, IMAGE-MAKING

ROXANA MARCOCI
THE MUSEUM OF MODERN ART, NEW YORK

Published on the occasion of the exhibition *Comic Abstraction: Image-Breaking, Image-Making,* March 4–June 11, 2007, at The Museum of Modern Art, New York, organized by Roxana Marcoci, Curator, Department of Photography.

The exhibition is supported in part by Jerry I. Speyer and Katherine G. Farley and by Susan G. Jacoby.

Additional funding is provided by The Friends of Education and The Contemporary Arts Council of The Museum of Modern Art.

The publication is made possible by Agnes Gund and Daniel Shapiro.

Produced by the Department of Publications
The Museum of Modern Art, New York
Edited by Libby Hruska
Designed by Naomi Mizusaki, Supermarket, New York
Production by Elisa Frohlich
Typeset in Benton Gothic and Ziggurat
Printed and bound by Oceanic Graphic Printing, Inc., China
Printed on 170 gsm New G-Matt paper

Library of Congress Control Number: 2006938310
ISBN: 978-0-87070-709-4

Published by The Museum of Modern Art
11 West 53 Street, New York, NY 10019-5497
www.moma.org

Distributed in the United States and Canada
by D.A.P./Distributed Art Publishers, Inc., New York

Distributed outside the United States and Canada
by Thames & Hudson, Ltd, London

Cover:
Rivane Neuenschwander
Zé Carioca no. 4, A Volta de Zé Carioca [The Return of Zé Carioca] (1960). Edição Histórica, Ed. Abril (detail). 2004
Synthetic polymer paint on comic book pages, thirteen images, each 6 ¼ x 4" (15.9 x 10.2 cm)
The Museum of Modern Art, New York. Fund for the Twenty-First Century, 2005
(see plate 48)

Printed in China

CONTENTS

FOREWORD

From the moment that The Museum of Modern Art was founded in 1929, it has made a sustained commitment to the scholarly presentation of contemporary art. *Comic Abstraction: Image-Breaking, Image-Making* presents a wholly new analysis of work made by thirteen artists over the past fifteen years. This publication and the exhibition it accompanies investigate how these figures have dismantled comic imagery found in sources such as the Sunday funnies, cartoons, Japanese anime and manga, and children's coloring books to create abstractions. The artists included are as diverse as the methods they use to tweak, twist, and erase highly recognizable comic characters in their sound and video installations, paintings, sculptures, and drawings. Their cultural backgrounds and different geographical locations play into the myriad ways they imbue each eruption of their motifs with highly personal commentary to produce political and social critiques of our complex world.

Although thematic group shows can never be comprehensive or definitive, Roxana Marcoci, Curator in the Department of Photography, has presented an innovative, conceptually persuasive selection of comic abstraction in its many guises. While other exhibitions have addressed comic figuration in contemporary art, she has questioned how those images have been utilized as starting points for erasure and blurring. Her essay here provides an analysis of the motivations that have led multiple artists to work in this vein as well as of the critical gestures produced through the artwork itself. In addition, her interviews with the artists document the who, what, when, where, and why behind their gravitations toward abstracting comic material. Although the study of contemporary art must always be rooted in close visual examination, our understanding is enhanced by hearing firsthand the artists' explanations of their intentions.

This exhibition has benefited greatly from the generosity of a number of individuals and institutions who have allowed us to share important works from their collections with the public, and I am deeply grateful to them. My heartfelt appreciation also goes to Jerry I. Speyer and Katherine G. Farley and to Susan G. Jacoby, who have helped to make this exhibition a reality. Great thanks are due to The Friends of Education and The Contemporary Arts Council of The Museum of Modern Art for providing additional funds for the exhibition. I am tremendously indebted to Agnes Gund and Daniel Shapiro, whose support has made this publication possible. Finally, I salute and offer my greatest thanks to the artists, whose generosity in meeting the countless necessities of such an ambitious project has matched the wit and originality of their art. Their work proves that comic imagery is not merely meant to entertain; it can also be an apparatus for change.

Glenn D. Lowry
Director, The Museum of Modern Art

COMIC ABSTRACTION:
IMAGE-BREAKING, IMAGE-MAKING

ROXANA MARCOCI

Hogan's Alley, which featured the well-known character the Yellow Kid, is usually credited as being the first mass-produced comic strip.[1] Created by Richard Felton Outcault, it was published between 1895 and 1898 in the newspapers *New York World* and *New York Journal*. Since then, comics have been disseminated to audiences as vast and diverse as comics themselves. From Sunday newspaper "funnies" like *Dick Tracy* and serialized comic books such as *Superman* to Walt Disney's cartoon shorts and feature-length films, comics have offered a bridge between disposable modes of visual expression and rarified brands of "fine art." In the United States and Europe, comics have stood at the nexus of the high-low debate, while in Japan, manga (comic books) and anime (animated films) were never differentiated from art. Comics have often tackled thorny political and social issues, yet they have generally been interpreted as positive expressions of popular culture. When painters and sculptors have incorporated them into their own work, especially in Pop art of the 1960s, they have unabashedly celebrated both the super-heroes and the lowbrow "stuff" that populates American culture.

Although there have been numerous efforts to address the impact of mass culture on contemporary art, these have generally focused on ubiquitous figuration and easily identifiable pop characters and themes. This study approaches the topic from a different angle, looking at how artists—particularly those working in the last fifteen years—have used the vernacular language of comics as a springboard for abstraction, not to withdraw from reality but to engage with it more critically. The act of abstracting a comic image entails blurring, erasing, and a kind of "unpainting" that presents to the eye two images, one in a stage of formation and the other in a state of removal. The poignancy inherent in this discrepancy raises the stakes attached to recognition.

Before turning to the creative misalliance between comics and abstraction, it is enlightening to look at another age engaged with the dual process of making and unmaking images. Joseph Leo Koerner provides an example in his landmark book *The Reformation of the Image* (2004). Taking as his subject sixteenth-century Lutheran art and the iconoclastic climate from which it emerged, Koerner recounts that while Martin Luther was hiding from Catholic forces in 1522, zealous parishioners destroyed the sacred images in the church of his ministry. On his return to Wittenberg, Saxony, later that year, the reformer repudiated the iconoclasts' acts and sought to undo what they had unleashed. Luther denounced images not for what they were in themselves, but for the idolatry they inspired. He judged the riotous actions of image-breakers to be similar to those of Catholic idolaters who venerated pictures and, in so doing, proved their belief in the power of images. By treating the representational beliefs of their foes as real, the iconoclasts took the image literally, becoming image-makers in turn.

The parallels between iconoclasm and idolatry suggest how acts of destruction can create images just as potent as the ones they seek to displace. Koerner's book rests on the premise that images never go away, and that iconoclasm is more than just an act of defacement. Rather, it is a gesture that paradoxically resurrects the very image it assaults. Koerner defines "iconoclash" as the "mix of having images and having done with images."[2] In essence, iconoclash is a gesture that produces disorder in the interpretative approach of any dialectical system.

A new generation of artists has taken up this idea, challenging the quarrel of opposites whereby one side proposes to upend the other. Simply inverting the terms of a given discourse—for instance, stating that abstraction obliterates figuration—seldom produces a change in perception because it leaves the basic structure of the earlier form intact. How representational structures are put to use is a more significant question. Moving beyond the image wars rooted in the conflict of binary opposites, the strategy of a critical approach seeks to recognize every act of defacement as itself a creative act, and one for which the maker must take responsibility. Above all, this task involves investigating the life of images and the way these images circulate in the everyday.

This publication, along with the exhibition it accompanies, looks at a group of artists who have abstracted images culled from slapstick, comic strips and films, caricature, cartoons, and animation to create an experimental mode that addresses perplexing questions about war and global conflict, the loss of innocence, and ethnic stereotyping. It offers the first investigation into the outgrowths of comic abstraction and the ways in which latent representation

Fig. 1. *The Powerpuff Girls*. Created by Craig McCracken.
Image from *The Powerpuff Girls: Titans of Townsville!* 2003

and erased figuration take on renewed social and political relevance. What does it mean to confront politics with humor? How might comics serve as an effective medium for tackling difficult issues? One answer is that humor empowers through subterfuge. Playing with comic motifs in art is not unlike making a joke: both acts aim to perturb, insinuate, tease, and demystify assumptions. Bridging the rift between abstraction and comics in ways that are at once critical and playful, *Comic Abstraction: Image-Breaking, Image-Making* highlights the intensely personal bonds that contem-

GO, GIRLS, GO!

WE'VE GOT A JOB TO DO!

porary artists maintain with the political realities of the world. It also underscores the way popular imagery—so deeply imprinted in our collective consciousness—carries an extreme visual potency even when totally abstracted.

Espousing superhero comic characters as legitimate catalysts for change, **Polly Apfelbaum**'s abstract works are made of malleable pieces of dyed velvet. *Blossom* (2000; plate 4), a large circular, floor-hugging painting constructed from hundreds of shimmering psychedelic blasts of fabric, is one of four abstractions inspired by the popular animated series *The Powerpuff Girls* (fig. 1). The creation of CalArts graduate Craig McCracken, this television series features three toylike action figures—Blossom, Bubbles, and Buttercup—whose mission is to fight crime and save the world from evil before bedtime. Blossom, the invincible red-haired, pink-eyed leader, possesses the special power of breathing ice. The blonde, blue-eyed Bubbles, the group's comedian, speaks every language (both extant and imaginary), from Spanish to Squirrel. Finally, the black-haired, green-eyed Buttercup, the strongest fighter of the trio, enjoys the somewhat prosaic ability of rolling her tongue. Making effective use of the little-known tradition of "bubblegum anime," a type of Japanese animation that highlights the "rainbow" effect of images, this cartoon series combines characters that are both cutely feminine and acutely tough. Discussing the rise of girl power, Apfelbaum notes: "I liked the idea of a strong somewhat promiscuous female role model, the slightly out-of-control quality of these cartoon characters."[3]

Each of Apfelbaum's floor paintings (fig. 2) constitutes an abstract portrait of the color-coded Powerpuff Girls and of Townsville, where they reside. This series is part of a group of works the artist calls "fallen paintings," in reference to their irreverent position on the ground. The Powerpuff paintings—like the cartoons on which they are based—are highly controlled and painstakingly put together while still articulating the delirious thrill of topsy-turvydom. "To step into one of these installations," David Pagel notes, "is to imagine that you're in a big printed picture whose Benday dots are on acid."[4] The throbbing beat of the crushed velvet, stained with Sennelier dye (a French brand available in 104 hues), conveys a pop-carnivalesque spirit that brings to mind spectacular street festivities, such as the Mummers Parade, which the artist witnessed while growing up in Philadelphia. The intricate, kalei-

Fig. 2. Polly Apfelbaum. Installation view of the exhibition *Powerpuff* at D'Amelio Terras, New York, 2000 (foreground: *Bubbles*; background left and right: *Buttercup* and *Blossom*)

Fig. 3. Film still from *Footlight Parade*. 1933. Choreography and staging by Busby Berkeley

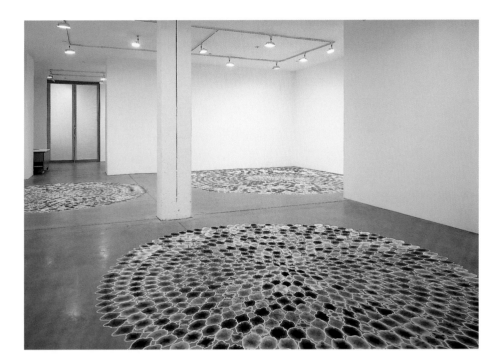

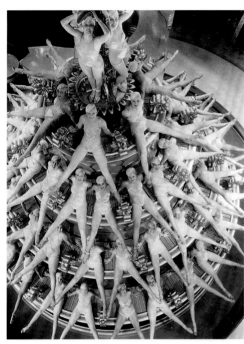

doscopic patterns of the floor paintings are also a takeoff on the glittering choreography of Hollywood musical productions like Busby Berkeley's *Footlight Parade* (fig. 3). Berkeley's legendary "human waterfall" number featured chorus girls costumed in ropes of pearls who were showered with a colored mist from hundreds of tiny water sprays.

In the Powerpuff paintings, Apfelbaum distills McCracken's iconic characters to their essence. Her unabashed embrace of polychromy and exuberant, saturated color recalls David Batchelor's book *Chromophobia* (2000), a study of Western society's deep-rooted suspicion of color. He writes, "Chromophobia manifests itself in the many and varied attempts to purge colour from culture, to devalue colour, to diminish its significance, to deny its complexity."[5] Batchelor continues his discussion with a statement that seems to have a direct bearing on Apfelbaum's work: "Colour is made out to be the property of some 'foreign' body—usually the feminine, the oriental, the primitive, the infantile, the vulgar, the queer or the pathological."[6] Batchelor's description of the simultaneously subversive and playful properties of color mirrors Apfelbaum's abstracted depictions of the Powerpuff Girls—feminine, oriental, infantile, and vulgar—and points out that even pure color conveys strong, often impure, associations.

This series builds on Apfelbaum's earliest group of Disney-inspired velvet pieces from 1992. These first works include *Sleeping Beauty*, *Peggy Lee and the Dalmatians* (plate 1), and *The Dwarves without Snow White* (plate 3), whose titles evoke archetypal feminine role models. According to the artist, she uses titles to give identity to otherwise abstract motifs and selects specific colors to enhance their associative possibilities. Apfelbaum has also made a series of works, including *L'Avventura* (1994; plate 5), *Zabriskie Point* (1994), and *Red Desert* (1995; plate 6), based on Michelangelo Antonioni's eponymous films of the 1960s. The latter refers to Antonioni's first color film, made in 1964, in which he played with bold artificial hues to intensify the female lead's sense of malaise. Drawn to Antonioni's intimate psychological portrayals of individuals trying to adjust to the alienating conditions of modernity, Apfelbaum's installations similarly use color to explore unruly emotional states. In *Red Desert*, the heroine's quicksilver mood shifts are translated into large sheets of bright red velvet marked by a grid of black stains. In *L'Avventura*, the confettilike explosion of fabric snippets assembled from scraps in candy colors echoes the film's unhinged double narrative, which begins with the end of one love affair and ends with the beginning of a new one.

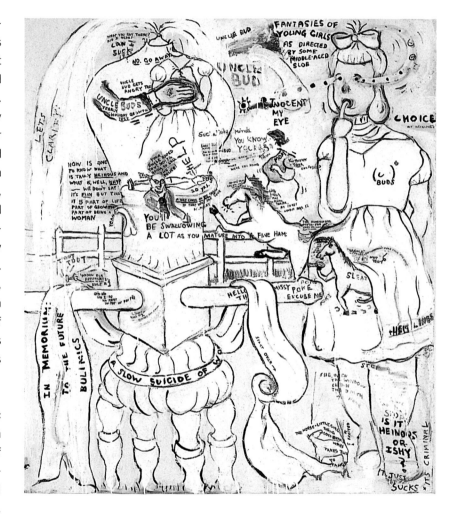

Just as Apfelbaum's works draw on specific narrative references, their artistic and literary associations are also varied and extensive. Her stained velvet installations often relate visually to the Color Field abstractions of Helen Frankenthaler and Morris Louis. At the same time, Apfelbaum's method of display conjures up the Post-Minimalist practice of scatter art. Lynda Benglis's exuberant spills of multicolored poured latex displayed directly on the floor offer a strong precedent. In terms of literary sources, Apfelbaum finds an affinity between her works and the ideas of Italian novelist Italo Calvino, who suggests in *Italian Folk Tales* (1975) that folk and fairy tales are in fact tough and unsentimental narratives. In his *Six Memos for the Next Millennium* (1988), Calvino stresses that stories should be narrated with lightness and immediacy, as if they are a series of comic strip frames. Like Apfelbaum, Calvino insists on the priority of the image, which has its roots in his preliterate passion for cartoons.

Straddling the line between abstraction and comic representation, **Sue Williams**'s work is infused with a salacious tone and a scurrilous locker room sense of humor. Taking the war between the sexes as her primary subject, her paintings are permeated by sexual motifs that touch on issues of abjection and violence, rendered in strokes of vivid color with a fluid, cartoonish energy. Because of her mercilessly mordant tone, Williams has been hailed as "the James Gillray of sexual politics, feminism's Honoré Daumier, or the equal in viciousness and sophistication to [William] Hogarth"—placing her in the grand tradition of the most infamous satirists in the history of art.[7]

Williams emerged in the mid-1980s as a gutsy painter whose autobiographical work integrates sardonic captions mixed with mocking dialogue, jokes, and indictments to create mutinous images of spousal abuse, rape, and murder. In *Relax* (1992), the sculptural replica of a battered woman's body covered with footprints and bruises is also marred by words scrawled in a quick, roguish hand that impersonates the attacker's voice: "Oh do you think you could just relax?/So uptight/Can't enjoy yourself." The violence at the heart of Williams's subject matter is echoed by the aggression of her technique, which distorts and disfigures the characters that populate her canvases. Discussing the artist's denunciation of societal indifference toward violence, particularly rape, Hannah J. L. Feldman writes: "*Relax* does more than just present the event it depicts; it bears witness to the history of rethinking rape as a story of sexual pleasure."[8] Similarly, the painting *Uncle Bud* (fig. 4) parodies the idea that young girls daydream of rape. It offsets a cartoonlike scene of sexual harassment with the phrase: "Fantasies of Young Girls as Directed by Some Middle-Aged Slob." In these early works, Williams tackles taboos about gender identity and social dysfunction, often visualizing the inexpressible through dark humor.

By 1994 Williams had dispensed with the cartoon-based style and text-heavy format that she had been using throughout the

previous decade. Scenes rife with sexual violence gave way to exuberant, densely layered abstract compositions, which have been described as "road maps to a psychosexual geography."[9] In *Green Hand and Tongue Deal* (1997; plate 70) and *Large Blue Gold and Itchy* (1996; plate 71), swooping strokes in the shape of fleshy feet, rubbery fingers, grabbing hands, and flabby tongues morph into images of sexual tension that curl over the surface of the canvases in zingy, playful rhythms. The artist remarks that these freewheeling abstractions "always start with a line that's part of a body. That's the compulsion behind the line."[10] Although Williams's linear style relates to Arshile Gorky's and Willem de Kooning's gestural abstractions from the 1940s, the details of her floppy, disjointed bodily fragments also read like avatars of the Surrealists' automatist imagery.

Tethered to Surrealism's rich network of visual allusions—chief among them foot fetishism and an obsession with toe licking—Williams uses displaced sexual motifs, such as spiky heels, pointy shoes, big toes, and pudendalike feet. In 1929, French Surrealist Georges Bataille published a highly influential short text, "Le gros orteil" ("The Big Toe"), in the avant-garde art review *Documents.* In this text, Bataille commented on Jacques-André Boiffard's undignified close-up photographs of magnified toes with gnarly corns and roughly hacked nails (fig. 5), turning classic foot fetishism into an argument about "base seduction." Denouncing the repressive hierarchy of the "civilized" body that elevates the rational while

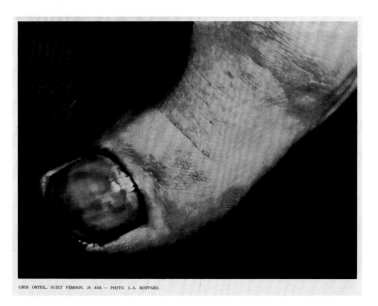

GROS ORTEIL, SUJET FÉMININ. 24 ANS. — PHOTO. J.-A. BOIFFARD.

inhibiting the instinctual, Bataille contended that the big toe is "the most *human* part of the human body."[11] He interpreted the upright stance of the body through its relationship to the ground, noting the base horizontality of the toe's position and its abject relationship to the earth. He concluded that the toe's seductiveness is tied to its grossness, which also explains the hilarity often provoked by the sight of it.

Rejecting the unitary, classical idealized body in favor of the castoff and the repulsive, Williams's toes and feet are invested with sexual energy. In *Creamy Floral* (fig. 6), she defines a girl's anatomy strictly by her lower body. Clad in silky black shoes, the girl's feet protrude from puffy culottes with a slit in the garment that exposes her genitalia. The big toe makes its appearance in numerous works of the 1990s, from the orgiastic *Special Occasions, Special Toes* (1996), a frenzied web of foreshortened bodies with giant toes, to the abstraction *Mom's Foot Blue and Orange* (1997; plate 69), a composition of free-floating pleats, bits of skirt, and an accretion of elongated shapes resembling frolicking toes and flopped-over feet. Williams identifies her source of inspiration as the famous "hinged foot" of Don Martin's cartoons in *Mad* magazine, which she greatly admired as a child. She states, "People don't often talk about the fact that my work is funny, but that's definitely one of my criteria. I'm really happy if the paint comes out well and it's a really goofy image, like a new dumb take on toes."[12]

Fig. 7. Arturo Herrera. *A Knock*. 2000. Cut-and-pasted printed paper on paper, 70 x 60" (177.8 x 152.4 cm). The Museum of Modern Art, New York. Purchase, 2002

Figs. 8–9. Arturo Herrera. Studies for *Three Hundred Nights*. 1998. Cut-and-pasted printed paper on paper, each 12 x 9" (30.5 x 22.9 cm). Collection of the artist

Undoing figuration takes on different psychological implications in the work of **Arturo Herrera**, who revisits age-old themes of innocence and experience. From his first billboard project in Chicago in 1995 to his paper collage cutouts (fig. 7) and wall paintings, Herrera excerpts, slices, fragments, and reconfigures images from the pages of cartoons, fairy tales, and coloring books. His metamorphosed characters, mostly purloined from Disney's repertoire—including Goofy, Bambi, Dumbo, Pluto, and Snow White and the Seven Dwarfs—surface from beneath layers of scrawls, drips, smears, and loops. Herrera all but obscures the figures to create an abstracted

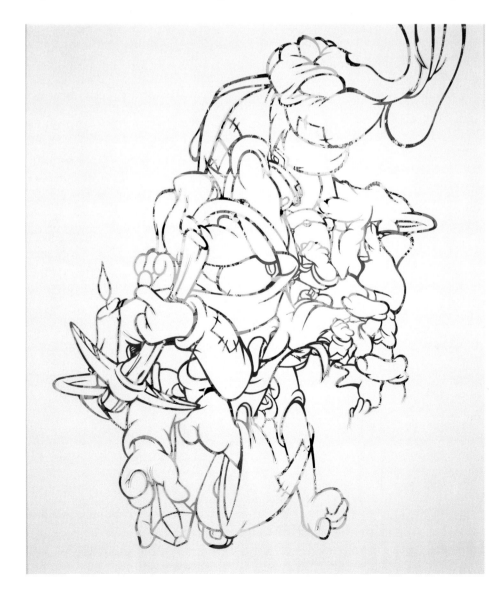

universe of forms that invokes unsettling collisions between latent juvenile fantasies and displaced adult desires.

After moving from his native Caracas to the United States, Herrera studied art at the University of Illinois, where he became familiar with the 1960s comic book–based collages of Chicago Imagist Ray Yoshida and the violent and perverse humor of "outsider" artist Henry Darger. The distinctive character of his art contributes to a larger dialogue that took place in the late 1980s and early 1990s among artists, including Mike Kelley, Jeff Koons, Paul McCarthy, and Charles Ray, whose works address the impurity of adolescence and the dissolution of identity structures, especially that of the nuclear family. Consonant with his contemporaries, Herrera hones in on the imagery and styles of pulp comics while adding his own surrealist spin that recasts the innocuous as the uncanny. Early in his career he turned to low-cost materials—including used books, magazines, and comics—as a prime source. He notes, "Cutting these 'sale bin' books produced the most surprising and challenging fragments filled with abstract and surrealistic references while maintaining a lingering connection to their origins."[13] Like Williams, Herrera builds on Surrealism as he stakes out a distinctly personal position in relation to his psychologically charged subject matter.

The motifs seen in some of Herrera's wall paintings, such as the orange Popsicle-colored abstraction *Tale* (1995; plate 17), may suggest a number of possible sexual and violent scenarios. Critic Neville Wakefield notes that "Donald Duck's beak in Cinderella's spleen or Jiminy Cricket's head up Pluto's ass" create forms that distort and corrupt childhood innocence via worldly experience.[14] In other works, such as *Three Hundred Nights* (1998; plate 19), the motifs are lifted straight from the covers of a Swiss fairy tale book (figs. 8–9) and reworked as a perversely erotic game between a character dressed

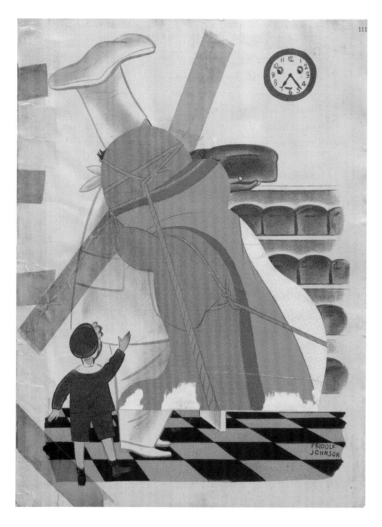

in dazzling Matisse-inspired colors and another who is submissively bound with thick ropes. The two works invoke fairy tale fantasies with a force that replicates the disorderly energy of a child's libidinal play.

Herrera also mines children's material to reveal darker fantasies in *All I Ask* (1999; plate 21), a wall painting inspired by a Snow White coloring book that the artist bought at an Odd Jobs store in New York City. The book recreates Disney's 1937 animated film through seventy line drawings, which Herrera cut with an X-Acto knife and scissors and then reassembled into an abstract, allover drawing of fused body parts before transferring to the wall. Although Herrera leaves discernable bits of skewed anatomy, the entire image never coalesces into a cohesive tale. An upside-down Snow White is entwined with dangling animal parts, while the dwarves are drawn into scenes of sexual intimation. A case study in image defacing, *All I Ask* turns the Disneyesque characters— the epitome of childhood innocence—into a riotous insurrection of lines. Extracting the ballooning gestures of cartoons into a maelstrom of preternaturally swollen curves, Herrera probes how much vestigial narrative is necessary before the viewer can apprehend the children's book borrowings.

Herrera often thwarts our attempt to identify his source material by scraping and splicing scenes from the same coloring book and combining the cutouts with his tactile spill and drip ink drawings. *Night Before Last* (2003; plate 18) incorporates eight drawings that have been overlaid twice, then flipped and reversed. Moreover, it refers to another large, playful wall painting that adjoins four of these drawings in elegantly incoherent, sinuous, and—as always— insinuating motifs. Herrera also produced *Untitled* (2000), another wall painting for which he doubled and inverted the motifs of *All I Ask*. In addition to creating an inverted mirror image, he explains that he "added, deleted, and juxtaposed fragments to build up a new work that is harder to read while being seductively accessible. This doubling-up sets in motion unlimited paradoxes that engage the viewer visually and psychologically."[15] As evident from the many steps involved in his densely braided compositions, the artist considers alternative narratives by means of reversals and reflections, creating images within images that take their life-forms as much from Disney as from Sigmund Freud. He also reclaims humor by defamiliarizing fairy tale figures as polymorphous abstractions. At once winsome and psychically charged, Herrera's art reflects the particular urgencies of our time, presenting a view of childhood that counters the archetypal optimism of American cartoons.

Dwarfs reminiscent of Diego Velázquez rather than those of Disney populate the work of **Juan Muñoz**, inspiring a darkly comic universe that centers on the absence of human communication, the distance this condition creates, and the desire to surmount it. Born in Madrid in 1953, Muñoz grew up during the last two decades of

General Francisco Franco's dictatorship, an era when freedom of speech was repressed in Spain. Until his death in 2001 at the age of forty-eight, Muñoz experimented with sound-based installations as a means of interlocution. In the same vein, he made numerous drawings and sculptures of open mouths that suggest talking, laughing, or screaming. Muñoz also modeled many large-scale "conversation pieces," in which bottom-heavy figures resembling wobbly toys congregate in groups, or isolate themselves from one another in order to evoke social estrangement (plate 40).

Muñoz's characters, including the ventriloquist's dummy (plate 37), the automaton, and the dwarf, are part of a long lineage of misfits. The latter, an ironic counterpart to superhero characters, is deeply rooted in the cultural heritage of Spain, and descends from the works of Velázquez, Luis Buñuel, and earlier forms of carnival that share the enfranchising power of laughter and impiety. "Because of his physical distortion," Muñoz notes, the dwarf "was allowed to distort or exaggerate reality."[16] Muñoz's theatrical stage sets are animated by fools and jesters and by laughing "Chinese" men (plate 39), so called because of how Westerners have interpreted the "otherness" of their Asian features. Like other artists of his generation, including Robert Gober, Charles Ray, and Thomas Schütte, Muñoz engaged in an equivocal form of figuration. He not only distorted the figure—creating characters kindred to Gober's radically truncated bodies, Ray's uncanny mannequins, and Schütte's puppetlike players of the 1990s—but, on occasion, abolished it altogether.

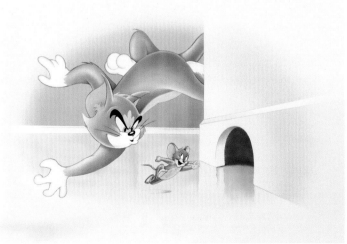

Waiting for Jerry (plate 36), conceived in 1991 for an exhibition at the Van Abbemuseum in Eindhoven, The Netherlands, is a case in point. Plumbing the disquieting world of childhood, this sound installation exudes at once a sense of menace and an absurd humor. A dark, vacant room is lit only by a trace of light, which is visible through a mouse hole cut into the foot of a wall. A soundtrack of cartoonlike noises and music reminiscent of the animated cartoon series *Tom & Jerry* (fig. 10) fills the room. The music builds to the climactic moment when an unseen cat (Tom) waits to snatch a mouse (Jerry) that may or may not materialize. With no characters, the installation is an entirely abstract environment, yet Muñoz still imbues it with the mischievousness of its animated inspiration. As with many of his other works, *Waiting for Jerry* includes references to Samuel Beckett's brand of theater as a drama of discomfiting situations involving missing players and a comically absurd engagement with the audience. His work also owes much to the facetious spirit of French avant-garde composer Erik Satie, who broke with the conventions of the concert hall through his *musique d'ameublement* (furniture music), a type of "background" music that intermixed the sounds made by the audience during intermission time as they mingled and talked.

Sound continued to play an important role in Muñoz's work throughout his career. In his 1997 BBC radio performance *A Man in a Room, Gambling* (fig. 11), the artist impersonated a trickster who described a series of card tricks against a soundtrack specially orchestrated by the English composer Gavin Bryars. Muñoz explained the art of magic in ten five-minute segments that were broadcast on the radio before the evening news without any introductory announcements. He wanted to offer listeners an utterly mysterious performance while still insuring that the recordings were accepted without question. Michael Brenson observes that although the explanation of magical acts depends on looking, Muñoz's sound piece derived its pleasure from undermining confidence in visual observation, which is itself a necessary characteristic of illusory games and trickery.[17] Four years earlier, in *Stuttering Piece* (1993; plate 38), Muñoz used sound in the form of elliptical dialogue. A pair of small figures, seated on tiny boxes, listens to a looped snippet from transcripts of mundane conversations tape-recorded in bars or cafés: "What did you say?/I didn't say anything./You never say anything./No./But you keep coming back to it." Once

again, the absurdist, fragmentary speech recalls the plays of Beckett.

Muñoz's sound installations, in which the aural supercedes the visual, propose a redefinition of the art object that touches on iconoclasm. The artist achieved this through his interest in exploring sound without an accompanying image as well as his desire to capture the moment when sound becomes silence. Neal Benezra traces Muñoz's interest in iconoclasm to 1987, the year the artist began writing "The Prohibited Image," a text not published until 1992.[18] At the beginning of this essay, Muñoz cites a preface written by art historian Ernst Gombrich for the 1978 edition of Ernst Kris and Otto Kurz's book *Legend, Myth, and Magic in the Image of the Artist* (1934). In this preface, Gombrich mentions that Kurz dedicated the later years of his life to the study of iconoclasm in various religions and cultures, a detail that led Muñoz to embark on a journey that took him to the archives of the Warburg Institute in London, where Kurz had worked as a librarian. There he found Kurz's papers, revealing in minuscule print "hundreds of unconnected notes under the heading 'Prohibited.' " Muñoz wrote that "these notes must have allowed Kurz to trace out a detailed map of the prohibition of images in the history of representation."[19] In the end, Muñoz's impulse to pass beyond representation—or to abandon representation entirely—derives its meaning not from a desire for reductivism of the sort that iconoclasm yields but from an inexorable search to communicate, and to make art "speak."

The text-based performance aspect of Muñoz's work finds a different expression in the practice of **Ellen Gallagher**, whose elegant, labor-intensive paintings and collages pointedly refer to the myths of racist lore. The daughter of a white Irish mother and a black Cape Verdian father, Gallagher grew up in a working-class environment in Providence, Rhode Island. While studying in the late 1980s and early 1990s at the School of the Museum of Fine Arts, Boston, she became involved with the Dark Room Collective, a group of young African-American writers from Cambridge. Founded in 1988 as a place for authors to read their poetry and stories, the collective became an activist community of artists. The writings of Kevin Young, Thomas Sayers Ellis, Samuel R. Delany, and others informed Gallagher's own considerations of racial representation (or lack thereof) and stimulated her interest in crossing language with performance. In her collages, made on the pages of black magazines published from the 1950s to the 1970s during the Civil Rights Movement—including *Ebony, Our World, Sepia*, and *Black Stars*—Gallagher confers a sense of history and

Fig. 12. Ellen Gallagher. *Skinatural*. 1997. Oil, pencil, and plasticine on magazine page, 13 ¼ x 10" (33.7 x 25.4 cm). The Museum of Modern Art, New York. Gift of Mr. and Mrs. James R. Hedges IV, 2000

transformation (fig. 12). She erases or paints over the faces and eyes of black models and adds caricatural marks to disrupt historical signifiers that have naturalized black popular culture, fashion, and race, thus creating new images of the African-American body.[20] Much as Herrera produced quirky takes on childhood cartoon characters, Gallagher suggests a fine line between comic book imagery and outright stereotype.

Gallagher also embeds racial subtexts in otherwise abstract pictorial images. In her paintings *Bubbel* (2001; plate 12), *Oh! Susanna* (1993 and 1995; plates 13 and 14), and *They Could Still Serve* (2001; plate 16), minuscule marks of racist caricature—blubber lips, popping eyeballs, and Afro hairdos—percolate across the sheets of lined penmanship paper that cover the canvases.

Often built up in shallow relief, these shorthand signs look abstract from a distance. Only on closer scrutiny are they revealed to be stock derogatory emblems of black minstrelsy: ever-smiling Mammies, inky Sambo dolls, and slaving Uncle Toms. By inserting these provocative snippets on grade-school paper, Gallagher turns the whitewashed Minimalist grid of artists such as Agnes Martin into a "prison house of race talk."[21]

Gallagher also exposes Hollywood's propensity to infantilize blacks as simpleminded, uncivilized, and inferior. Popularized in the nineteenth century, the minstrel is a classic example of cultural domination in which white performers with blackened faces act out a comedy of manners about "blackness without blacks."[22] Rubbing burnt cork or shoe polish on their skin and sporting wooly wigs, gloves, and tails to lampoon black physiognomies and appearances, white comedians relentlessly portrayed African-Americans as a cast of buffoonish, lazy, and debilitated characters. In 1828 the actor Thomas Dartmouth "Daddy" Rice introduced his act "Jump Jim Crow," in which he poked fun at the song-and-dance of a crippled African-American by using wild upper-body movements with little mobility below his waist. By 1838 the name Jim Crow had become a racial slur. From the end of Reconstruction in 1877 until the beginning of the Civil Rights Movement in the mid-1950s, the term was synonymous with Southern segregation and discrimination. During the first two decades of the twentieth century, black pioneers of the stage, like Bert Williams, also performed in blackface (fig. 13), reclaiming the genre for black performers. Gallagher draws on the recitals of Williams, which she considers to be "an art not merely an act,"[23] and notes that in her own work the "disembodied eyes and lips refer to performance, to bodies you cannot see, floating hostage in the electric black of the minstrel stage."[24]

Mixing modernism and minstrelsy, Gallagher is familiar with the writings of Gertrude Stein, whose experiments with language are defined by a highly idiosyncratic, playful, repetitive, and at times humorous style, such as her famous statement "Rose is a rose is a rose is a rose."[25] This type of repetition is paradigmatic to Gallagher's work. In *Untitled* (1996–97; plate 15), the iteration of eyeballs, set in motion as they perform against the grid of penmanship sheets affixed to the top of the canvas, is made up of five parts: some of the eyes look straight ahead while others look up, down, right, and left. The work's meaning develops from the

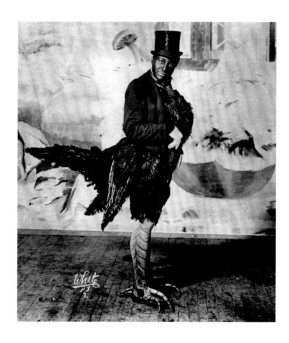

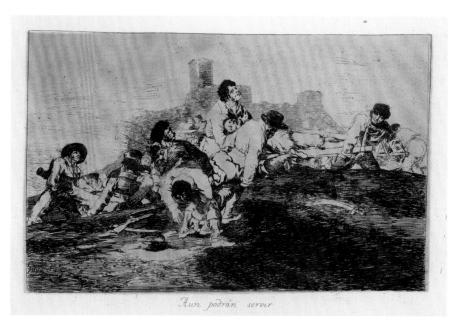

sequencing and looping that rely on the subtle differences between repetition and revision. Pointing to the influence of both Stein's use of language and Williams's performance style, Gallagher writes:

> You know I love Gertrude Stein. In fact I write like Gertrude Stein, like somebody who wishes she could write like Gertrude Stein. It is this notion of repetition and I think of Bert Williams and the way he repeats something again and again and the first time you hear it it's over here, the second time over there, and the third it jumps again to another place. It's like blues or hip-hop. You've got this original loop and then all these other rhythms that build off of it. So that anytime you come back to your loop it is always different, always displaced somehow even though it is the same beat or phrase.[26]

The shifting eyeballs reappear in *They Could Still Serve*, which takes its title from Francisco de Goya's etching *They Can Still Be of Use* from the series *The Disasters of War* (fig. 14), a caustic meditation on the brutality and futility of human warfare. "Bruised into a kind of caricature,"[27] as Gallagher puts it, the disembodied eyes in this work are reminiscent of lynchings and

other "caprices" of inhumanity. In *Oh! Susanna* from 1993, the accretion of hundreds of black-and-white eyeballs alternates with smiling bean-shaped lips in a dizzyingly abstract sea. Racial "equality" is reached through the clichéd blackface imagery that is punctuated by stingingly comic images of whiteness—profiled heads of blonde, blue-eyed women with Pinocchio noses. Although the interracial hybridity of this coupling finds full expression in the image of the Caucasian Negro that appears a decade later in the portfolio *De Luxe* (2005), here it still refers to an identity in search of a resolution to racial conflict. The title *Oh! Susanna* refers to Stephen Foster's American folk song of the same name (1848), which originated from a slave lament about families being torn apart. When the song became popular in the West it was associated with the California Gold Rush, and the racial element was eventually erased. In effect, Gallagher notes that "a very specific loss became universal once race was removed."[28] Gallagher's work disrupts the idea that race and identity are predetermined or fully fixed, and through parodic repetitions and inversions she reintroduces taboo aspects of history to question if core assumptions have changed.

Similar to Gallagher's concern with past and present social manifestations of racial difference, **Franz West**'s experience of art

Fig. 15. Otto Kobalek, Lisa de Cohen, Janc Szeni, and Franz West using Adaptives by West at the Wittgenstein House, Vienna, late 1970s

Fig. 16. Reinhard Priessnitz with an Adaptive by Franz West, 1975

Fig. 17. Film still from *Coney Island.* 1917. Left to right: Alice Mann, Fatty Arbuckle, and Buster Keaton

depends on social use. Consequently, for the last twenty years he has made variously interactive art in the form of portable or wearable objects, pieces of furniture, and inhabitable environments. West states, "It doesn't matter what the art looks like but how it's used."[29] This experiential spirit is critical to his body of work. West came of age in the late 1960s, a time when postwar Austrian art was overtaken by the iconoclastic, self-destructive, and quasi-mystical rituals of the Vienna Actionists: a group of artists, including Hermann Nitsch, Otto Mühl, Günter Brus, and Rudolf Schwarzkogler, who used blood, symbolic mutilation, and sex to protest against the conservative climate of the day. West was first drawn to the Actionists, but recoiled from their expressionist aesthetic and idea of cathartic pathos. Instead, he became

associated with an underground circle of bohemians that consisted of a mix of writers and musicians, artists, members of alternative communal-living groups, and philosophers.[30] Among them was the poet Otto Kobalek, West's half brother.

Described as a "Beckettian comic of the forlorn,"[31] Kobalek participated in the Viennese Happenings and literary cabarets of the 1960s and was in contact with members of an experimental collective of writers known as the Vienna Group. This consortium, which included Konrad Bayer, Gerhard Rühm, Oswald Wiener, and Reinhard Priessnitz, was engaged with the philosophy of language and semantic games, especially as postulated by the Austrian philosopher Ludwig Wittgenstein in his influential book *Philosophical Investigations* (1953). Wittgenstein examined

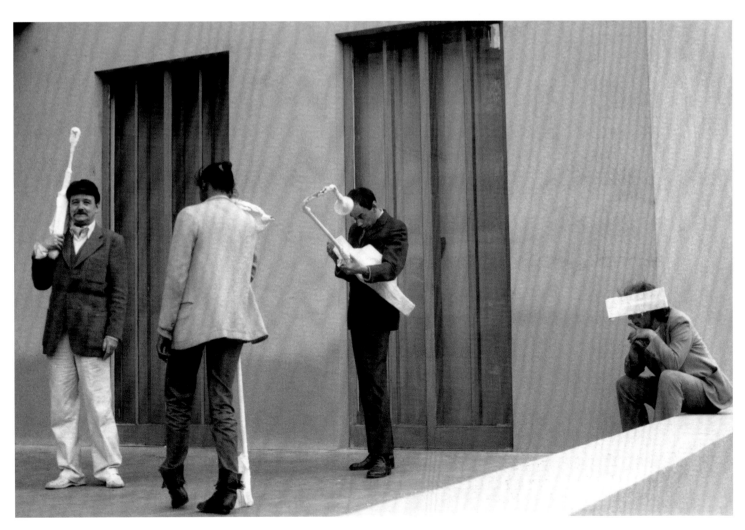

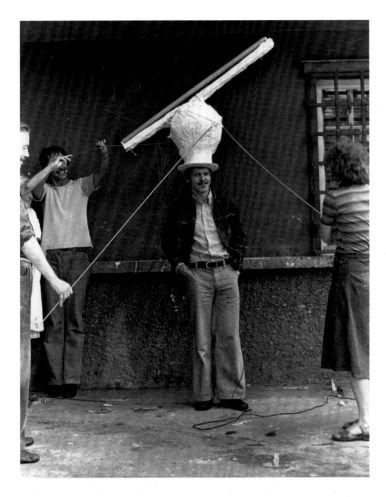

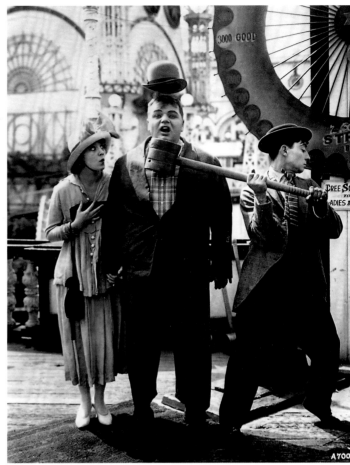

how the conceptual confusion surrounding language is at the basis of most philosophical problems, and concluded that the meaning of any word *is* its "use." He argued that a word's importance is not defined by reference to things, but by the way that word is employed. Two conclusions followed: first, that the meaning of words is not fixed, but instead changes within the context of their applications; and second, that meaning happens *between* language users in the public space of exchange. These intellectual deliberations were influential to West, who regards art as meaningless unless put to social use. In 1985 West produced *Wittgensteinzitat* (Wittgenstein Quotation), a sculpture of a scribble that the philosopher made in the margins of his book *Lectures and Conversations on Aesthetics, Psychology, and Religious Belief* (1968). In addition to Wittgenstein's influence, West was also close to Priessnitz, who became an intellectual mentor to him.

In the mid-1970s West began making a series of whimsical, portable sculptures, which Priessnitz termed *Passtücke*, loosely translated as "Adaptives." The term comes from Wiener's experimental novel *Die Verbesserung von Mitteleuropa* (The Improvement of Central Europe) (1969), which involves the concept of a "bio-adapter," a device that enables the human body to have a direct experience of reality which otherwise would be mediated by language. In a photograph from the late 1970s, West, Kobalek, and friends demonstrated how the Adaptives can be put to use by striking different poses and adopting different attitudes in an ad hoc performance held at the Wittgenstein House in Vienna (fig. 15). Made of plaster, papier-mâché, polyester, and bandage material

wrapped around wire frames, the Adaptives (plates 66–68) are abstract, oddly misshapen objects that the audience can handle, hug, cradle, or wield in any way desired. Disrupting the natural poise of the body and often leading to comic scenarios, they can turn even the most adroit participants into Buster Keaton performers (figs. 16–17). In this sense, Robert Storr astutely points out that the comedy of West's work is associative and implicitly corporeal rather than literal.[32]

When interacting with the Adaptives, one unlocks the hidden gestural life of his or her body in such a way that tension and anxiety as well as humor come to light. This explains why West defines these works as a "representation of neuroses," a seemingly apt description considering that Austria is not just the artist's birthplace but also the cradle of psychoanalysis.[33] These objects involve an equivocal system of postures and poses that are at once liberating and reminders of social repression. According to West, their genesis is linked to Kobalek's lexicon of "gesticologies," the theatrical posturing and aberrant grimaces his brother made when he talked. But the emphasis on gesture is embedded in a broader Austrian artistic lineage as well, including the arrestingly contorted physiognomies seen in Oskar Kokoschka's and Egon Schiele's portraiture that incorporates performance or puppetry.

In the mid-1990s West began making experiential environments in which he could present his work in combination with pieces made by other artists. In *Mirror in a Cabin with Adaptives* (1996; plates 64–65), he displayed four Adaptives outside of a cabin with a "how-to" video. The interior featured a mirror sculpture

Fig. 18. Michel Majerus. *Untitled.* c. 1995. Magazine page with paint, 10 ¼ x 8 ⅜" (26 x 21.3 cm). Estate of Michel Majerus

Fig. 19. Michel Majerus. *fuck off.* 2000. Synthetic polymer paint on canvas, 9' 11 ¼" x 10' 11" (303 x 333 cm). Boros Collection, Germany

conceived by the artist Michelangelo Pistoletto so that participating viewers could watch themselves interact with the objects. Explaining the significance of his work's social use, West says:

> I like the *Passtücke* very much, for one simple reason: the concept that you go to the museum and pick up the object. So, the object must not be behind glass, but should be presented as such that one can do something with it. Most people don't even know what to do with it. That is the experience I made. The videos show what others have done with it. But you can do something entirely different with it.[34]

Turning the museum space—a bastion of iconophilia—into a site for irreverent iconoclasm, and playing humor against aestheticism and abstraction against narrative allusion, West's Adaptives combine an art of reflection with an art of address.

When the artist **Michel Majerus** died at the age of thirty-five in a 2002 plane crash in his native Luxembourg, he left an impressive ten-year body of work made from images taken from art history, advertising, comic strips, computer games, film and television, and even music. For Majerus, art was a compendium of gestures and styles that could be digitally sampled, mixed, remixed, spliced, and sequenced into compositions through the layering tools of Photoshop. The software allowed him to weave his source materials to a greater degree than that seen in the work of earlier artists who embraced a similar collage aesthetic, such as Robert Rauschenberg or James Rosenquist. With the aid of computer technology, Majerus created a bold new brand of painting-based installations that were still made by hand. Grinning heroes from Super Mario Bros. video games and the animated film *Toy Story* bump against the work of Andy Warhol and Martin Kippenberger; lyrics from pop songs abut glossy advertisements; the graphic style snatched from flyers of the German techno music scene intersects with Japanese manga culture. Through his widely eclectic visual experiments, Majerus destroyed the divide between high and low culture.

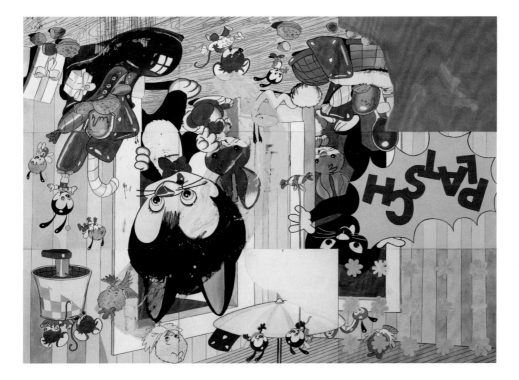

Part of a growing generation of artists living and working in Berlin after the Wall came down, Majerus had studied in the early 1990s with Conceptual artist Joseph Kosuth at the Staatliche Akademie der Bildenden Künste Stuttgart. Taking cues from the strategies of Pop and Conceptual art, he treated painting as a zone of contamination yet distinguished his work from that of his predecessors by experimenting with electronic media. Christoph Heinrich explains that, having grown up with computer and Internet access, Majerus had sought to convert his knowledge of "the 'cold,' new media to the traditional medium of painting directed by the warm hand."[35] The electronic genesis of his rapidly executed pictures produced a cool, precise, almost mechanized feel while the handmade rendition conferred an autographic expression. It was this jarring mismatch that Majerus's work aimed to deliver.

During his student years, Majerus was part of an artist's collective known as 3K-NH that produced two exhibitions in the two years of its existence. The first show, organized by Kosuth in 1992 at the Stuttgart academy, included Majerus's frieze of fifty small portraits derived from the animated sitcom The Simpsons, a satirical take on the middle-class American lifestyle. The following year, the second exhibition, held in Berlin—where Majerus had moved in 1993— included a mural in which the Nintendo figure Super Mario made its first appearance. A passionate Nintendo player, Majerus often quoted its imagery in his works. In 1995 he modified the image of Donkey Kong (fig. 18), taken from the cover of the magazine Donkey Kong Country 2: Diddy's Kong Quest. He emphasized the character's comically bulging eyes and engulfed the rest of the picture in a fog of thick paint. Majerus later reused the motif in the painting fuck off (fig. 19) by mixing it with fragments of lettering and painterly flourishes. His playful use of comics coupled with borrowings from digital culture was brought into full focus in his 1993 exhibition at Kunsthalle Basel, for which he produced the monumental Katze (fig. 20). Made of nine assembled canvases that juxtapose splinters of cartoon animations with unfinished colored areas, Katze reveals Majerus's sense of humor and deliberately superficial style. He transformed the cat's green eye from this work into a completely abstract sign in Untitled (62) (1996; plate 25), one of the small-format paintings from his "endless" untitled series (plates 22–27).

The influence of computer games recurs in many guises and forms in Majerus's work. A stack of boxes imprinted with the figures of Woody and Buzz Lightyear (plate 28), from Disney's first purely computer-animated feature film, Toy Story, echoes Warhol's Brillo Boxes. A later painting features the leggy figures that pepper the screen of the Atari video game Space Invaders. In 1994 Majerus developed the idea of a "walk-in painting" for his first exhibition at neugerriemschneider in Berlin (plate 31). Taking over the gallery's small quarters on Goethestrasse, he applied a layer of asphalt to the floor and covered the walls with panel paintings of abstract splashes as well as a floor-to-ceiling blow-up comic book. Turning the gallery space inside out, he animated it with the explosive energy of the street.

The new methods of image production that Majerus explored in his paintings seeped into the digital sources he used to make his multiscreen video installation michel majerus (2000; plate 29). Flashing across the surfaces of twenty-five stacked monitors is

fig. 20. Michel Majerus. Katze. 1993. Oil and synthetic polymer paint on canvas, nine parts, overall 23' 5" x 31' 8 ¾" (714 x 966 cm). Estate of Michel Majerus

the animated image of Majerus's constantly changing and morphing signature. As soon as it articulates itself, it disintegrates into a maelstrom of virtual layers. This work projects an abstract portrait of an artist flirting with the Warholian trope of celebrity as recognizable identity. At the same time, it creatively engages with the imagery of the music video industry. In conjunction with this video, Majerus composed a series of paintings highlighting his fragmented name. In *eggsplosion* (2002; plate 30), his signature serves as a foil for a cluster of eggs that refers to Kippenberger's egg mythology: the world as giant egg, the artist as "egg man," the egg as reproductive matter, and the egg as a symbol of resurrection (fig. 21). With his ever-present sense of humor, Kippenberger explained his obsession with the egg:

In painting you have to be on the lookout: what windfall is still left for you to paint. Justice hasn't been done to the fried egg.

Warhol's already had the banana. So you take a form, it's always about sharp edges, a square, this and this format, the golden section. An egg is white and flat, how can that turn into a colored picture? If you turn it around this way and that, you'll come up with something. Maybe even social politics, or jokes.[36]

Like Kippenberger, Majerus betrayed a fondness for such prosaic motifs. Within his work he created a space where banality could be deployed to make a joke for political ends, or to celebrate the profusion of images generated by the current media. Majerus wanted to absorb everything in his work, as he proclaimed with his usual casualness in a phrase inscribed at the bottom of *eggsplosion*: "catch 'em all!"

Similar to Majerus's engagement with the raucous imagery of popular culture, much of **Philippe Parreno**'s work questions the nature of images and the way they circulate in everyday life. "A good image is always a social moment," says Parreno, whose works are shaped less as images to be interpreted than as the interpretation of social acts.[37] Parreno's practice revolves around what he refers to as an "aesthetic of alliances," by which he means conversations, dialogues, and group debates with other artists, writers, architects, and scientists. Born in Oran, Algeria, Parreno studied at the École des Beaux-Arts in Grenoble in the 1980s. Since the early 1990s most of his projects have been developed in concert with his friends, artists Pierre Huyghe, Dominique Gonzalez-Foerster, Rirkrit Tiravanija, Liam Gillick, Carsten Höller, and Douglas Gordon.

In 1999 Parreno initiated his best-known collaborative project, *No Ghost Just a Shell* (1999–2002). Together with Huyghe, he bought the rights to a cartoon character that they named Annlee. She was purchased for the sum of 46,000 yen from Kworks, a Japanese agency that specializes in figures designed for use in anime films and manga comic books.[38] Unlike Apfelbaum's abstractions of strident female cartoon characters, the character Huyghe and Parreno purchased was a cipher that initially had no name or biography—she was just a two-dimensional image in a mail-order catalogue. Parreno recounts the genesis of this project: "In the beginning, we didn't necessarily look for a character with a human appearance, we wanted to buy a sign. Annlee was melancholic, and that's what resounded with us. We wanted to tell the

Fig. 21. Martin Kippenberger. *Untitled*, 1988. Oil on canvas, 7' 10 ½" x 6' 6 ¾" (240 x 200 cm). Private collection

Fig. 22. Stephen Shore. *Andy Warhol and Silver Clouds at The Factory*, 1966. Gelatin silver print. Collection of the artist

Fig. 23. Philippe Parreno. *Speech Bubbles*, 1997. Synthetic polymer paint and ink on synthetic polymer sheet, 11 ⅞ x 15 ¾" (30 x 40 cm). Collection of Jack Wendler

In one of his earliest projects, titled *No More Reality: Children Demonstrate in Schoolyard* (1991; plate 54), Parreno considers the function of protest in art. What kind of images should one use in a political demonstration? To help explore this question, the artist organized a workshop for the children at a primary school in Nice. The utopian demands made by the young students—for instance, to have snow in summertime—applied the mechanics of politics to completely apolitical causes. Seeking to transform the world, not just interpret it, the group marched with placards reading "No More Reality."[44] For a related project, titled *Speech Bubbles* (1997; plate 53), Parreno devised a cluster of unmarked, white helium-filled balloons made in the shape of comic book bubbles. The installation nods to Warhol's *Silver Clouds*, mylar balloons in the shape of oversized pillows that the artist produced in 1966 and exhibited at Leo Castelli Gallery (fig. 22). Parreno's balloons playfully float in the air like abstract shapes, recalling the carnivalesque atmosphere of Warhol's silver-coated studio—a.k.a. The Factory—yet the allusion to the notion of the factory is multifaceted: *Speech Bubbles* was originally conceived for the Confédération Générale du Travail (French Union Association) to serve as a tool for organized protest and a model of political representation in a French workers' union strike (fig. 23). The piece was intended to allow individuals to write in their own shibboleths, or, as the artist put it, to "mark in their own demand, while still participating in the same image."[45]

While Parreno's *Speech Bubbles* transform viewers into politicized cartoon characters, Brazilian artist **Rivane Neuenschwander**'s work

history of a sign."[39] Parreno and Huyghe invited fifteen artists to give life to this virtual persona in the form of short video animations. The aim was to flesh out a character with no fixed identity. With each personification, Annlee earned different psychological traits, spoke different languages, and experienced different stories, becoming a blank screen onto which individual fantasies and ideas could be projected.

In Parreno's stirringly poetic piece *Anywhere Out of the World* (2000; plate 56), Annlee speaks in the voice of an actual fashion model whom the artist interviewed. She explains in a deadpan voice that she is a commodity designed to sell fantasies to others: "I belong to whomever is able to fill me with any kind of imaginary material. Anywhere out in the world, I am an imaginary character. I am no ghost, just a shell."[40] In Huyghe's scenario, *Two Minutes Out of Time* (2000), Annlee includes the viewer as an intimate part of her story: "I have become animated, however not by a story with a plot, no . . . I'm haunted by your imagination . . . and that's what I want from you . . . See I'm not here for your amusement . . . You are here for mine!"[41] And in Gonzalez-Foerster's version, Ann Lee [sic] in *Anzen Zone* (2000), a doubled Annlee speaks in a threatening tone in competing English and Japanese: "There will be no safety zone. You will disappear into your screen. I make this promise. I promise you."[42] Immersed in a chillingly virtual reality is an animated character with an utterly human dimension. In December 2002 Annlee had her final incarnation as a fireworks display at the Art Basel Miami Beach art fair—the perfect site for a commercially acquired image to bid farewell and vanish into the sky, taking her copyright with her (plate 57). Philip Nobel remarks that *No Ghost Just a Shell* is an experiment about "naming and signification, the creation of a platform for artistic community, even about the perils of copyright in the digital

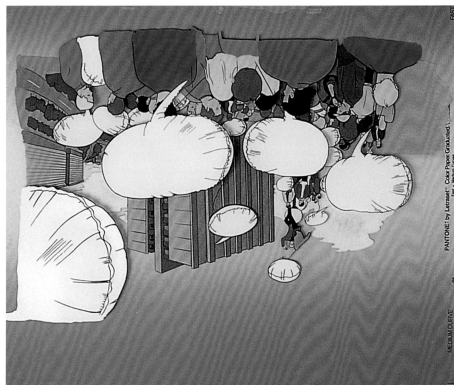
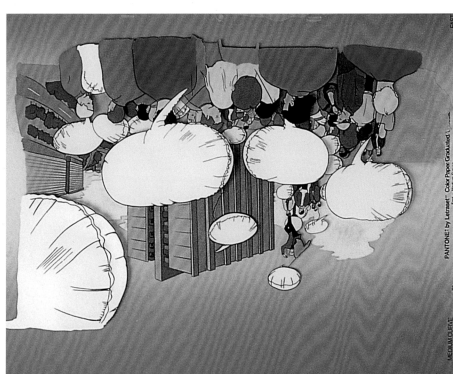

allows them to step *inside* a comic book. Neuenschwander is inspired by Parreno's inquiry into the life of images, but her own exercises with language games and politically conscious abstractions lie closer to the 1960s work of Brazilian Neo-Concrete artists such as Lygia Clark and Hélio Oiticica. In her series *Involuntary Sculptures (speech acts)* (2001–02), makeshift objects constructed out of "poor" materials distinctive of Clark's and Oiticica's oeuvres bear the traces—as cited in the parenthetical title—of places where speech is particularly present. She made these miniature assemblages from napkins, straws, matches, and matchboxes during conversations with friends in cafés and restaurants. In one sense, these small works constitute an inventory of the artist's oral activities. In both construction and title they also relate to Brassaï's *Involuntary Sculptures* (1933)—photographs of everyday ephemera transformed into mysterious artifacts—that were published in the Surrealist magazine *Minotaure*. Neuenschwander's interest in communicative systems takes yet another form in her series of drawings *Starving Letters* (2000), for which snails were tirelessly directed by the artist's hand to gnaw at letter-sized sheets of rice paper. The result is an organically abstract alphabet that alludes to the idea of garbled communication and "eating one's words."

Like Apfelbaum and Herrera, Neuenschwander also tackles the politics of Disney. For thirteen series of drawings titled *Zé Carioca. Edição Histórica, Ed. Abril* (2004; plates 46–52) she dismantled a historic edition of Zé Carioca, a popular Brazilian comic book published by Disney. This commemorative edition, containing stories published between 1942 and 2003, was released to mark the sixtieth anniversary of the series, which incorporates aspects of Brazilian culture and language. Neuenschwander took each page of a story and overpainted the cartoon figures in bright monochrome colors. She also covered the dialogue in the text bubbles with white paint so that no text remains on any of the pages. Her abstractions point to the influence of Raymundo Colares, who was also inspired by the American comic books that he read in his youth. In 1968 he developed his series *Gibis*, intricately crafted books made from colored paper cut in abstract geometric forms. The beauty of Colares's books lies in their ever-changing formal compositions: as viewers turn the pages, visual planes morph and unfold. By obliterating the characters, words, and narrative structures in *Zé Carioca*, Neuenschwander turns each page of the comics into an abstraction, inviting viewers to imagine their own stories and dialogues.

Zé Carioca, a soccer-playing green parrot whose name loosely translates as "Joe from Rio," can be understood as a stand-in for the Brazilian everyman. He was created in 1941 when Walt Disney visited South America with the aim of supporting American relations with the region during World War II. In 1943 the character came to life in the animated classic *Saludos Amigos* (*Hello Friends*) as a singing, dancing trickster who gyrated to the samba music of carnivale. The nonchalant Brazilian parrot is both a sympathetic character and a swindler—a comic hero who tries to gain fortune without exerting much effort (figs. 24–25). Having grown up with cartoons, Neuenschwander recalls that at times Zé Carioca

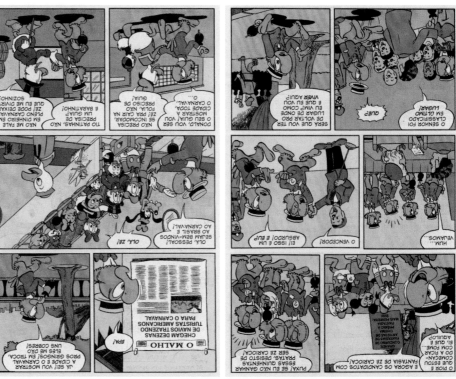

Figs. 24–25. Two pages from *Zé Carioca no. 4,
A Volta de Zé Carioca [The Return of Zé Carioca]*
(1960) (Edição Histórica, Ed. Abril)

acted in stories with nationalistic overtones. She says, "His character was based on a stereotypical cliché of the Brazilian, or more precisely, the *Carioca* (someone born in Rio de Janeiro): street-smart, lazy, a lover of soccer and samba, a flirt and a swindler. The cliché of the cliché, he ended up helping to crystallize the national image of the *malandro* (rascal)."[46] Carrying Disney's imprimatur, Zé Carioca is typecast in stories whose titles, like "How to Get Lunch for Free" (1942) and "Soccer Champion" (1955) (plate 47), cement the stock image of Brazilians as imagined by the American entertainment industry. Yet this depiction is never purely disparaging. It includes elements of affection and ridicule, mimicry and aversion, typecasting and accurate portrayal, while translating an American idiom into a more localized character that straddles the line between nationalism and internationalism.

Fascinated by the character's social ambivalence and how stereotypical images are produced and perpetuated, Neuenschwander returned to the motif of Zé Carioca several times in varying formats. In the first series, she abstracted the pages of comic books while retaining their original titles and dates. Then she composed a second series in which she transposed the abstract sheets onto the wall (fig. 26). Each panel became a large blackboard upon which viewers could draw and write stories, or even alter narratives by adding layers to existing marks. The accretion of lines creates an increasingly puzzling image that can be seen as a composite picture of Brazil. Neuenschwander's last series pertaining to Zé Carioca was done at the Saint Louis Art Museum in 2005, when the artist was invited to organize a workshop with students from local schools. Without telling the students that Zé Carioca is a parrot, she described Disney's trip to South America and asked them to create their own characters to portray present-day Brazil. Disney's original enterprise engaged in "manufacturing" a narrative fantasy out of a corporation's own myth-making schemes.[47] The students' new characters, which ranged from a peacock with Nike tennis shoes to an anteater, restaged Disney's cartoon imaginings in ribald fashion while also denting the credibility of a single representation of an entire culture.

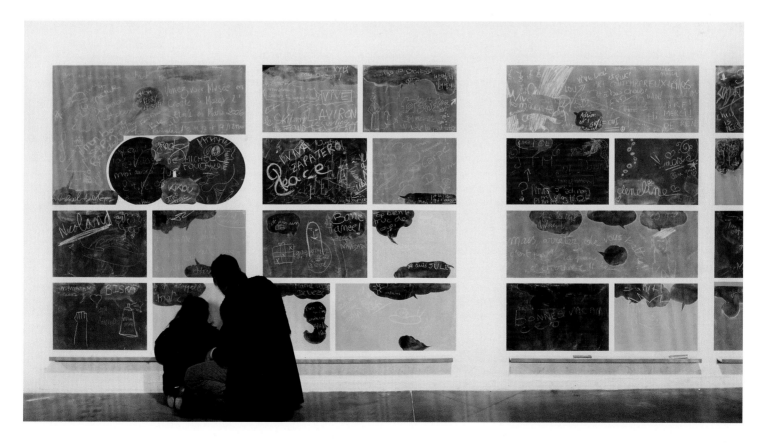

Fig. 27. Gary Simmons. *No. 4 Green* from the series *Erasure.* 1992. Chalk on paint on paper, 27 ¾ x 20 ¼" (70.5 x 51.4 cm). Collections of Peter Norton and Eileen Harris Norton, Santa Monica

Akin to Gallagher's racially encoded doodles on penmanship paper and Neuenschwander's subversive reworkings of comic books, **Gary Simmons**'s chalk drawings on blackboards of partially erased cartoon characters address ethnic typecasting in pedagogical settings. Simmons's interest in the blackboard as an artistic vehicle began after he completed his studies in 1988 at the School of Visual Arts in New York and took occupancy of his first studio, located in a classroom of a former vocational school in midtown Manhattan. A couple of years later he moved to Los Angeles to pursue graduate school at CalArts and planned to collaborate with a fellow student on a film about childhood education. This project led him to examine how one's formative memories are constructed through cartoons and Hollywood animated films, and to search for embedded stereotypes. Simmons says:

> Looking at *Dumbo* or *Snow White and the Seven Dwarfs*—all those great Disney films—I began thinking critically about them. *Dumbo* stuck out the most because of the crows. I found that when I talked about these crows there was a division along racial lines in memory and that struck me. A lot of black folks remembered them because they identified with the stereotypical shucking and jiving crows, and a lot of people who were not of color did not remember them at all.[48]

The artist's memories of racial division lurking inside seemingly innocent, race-neutral images are at the root of his work.

Simmons's works from his *Erasure* series, including those that are part of the series *Black Chalkboards* and *Green Chalkboards*, both from 1993, are populated by cartoon characters from films of the 1930s and 1940s who embody racial stereotypes (plates 59–62). For instance, Dumbo's servants—a group of crows led by the head bird named Jim Crow—speak in a black, colloquial dialect (fig. 27). *Little Ol' Bosko and the Pirates* features a monkeylike character, later made into a little African-American boy with exaggerated features. In some cases, the emphasis is placed on specific parts of their physiognomies—the thick-lipped smile of *The King* (plate 59) or the wide-open eyes of *Toothy Grin* (plate 61)—because, Simmons explains, "there are those old jokes: 'Open your eyes or smile, so I can see you in the dark' or 'Don't shoot until you see the whites of their eyes.' "[49] In a sprawling chalk and slate paint mural titled *Wall of Eyes* (1993; plate 58), Simmons assembled the eyes of cartoon figures from his previous works into an allover composition and then partially erased them. The result is a smeared, murky, out-of-focus field of disembodied eyes in which one can still read cartoonish expressions of surprise, panic, gloom, and hilarity. Simmons's objective is not to eradicate the racial imagery but, rather, to cast a critical light on it and thereby make the act of looking less passive. His gestures of erasure create traces of a ghostly presence, confronting viewers with indiscernible specters of a troubled past.

Simmons expends as much energy erasing his drawings as he does constructing the images. After meticulously drafting his

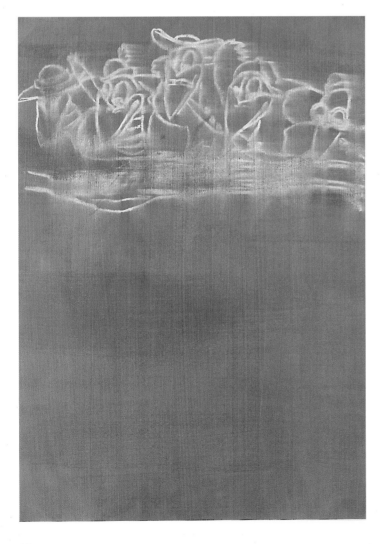

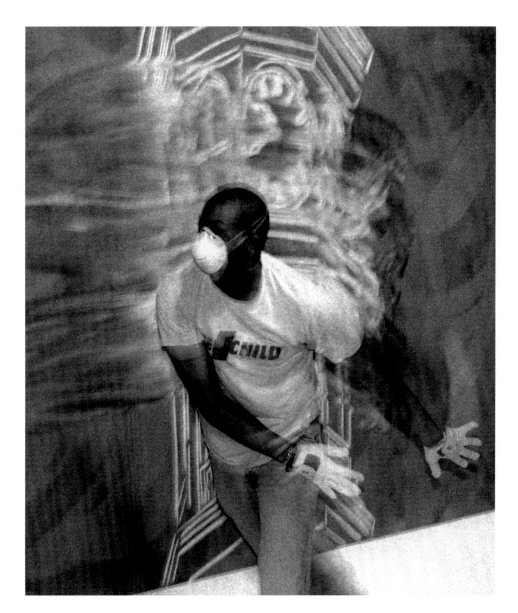

pictures, he attacks the sketch with his hands clad in thin golf gloves (fig. 28), which allow him to feel the surface of the wall and vary the amount of pressure needed to wipe out a drawing without completely destroying it.[50] Each drawing bears evidence of the physical labor and tactility of its creation and destruction: trails of dusty handprints and strokes of white chalk read like racist ciphers flaring up through heavily worked surfaces. Like Rauschenberg's provocative 1953 erasure of a drawing by de Kooning, Simmons presents an extreme version of drawing as a process of subtraction. Resistant to closure and fixity, Simmons's ephemeral lines evoke the haunting and uncertain texture of memory, the discontinuities that memory provokes, and the moral struggle against the erosive power of forgetfulness.

In 1996 Simmons produced a new series of erased drawings, including *Reign of the Tec* (after the automatic weapon Tec-Nine), *Blow Out*, and *Mr. Ricochet*, which depicts clouds pierced by speeding bullets. A related mural of the same year, *boom*, shows a cloudburstlike blast that carries uneasy associations with images of war (plate 63). Simmons likens it to the classic cartoon scenario in which two figures fight, their bodies clash, and then disperse into an explosion that suggests both motion and matter. In comics, the blast "is a comedic trope for violence," he says. "It is fascinating the way violence entertains people. Cartoons are the first and earliest form of getting pleasure from a violent act. This explains why *boom* is such an important piece."[51] Simmons's observation recalls Salvador Dalí's jesting remark: "Every time someone dies it is [Walt Disney's] fault."[52] In terms of sensorial sources, *boom*'s explosive sound derives from a study called *Boombastic* (1996), which takes its punning title from a popular dancehall song reliant on deep, penetrating bass.

Seeking to saturate the viewer's senses, *boom*'s onomatopoeic effect approximates the visual noise of street culture. It resonates with the anarchic energy of hip-hop and graffiti art that defined Simmons's youth in New York City, when he would decorate the concert jackets of high school pals with airbrushed designs lifted from record album covers. While Simmons examines the means by which racial stereotyping is imprinted in American history through his erasure drawings, *boom* is a celebration of black music and empowerment within mainstream American culture.

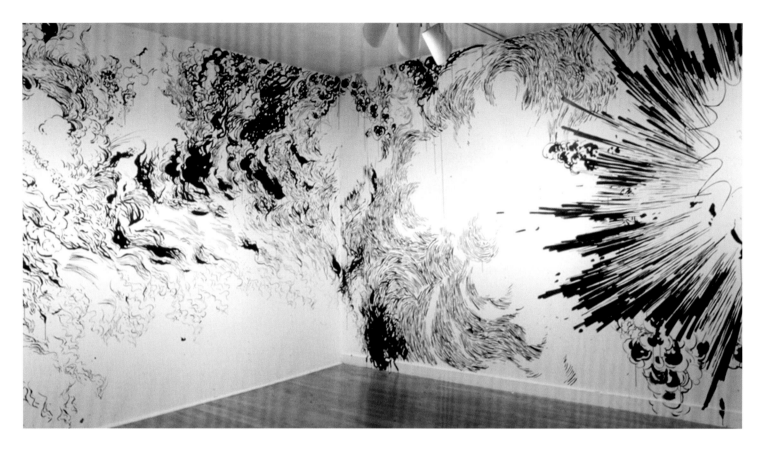

Julie Mehretu also explores the possibilities of working directly on the wall (fig. 29). Her paintings—like the walls of a city covered with inevitable graffiti—convey the chaos of large metropolises, marked by mass migration, warfare, and political riots. Generating a new form of history painting, Mehretu extrapolates bits of architecture and history from her own itinerant experiences to create synthetic worlds that shatter into numerous pictures and stories. Born in Ethiopia's capital, Addis Ababa, she grew up in Lansing, Michigan, studied in Providence, Rhode Island, and Dakar, Senegal, and currently lives and works in New York. Her laboriously layered paintings mine a span of art history as broad as her own nomadic geographical trajectory. Influences include Vasily Kandinsky's abstractions of dazzling colors and geometric lines, dots, curves, and arcs; the whooshing vectors of the Italian Futurists, defined by their thirst for speed, dynamism, and mechanized warfare; the politically engaged cartographic impulses of the Situationist International during the 1950s and 1960s; and the iconography of contemporary comic books and graffiti.

Born in 1970, at a time when Ethiopia was attempting to create a utopian society under the influence of a pro-Soviet Marxist-Leninist junta, Mehretu became fascinated by activist ideals. Kandinsky's essay "The Great Utopia" (1920), in which the Russian artist explored the revolutionary potential of abstract painting in the wake of the Russian Revolution, was instrumental to her artistic creations, in which personal and social, historical and fictional communities collide. At the root of such juxtapositions lies Mehretu's ability to envision ties with more than one place at a time and to create a model for a new type of community that is not exclusively nationalist or inclusively global, but rather unreservedly cosmopolitan. The term cosmopolitan refers to dwellers

of the world, including the particular experiences of exiles, immigrants, nomads, and the diaspora, whose sense of belonging, or of home, is constructed in the process of relocating to one part of the world while preserving attachments to another. This idea helps to explain Mehretu's emphasis on places of transit and systems of motion: airports, highways, subways, flight patterns, wind and water currents, comic book pyrotechnics, and satellite trajectories all appear in her work.

Mehretu produced *Bombing Babylon* (plate 35) in 2001 with multiple influences at play. Umberto Boccioni's *The City Rises* (fig. 30), an important Futurist exaltation of action, speed, and the effects of simultaneity and kinesthesia, finds resonance in this work, as does a found comic book image titled *Bloom! Bawoom!* (fig. 31), which illustrates two explosions. Bursting with colors, sights, sounds, and movements of people from one place to another due to war and conflict, the painting harks back to the brand of modern iconoclasm espoused by the Futurists. Energetic arcs of black ink express gestures of protest, while vibrant red and orange fireballs scrounged from cartoons twinkle and gambol, all fomenting the possibility of civic uprising. Mehretu's method of configuring a dynamic urban design as a set for displaced communities echoes the ideas of the Situationist architect Constant, whose drawings for a utopian project called *New Babylon* (1958) detail high-tech mobile megastructures that would constantly evolve and move across European cities.

Mehretu's own movements—shuttling between the African and North American continents in a contemporary personification of the African-American—are conjured in *Retopistics: A Renegade Excavation* (2001; plate 33). The artist explains: "I wanted *Retopistics* to be made of the conglomerate of all airport plans.

As I was looking for them, I realized that the most economically viable countries provide plans for their airports. I found so many maps for international airports in the U.S. and Europe. Ethiopia, however, had none: the Addis Ababa airport is just a box."[53] Mehretu articulates travel as an alternative form of communality outside the national space. In addition to spaces of transit, where people from different parts of the world conglomerate, the painting also includes populist amphitheaters and sports stadiums as well as plans for public buildings by architects Bernard Tschumi, Tadao Ando, and Zaha Hadid.

In *Looking Back to a Bright New Future* (2003; plate 32), Mehretu articulates her long-standing interest in the legacy of modernist visionary architecture by combining the 1950s urban plans of Lúcio Costa and Oscar Niemeyer for the futurist city of Brasília with an imaginary rendition of the biblical Tower of Babel. Bold red sunbeam-style lines radiating from a central point on top of the composition allude to Soviet graphic propaganda designs of the 1920s. With its kaleidoscopic multiplication of cartographic fantasias, zany dance of machine parts, and foray into abstraction, the work conveys a sense of "speed, dynamism, struggle, and potential," capturing the early twentieth-century utopian promise of a better future.[54]

Empirical Construction: Istanbul (2003) is Mehretu's first painting dedicated to one particular city. Istanbul—the only metropolis in the world that is geographically situated on two continents—boasts syncretic, cross-cultural Asian and European influences that articulate the possibility for a wider mode of belonging. In a whirling diorama of the Turkish capital, the architecture and geography seem to be in fervent animation. Mehretu worked on this painting from a series of photographs of the Old City taken from the top of Galata Tower in a 360-degree circle. She inserted urban elements in a weightless, domelike form inspired by the Hagia Sophia—one of the greatest surviving examples of Byzantine architecture that has served as both a Christian Greek Orthodox church and an Islamic mosque—and mixed them with blueprints outlining the modernization of Turkey. Punctuated by the ebb and flow of graphic brushfires and the abstracted consumer logos of global communication systems and capital exchange, the painting conveys the identity of a city that is cosmopolitan, frenzied, and in a perpetual state of becoming, while also suggesting a tense rapprochement between religions and cultures in the post 9/11 era.

Teeming with details that have been drawn, painted, sprayed, stenciled, and traced, *Black City* (2005; plate 34) is Mehretu's most cinematic montage of architectural plans. The painting conflates two building types—the sports stadium and the armed stronghold—and constructs them in numerous layers. A field of black shapes applied on primed canvas structures the space, while a coating made of sanded acrylic silica creates an atmospheric space between the ground and the subsequent layers. Additional tiers of densely packed plans of military and athletic fields are applied, creating an interpenetrating series of almost

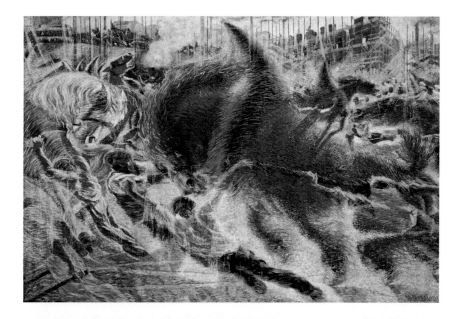

archeological strata. Inscribed on a final veneer are minute buzzing hives of hundreds of abstract Lilliputian figures. These "characters," as the artist calls them, rendered in a playful scrawl of dots and hatching, are agents of change. They act like superhero figures in comic books, fighting against malevolent forces, escaping cartoon explosions, overthrowing obsolete systems, and performing miraculous deeds.

Like Mehretu, **Inka Essenhigh** sees her canvases as arenas for action. Her comically exaggerated scenes of goofy calamity and cyborg-mutations are informed by media-driven millennial obsessions, among them the fear of faceless terrorism[55] and the morphing reality of cyberspace. Offering a sense of "futuristic déjà-vu," her paintings have been variously described as "surreal riffs on Japanimation," "Disney-meets-manga," "manga-meets-[Roberto] Matta," and a "cross between Rube Goldberg and Raymond Roussel."[56] In each of her paintings, Essenhigh invents a synthetic world peopled by a tribe of stylized superheroes. She plays with the spatial plasticity of perspective and foreshortening in ways that are similar to computer-generated environments and dear to cartoonists. Like Plastic Man, Mr. Fantastic, and other rubbery characters, her endlessly malleable figures have the ability to mold their bodies into any conceivable shape.

In 1996 Essenhigh painted her first cartoonlike figures on monochrome backgrounds in a series of "wallpaper" paintings. In *Wallpaper for Girls* (1996), repeated images of uniform, toylike female figurines with comically exaggerated and twisted bodies are aligned in a pattern. Using high-gloss industrial enamels, she flattened the picture plane, seeking to emulate the shallow, artificial space of Japanese comic books and films, which provide a sense of escape from the experience of everyday life. The artist notes that the "plastic look of surfaces conveyed by the enamel paint gives [her] paintings their ultimate content."[57] Essenhigh's views are similar to those articulated by Japanese artist Takashi Murakami, who asserts that the world of the future promises to look like the Japan of today, a world in which comics, entertainment, and mass-media industry yield an exceedingly two-dimensional view of existence. Essenhigh also presents her vision of an imaginary future by reshaping the influence of science fiction comics in light of digital technology and the flat surfaces of television screens, laptops, and electronic billboards.

Between 1996 and 2000 Essenhigh made a series of paintings distinguished by crisply polished colors, immaculate facture, sharply outlined contours, and lack of visible brushstrokes. The graphic punch, pliancy of line, and supple shift of one form into another adds to her stylized, abstract compositions a sense of humor reminiscent of cartoon animations. Slapstick actions, rising at times to grotesque heights, are set against dark scenes of apocalyptic devastation, nuclear holocaust, and unnerving genetic mutations, such as flooding in *Deluge* (1998), all-consuming fire in *Volcanic Ash* (2000), war in *Explosion* (1999; plate 10), and surgical intervention in *Reconstruction* (2000; plate 9).

Like some of her contemporaries, including Murakami, Matthew Barney, and Mariko Mori, Essenhigh's world is one in which invasive technology has altered human anatomy. *Fountain of Youth/Florida State Seal* (1999; plate 11) portrays a Disneyesque theme park setting with an artesian fountain at its center, out of which emerges a body shaped by a comically mutant force of nature. The work is a parable about the dream of immortality, which is achieved in advanced capitalist society through prosthesis, plastic surgery, genetic engineering, cloning, and other kinds of biomechanical syntheses. Essenhigh draws upon experiences of athletic training and technological streamlining, blurring the distinction between organic creatures and inorganic machines. In *Cheerleaders and Sky* (1999; plate 8), an exuberant turquoise sky sets off abstract figures dressed in sports gear. Its overall effect recreates the Rococo buoyancy of Giovanni Battista Tiepolo's eighteenth-century ceiling frescoes. Yet, in Essenhigh's painting, Tiepolo's pantheon of heavenly creatures, cherubs, and allegorical figures is substituted by a group of mechanomorphic cheerleaders, who now usurp the throne once reserved for the Virgin Mary or Cleopatra. Headless, faceless, and devoid of human consciousness, these figures "mimic the future," a future in which, the artist says, all is "made of plastic material that won't decompose."[58]

What does Essenhigh's strange conjunction of athletics, fashion, and technology add up to? It could certainly be a mythology for and about a contemporary American society seeking to transcend human obstacles and attain inorganic perfection. The artist comments: "I see [my work] as being about America: fake, fun, pop, violent, but also quite attractive."[59] In *Born Again* (1999– 2000; plate 7), Essenhigh proffers the rebirth of America as a

Fig. 32. Takashi Murakami. *ZuZaZaZaZaZa*. 1994.
Synthetic polymer paint and silkscreen on canvas
mounted on board, 59 x 67" (150 x 170 cm).
Ryutaro Takahashi Collection, Tokyo

nation vibrating with a futuristic anime quality. The painting
presents a morphing human body halfway to becoming some-
thing else. It is a force still without form, but one with infinite
possibilities. Humor in this case is precisely the offshoot of
altered realism.

A leading figure of the recent Japanese cultural explosion,
Takashi Murakami, like Essenhigh, identifies cultural and political
meanings in his abstract and figurative motifs culled from anima-
tion and comic books. Infused with humor, his art also tends to be
dark, touching on the complicated circumstances of contemporary
Japanese identity created by World War II. Murakami's early ambi-
tion was to be an animator in the style of the pioneering Japanese
filmmaker Yoshinori Kanada, who in the late 1970s and early
1980s produced a type of science fiction animation featuring the
sequential image of an explosive fireball. Impressed by this image,
Murakami playfully used it in his later work. After receiving his
doctorate in 1993 from Tokyo's National University of Fine Arts
and Music in *Nihon-ga* painting, a national style fusing traditional
Japanese and Western painting techniques, Murakami became
involved with the subculture of *otaku* (the term applies to fans of
anime and manga).

Over the next few years, Murakami developed the main points
explored in his text "The Superflat Manifesto" (2000). His use of the
term "superflat" refers not only to today's plasma-screen-oriented
generation but also to his belief in the leveling of distinctions
between *geijutsu* (arts and crafts) and *bijutsu* (fine art). To prove
his thesis, Murakami traced the stylistic principles of his work
back to the *Ukiyo-e* tradition of the Edo period (1603–1868).
Ukiyo-e, or "pictures of the floating world," is a school of Japanese
printmaking that depicts secular scenes from the entertainment
world of teahouses, Kabuki theater, and geishas. The prints fea-
ture flat, decorative colors and expressive patterns. Murakami
found inspiration in the nineteenth-century *Ukiyo-e* artist
Katsushika Hokusai, artists Andy Warhol and Jeff Koons, and the
animator Kanada. Murakami has repeatedly underscored the
similarities of each artist's intentional, gradual flattening of the
picture plane.

Championing the global crosscurrents of contemporary culture,
Murakami established the Hiropon Factory on the outskirts of Tokyo
in 1995. In 2001 he opened the Kaikai Kiki Studio in New York.

While Hiropon takes its name from the Japanese word for speed—
a popular, recreational drug in postwar Japan—its structure is
modeled on Warhol's Factory. Yet, with one hundred employees,
Murakami's complex system of studio production supersedes
Warhol's prototype. He has expanded on the Warholian trope of
an "artist's studio as small business" by making his own enter-
prise into an international conglomerate that mimics and adopts
the expansionist logic of capitalism. Murakami's business model
seems closer to Disney's Pixar Animation Studios or George
Lucas's Lucasfilm: Hiropon Factory and Kaikai Kiki Studio are
involved with the creation of artworks and animated films and
with the production and distribution of lucrative commercial
objects such as toys and handbags.

In 1993 Murakami and his assistants produced a trademark
character titled Mr. DOB (Japanese slang for "why?"). The direct
offspring of a robotic cat named Doraemon, Mr. DOB is also a
distant relative of Disney's Mickey Mouse. Mr. DOB has taken on
various guises, ranging from a smiling little mouse who is shot
into space on a spurt of suggestive white liquid in the painting
ZuZaZaZaZaZa (fig. 32) to a demonlike representation of chaos
in *727* (1996; plate 41). This intrepid rodent hero has also appeared
in many other paintings, inflatable balloons, and merchandise,

Fig. 33. Takashi Murakami. Installation view
at Turin Triennale, 2005. Figure: *Hiropon*. 1997.
Painting: *Cream*. 1998

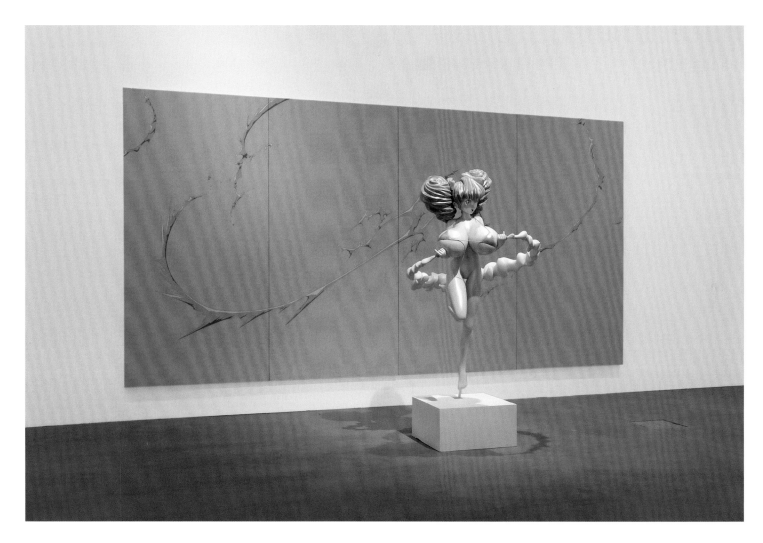

and represents for Murakami a symbol of the two opposing but interlinked tendencies that shape Japan's postwar identity—one angling toward cuteness and infantilism, the other toward violence and destruction.

The painting *Super Nova* (1999; plate 45) blends equal doses of fantasy, apocalypse, and innocence. It consists of a frieze of candy-colored psychedelic mushrooms bearing exaggerated round eyes adorned with three eyelashes, a convention for depicting Occidental features derived from manga and anime. The mushrooms are aligned on seven silver panels, which form a continuous image over thirty feet long when they are joined side by side. The work's scale and motif conjure up unsettling memories of mushroom cloud blasts resulting from the two atomic bombs—

"Little Boy" and "Fat Man"—that American forces dropped over Hiroshima and Nagasaki in 1945. The traumatic attacks suffered by Japan inform not only Murakami's art but also his curatorial projects, in particular the exhibition *Little Boy: The Arts of Japan's Exploding Subculture*, which he organized in 2005 at the Japan Society in New York. Taking its title from the codename for the nuclear weapon detonated in Hiroshima, the exhibition explored Japan's postwar "dependency on the U.S. as 'protector' and 'superpower.' "[60] Alexandra Munroe explains that this condition began with the devastation of the atomic bomb and the succeeding American-led occupation from 1945 to 1951 and continues today, "resulting in a willful negation of both adulthood and nationhood."[61]

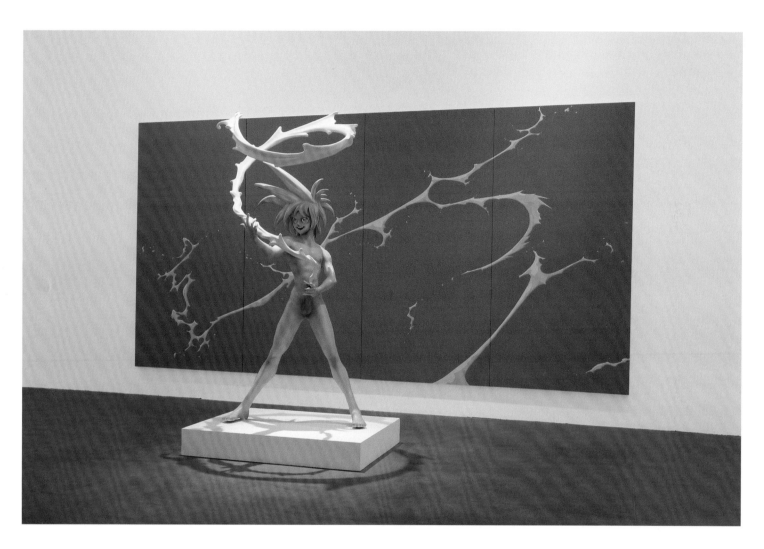

Murakami's first life-size painted fiberglass sculpture *Miss Ko²* (1997; plate 42), a high-breasted, stiletto-heeled, blonde porn star look-alike pilfered from a popular Japanese animated cartoon, expresses the fraught juvenile mentality at the core of Murakami's *Little Boy* thesis. With one arm extended to the viewer in a friendly greeting and the other pointing downwards, fist clenched in martial arts fashion, her passive-aggressive pose evinces "Japan's psycho-sexual complexes."[62] The impossible proportions of *Miss Ko²*'s physique, with her grotesquely inflated breasts, reduced waist, and elongated legs, depict the limitless potential of the modern body in the age of silicone implants and liposuction. Murakami's superwoman suggests that fantasy can now dictate human form.

Miss Ko² is the source for two other erotically charged sculptures, *Hiropon* (fig. 33) and *My Lonesome Cowboy* (fig. 34). *My Lonesome Cowboy* depicts a sneering, nude cartoon boy with a gravity-defying jet of semen spiraling up into the air like a lasso. *Hiropon* portrays a young woman with unnaturally large, bright eyes and even more oversized breasts jumping a rope formed by streams of milk flowing between them. Speaking of these figures, Murakami points out that "like Hokusai's pictures, sex in Japan is stylized."[63] His viewpoint is not surprising since the erotic manga genre developed from the uninhibited woodblock prints of the Edo period. Hokusai first introduced the term manga to describe his own fifteen-volume collection of cartoons, *Hokusai Manga* (1814). He became famous for his series of prints *Thirty-six Views*

of Mount Fuji (1830–32) that also includes *The Great Wave at Kanagawa* (fig. 35). Depicting a dramatic wave in motion, Hokusai's seascape influenced Kanada's cosmic eruption seen in his 1979 signature film *Galaxy Express 999.* Evoking the destructive powers of the atomic bomb, Kanada's film in turn paved the way for the burgeoning market of Japanese anime of the 1980s and 1990s that revolved around the imagery of nuclear explosions and postapocalyptic salvation.

Directly adapted from Kanada's film, Murakami's *Splash* paintings belong to a series of abstractions that include *Cream* and *Milk*, both of 1998 (plates 43 and 44). In these two panoramic paintings, a liquid line arcs across gendered, color-coded blue and pink backdrops. The abstract splashes allude to the fertile fluids discharged by the figures in *Hiropon* and *My Lonesome Cowboy*, and when paired with the two sculptures, the paintings epitomize the figures' adolescent sexual fantasies. The four-panel structures of *Cream* and *Milk* retain the elegance of Japanese folding screens traditionally decorated with landscape motifs, while in both subject and style they

are reminiscent of anime and manga in which sexuality is usually inferred rather than represented in graphic detail in order to evade censorship. Murakami seems to suggest that Japan's postwar impotence finds its most procreative expression in the erotic and infantile culture of comics.

Comic Abstraction: Image-Breaking, Image-Making brings together thirteen contemporary artists whose works from the early 1990s to the present offer an immensely rich and suggestive account of the interplay between abstract and comic models of representation. The alliance of abstraction and comics generates a hitherto unexplored world of vestigial images, which cannot be traced to one model alone. Comics, from Disney's cartoons to Japanese manga and anime, serve as an empirical reservoir for humorous characters and stories. Through varied strategies of erasure and blurring, abstraction intensifies the ambiguity between what is seen and what is represented and instills critical doubts about the illusion of transparent reality and pure form. At the same time, it offers a new model for examining the power of images—the way they circulate in everyday life, the stories they purport to tell, and, by extension, the mythologies that lurk beneath their surfaces. These mythologies are often pregnant with memories fraught by racial, sexual, or ethnic stereotyping. In a text on the structure of laughter, Robert Storr differentiates between "laughing at" and "laughing with" the subject of a joke, noting that stereotypes "can be repossessed by those they offend and inverted to expose just how absurd they are, and how, rather than lampooning their ostensible targets, they reflect the skewed world view of their inventors."[64] Unlike the Lutheran idolaters of the sixteenth century with which this essay opened, the artists in *Comic Abstraction* do not dream of breaking the images that harbor such deep-seated clichés. Rather, they strive to make them more visible to the world.

Notes

1. According to numerous scholars, the precursor to modern comics is the satirical work of Swiss artist Rudolphe Töpffer, who in 1827 created a proto-comic strip and subsequently published seven graphic novels. Richard Felton Outcault's 1895 *Hogan's Alley* is the first comic strip to use the speech balloon. Around 1900, the terms "comics" and "comic strip" came into common use. They were derived from the strips of pictures printed in magazines and newspapers, which were all funny or comic in content. At first, newspaper comic strips were called "funnies," and later the term comics became more popular.

2. Joseph Leo Koerner, *The Reformation of the Image* (Chicago: The University of Chicago Press, 2004), p. 12. The term "iconoclash" was first coined by Bruno Latour for an exhibition he co-organized with Koerner at the Center for Art and Media in Karlsruhe, Germany.

3. Polly Apfelbaum, "Interview with Polly Apfelbaum by Claudia Gould," in *Polly Apfelbaum* (Philadelphia: Institute of Contemporary Art, University of Pennsylvania, 2003), p. 11.

4. David Pagel, "Once Removed from What?" in Dana Friis-Hansen, *Abstract Painting, Once Removed* (Houston: Contemporary Arts Museum, 1998), p. 27.

5. David Batchelor, *Chromophobia* (London: Reaktion Books, 2000), p. 22.

6. Ibid., pp. 22–23.

7. Adrian Dannatt, "Sweet Williams," *Parkett*, nos. 50–51 (1997): 189.

8. Hannah J. L. Feldman, *The Subject of Rape* (New York: Whitney Museum of American Art, 1993), p. 20.

9. Leslie Camhi, "Domestic Horrors," *Parkett*, nos. 50–51 (1997): 202.

10. Williams, quoted in Grady T. Turner, "Sue Williams: Spinning Figures," *Flash Art* 32, no. 208 (October 1999): 88.

11. Georges Bataille, "Le gros orteil," *Documents*, no. 6 (November 1929): 297–302. Translated as "The Big Toe" and reprinted in *Visions of Excess: Selected Writings 1927–1939*, trans. Allan Stoekl (Minneapolis: University of Minnesota Press, 1989), pp. 20–23.

12. Williams, quoted in Turner, "Sue Williams," p. 89.

13. See interview with the author on p. 64 of this volume.

14. Neville Wakefield, "Mix Not Match Not," in *Arturo Herrera* (Chicago: The Renaissance Society at The University of Chicago, 1998), p. 15.

15. See interview with the author on p. 66 of this volume.

16. Juan Muñoz, "A Conversation, January 1995," by James Lingwood, in Lingwood, *Juan Muñoz: Monologues and Dialogues* (Madrid: Museo Nacional Centro de Arte Reina Sofía, 1996), p. 66.

17. Michael Brenson, "Sound, Sight, Statuary," in *Juan Muñoz* (Washington, D.C.: Hirshhorn Museum and Sculpture Garden, Smithsonian Institution; Chicago: The Art Institute of Chicago, 2001), p. 156.

18. Neal Benezra, "Sculpture as Paradox," in *Juan Muñoz* (see note 17), p. 48.

19. Juan Muñoz, "The Prohibited Image," in *Juan Muñoz* (see note 17), p. 77. Muñoz dedicated a piece to Kurz, titled *Minaret for Otto Kurz* (1985).

20. See Jeff Fleming's excellent text *Ellen Gallagher: Preserve* (Des Moines: Des Moines Art Center, 2001), pp. 6–8.

21. Greg Tate, "Rewind," in *Ellen Gallagher* (Boston: Institute of Contemporary Art, 2001), p. 14.

22. Scott Bukatman, *Matters of Gravity: Special Effects and Supermen in the Twentieth Century* (Durham, N.C.: Duke University Press, 2003), p. 148.

23. Ellen Gallagher, "This Theater Where You Are Not There: A Conversation with Ellen Gallagher by Thyrza Nichols Goodeve," in *Ellen Gallagher* (Birmingham, England: Ikon Gallery, 1998), p. 20.

24. Ellen Gallagher, "1,000 Words," *Artforum* 42, no. 8 (April 2004): 131.

25. Stein's famous line "Rose is a rose is a rose is a rose" first appeared in "Sacred Emily" (1913), a poem included in *Geography and Plays*, pp. 178–88 (Boston: Four Seas Co., 1922), and showed up in later works as well.

26. Gallagher, "This Theater Where You Are Not There," p. 22.

27. Gallagher, quoted in Julie L. Belcove, "Gallagher's Travels," *W* (March 2001): 496.

28. Ellen Gallagher, interview by Jessica Morgan, in *Ellen Gallagher* (see note 21), p. 22.

29. Franz West, interview by Iwona Blazwick, James Lingwood, and Andrea Schlieker, in *Possible Worlds: Sculpture from Europe* (London: Institute of Contemporary Arts and Serpentine Gallery, 1990), p. 85.

30. See Robert Fleck, "Sex and the Modern Sculptor," in Fleck, Bice Curiger, and Neal Benezra, *Franz West* (London: Phaidon, 1999), p. 35.

31. Robert Storr, "Sunday in the Park with Franz," in Storr, Ulrich Loock, Nicolas Bourriaud, and Kristine Stiles, *West: Pensées Features Interview Anthology* (London: Whitechapel Art Gallery, 2003), p. 40.

32. Robert Storr, "Franz West's Corporeal Comedy," *Art in America* 91, no. 10 (October 2003): 99.

33. West, quoted in Fleck, "Sex and the Modern Sculptor," p. 48.

34. West, quoted in Hans Ulrich Obrist, *Interviews*, vol. 1 (Milan: Edizioni Charta, 2003), p. 932.

35. Christoph Heinrich, "From Paintbrush to Pixel and Back Again: Painting Between Retro and Science Fiction," in *Ice Hot: Recent Painting from the Scharpff Collection* (Hamburg: Hamburger Kunsthalle; Stuttgart: Staatsgalerie Stuttgart, 2003), p. 10.

36. Martin Kippenberger, "Interview with Martin Kippenberger," by Daniel Baumann, in *Martin Kippenberger*, ed. Doris Krystof and Jessica Morgan (London: Tate Modern, 2006), p. 63.

37. Parreno, quoted in Tom Morton, "Team Spirit," *Frieze*, no. 81 (March 2004): 85.

38. In 1999, 46,000 yen was approximately $415.

39. Parreno, quoted in Obrist, *Interviews*, p. 720.

40. Philippe Parreno, "Anywhere Out of the World," in Sabine Breitwieser, *Double Life: Identität und Transformation in der zeitgenössischen Kunst* (Vienna: Generali Foundation, 2001), p. 197.

41. Pierre Huyghe, "Two Minutes Out of Time," in Breitwieser, *Double Life* (see note 40), p. 122.

42. Dominique Gonzalez-Foerster, "Ann Lee [*sic*] in Anzen Zone," in Breitwieser, *Double Life* (see note 40), p. 102.

43. Philip Nobel, "Sign of the Times," *Artforum* 41, no. 5 (January 2003): 109.

44. See Nicolas Bourriaud, *Postproduction* (New York: Lukas & Sternberg, 2002), pp. 67–70.

45. The phrase "Everyone can mark in their own demand, while still participating in the same image" is part of the caption of *Speech Bubbles* (fig. 23).

46. See interview with the author on p. 96 of this volume.

47. See Robin Clark, *Currents 93: Rivane Neuenschwander* (St. Louis: Saint Louis Art Museum, 2005), n.p.

48. See interview with the author on p. 108 of this volume.

49. Ibid., p. 110.

50. For a discussion of Simmons's working process see Lisa Lyons, *Gary Simmons: Erasure Drawings* (Los Angeles: Lannan Foundation, 1995), n.p.

51. See interview with the author on p. 111 of this volume.

52. Dalí, quoted in Ingrid Schaffner, "Pop Icons: A Little Idyll and Selected Quotes," in *Pop Surrealism* (Ridgefield, Conn.: The Aldrich Museum of Contemporary Art, 1998), p. 123.

53. Mehretu, quoted in Carly Berwick, "Excavating Runes," *Art News* 101, no. 3 (March 2002): 95.

54. Julie Mehretu, "Looking Back: E-mail Interview between Julie Mehretu and Olukemi Ilesanmi, April 2003," in Douglas Fogle and Olukemi Ilesanmi, *Julie Mehretu: Drawing into Painting* (Minneapolis: Walker Art Center, 2003), p. 14.

55. See Christian Viveros-Fauné, "Calamity Inka," http://www.artnet.com/magazine_pre2000/reviews/viveros-faune/viveros-faune2-5-99.asp.

56. "Surreal riffs on Japanimation" is from Michael Kimmelman, "Inka Essenhigh: A Painter with Pop," *New York Times Magazine*, November 17, 2002, p. 37; "Disney-meets-manga" is from Violet Fraser, "Inka Essenhigh: A Brush with Violence," *Art Review* 53 (November 2002): 41; "manga-meets-[Roberto] Matta" is from Andrea Scott, "Inka Essenhigh," *Time Out New York*, December 5–12, 2002, p. 65; a "cross between Rube Goldberg and Raymond Roussel" is from Barry Schwabsky, "Inka Essenhigh," *Artforum* 37, no. 8 (April 1999): 124.

57. Inka Essenhigh, *Berlin Biennale 2001* (Berlin: Berlin Biennale für Zeitgenössische Kunst, 2001), p. 79.

58. Essenhigh, quoted in Viveros-Fauné, "Calamity Inka."

59. Essenhigh, quoted in *Casino 2001* (Ghent: Stedelijk Museum Voor Actuele Kunst, 2001), p. 223.

60. Alexandra Munroe, "Introducing Little Boy," in *Little Boy: The Arts of Japan's Exploding Subculture*, ed. Takashi Murakami (New York: Japan Society; New Haven, Conn., and London: Yale University Press, 2005), p. 246.

61. Ibid.

62. Takashi Murakami, *Summon Monsters? Open the Door? Heal? Or Die?* (Tokyo: Museum of Contemporary Art, 2001), p. 142.

63. Murakami, quoted in Amada Cruz, "Dob in the Land of Otaku," in Cruz, Midori Matsui, and Dana Friis-Hansen, *Takashi Murakami: The Meaning of the Nonsense of the Meaning* (Annandale-on-Hudson, N.Y.: Center for Curatorial Studies Museum, Bard College, 1999), p. 19.

64. Robert Storr, *Disparities and Deformations: Our Grotesque* (Santa Fe: SITE Santa Fe, 2004), p. 26.

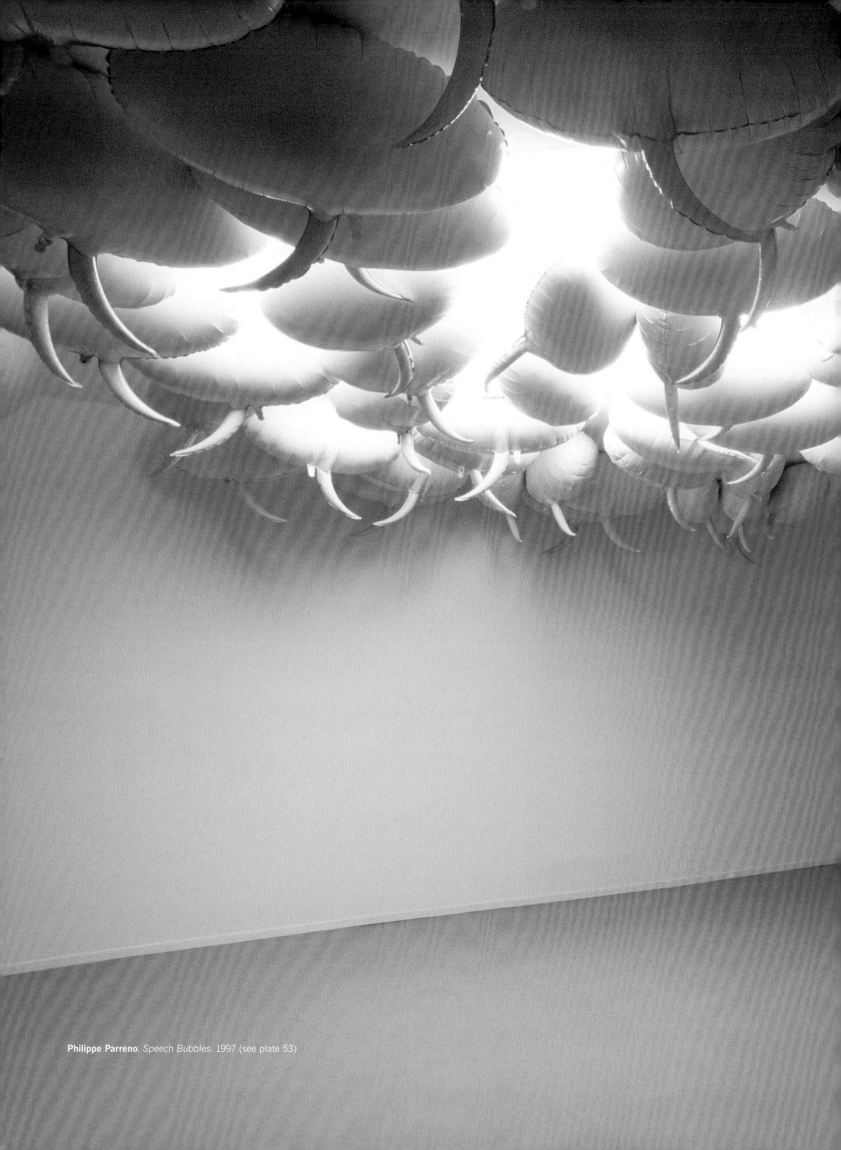

Philippe Parreno. *Speech Bubbles*. 1997 (see plate 53)

INTERVIEWS AND PLATES

POLLY APFELBAUM

Roxana Marcoci: Let's start by discussing how you began making your first "fallen paintings."

Polly Apfelbaum: "Fallen paintings" was a term I started using *after* these pieces first began to be shown in the early 1990s. It was a way of talking about these works as hybrids between painting and sculpture, something that couldn't be easily pinned down to a category. I started working on the floor as a sculptor, which is how I defined myself when I first started showing. My references were Carl Andre, Lynda Benglis, and Barry Le Va. The floor was an emotionally charged, low, irreverent space, a place where you throw things, where you drop your dirty clothes. Something precious like an artwork was not supposed to be on the floor. I was aware of that historical tradition, the whole post-studio tradition, Robert Smithson and the idea of sculpture's "expanded field," which was part of the climate when I was in school. My work has also been contextualized by others as a response to that history. *Spill* (1992–93) was shown at MoMA in the 1994 show *Sense and Sensibility: Women Artists and Minimalism in the Nineties,* organized by Lynn Zelevansky.

RM: At that time, were you thinking of horizontality in historical terms? Although exhibited on the wall, Jackson Pollock was the first to brand his work "horizontal," but paintings from Andy Warhol's series of dance diagrams (1962) to Lynda Benglis's *Bounce* (1969) were actually displayed directly on the floor.

PA: It was somewhat later that I began thinking about these as hybrids between painting and sculpture, and the dialogue between the horizontal and the vertical—as in Pollock's work or Warhol's *Dance Diagrams* or the piss paintings [Warhol's *Oxidation* paintings] for that matter—talk about low. It was a question of becoming more aware that the issues I was dealing with were painterly issues: color, line, flatness, and certain notions about form. Today there is a wider notion of what painting might be, that it is a kind of emotional space as much as a physical space. People are more comfortable with these contradictions. Moving to the floor opened up a new space for painting. I think the newer work—*Cartoon Garden* (2005) in particular—is more about the horizontal field conditions that go back to Warhol and Pop art.

RM: There is something to be said about your use of eye-candy colors and fabrics. Your work seems to relate pictorially to 1950s Color Field abstraction, but in your use of devalued materials you come closer to *Arte Povera* artists. At the same time, your sub-

jects reflect an interest in popular culture and feminism. Can you talk about the sources that inform your practice?

PA: It's interesting you mention *Arte Povera.* I lived in Spain in the early 1980s and saw a big show of that work in Madrid. There was also a show at P.S.1 in 1985. My colors are lush and artificial, which is less *Arte Povera,* but the mix of high and low is similar. I was also aware of the Support/Surface group in France. What was going on in Europe—abstract work that was slightly out of the mainstream—definitely had an effect on my work. I have always liked more quirky abstract painters—Larry Poons, for example, or Paul Feeley. Anne Truitt is also interesting because her work is between painting and sculpture. I had originally moved to New York City in 1978 and was also probably influenced by Pattern and Decoration. There were a number of interesting women artists who had emerged around that time, everyone from Elizabeth Murray to Lynda Benglis, Ree Morton, and Jennifer Bartlett; and not only women, but also Richard Tuttle, Alan Saret, Lucas Samaras, and Alan Shields. In those days, it was slower. You didn't move to New York and start showing right away, so I had time to work, travel, and absorb these influences.

I came back to New York from Spain in the mid-1980s and started showing in the East Village. I exhibited in a gallery with a bunch of CalArts people. The scene was more about appropriation and Neo-Geo than Neo-Expressionism, which was fine with me. I was working with found and fabricated pieces in series, but with a similar sense of play between abstraction and recognition. It was a very open time. There were a lot of other sources—film, especially Michelangelo Antonioni (*Red Desert,* for example) and things I was reading. Italo Calvino's book on fairy tales or *Six Memos for the Next Millennium,* in which he talks about lightness, immediacy, style, and structure, made a big impact on me. One of the things I took from Calvino was his idea that folk art and fairy tales are not sentimental, but tough, even ugly, and full of what he calls "hard logic." I like the immediacy and the simplicity of that work, which is very abstract and in a way very close to early cartoons, like the ones that featured the Yellow Kid [in the 1890s], which used simple geometries of a circle for a head, eyes, mouth, or ears.

RM: If I understand correctly, when marking the fabrics you follow a system based on the Sennelier 104-color dye chart. How do you decide on the colors for each piece? Are you experimenting with the psychology of colors or do you use colors as readymade material?

PA: It's true that there is always a structure or a pattern or a working idea behind the color. It's not just arbitrary or expressionistic. But it's also important to say that the system is completely intuitive, something I am always experimenting with. I like these supposedly structured systems that turn out to be kind of obsessive and crazy—like Alfred Jensen. No one could hope to figure out his systems. It's not what the system gives him as a means to an end or a way of controlling color, but the system itself that becomes fascinating in the end. I love the completeness, all the small steps of color charts.

I started numbering with the piece *Ice* (1998). It was a way to ensure that I would use all 104 colors in the dye set (each dyed to black and the primaries) so that the piece becomes a giant color chart setting out these relationships. If the dye chart is a structure, then each piece also has a very specific color idea within the available options. One color is always a base color, which may have some sort of outside reference—black for *Ice* or hair colors for the *Powerpuff* pieces. Structure doesn't preclude an emotional response to color. What's interesting to me about color is that, like music, it is always evocative. It's emotionally rich without being specific in content. Color has such a wide range of associations. I don't see a contradiction between structure and emotion. I think that's a false dilemma. Someone I admire a lot is [Warner Bros. animator] Chuck Jones; these early animation artists had to work within incredibly exacting constraints, but the results are so fluid, so effortless and associative.

RM: What initially prompted you to abstract a scene from Walt Disney? I am thinking of any number of works, such as *Peggy Lee and the Dalmatians* (plate 1) or *The Dwarves with Snow White* (plate 2) or *The Dwarves without Snow White* (plate 3), all from 1992.

PA: The pieces you mention are all from a show in 1992 that I called *The Blot on My Bonnet.* Part of the idea for this show was to work with the stain, the blot, to mobilize imperfection. I started thinking about this supposedly perfect cartoon world, which actually turns out to be much darker and more layered. Sometimes it's easier to deal with certain ideas in an artificial, cartoon world. It allows me to be playful and serious at the same time. In working on the pieces, the titles always come afterward. I didn't start out to make a series of Disney pieces. It was more like a series of clues for the viewer, a way into the work, another layer of meaning, a connection to something outside of the work— something that everyone will know—more like an atmosphere

than a specific point of departure. I want to open up possible narratives by intermingling form and content. As I work, the titles are also another form of structure. The references may give me a certain color vocabulary, working rules, or a series of relationships. In other words, it's a very abstract filter. It's important to keep the connection loose.

RM: *Blossom* (2000; plate 4), which is in MoMA's collection, is one of four works inspired by the popular Cartoon Network animation series *The Powerpuff Girls* (fig. 1). The series features three toylike girls—Blossom, Bubbles, and Buttercup—whose mission is to fight crime and save the world before bedtime. You invest each work with an implicit feminist discourse. Can you talk about the ascent of girl power in these works?

PA: I was certainly interested in the Powerpuff Girls as a model of feminine strength: a way of putting together "cuteness" and "power." It was appealing to me that those two characteristics don't normally go together. There is something a little perilous about the combination as everything works just on the edge of chaos. It's also about being comfortable with contradiction and different generations of feminism. It's remarkable that the Powerpuff Girls were created by a man. He went to CalArts and knows a lot about art and cartoon history. He had a hard time getting them on the air because the network thought they would turn off fifty percent of the audience (little boys). It did not, but it took him a long time. I was thinking about parallels in how people responded to the feminine in my work. It has taken time to get beyond the obvious.

RM: Although highly controlled and painstakingly assembled, your works articulate the delirious thrill of topsy-turvydom. Would you describe *Blossom* as carnivalesque?

PA: That's interesting. I had not made that direct connection. Thinking about it, certainly the sense of abandon and the highly decorated costumes of Mardi Gras or the Brazilian carnivale fascinate me. I grew up watching the Mummers Parade in Philadelphia. So, there is a shared sensibility in all that color and movement. But I don't see it in terms of a search for some sort of vernacular authenticity. In that sense, what I feel closer to is more of a mass-culture trashy Hollywood sensibility—like Busby Berkeley musicals (fig. 3) or Esther Williams or trippy 1960s animation. They all encompass that sense of over-the-top pattern and spectacle where the bodies make abstract patterns and shapes.

As I understand it, the carnivalesque is always defined as the other of the "everyday"—a delirious escape from the sameness of

plate 3. **Polly Apfelbaum**
The Dwarves without Snow White. 1992
Synthetic crushed stretch velvet, fabric dye, and cardboard boxes, box (each): 27 x 16 x 3" (68.6 x 40.6 x 7.6 cm) (installation view at Amy Lipton Gallery, New York, 1992)
Brooklyn Museum, New York

(next page)
plate 4. **Polly Apfelbaum**
Blossom. 2000
Synthetic velvet and fabric dye, approx. 18' (548.6 cm) diam.
The Museum of Modern Art, New York. Gift of Donald L. Bryant, Jr., Bobbie Foshay-Miller, Ricki Conway, Susan Jacoby, Jo Carole Lauder, Steven M. Bernstein, and Brook Berlind, 2001

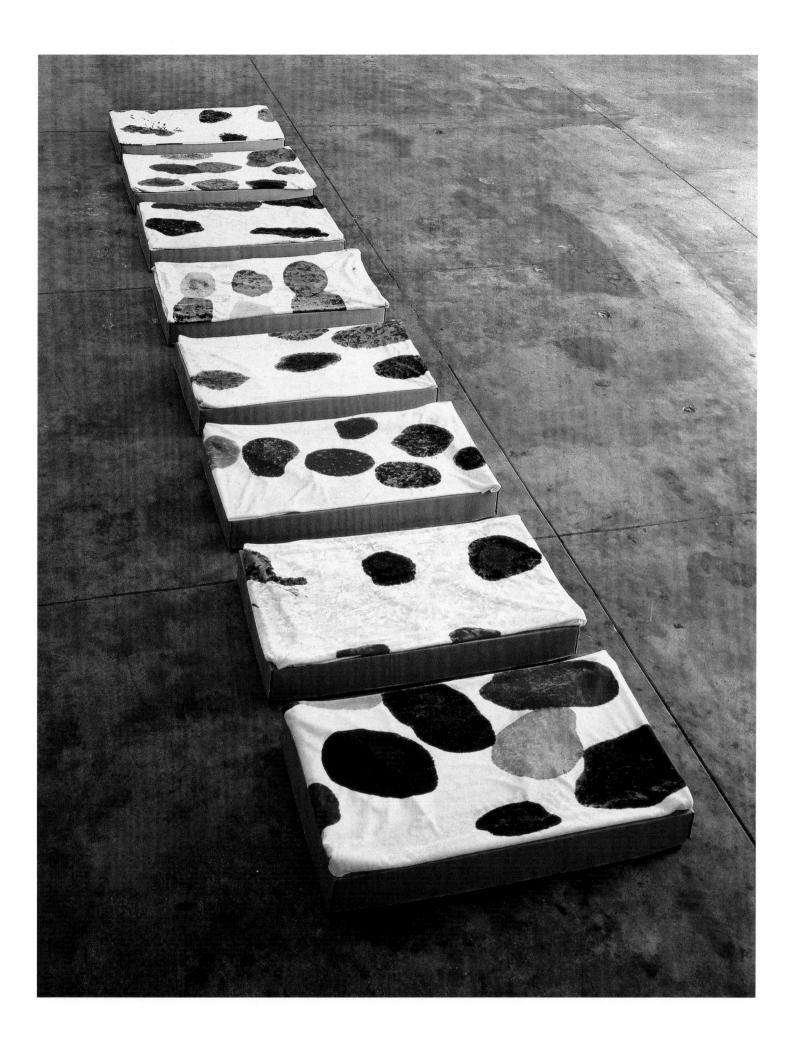

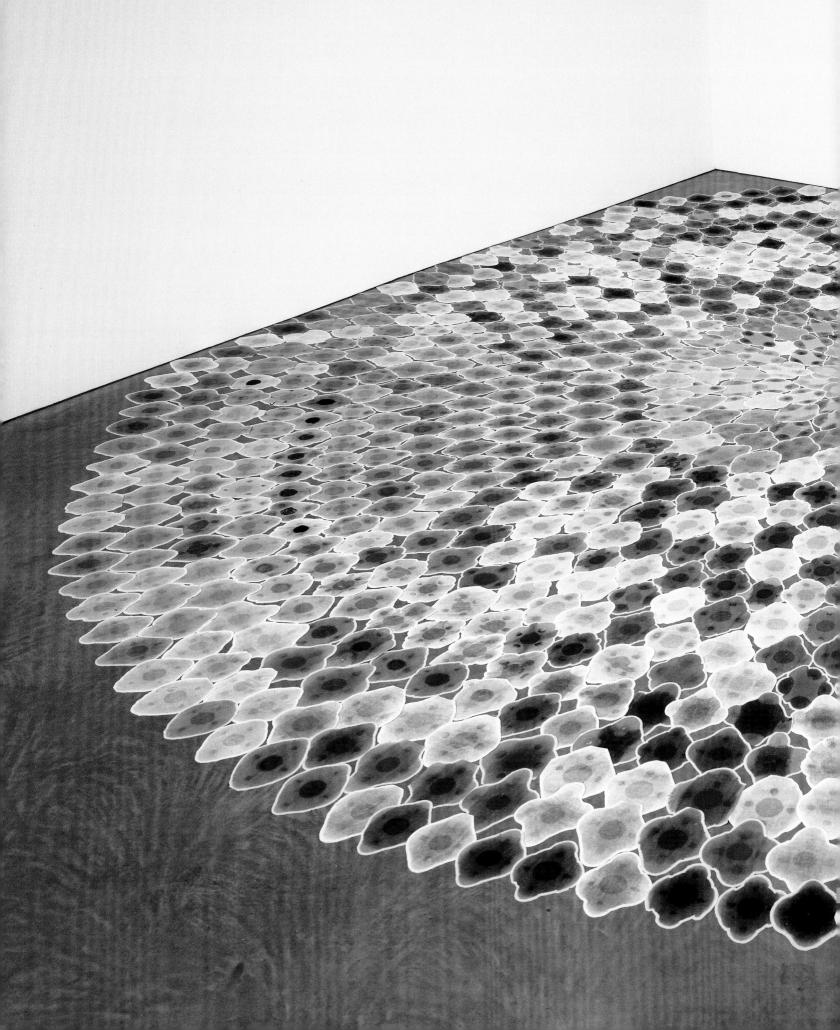

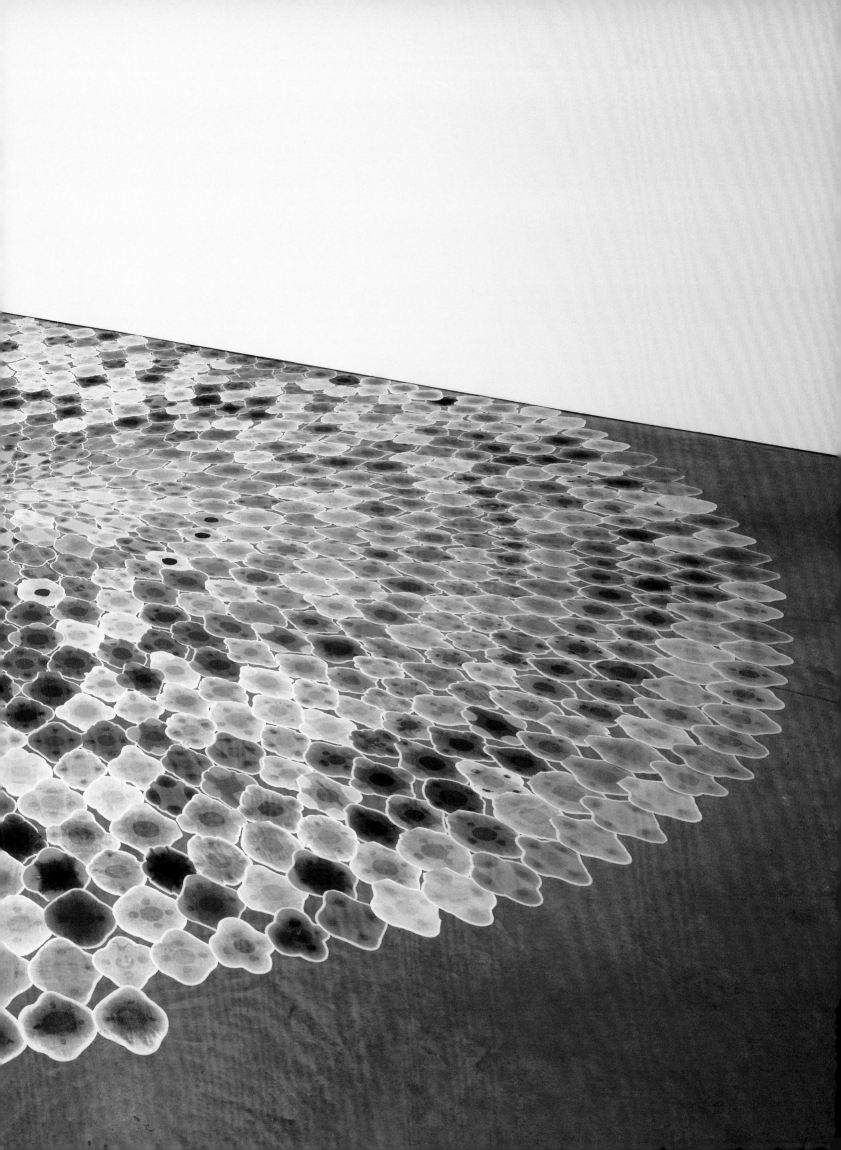

work. The Hollywood spectacle is more of an extension of the everyday toward a kind of decorative excess. The controlled chaos of cartoons is actually highly structured because it is the product of repetition and accumulation (think of all those separate frames that the old animators had to draw by hand!). This is closer to a pop sensibility, and in the end it's what I feel closer to.

RM: What about the performance-based aspect of your work? It has often been suggested that entering one of your installations is like crossing the threshold of a Benday dot picture.

PA: It's important to me that people have to move through the works so the spectator activates it and participates in the experience. As you move, the color and the nap of a fabric change and the work plays a lot with light. I am always working with site, scale, and the architectural setting. There is a performative aspect to the way in which the same piece will be installed in different locations, like a piece of music that changes each time it is performed. It's also true that making my work is time-consuming, and the process itself is highly repetitive. I do not work with assistants. I do it all myself: dyeing, cutting, testing. Some of these installations take days of bending over to place each piece. It's slow work, but I don't necessarily see that as a performance. For me, it's something more private. I don't want to make a spectacle out of the process, but there is a kind of accumulated time in the pieces. In pointillism or a Benday dot picture, you are aware of the parts and the whole simultaneously, you break it down into parts and sense the individualism of each point as something made. I sometimes think of the fabric pieces as brushstrokes.

RM: How does the world of comic animation intersect with abstraction?

PA: Much of the canonical Greenbergian ideas of abstraction—flatness, solid blocks of color, etc.—are also characteristics of cartoons. You can make a figure with such simple, flat geometries in cartoons. This is changing with contemporary cartoon animation, which is more about realism, because it has to do with what

you can do on the computer. The figures in *Toy Story* or *Monsters, Inc.* are not abstract at all. For me, something has been lost. Flatness, solid colors, and drawn outlines are a part of the vocabulary of modern abstraction.

RM: Culled from films, novels, or comic books, your titles refer to the content of the works. Past the titles, how do you explain that no matter how much you abstract a comic book scene, the vestigial image behind abstraction still remains quietly visible?

PA: I hope that it does remain visible. I think this persistence of the figure perhaps comes from the way I think and work abstractly. I rely on a certain idea of abstraction to keep the work open-ended. That is to say, if you think of abstraction as something final, absolute, and totalizing, then there is no possibility of content or figure or image. This is a very narrow idea of abstraction for me. I'm attracted to a looser idea of abstraction as something provisional, conditional. I think abstraction is part of the texture of modern life; it's always there under the surface. Money is abstract, the Internet is abstract, and relationships are abstract. I think this is part of why abstraction shows up in both cartoons and abstract painting.

By thinking of abstraction *not* as an absolute, you open up the possibility of a much richer dialogue between content and form. Think of Philip Guston's late paintings, for example, which I've always liked. There is room for the viewer to see the abstract as figural or the abstraction in the figure. This has been important, as I've introduced into my recent work more explicit imagery, such as flowers, bones, and eyes. But these images are reduced to a few iconic lines. Like a cartoon of an eye or a bone, it's just geometry. In works like *Cartoon Garden* or *Gun Club* (2002), however, it's also the accumulation and repetition of this image that creates an abstract field. The structure and overall effect is about activating an optical field based on the positive and negative space that relates to fields, gardens, mold, lichen, and lily pads. It becomes a whole series of open-ended references that are more about pattern, structure, and repetition.

plate 5. **Polly Apfelbaum**
L'Avventura. 1994
Synthetic velvet and fabric dye, approx. 20 x 20'
(609.6 x 609.6 cm) (installation view at Zilkha
Gallery, Wesleyan University, Middletown,
Connecticut, 1994)
Collection of the artist

plate 6. **Polly Apfelbaum**
Red Desert. 1995
Synthetic velvet and fabric dye, approx. 8 x 20'
(243.8 x 609.6 cm) (installation view at Neue Galerie
am Landesmuseum Joanneum, Graz, 1995)
Collection of the artist

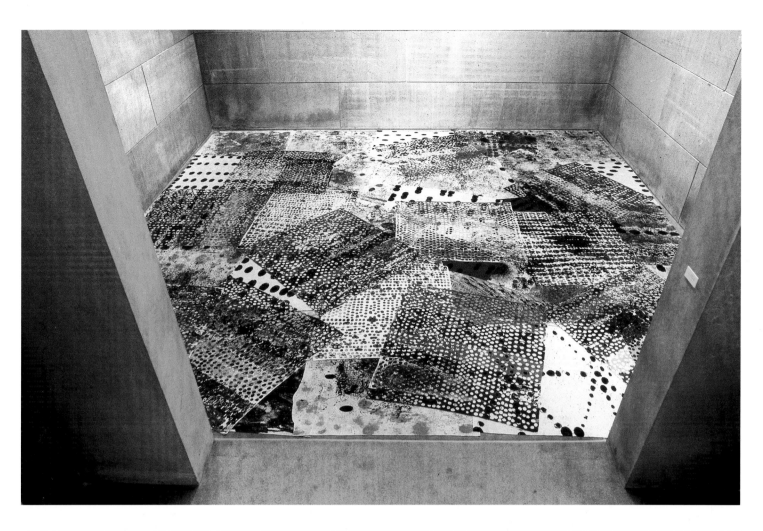

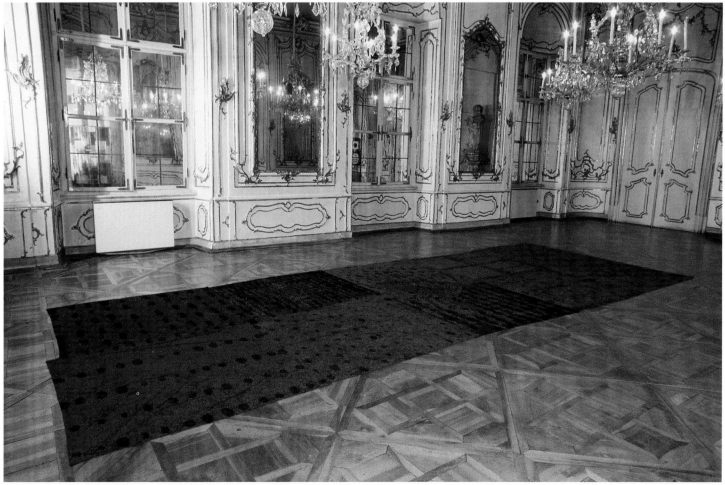

INKA ESSENHIGH

Roxana Marcoci: Your enamel paintings of the late 1990s and early 2000s combine a range of references, from Surrealist and traditional Japanese paintings to anime and manga. Is it fair to say that the legacy informing your work runs from Salvador Dalí and Yves Tanguy to the *Teenage Mutant Ninja Turtles*, Soga Shohaku, and Katsushika Hokusai (fig. 35)? Can you talk about this mix of sources?

Inka Essenhigh: I was not influenced by any particular style. In fact, I think I was trying to avoid Surrealism because at the time I didn't think of it as great art. I grew up on comics and a lot of television. Cartoons and drawing were a way for me to make images that looked like they were about today. Looking contemporary was very important to me. I was definitely uninterested in appropriating comic book imagery. When I draw from life, my line is naturally calligraphic and arabesque. This lends itself to looking like Asian art, which I love, as well as some of the Western art that was influenced by it, such as Post-Impressionism. The surface and style of my earlier work was also due to my use of enamel paint. Those colors are opaque and came with names such as Robin's Egg Blue, which embodied the fashion of the times. I recognized the Asian-looking part of the work as the classy part; the Dalí/Disney part was something I had to accept.

RM: Style is part of your subject matter. You play with spatial plasticity—specifically, perspective and foreshortening—in ways that are dear to cartoonists. Also, your characters are always in the act of metamorphosis. You mentioned to me that you are attracted to the loaded portrait-caricatures of Honoré Daumier and Francis Bacon's morphing scenes. What can you say about the notion of altered realism?

IE: Altered realism is meaningless if it doesn't connect emotionally with the viewer. At the same time, I'm naturally drawn to large dramas with costumes and artifice. It makes sense to me that I would want danger and outrageousness to come into my life after growing up in a safe upper-middle-class suburb of Ohio. Heavy metal music and gangsta rap are popular in places like this; it's an attractive fiction for those kids. In *Explosion* (1999; plate 10), I painted a bunch of people being blown up, but I emphasized the uneven, imperfect way the bodies get destroyed as some parts burst while other parts go "thud" and a bone goes flying. I guess I had to put a lot of comedy in my work to cool down the dramas. I needed to find the right emotional temperature in proportion to my real life.

RM: At the same time, your rubbery characters recall the comic book characters Plastic Man and Mr. Fantastic. Are these superheroes of interest to you?

IE: I suppose they are, but this material is so taken for granted that I don't think about them much. I saw watered-down versions of them on Saturday morning cartoons as a kid. I loved Warner Bros. cartoons the best. In book form, I really grew up on Tin Tin and Asterix.

RM: You once said: "I'm simply using the language of cartoons; just aestheticizing it into an abstracted event."[1] Tell me more about the connection between comics and abstraction in your work.

IE: In comics, the story is the most important thing. A story unfolds over time, but on a single canvas it can be represented by symbols or in an abstract way. Lines indicating motion are a common comic book trick that I use a lot. Sometimes the most important visual element is the motion line, as seen in *Mob and Minotaur* (2002). The biggest shape in the painting is the dark red swoosh marks made by a bat hitting the minotaur. Visualized sound effects are another example of this connection. What "tink, tink, tink" or "boom" looks like are abstract imaging issues. My painting is a process of Abstract Expressionist–like improvisation, although I use hard-edged shapes that turn into stories.

RM: A number of figures in your paintings are faceless or headless. They are involved in comical scenes of goofy calamity and cyborg mutations that seem to be informed both by sci-fi comic strips and media-driven fixations with faceless terrorism. Who are these characters?

IE: These people are amoral. They represent you and me. We do things that have consequences that might be good or bad, but of which we are oblivious. I don't think of these people so much as cyborgs but as representatives of their actions. For example, a man working with wrenches would have wrenches for hands.

RM: What is going on in *Cheerleaders and Sky* (1999; plate 8) and *Born Again* (1999–2000; plate 7)?

IE: In *Born Again,* the sun rises over the curved earth, splitting the canvas into two parts that show above and below ground. The figure on the bottom left is eating. He is symbolically underground. His excrement will go into the earth and fertilize things that the sun will activate into growing. But instead of plants, people sprout up. I suppose that I made a muddle out of the idea of plants and people growing, that people need to find a higher purpose. A search for god is as much a biological function as a pumpkin becoming orange. Once again, this is just what comes out as I free-associate on the canvas.

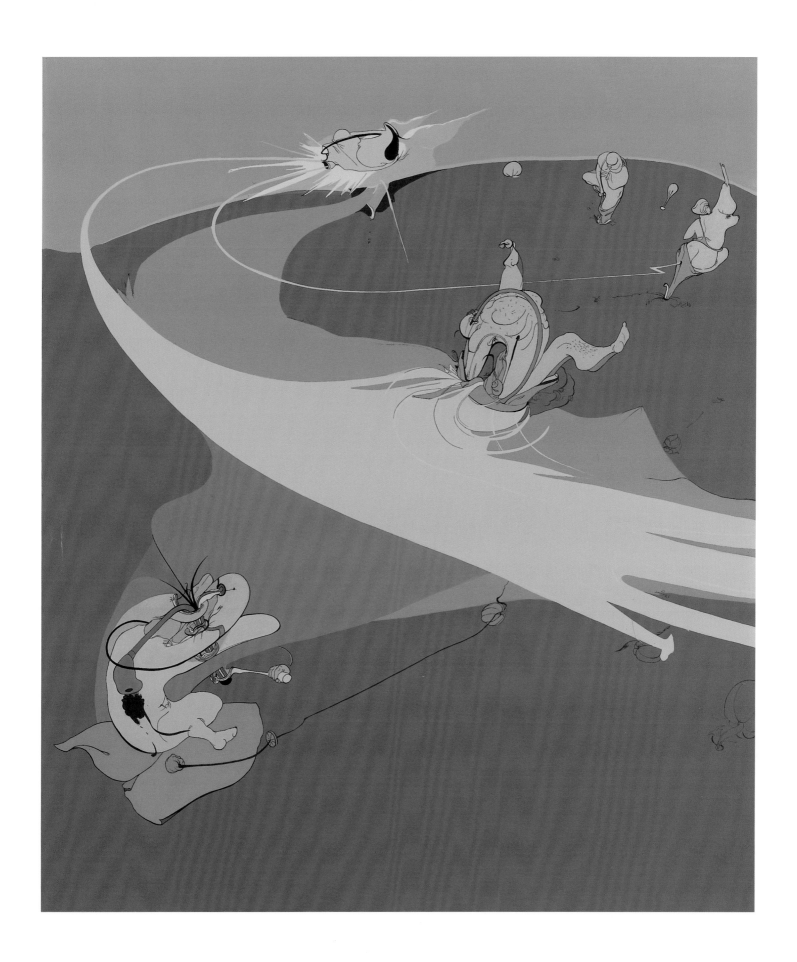

plate 7. **Inka Essenhigh**
Born Again. 1999–2000
Enamel on canvas, 7' 6" x 6' 6" (228.6 x 198.1 cm)
Tate, Purchased 2001

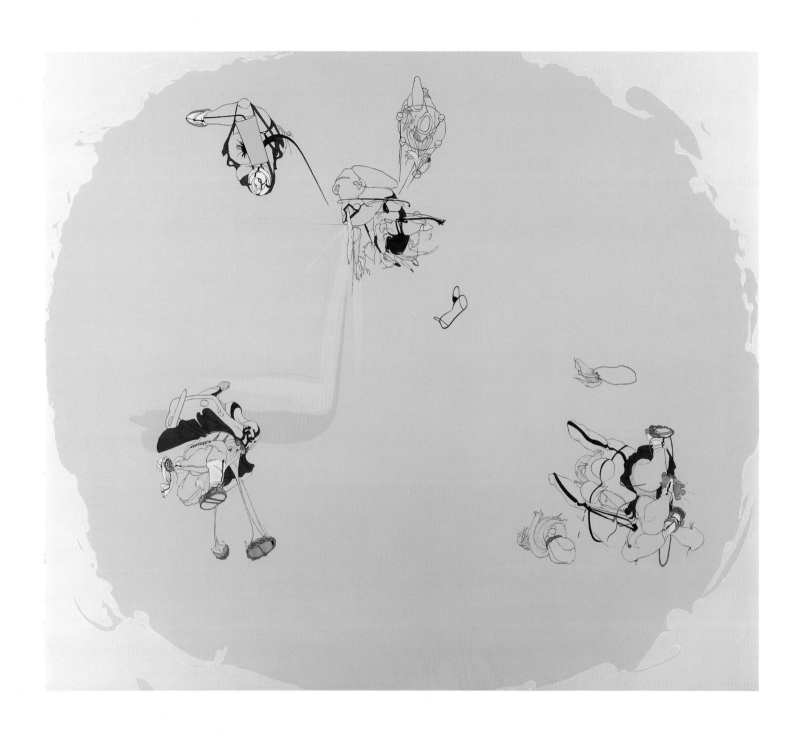

plate 8. **Inka Essenhigh**
Cheerleaders and Sky. 1999
Enamel on canvas, 6' 6" x 7' 6" (198.1 x 228.6 cm)
The Schorr Family Collection

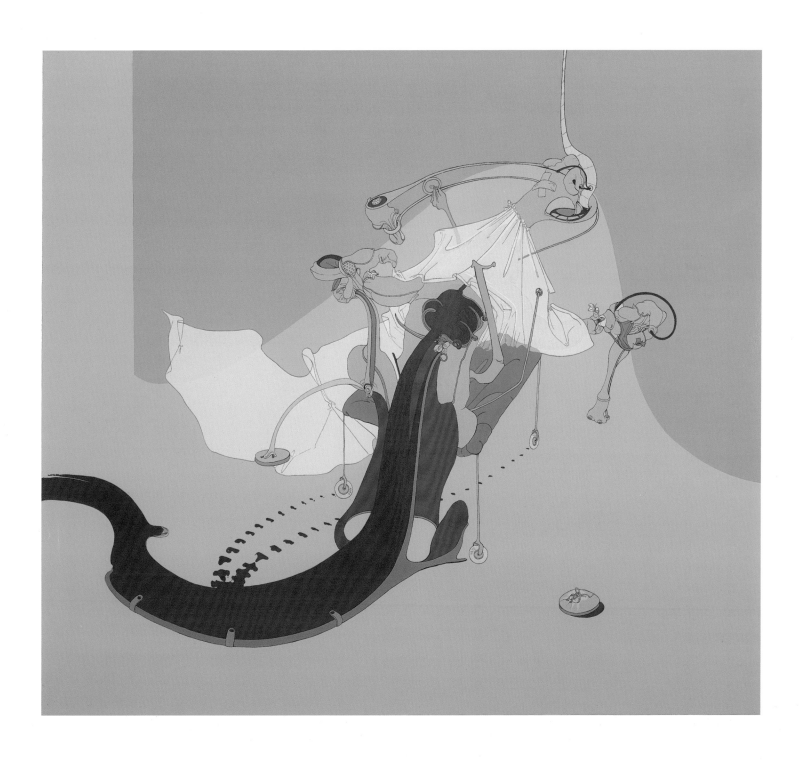

plate 9. **Inka Essenhigh**
Reconstruction. 2000
Enamel on canvas, 6' 8" x 7' 6" (203.2 x 228.6 cm)
Collection of Frederic Bouin, New York

In *Cheerleaders and Sky*, a bunch of cheerleaders are dropped from the sky. As usual, I started off with just one color and allowed whatever popped into my mind to lead my brush. Blue made me think of sky. I suppose the cheerleaders must be divine if they come from the heavens, but they drop like fat turkeys while trying to maintain their composure. The cheerleader on the right tugs at her skirt to make sure that too much of her underwear doesn't show.

RM: There are frequent references to Futurism in your images of sports gear and notations of speed and flux. Are these recurrent motifs in your work? What is their implication?

IE: My work is a lot like Futurism. One of the main differences is that speed is more symbolic than painterly in my work. I make curvilinear rather than straight diagrammatic lines, which happily correspond to contemporary fashion design. Sports gear and most everything else are ergonomically designed. Things for the body are curved and bumped to "make room," as if in agreement with the fact that the world is uneven and asymmetrical. This design goes along with one of my favorite themes: the control of nature (i.e., your new Gore-Tex shoes will get you through rough weather). But the characters in my paintings still tend to get swept away by overwhelming forces.

RM: In some of your works, you develop disaster-movie scenarios in which figures are sucked into black holes and worlds collapse. Are you aiming to expose the makeup of a world run astray?

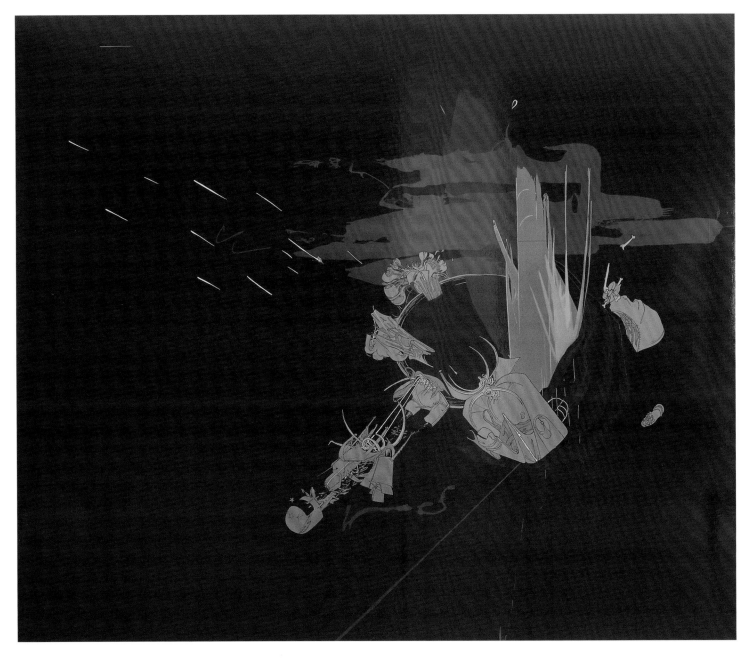

plate 10. **Inka Essenhigh**
Explosion. 1999
Enamel on canvas, 6' 4" x 7' 6" (193 x 228.6 cm)
Private collection

IE: Yes, but it's not really anybody's fault. Or maybe it's mine and I don't really feel like I've done anything wrong. I do enjoy disaster scenarios. I'm not sure why. Maybe I like the idea of getting ready for them. Or perhaps it puts my own life into context, helping me to be thankful for what I have and to compare what I have in light of other people's discomforts in the past. Do we have it better than people did in the past? Are we different, considering that the living almost outnumber the dead? Thinking about disaster scenarios exercises my imagination.

RM: In the oil paintings made in the aftermath of September 11, 2001, the characters are still exaggerated and cartoonlike, yet the mood has become increasingly dark. I am thinking of apocalyptic images, such as *Arrows of Fear* (2002) and *Straight to Hell* (2003). Do you accept the notion of testimony as a part of these works?

IE: I do! I think the paintings were always just as dark, but the people were generally faceless. The move to oil paint happened before 9/11, but in large part it enabled me to start making faces and individualizing these people, which I couldn't do in enamel for some reason. 9/11 encouraged me to paint what and how I wanted. I wanted to make something that felt less like a video game.

1. Inka Essenhigh, "Inka Essenhigh: A New Grammar of Motion," interview with David Hunt, *Flash Art* 33, no. 214 (October 2000): 75.

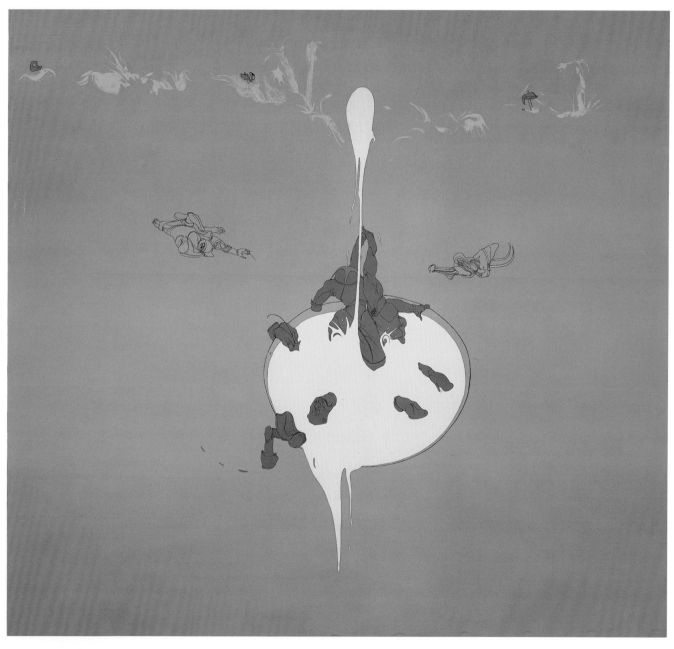

plate 11. **Inka Essenhigh**
Fountain of Youth/Florida State Seal. 1999
Enamel on canvas, 6' 2" x 6' 8" (188 x 203.2 cm)
Collection of Stephanie and Mark J. Lerner

ELLEN GALLAGHER

Roxana Marcoci: In the early 1990s, you attended the School of the Museum of Fine Arts, Boston at the same time that you were also involved with the artistic Dark Room Collective. Who were the people who influenced your thinking at that time?

Ellen Gallagher: I was reading Bob Kaufman's poetry (as transcribed by Allen Ginsberg) and painting these elephant fairies, which were supposedly based on some of the imagery in the poems. When Samuel Delany read from his work at the Dark Room, I had the paintings hanging. More important was the opportunity to meet and be in the physical presence of artists and writers whose work meant so much to me. Sometimes just being in the same room with a person can bring about other concepts of understanding you may not immediately be able to access through the work. I remember Delany had all of these keys on an elaborate silver chain, which hung from his belt. It sparkled from his hip as he stood in the parlor and read from a story involving armor and metallic men and freedom.

RM: It was also in the early 1990s that you began collating penmanship paper in your large-scale paintings, thus building a connection between painting, comic books, and the act of writing. Is the epistolary style of these works related to your contact with the writers of the Dark Room Collective?

EG: There is something to do with readability, with the idea of writing, which is seen as purely discursive, while painting is not. Writing doesn't necessarily have to have a physical presence or location. It can be entered in so many different ways, especially the poetry coming out of the Dark Room, which was often densely layered and oblique.

The penmanship paper is another aspect of the project, along with the repetitions and revisions, the fluctuations in scale between the miniature and the gigantic, and the fact that these already disembodied signs from performance are reconstituted in paint and pages stacked sideways. The penmanship paper is the critical frame for the argument. Like a support or coda, it's the part with no form. The sense of a neutral surface that can accommodate any mark seems to be an ideal way of communicating freedom.

At the same time, the cheap aspect of the paper has the ability to reproduce itself endlessly. The penmanship pages are widely distributed in classrooms and online. I wanted to see what happened when you instrumentalize the page—glued, stacked sideways, or in cross-sections. I was interested in the idea of using practice paper as a kind of structure. Could the pages exist as a painting support while simultaneously remaining linked to distribution, even freedom—however idiosyncratic and inscrutable?

RM: This is interesting since you continuously experiment with new approaches in different media. Most recently you have started drawing directly on 16 mm film. Can you explain how this all works together?

EG: There really isn't any rational link, except that I was making the films at the same time I was making the *Watery Ecstatic* drawings and the *eXelento* paintings (both begun in 2001). The works are often shown together, but they don't come with an interlocking list of demands or a political complaint. Other forms of perception are activated within the parameters set up between the films, paintings, and drawings. By weaving together banal information alongside more meaningful information, their surfaces release multidirectional associations. Because this allows for elasticity between different associations, everything exists all at once. It undermines the order built into an individual work.

RM: I am interested in how your motifs and materials actually relate to performance. "Blackface" signs—blubber lips, bulging eyes, flipped Afro hairdos—often percolate across the grade-school papers adhered to your canvases. These disembodied eyes and lips seem to be set in motion as in a minstrel show, performing against the grid of the writing paper, whereas your experimentations with plasticine evoke stop-action animation. Can you talk about the language of performance in your work?

EG: I am interested in the development of Gertrude Stein and Bert Williams in light of modernist language experiments. They both used repetition to alter the familiar into something inscrutable and uncontainable. They constructed a precise nonsense based on real words with real meanings. Stein's use of emphasis and space to alter the context and meaning of words is very much linked to Williams's performances. He used the blackface minstrel mask for more than just critique or parody; he understood the eclipse of the African body into American blackface. As form in motion rather than a static entity, his mastery of the minstrel mask was unparalleled.

In my own work, I make a cosmology of signs based on this kind of deformation. Through my transcriptions, the delimited signs I select become intensely personalized. I begin with a limited class of signs and, like a musician or conductor, revisit and repeat them with slight changes. As the signs are revised and reemphasized, the threads between them become more expansive.

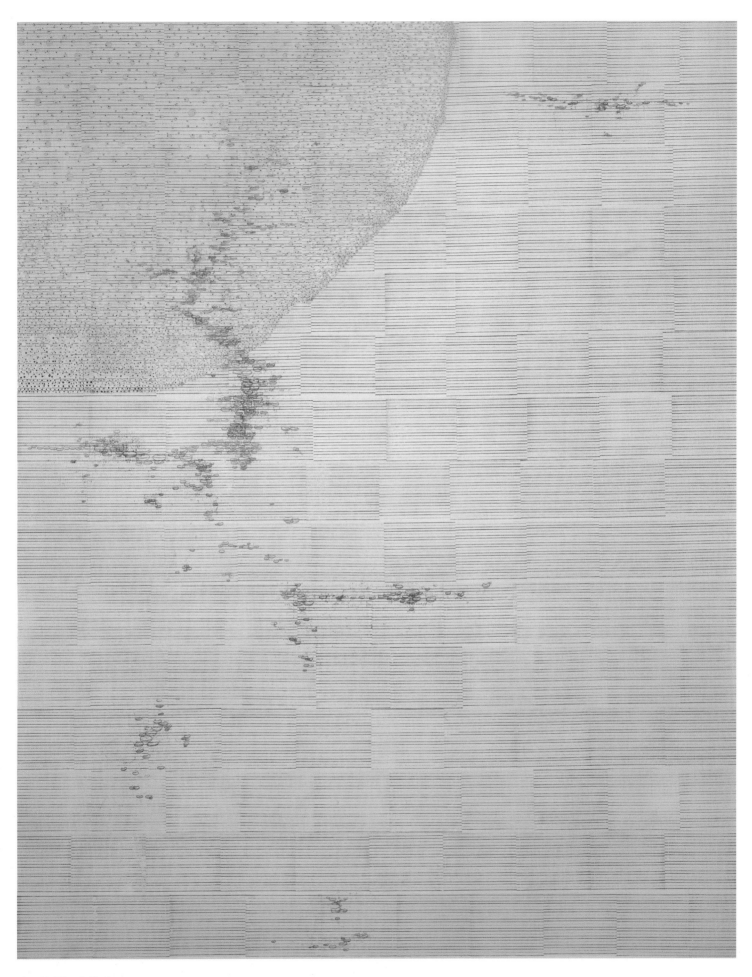

plate 12. **Ellen Gallagher**
Bubbel. 2001
Oil, ink, and paper on linen, 10 x 8' (304.8 x 243.8 cm)
Albright-Knox Art Gallery, Buffalo, New York

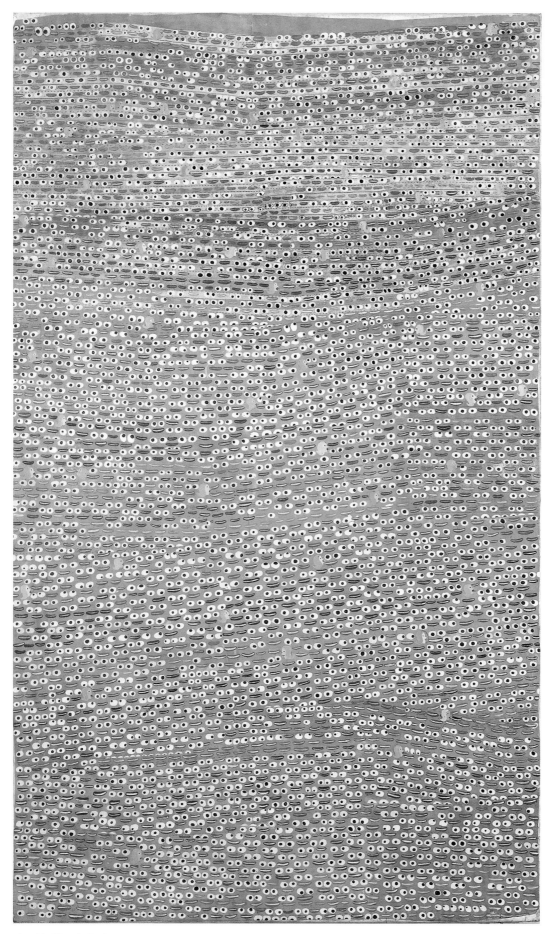

plate 13. **Ellen Gallagher**
Oh! Susanna. 1993
Oil, pencil, and paper mounted on canvas, 60 x 36" (152.4 x 91.4 cm)
Collection of Michael and Joan Salke, Naples, Florida

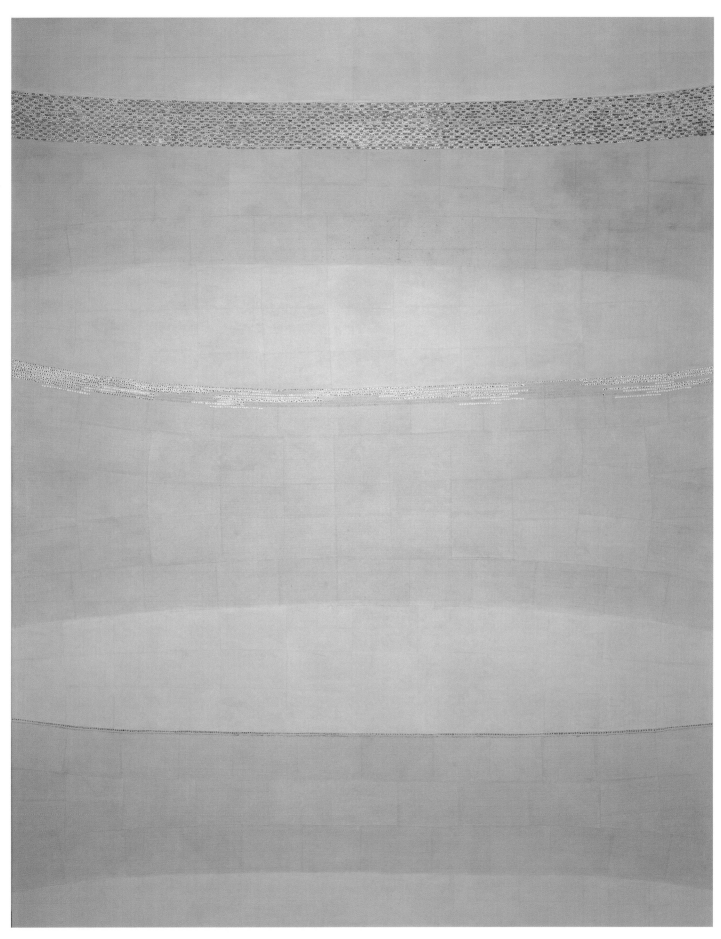

plate 14. **Ellen Gallagher**
Oh! Susanna. 1995
Oil, pencil, and paper mounted on canvas, 10 x 8' (304.8 x 243.8 cm)
The Museum of Modern Art, New York. Fractional and promised
gift of Michael and Judy Ovitz, 1997

RM: Let's discuss some of the titles of your works like, *Oh! Susanna* (1993 and 1995; plates 13 and 14) and *They Could Still Serve* (2001; plate 16).

EG: The title *They Could Still Serve* comes from Goya's print series *Disasters of War* (1810–20). In this particular etching [*They Can Still Be of Use*] (fig. 14), wounded and dying soldiers are assessed for battle fitness. As their eyes try to look out across the page, a single eyeball dangles from the edge of a bayonet.

They Could Still Serve is made from penmanship pages that have been individually stained and then reassembled on the canvas. Each staining has its own distinct history and border. When the pages are glued to the canvas, they become atmospheric and simultaneously fall apart. Just like when you listen to a musical track and can hear the way it was put together, you can see the different layers in the painting, but it still reads as a convincing whole. Long, gluey veins are looped and drawn onto that surface. The veins are stopped with a scattering of tiny white oil paint circles. Disembodied eyes cannot resist the gravitational pull toward this one dying eye—a bruised, pigment-stained page that remains alien.

The title *Oh! Susanna* comes from the Stephen Foster lyric that was originally a slave lament. I was interested in how the song was transformed into an American story about westward expansion. It also expresses the loss and aching memory of families who were torn apart by the economics of slavery. The specifics of race and slavery have been sublimated in order for it to function as an American folk song.

RM: What is the relationship between the 1993 and 1995 versions of *Oh! Susanna*?

EG: In the first painting, movement is generated by the spatial distribution of the blonde heads. I started with a written list of blonde wig ladies. They were not necessarily blonde or even women, but they had to have some *créolité*: Elizabeth Montgomery, Marvin Gaye, Prince, Iggy Pop, Jennifer Beals, Andy Warhol, Lisa Bonet, Ian Curtis, Sade, Madonna, Little Richard, Jeff Buckley, Diana Ross, etc. Although the blonde heads are cartoons, I was always making a specific person from my list. The list was very important to me, but the heads still had to be cartoons. From a distance they should all look the same, like flickers of color as the disembodied eyes and lips flow in and away. I built up different areas of the painting and then went back to the top and worked my way down. It was a delirious process as I labored day and night for about three weeks. Even where the painting breaks apart, it is still tightly woven. I was interested in the focus and remove I generated while making that work.

To a greater extent, the second painting directly addresses the absent body that is implied in the first painting. Here, the disembodied heads, eyes, and lips are literally shadowed by my body. The smears staining the upper "blank" pages seen just below the top arc of paint accumulation were made from the bottoms of my feet as I knelt on the canvas to paint. The stains function as a ghostly anchor between the paint and pencil accumulations floating above. The performative flicker that spreads outward from the heads in the first painting became an ellipse moving downward across the surface. The vantage point is simultaneously aerial and sideways, a cross-section descent through a paper volcano.

RM: Your work narrows the space between the abstract and the social. Can you elaborate on your work's relationship to cartoons, caricature, and minstrelsy? What happens when you contaminate the model of modernist abstraction with tiny signs of racist caricature?

EG: Beginning with the ethnographic investigations of Henri Matisse and Pablo Picasso, experimentation is a mainstay of modernism. Even Marcel Duchamp's *Fountain* (1917) functions as a kind of ethnographic puzzle. But we as a society decide which experiments are culturally productive and modern and which are aberrations. Still, the experimentation that took place in America and Europe is not displaced outside of modernism.

The writings and performances of Gertrude Stein are understood as modernist language experiments. Josephine Baker's performances were well attended by the modernists in Paris. When you talk about Gertrude Stein hosting Picasso in her home and the fact that she and her brother Leo were important collectors, you are talking about milieu. Wasn't the minstrel stage part of that same milieu? Bert Williams taught himself to speak a "nigger dialect" as if it were a foreign tongue, which historian Houston Baker has called "white Dada at its most obscene." And if so, what could be more modern and more abstract than the total refiguration of the African body into American blackface?

RM: The idea of hybridization is also linked to abstraction. At times, you abstract your figures and at other times you make them eclectic. For instance, your image of the "blonde negress" is all about ethnographic eclecticism. This image is fraught with contradictory cultural signifiers that at once provoke and thwart conventions about racial difference. I am also interested in the correlation between the mixed cultural identity that permeates your work and your own hybrid Irish-African-American background.

EG: I think the hybrid forms and identities in my work have more to do with being born after the Civil Rights Movement rather than as some kind of mulatto evidence. The mixed cultural identity in

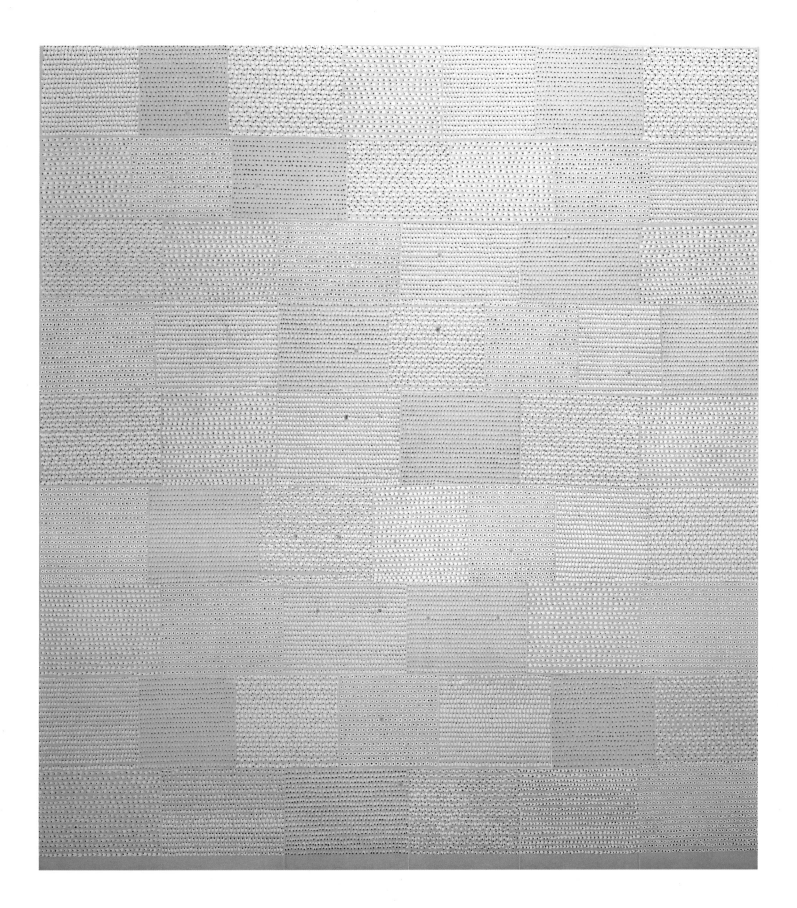

plate 15. **Ellen Gallagher**
Untitled. 1996–97
Oil, pencil, and paper on canvas,
64 x 58" (162.6 x 147.3 cm)
Hauser & Wirth, Zurich and London

my work comes from an opening in cultural perception that has been brought about by the social transformations that began to take place after the Civil Rights Movement.

I want to know something about how a poem or painting was made, the environment in which it was created, and the kinds of spaces these art forms can open up in culture. It may be about the different ways of apprehending form as compared with the desire to know something so completely through classification and reading. When I begin researching an idea, I want my investigations to help me get a hold of something historically and theoretically, but there is also this other sensibility that takes a form more like poetry. It exists as this other field of knowing that is set up between materials and ideas.

RM: What do you find to be the most effective way of denaturalizing the notion of racial identity? You have often said that your work is not merely a critique of stereotypes. Yet, a sense of parody emerges.

EG: Did you ever happen to read the black issue of the *New Yorker* from 1996 edited by Henry Louis Gates, Jr.?[1] The texts were densely mapped and all over the place. There were all kinds of articles written by various black writers, but someone forgot to tell the cartoonists about the theme of the issue. So the same artists who create all the *New Yorker* cartoons every week made the cartoons for the black issue. Every single one was about integration. It was as if the black characters could only exist in relation to The Crisis. There wasn't a single cartoon in which the black characters weren't thinking about white people. And it was funny, in a circumscribed kind of way. But the same problem happens with critique—it circles too closely with currency and cannot be separated from distribution and readability. Therefore, it can't be separated from power.

RM: You revisit the history of black popular culture, of minstrelsy, and of race in mid-twentieth-century America to expose the mechanisms of representation and open up a space of multiple identifications. Can historical truth be grasped or conveyed other than through the lens of critical revisionism?

EG: I transform real events and history in my work. It is very loaded material, but that doesn't mean it is clear where it will take you. You see the image, the material, and its historical implications, but it's also about the selection process. Wherever there is selection and editing, there will be invention. That falsification creates friction and energy. The signs may be exhausted. They are not new. However, as my relationship to the signs changes over time, their spatial proximity is always in flux. Like performers, my conscripted characters are forced to repeat their lines, and with each repetition, they experience themselves differently. Each repetition inaugurates an altered state. It's a shifting loop that with each rotation doesn't quite line up. Densities and expansions get created through deformation.

1. *New Yorker*, ed. Henry Louis Gates, Jr. (April 29–May 6, 1996).

plate 16. **Ellen Gallagher**
They Could Still Serve. 2001
Pigment and synthetic polymer on paper mounted on canvas, 10 x 8' (304.8 x 243.8 cm)
The Museum of Modern Art, New York.
Emily and Jerry Spiegel and Anna Marie and Robert F. Shapiro Funds and gift of Agnes Gund, 2001

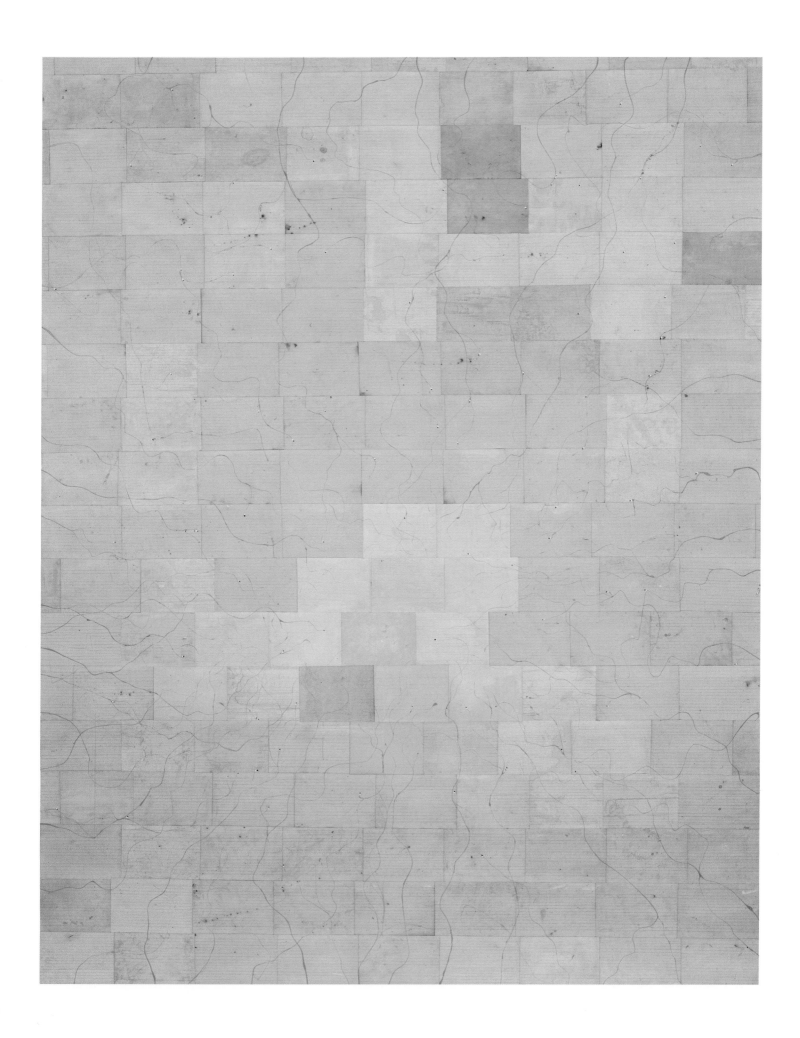

ARTURO HERRERA

plate 17. **Arturo Herrera**
Tale. 1995
Latex paint on wall, 16' 4 ⅞" x 65' 7 ⅜" (500 x 2,000 cm)
(installation view at Centro Galego de Arte
Contemporánea, Santiago de Compostela, Spain, 2005)
Collection of Diane and Bruce Halle, Phoenix, Arizona

plate 18. **Arturo Herrera**
Night Before Last. 2003
Synthetic polymer paint on wall, 13' 9" x 42' 11"
(419.1 x 1,308.1 cm) (installation view at Castello di
Rivoli Museum of Contemporary Art, Turin, 2003)
Collection of Jeff and Linda Krinsky

Roxana Marcoci: Let's begin by discussing how you decided to make your first collages.

Arturo Herrera: While living in New York City during the late 1980s, I had no access to a studio or much of a budget for supplies. I turned to collage because paper was inexpensive and widely available. With glue, scissors, and an X-Acto knife, I started making small images without knowing where it might lead.

RM: What initially prompted you to abstract a scene from a Walt Disney cartoon, a comic strip, or a children's coloring book?

AH: Secondhand shops like the Salvation Army and Goodwill as well as used bookstores and Dollar Days shops were my only sources for paper then. The chaotic variety of what they had was staggering. I bought old travel guides, fairy tales, how-to manuals, magazines, graphic novels, art history plates, illustration and decoration annuals, and foreign-language phrase books. The cheapest items were children's tales and coloring books that were scribbled or half-colored. Cutting these "sale bin" books produced the most surprising and challenging fragments filled with abstract and surrealistic references while maintaining a lingering connection to their origins.

RM: How do you explain that no matter how much you abstract a cartoon, the vestigial image behind abstraction still remains quietly visible?

AH: Animation and cartoons are part of our global contemporary culture. Their simplified forms and friendly colors are precise and carefully orchestrated to make an immediate impact. Old characters are kept alive in print and film or are discarded as new ones appear. They are branded on our minds and can't be obliterated. What intrigues me is that we all have a personal relation to a certain character or comic strip. Just a snippet of a specific image will rapidly pile up pleasure, identity, stories, and who knows what into a disorderly mix of associations.

RM: When you lived in Chicago in the early 1990s, you became familiar with the comic book–based collages of Ray Yoshida. Your use of comic cutouts recalls the black humor tradition of the Chicago Imagists. Can you talk about this lineage?

AH: Many members of The Hairy Who were active while I lived in Chicago during the 1990s. I often saw their work in galleries and museums and to this day I am challenged by it. However, my use of pop and readymade materials dealt less with their interest in the vernacular. Artists like Julia Fish and Tony Tasset at the

University of Illinois at Chicago had a more powerful influence on the potential of conveying ideas through images and objects.

RM: You once cited three works in MoMA's collection that are significant to you: Pablo Picasso's *Harlequin* (1915), Henri Matisse's *Dance* (1909), and Alberto Giacometti's *Woman with Her Throat Cut* (1932).[1] What role does the modernist tradition play in your practice?

AH: Modernism was utterly obstinate about itself while proclaiming a world full of uncertainty. It strove toward innovation while respecting tradition. It had a visual language born of intuition with an optimistic yearning to become universal. Well, it didn't work out as planned, but the debris is endlessly complex and fertile.

RM: You have said, "The best artworks are very rigorous but feel very casual."[2] Not surprisingly, you construct intricate images but you manage to make the process seem effortless. How do you actually produce your largest works such as *Untitled* (2000), which is included in this exhibition?

AH: The essential factors in developing a wall work are the architecture and function of the space, as well as the context in which the piece will be exhibited. Once these are defined, an image will be developed through sketches, photocopies, bottles of Wite-Out, transparencies, and small drawings directly applied to scale models. The most successful wall paintings and drawings occur when space and image are so integrated that they inform and enrich each other almost casually. The goal is to activate a space that the architect never intended to be painted by creating an image that feels like it has always been there.

RM: What kind of sources have you used in this work?

AH: *Untitled* is based on doubling up a wall painting from 1999 titled *All I Ask* (plate 21), commissioned for the *Color Me Blind* exhibition at the Württembergischer Kunstverein in Stuttgart. *All I Ask* was inspired by a Snow White coloring book that I found at an Odd Jobs store in New York in 1998. The book recreated Disney's 1937 animated film in seventy line drawings. *All I Ask* aimed for an abstracted familiarity, a subjective reinterpretation of this beloved fairy tale, an endlessly connected composition on the verge of transforming and collapsing on itself.

RM: *Untitled* is then based on doubling the composition of *All I Ask*. Is this the only instance when you overlaid, flopped, and replicated an image in its entirety? Are there other works that have spun off this matrix?

AH: After *All I Ask* I continued fragmenting and splicing entire

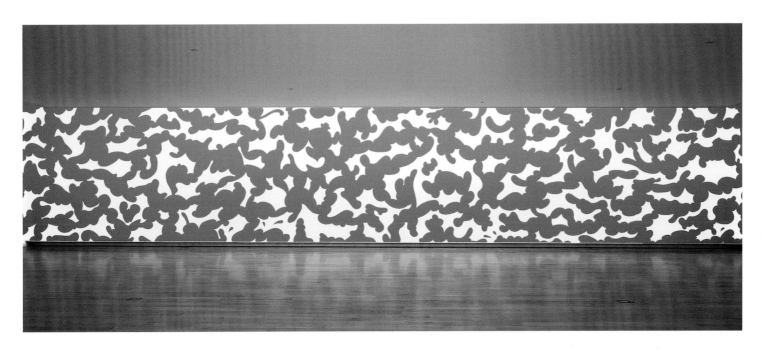

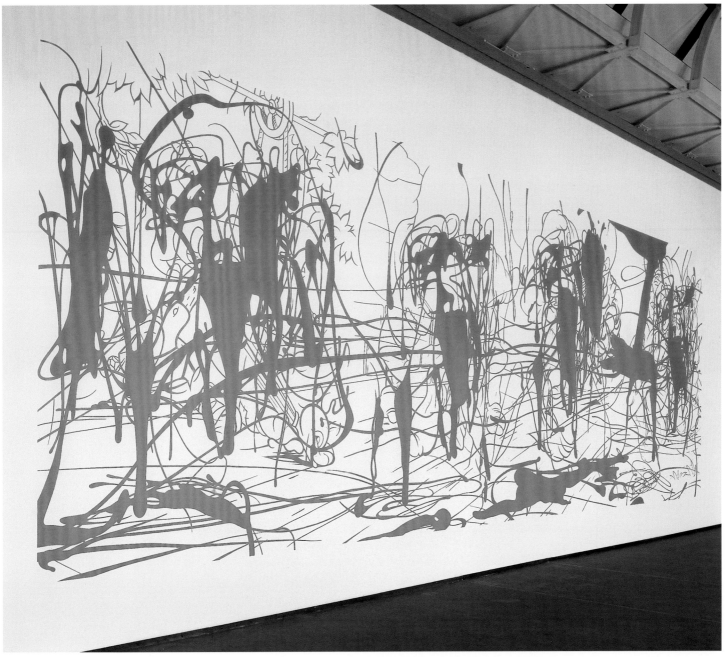

scenes from the same coloring book. I also incorporated some of my spill and drip ink drawings. The result was *Night Before Last* (2003; plate 18). Eight drawings were duplicated, flipped, and reversed in sixteen combinations. These in turn originated new pieces in a variety of media, color, and scale. Working on these encouraged me to replicate and turn *All I Ask* into itself. However, *Untitled* is not an inverted mirror image. I added, deleted, and juxtaposed fragments to build up a new work that is harder to read while being seductively accessible. This doubling-up sets in motion unlimited paradoxes that engage the viewer visually and psychologically.

RM: There is a certain obsessive quality about the combination of organic geometries and abstracted figures in *Untitled*. Do you see repetition as intrinsic to the concept of your work?

AH: Repetition allows the drawing not to be locked down, giving me the ability to push an image to its limits and reveal new propositions while reinforcing its original source. This pliability uncovers a variety of configurations that provides multiple views for both the image and the viewer.

RM: *All I Ask* was realized in two colors—beige marks on a cocoa ground. It's been suggested that this color scheme relates to aspects of race and bodily functions that have been persistently suppressed in Disney's story of Snow White. How did you decide on the blue-and-white color combination of *Untitled*?

AH: The color scheme for *All I Ask* was alienating because brown and white are psychologically opposed. Even though we see it everywhere, brown is the world's least popular color. I wanted this reference to be in dialogue with Snow White's seemingly harmless tale. I chose the exact opposite for *Untitled*. Blue is considered to be everyone's favorite color. It is commonly associated with harmony, infinity, intellect, and peace, among other attributes. Due to the complexity and abstract nature of the image, I wanted a color that the audience could embrace and trust. The perverse contradiction is that *Untitled* becomes deceivingly more readable, but offers no easy answers or objective resolutions. Snow White, chipmunks, hunters, birds, and dwarves are hybridized into a field of blue lines spilling over the edges of the wall.

RM: You take a figurative scene, cut it up, reassemble it, and turn it into abstraction. Can you talk about the process of deletion?

AH: I find fragments incredibly powerful. By deleting carefully, you enrich whatever is left. The hard thing is deciding what to delete.

RM: You delve into the dark, unresolved side of Disney, defamiliarizing the world of comics as we know it. At the same time, you explore the uneasy subjectivity of abstraction—the irrationality of the spill, the associative power of the biomorphic shape. How do these two worlds intersect?

AH: Disney avoids direct involvement with fairy tales as a way to deal with our fears and social/cultural codes. But the little we do see still resonates in our minds, confronting our anxieties and desires. Abstraction equally taps into a nonobjective system to propose other realities. The combination of both languages confronts the history of each individual through metaphor and memory.

RM: Some of your works are made with household latex paint and others with cutout felt. In what way is your choice of material important to the exchange you seek between hybrid abstraction and vernacular imagery?

AH: I don't try to match a material to a specific work. I enjoy the widespread availability and familiarity of house paint, felt, and MDF [medium-density fiberboard]. They are ideal everyday materials because they are easily manipulated and instantly recognizable and, like coloring books, they are cheap.

RM: In the sixty-five collages of the series *Keep In Touch* (2004), you have abandoned the idea of using found material. Instead, you hired a professional illustrator to hand-paint backgrounds culled from animated films. Next, you glued cutouts resembling animated figures on top of these original works. Are you interested in taking your images one step closer to animated film?

AH: In *Keep In Touch*, I commissioned specific backgrounds from animated films and illustrated books. These original paintings allowed me to remove characters and edit unnecessary details to create an empty, stagelike image where I could intervene. Thirteen motifs were repeated five times with slight variations. The resulting series of sixty-five images became static backdrops on which I collaged paper in a variety of media to suggest animated forms on the verge of movement. This method of working edged me closer to animation. For an upcoming project, I plan to substitute fragmented ready-made images found in cartoons and films for abstract drawings and photographs I made in the studio. These will be projected sequentially to suggest a moving image.

1. Herrera, quoted in Ingrid Schaffner, "Cut Up: The Art of Arturo Herrera," in *Arturo Herrera* (Xunta de Galicia, Spain: Centro Galego de Arte Contemporánea, 2005), pp. 129–32.

2. Herrera, quoted in Josiah McElheny, "Arturo Herrera," *Bomb*, no. 93 (Fall 2005): 70.

plate 19. **Arturo Herrera**
Three Hundred Nights. 1998
Latex paint on wall, 10' 6" x 15' (320 x 457.2 cm)
(installation view at Dundee Contemporary Arts
Center, Scotland, 1998)
Private collection

plate 20. **Arturo Herrera**
Untitled. 1998
Latex paint and plaster on wall, 10 x 48' (304.8 x
1,463 cm) (installation view at The Renaissance
Society at The University of Chicago, 1998)
Collection of the artist and Sikkema Jenkins & Co.

(next page)
plate 21. **Arturo Herrera**
All I Ask. 1999
Latex paint on wall, 11 x 35' (335.3 x 1,066.8 cm)
(installation view at Württembergischer Kunstverein
Stuttgart, 1999)
Collection of Rachel and Jean-Pierre Lehmann

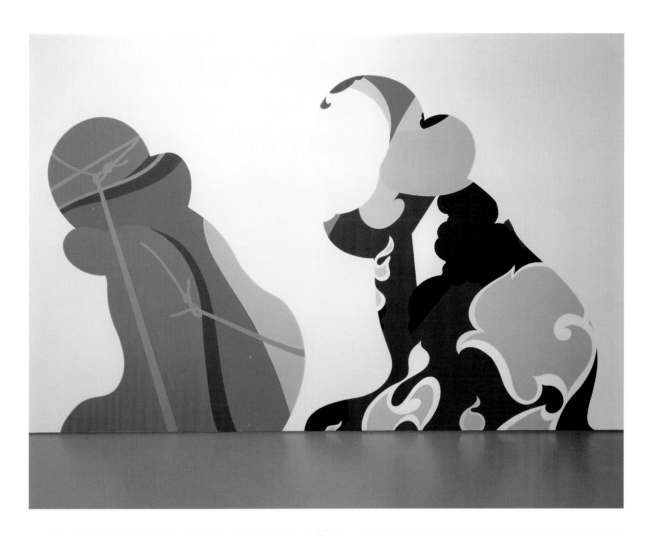

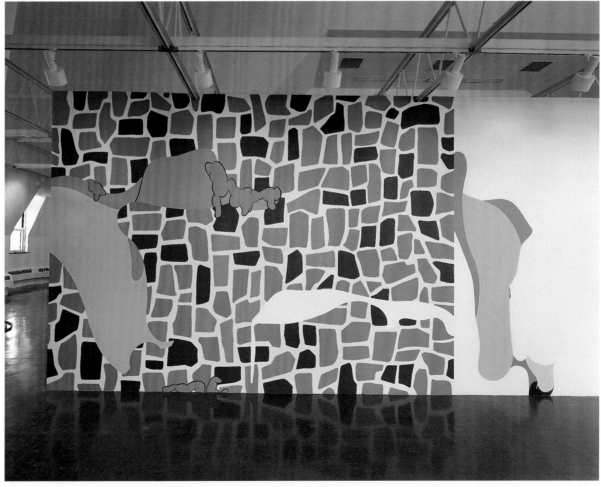

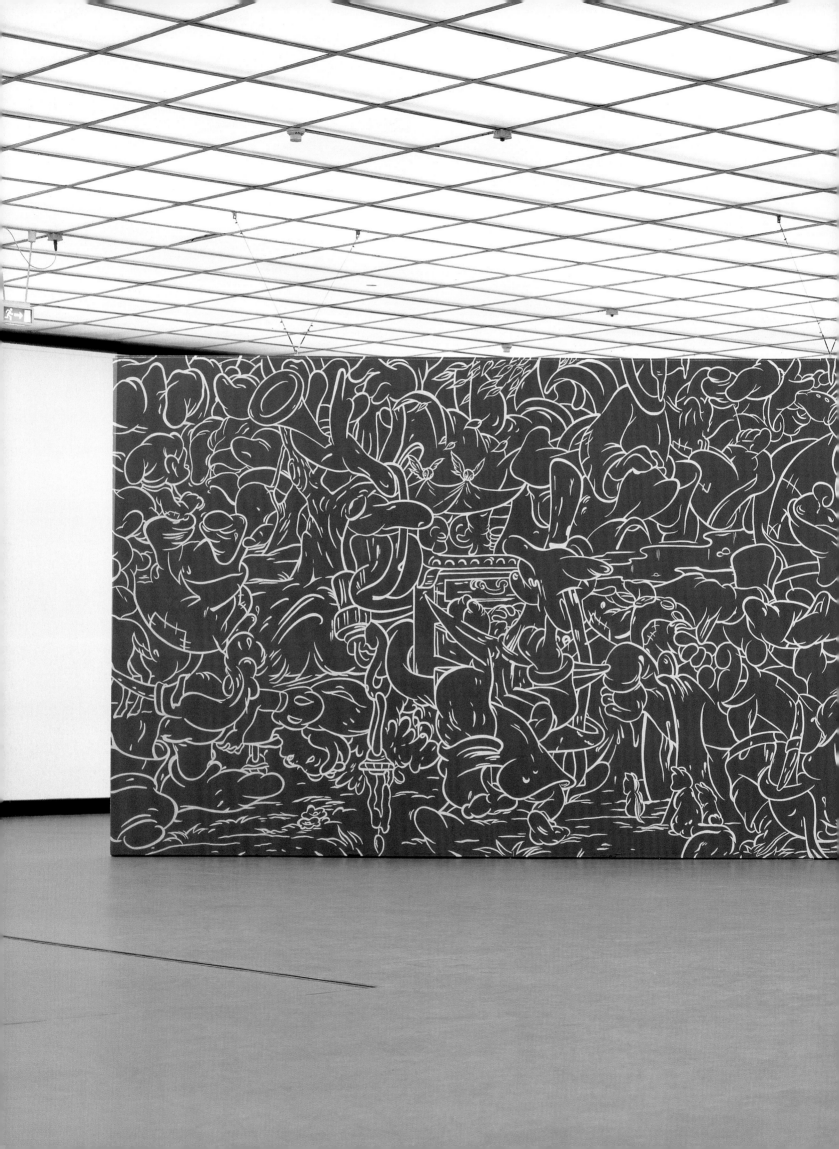

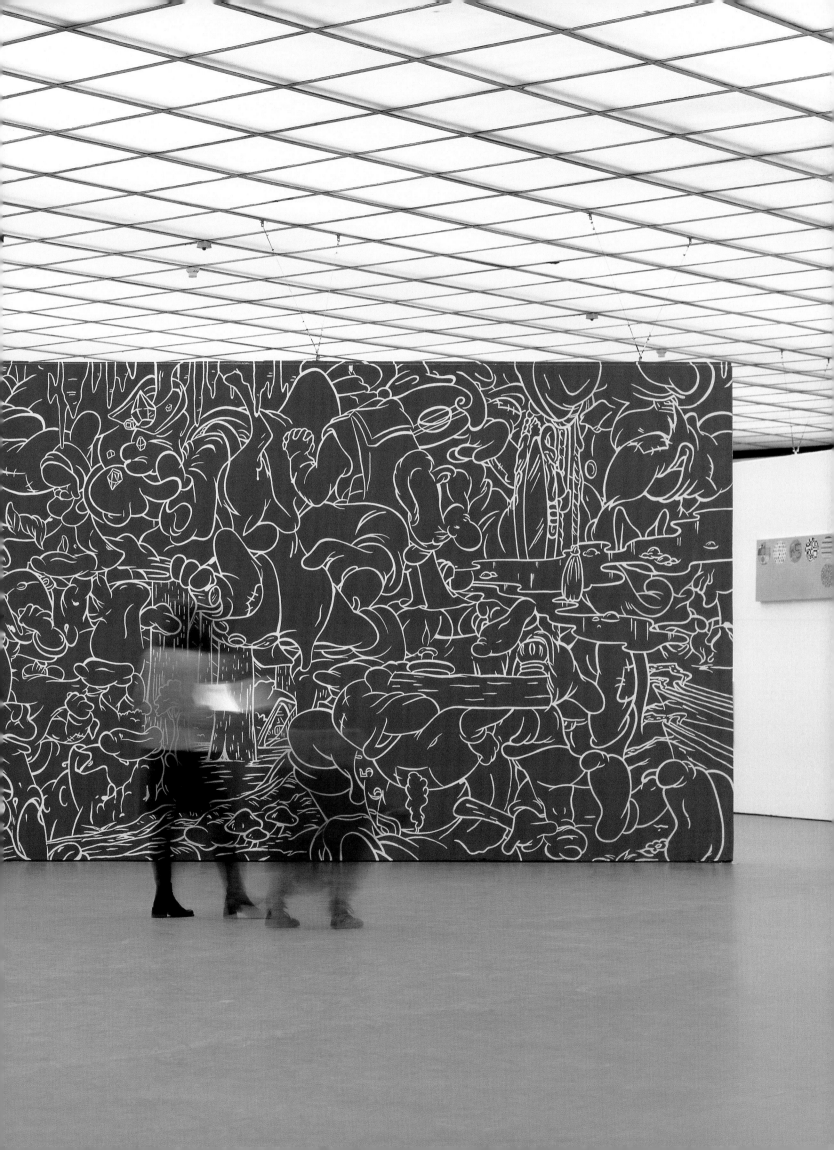

MICHEL MAJERUS

(1967–2002)

Do you know what Solo Morasso is? It's the mud monster that keeps appearing in Superman, that was turned into an immortal mud monster by some sort of chemical reaction following an atomic explosion. It feels horribly lonely, and every five years or so it leaves its slimy pond and heads for New York, where it inadvertently stomps on all the cars.
[E-mail correspondence to Bastian Krondorser, January 26, 2001]

I . . . am convinced that you don't yourself have control over the short period in which you do good things. Quite likely you don't ever know when it is. Probably it happens in the time when no one has any expectations of you and you don't have any expectations of yourself either.
[E-mail correspondence to Heike Foell, January 27, 2001]

Can you believe that I was in the Disney theme park even before the official opening? There was a concrete cast of a bear, carved out of wood, 5x as big as Jeff Koons' bear and carved identically. The rest was all crap except for one special effect you've seen before anyway. They have put this big wheel and the roller coaster right beside an artificial lake that everything is reflected in the water when it's dark, like a Jenny Holzer reflected in marble. To go there, I skipped another exhibition opening.

Last week I passed an idiots test. I was at a crossroads, to my left there was a large billboard with nothing on it and to my right an immense inflated Van Nuys Car Sales duck. The light was just about to turn green and I could only take one photo at the most. I don't know why, but I photographed the white billboard, idiot that I am. Goodness knows that with Photoshop I could change any stupid poster to white, but of course I don't do that, I leave that to others. At all events I didn't photograph the duck, and thus passed the dimwit test.
[E-mail correspondence to neugerriemschneider, Berlin, February 7, 2001]

I feel as if I had been derailed by some sabotage program, on a trip, registering impressions only in the form in which I can myself produce them in my work.

Yesterday I lay on the studio floor on a lovely warm chunk of polystyrene watching Wong Kar-Wai's 'fallen angels' on my laptop, and all the while it was growing dark and I lay on the floor dozing a little. Now and then I heard a telephone ring. . . . The mood of the film was very close to how I might have observed myself from the outside, lying here, alone and with this sprawling city all around me. There's simply nothing like the right films at the right time.
[E-mail correspondence to Heike Foell, April 10, 2001]

At 15, I went along with Schoenberg as one of the few composers for me, because of the atonal thing. I liked it a lot. I could easily recognize a structure in it that I could identify myself with, so I had the feeling this man wants people who don't feel comfortable with tonality to understand, or be able to do so. I found that a good basis for producing something of my own.
[E-mail correspondence to Robert Fleck, August 28, 2001]

Basically, I tend to choose raw material that has already filled a vacuum of that kind and is generally seen as too much, but actually means the same vacuum.
[Interview with Raimar Stange, in Sur.Faces, Interviews 2001/02, ed. Christoph Keller (Frankfurt: Revolver, 2002), p. 18]

plates 22–27. **Michel Majerus**
top: Untitled (100); Untitled (114)
middle: Untitled (107); Untitled (62)
bottom: Untitled (113); Untitled (95). 1996
Synthetic polymer paint on canvas,
each 23 ⅝ x 23 ⅝" (60 x 60 cm)
Boros Collection, Germany

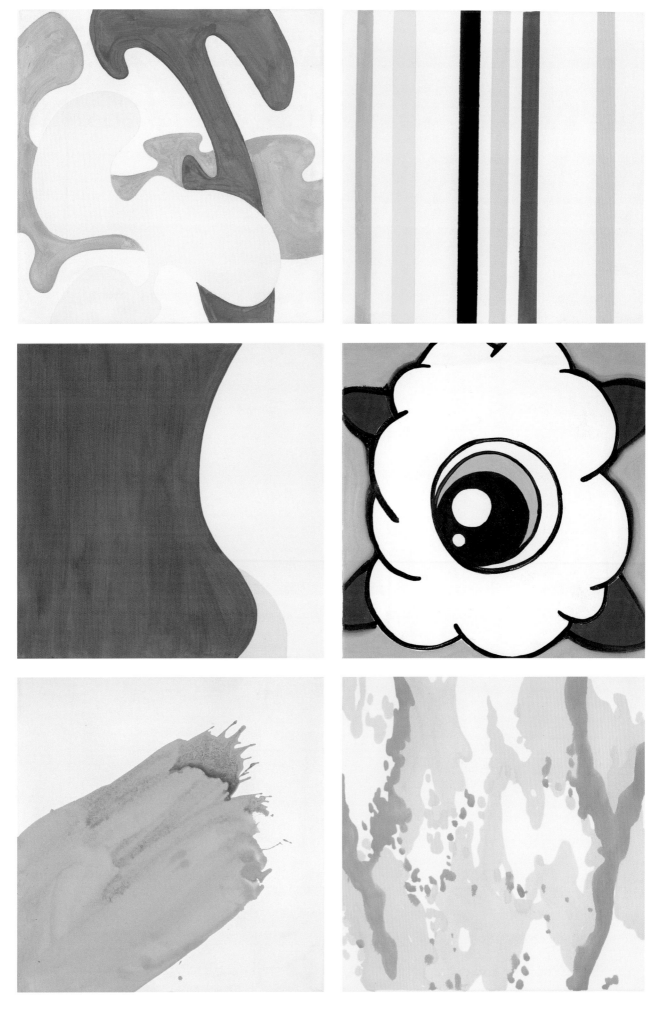

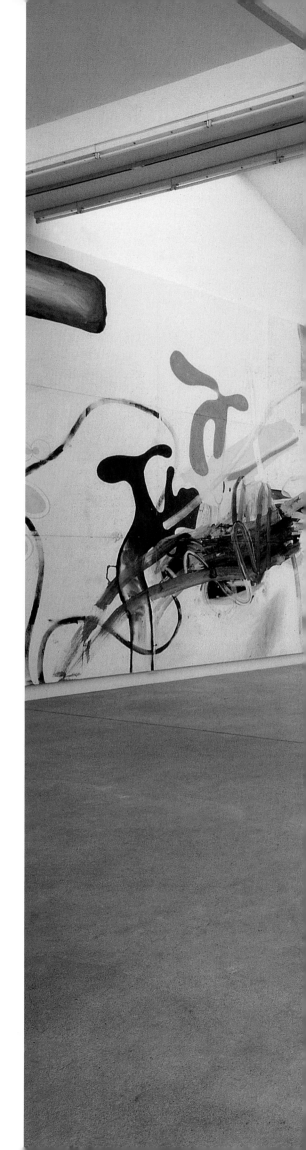

plate 28. **Michel Majerus**
Installation view at Galerie Monika Sprüth,
Cologne, 1996

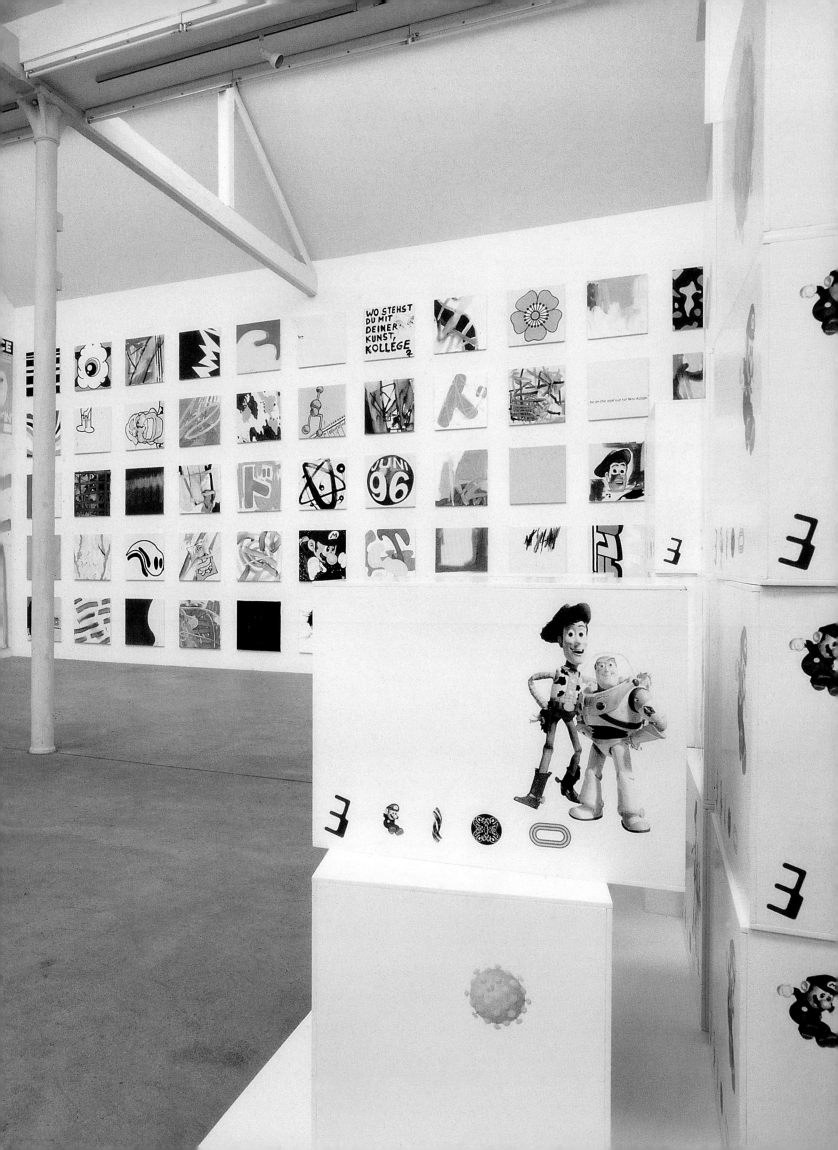

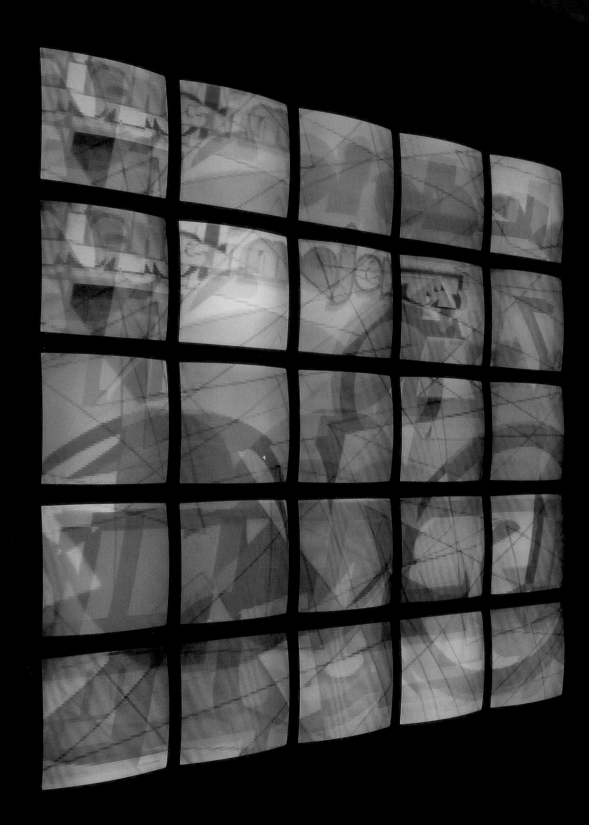

plate 29. **Michel Majerus**
michel majerus. 2000
Video projection on twenty-five screens,
30-minute loop (installation view at Hamburger
Bahnhof, Berlin, 2003)
Estate of Michel Majerus

plate 30. **Michel Majerus**
eggsplosion. 2002
Synthetic polymer paint on canvas, 9' 11 ¾" x 11' 5"
(303 x 348 cm)
Collection of David Teiger

(next page)
plate 31. **Michel Majerus**, *enlarge-o-ray . . . on!* 1994
Emulsion paint on wall and synthetic polymer paint
on canvas, wall: 11' 9 ¾" x 17' ¾" (360 x 520 cm);
canvas: 31 ¾ x 21 ⅝" (80.5 x 55 cm) (installation
view at neugerriemschneider, Berlin, 1994)
Estate of Michel Majerus

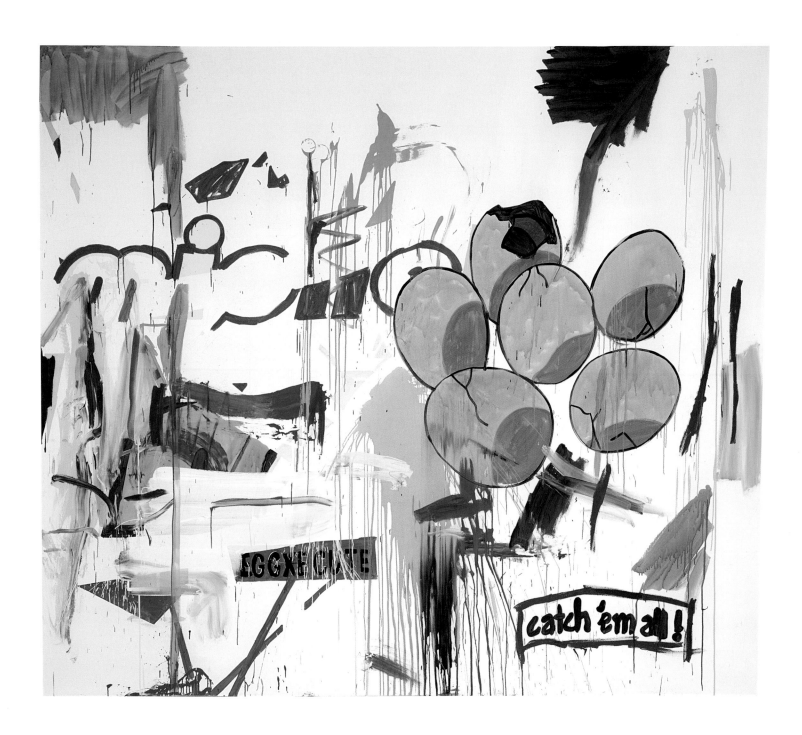

JULIE MEHRETU

Roxana Marcoci: Here is, I think, a sentence that reveals a lot about your work. You say: "I am interested in the multifaceted layers of place, space, and time that impact the formation of personal and communal identity."[1] Is montage the organizing principle of your work?

Julie Mehretu: The more I work, the more I find myself trying hard to avoid having one particular organizing principle. I want to constantly break down and dissect my work, processes, ideas, and concepts. I use various types of source materials and examine them through the lens of my work, responding to and recontextualizing them in drawing and painting. My method of finding and selecting material is usually informed by what is going on in the world around me and what I am attracted to. I usually focus on particular types of architectural plans, maps, news photographs, historical paintings, and graphics, creating a subtext for the work through this material. However, the actual paintings manifest from the congealing of all of these different elements into drawing and painting with ink, pigment, and acrylic.

RM: Your paintings conjure up a collision of architectural plans, graffiti, abstract marks, and pyrotechnics culled from comic books as well as incorporate calligraphic forms that you call the "characters." Can you talk about your sources and working process?

JM: I work with source material that I am interested in conceptually, politically, or even just visually. I pull from all of this material, project it, trace it, break it up, recontextualize it, layer one on the other, and envelop it into the DNA of the painting. It then becomes the context, the history, the point of departure. It becomes the place of the painting. The specific building types, the geometry and space of the picture grow out of that process. Sometimes I draw into that picture, responding to it with characters, marks, paint, signs, and symbols. Sometimes I layer with the paint. The submerged image then informs the genealogy of the picture. The characters and my mark-making are a part of an abstract language that I have been developing throughout the evolution of my work. There are also visible quotations from known graphics. In the past, these came from different sources, like comic books, graffiti, video game graphics, and motorcycle or car graphics. They were cultural signifiers that worked as indicators in the painting. Right now, however, I am interested in how to signify and point to those types of indicators out of my own language and through abstraction. I want to imply that language without directly quoting it.

RM: Is layering also a form of erasure?

JM: Yes, I think it is, much the same way that history is.

RM: The sources you use in your paintings are intensely abstracted. What is the rapport between abstraction and representation, specifically as it relates to the lexicon of cartoons and comics? I am thinking of works such as *Bombing Babylon* (2001; plate 35) or *Retopistics: A Renegade Excavation* (2001; plate 33), which include animated ribbons and comic-style explosions of color that hint at uneasy associations with rocket flares seen in war footage. I am interested in this "commix-ture" of history painting and cartoons.

JM: A representational gesture provides a point of entry into the painting and the abstract elements of the work. Initially, the cartoon and comic quotations offered a way for me to reference and indicate subversive action, aggression, and war. However, as my work has evolved and as the world has changed into a more blatantly aggressive third-world-war state, these types of markers seem insufficient. Prior to September 11, I would put a cartoon explosion over architectural marks as an indicator of the abstract gesture. The language of cartoons and comics could lighten the load and lessen the punch. The spaces of power could be fantastically destroyed and brought down by the riotous, disempowered, antiestablishment characters in the drawing.

As our behavior changed after 9/11, I stopped using that type of language. I lost my interest in the absurdity of the earlier pictures and really think more earnestly about my language. There can be some very interesting collisions between the different visual languages from comics to history painting, but in the past five years, my use of that language has shifted.

RM: Do you mean that the experience of September 11 has altered your understanding of the world, which in turn had an impact on the way you conceive your work?

JM: I think that 9/11 marked a particular paradigm shift, especially in terms of the American imperialist project. Because it dramatically changed the context of our world, it has also inherently changed the way I approach my work. The quotation of the comic has basically been digested into my lexicon. Rather than directly quote a particular cartoon to access the drawing, I just draw and sometimes comic gestures can be deciphered.

RM: Your canvases are full of incident. Tell me about the "characters," the "private urban fighters." Who are they? What role do they play?

JM: The characters are riotous, scrambling monsters, rebels, ghouls, and fighters. They are club bangers, rappers, DJs, churchgoers, musicians, poets, bankers, lawyers, politicians, dogs, birds,

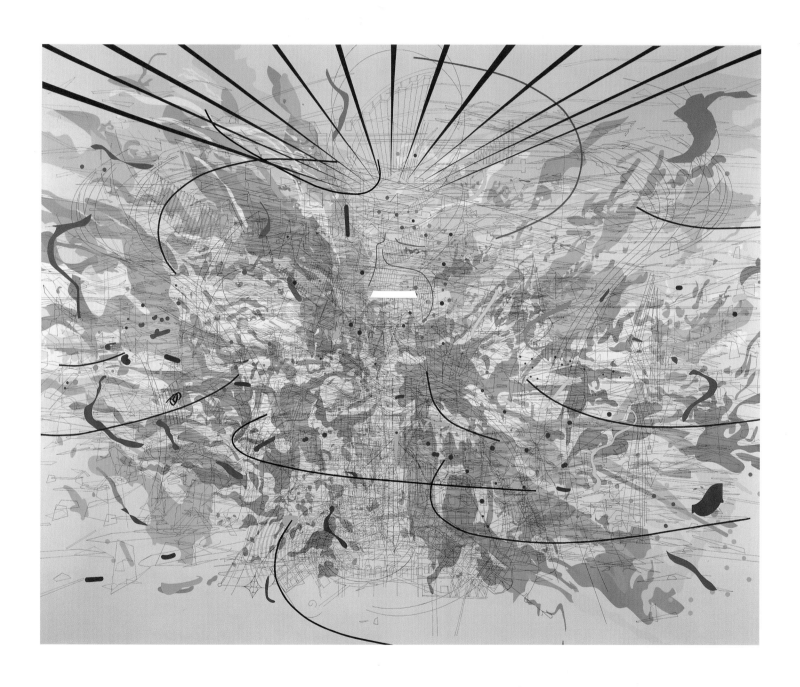

plate 32. **Julie Mehretu**
Looking Back to a Bright New Future. 2003
Ink and synthetic polymer paint on canvas,
7' 11" x 9' 11" (241.3 x 302.3 cm)
The Debra and Dennis Scholl Collection,
Miami Beach

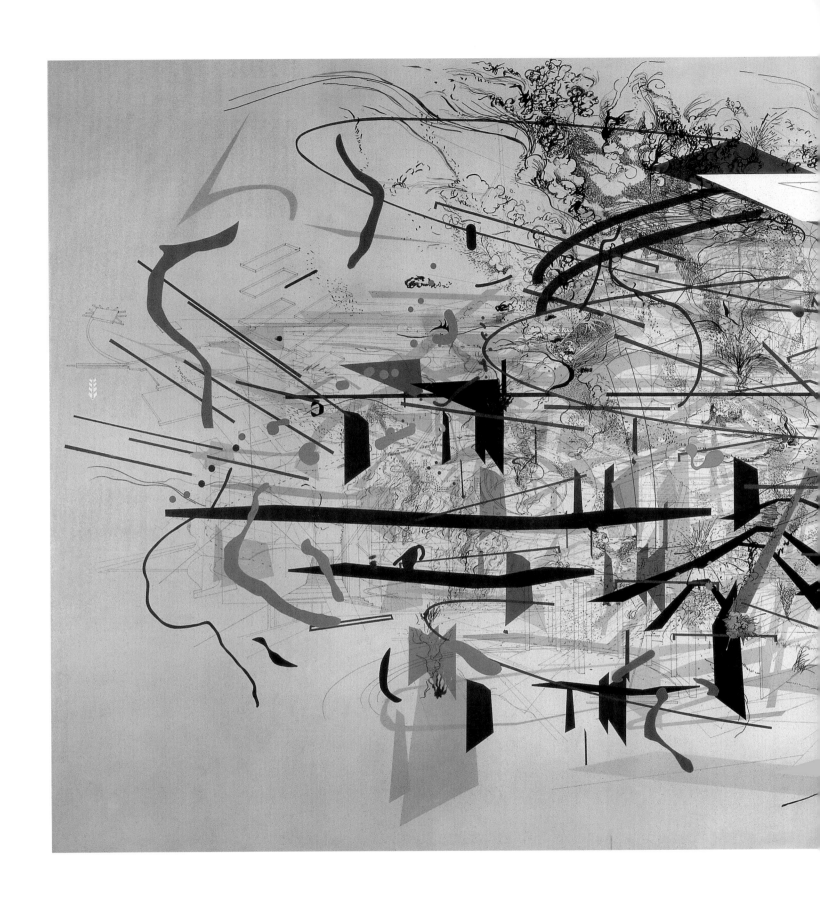

plate 33. **Julie Mehretu**
Retopistics: A Renegade Excavation. 2001
Ink and synthetic polymer paint on canvas,
8' 6 ⅜" x 18' (260 x 549 cm)
Dimitris Daskalopoulos Collection, Greece

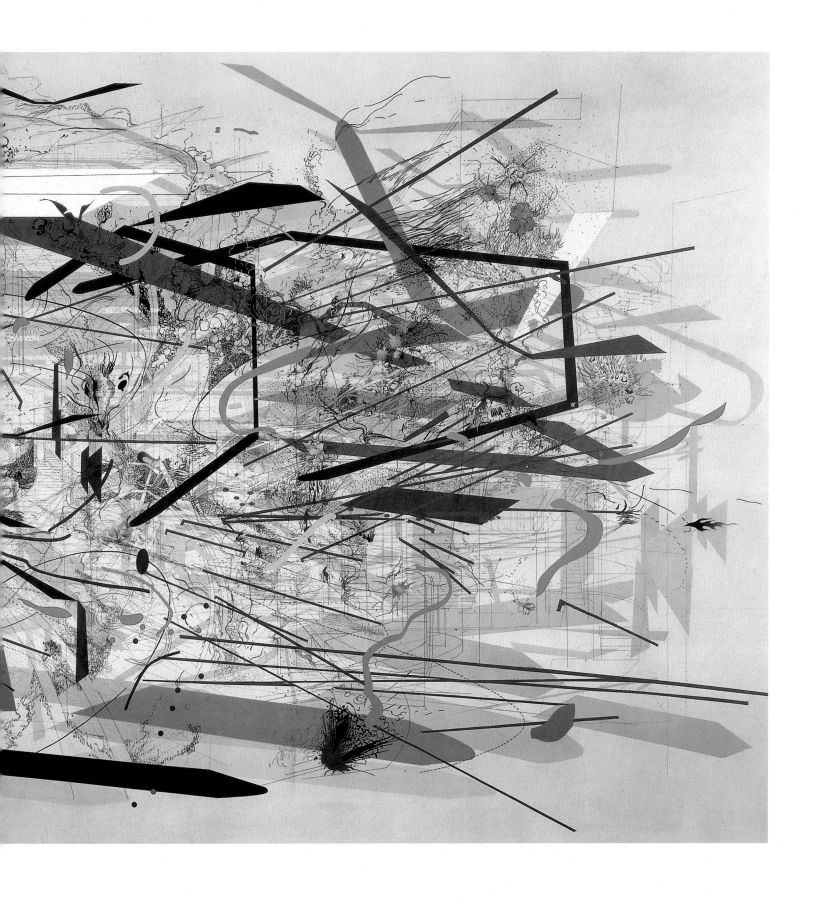

flag-wavers, screamers, insane sports fans, rap fans, rock fans, and students. They are not static. They are crowds, phenomena, marks, dots, dashes, gestures. They are social agents in one way or another.

RM: The superimposition of airport, highway, and subway fragments in your paintings gives a new twist to the concept of *dérive*, or drift, introduced in the late 1950s by the Situationist International. Guy Debord, the group's main spokesperson, and other members insisted on staging unusual excursions by devising vectors, itineraries, and passageways through the city to confound routine experiences. Their critically engaged practice turned the urban setting into a site of political license and collective festivity. What kind of situations do you want to create? And how is abstraction politically effective?

JM: The situations I create are spaces of subterfuge, control, and power turning in on themselves. They are broken up and digested by the drawing. They are expansive, open, accessible labyrinths that consume themselves, becoming more inaccessible and explosive through the millions of bits and parts. The Situationists created a method to subvert and shift space in a political gesture. In my paintings, the spaces and the bodies are political simply because they exist. It is the fact of their existence that engages them, be it politically, socially, or economically. They do not need to fabricate a political gesture because they are faced with that inherently. This is the place of departure for my characters. Abstraction allows for thinking of an issue from different perspectives, from many points of view. Nothing can be didactic in my abstraction. The spaces of power can be as beautiful as those marks challenging them. The gestures can be as hideous as the structures they participate within.

1. Mehretu, quoted in Douglas Fogle, "Putting the World into the World," in Fogle and Olukemi Ilesanmi, *Julie Mehretu: Drawing into Painting* (Minneapolis: Walker Art Center, 2003), p. 5.

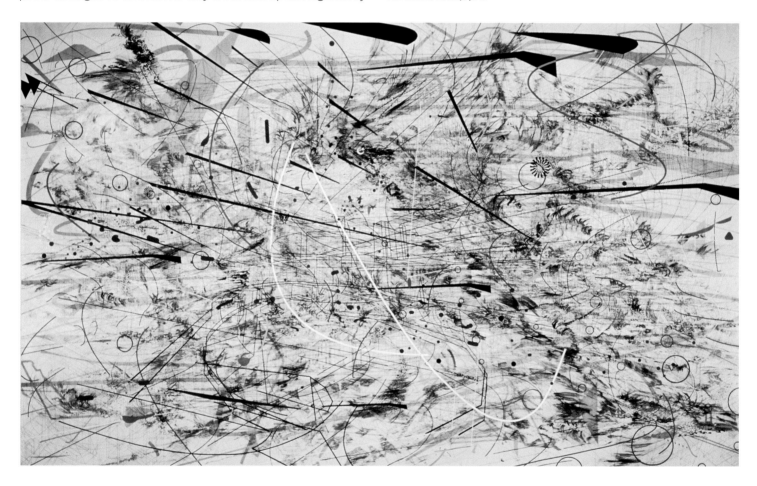

plate 34. **Julie Mehretu**
Black City. 2005
Ink and synthetic polymer paint on canvas,
9 x 16' (274.3 x 487.7 cm)
Ovitz Family Collection, Los Angeles

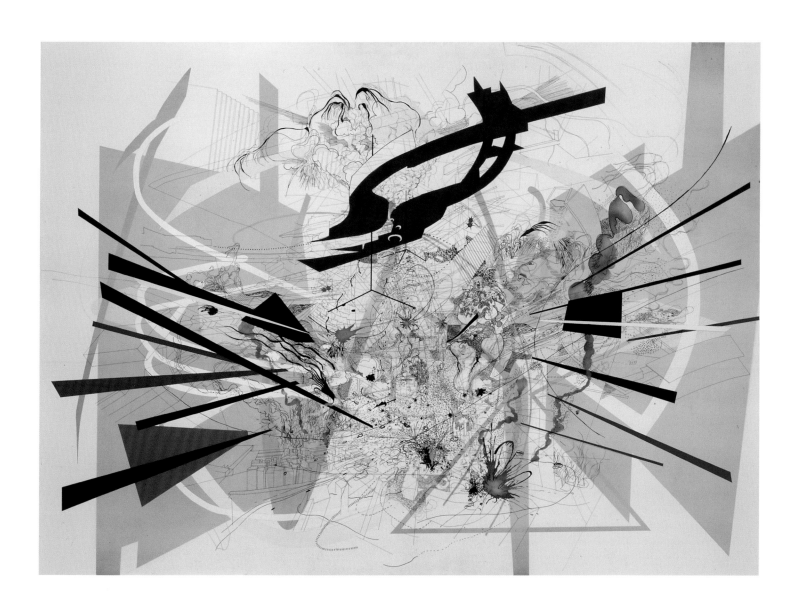

plate 35. **Julie Mehretu**
Bombing Babylon. 2001
Ink and synthetic polymer paint on canvas,
60" x 7' (152.4 x 213.4 cm)
Private collection, New York

JUAN MUÑOZ

(1953–2001)

Tom and Jerry embody what I most admire in art: an exact technique added to an arcane symbolism in such a balance that is rendered invisible for the spectator. The story is always the same, the storyteller is the one who really changes.

A mouse (or a cat) crashes against a door or is squashed by a falling wardrobe. Suddenly, its body is flattened and adopts the shape of a piece of paper.

A window is opened and the breeze rocks it like a leaf falling from a tree. It reaches the floor and we confront an epiphany, a compression of life's meaning.

A hole, just like Jerry's, through which to disappear from this race, these narrow escapes from an endless amount of things falling, this running away from all kind of objects. Maybe they are not exactly objects, but emotions, but they certainly seem to be collapsing all around! Yes, to have a hole to disappear.

Waiting for Jerry [plate 36] was built in 1991 as a gift for my daughter Lucía, who felt an unconditional solidarity with Jerry's need to defend himself from Tom's menacing presence. Nowadays, her younger brother Diego insists that this small and nervous mouse is a nightmare for the quiet and peaceful cat, who, like Diego and myself, only wants to lay down and do nothing but watch cartoons.

Waiting for Jerry was constructed in the Van Abbemuseum, Eindhoven, in 1991, as a humorous comment on what I thought at the time was an increasing amount of darkrooms in exhibitions. Seen with the added distance of time, I feel the piece has lost its social criticism but gained something else entirely.

plate 36. **Juan Muñoz**
Waiting for Jerry. 1991
Wall, light, and audio soundtrack, dimensions variable
(installation view at the Van Abbemuseum,
Eindhoven, The Netherlands, 1991)
Estate of Juan Muñoz

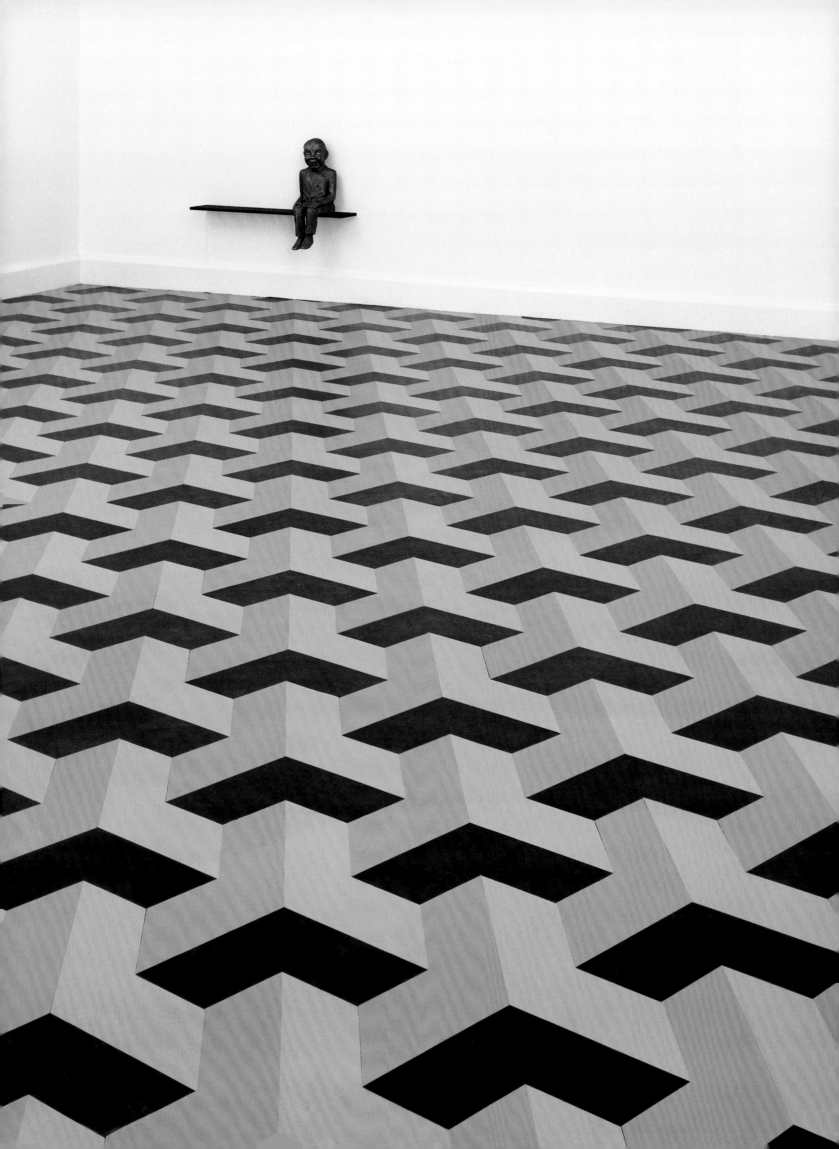

plate 37. **Juan Muñoz**
The Wasteland. 1987
Papier-mâché, paint, and rubber,
dimensions variable
Private collection

plate 38. **Juan Muñoz**
Stuttering Piece. 1993
Resin, cardboard, and audio soundtrack,
dimensions variable
Private collection

plate 39. **Juan Muñoz**
Towards the Corner. 1998
Resin and wood, overall 6' 10 ¾" x 12' x 31 ½"
(210.2 x 366 x 80 cm)
Tate, Purchased with assistance from
Tate Members 2003

(next page)
plate 40. **Juan Muñoz**
Conversation Piece (Dublin). 1994
Resin, sand, and cloth, each figure,
55 ⅛ x 27 ½ x 27 ½" (140 x 70 x 70 cm)
(installation view at Dublin, Ireland, 1994)
Estate of Juan Muñoz

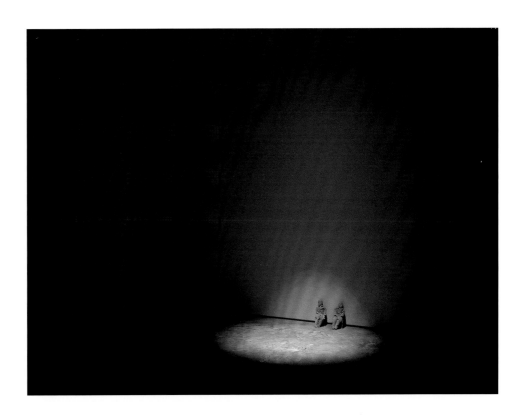

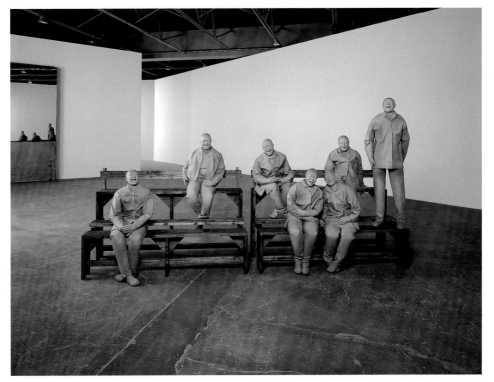

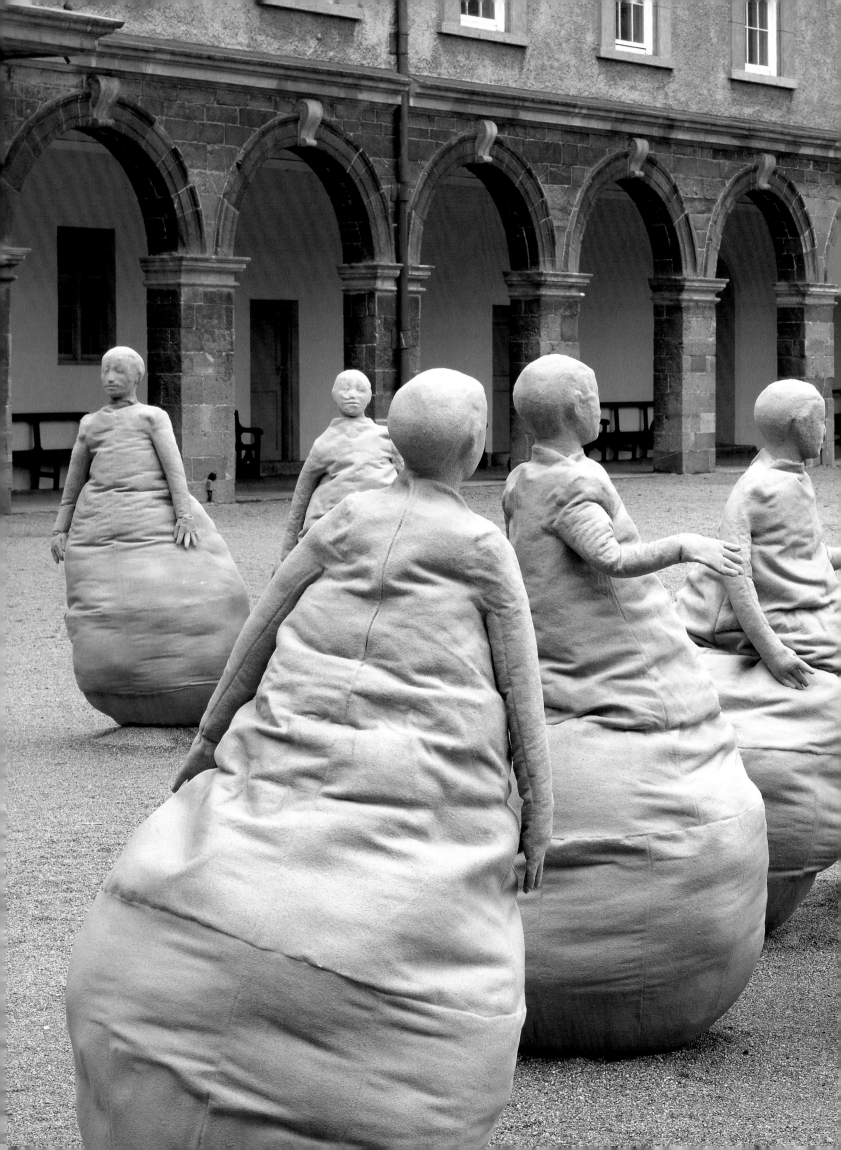

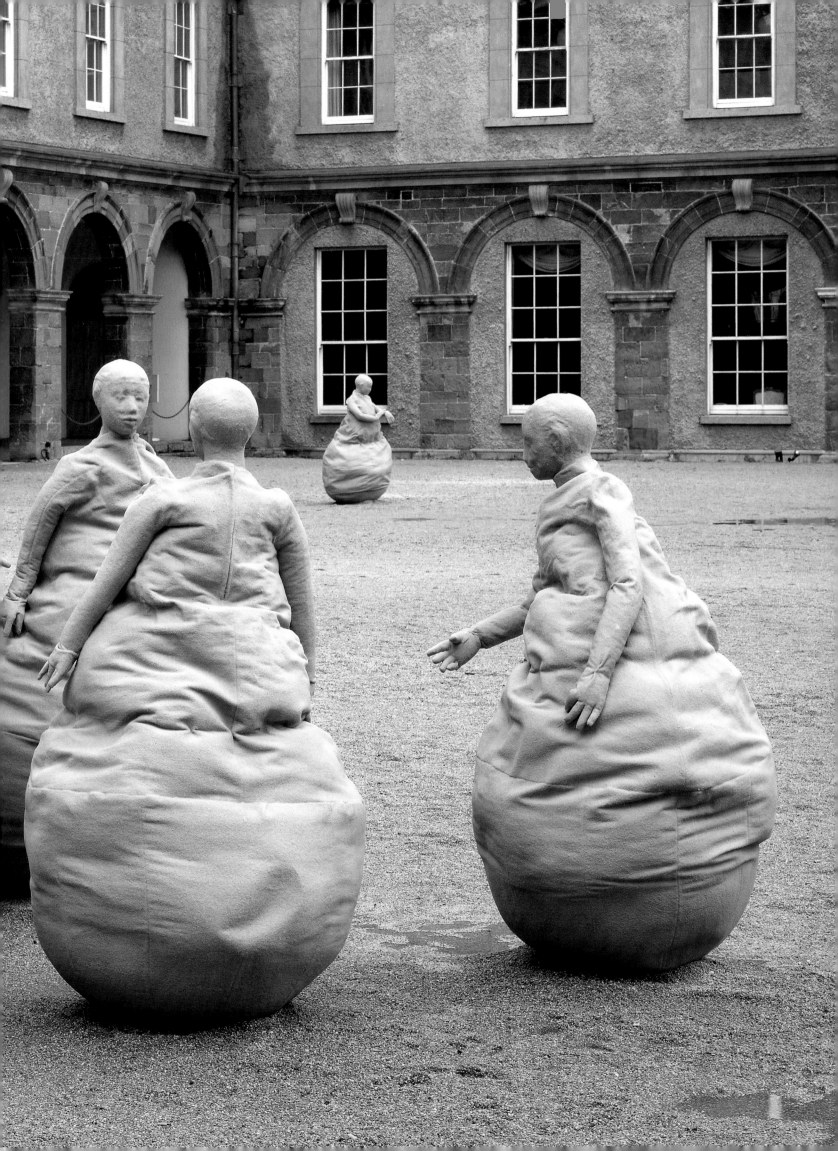

TAKASHI MURAKAMI

Roxana Marcoci: Let's begin by discussing your involvement with the fine arts and mass media. Your first aspiration was to become an animator in the style of Yoshinori Kanada, the pioneering Japanese filmmaker known for cult sci-fi animations from the late 1970s and early 1980s. Afterward, from 1986 to 1993 you studied the *Nihon-ga* style of painting, which combines traditional Japanese painting techniques with Western ones, receiving a doctorate from Tokyo's National University of Fine Arts. Then, in the early 1990s you got involved with Japan's *otaku* (geek) subculture of animation art. All these interests are merged in your practice. Is this due to the absence in Japan of any demarcation between high art, design, entertainment, and advertising?

Takashi Murakami: Under the clever taxation system of the American puppet regime, three generations of rich families emerged in the postwar years, but they have been unable to survive due to high inheritance taxes. In this system, all luxurious items are highly taxed, which has made it extremely difficult, without some justifiable reason, for items such as art to continue to exist, as there is little incentive to support or purchase them.

Hence, there has been very little flow of money into such fields as the pure arts, whereas it has been very easy for money to accumulate in the realm of commercial arts. Because of this, a great amount of artistic genius has focused on the commercial arts, while less has gone to fine arts. As a result, we find in the commercial realm expression and concepts that are superior even to those in the fine arts.

RM: Speaking about the junction between the commercial realm and the fine arts, in 1993 you created your signature pop icon, Mr. DOB, who bears a resemblance to Walt Disney's Mickey Mouse. Yet the source of inspiration is not Mickey but the Japanese cartoon character Doraemon. Would you say that Mr. DOB signaled your full-fledged engagement with *poku* (pop + *otaku*), which in turn marked a rupture with American prototypes?

TM: My creation of Mr. DOB was based less on this kind of thinking (the philosophy behind character iconography), and more in a spirit of critique of Japan's nearsighted world of art journalism. I created Mr. DOB at a time when art journalism in Japan was extremely interested in word art. Riding on that boom, one after another, young and vapid Japanese artists made art using words. They used English and German (apparently full of spelling errors), but at the time it seemed to stimulate a Japanese exoticism, and they were very cool. I was making fun of the art journals that held so much sway over artists, and their superficial, slanted presentation of Western art information.

So, to make a jab at that scene, I made a (very long) word art: DOBOZITE DOBOZITE OSHIYAMANBE. When you read it there is no implication; it is simply a meaningless message born from the Romanized spelling of a joke phrase from a Japanese comics series and a comedian's routine.

As evidence that character creation was not my main focus, you can see certain seeds of bad blood toward the Japanese art journalism present in the various signs and wall pieces that I created with the words DOBOZITE DOBOZITE OSHIYAMANBE in Mr. DOB's original exhibition. That exhibition was greeted by the Japanese art scene with bad reviews and simple disregard. Needless to say, everyone ignored Mr. DOB as well. But aside from the reviews, I got a different kind of feedback regarding Mr. DOB. I realized that the character Mr. DOB was, in fact, a "painting."

During all these movements in which it was impossible to make paintings, such as Pop, Minimalism, and Simulationism, I realized that I was searching for a sophistry to create just that. The beacon came as Mr. DOB.

RM: What led to the foundation of your Hiropon Factory?

TM: The Hiropon Factory came out of my interest in the Walt Disney animation studio and Lucasfilm. I created it while thinking that I wanted to adopt the art production system of hand-drawn animation industries, such as Hayao Miyazaki's Ghibli Studio in Japan. I was interested in setting up a workshop-style production space like the ones I had seen in *Cinefix* (an American visual effects journal) and *Animage* (a magazine published in Japan since 1976; it was revolutionary in its focus on animators themselves, and is still in print).

In an attempt to promote my workshop in America, I figured that if I used Warhol's name, it would be easy for art people to understand. And to top it off, I named the workshop after a legal drug—speed—that had been popular in Japan after the war. My use of this drug name, however, was both in consideration of Warhol and also came from my realization that *otaku* culture was the closest thing to drugs in Japanese society at the time. The name was part of the identification of the entire workshop that would base its activities around *otaku*.

RM: Actually, you have been called the Japanese Warhol. Do you see other parallels between your studio and Andy Warhol's Factory?

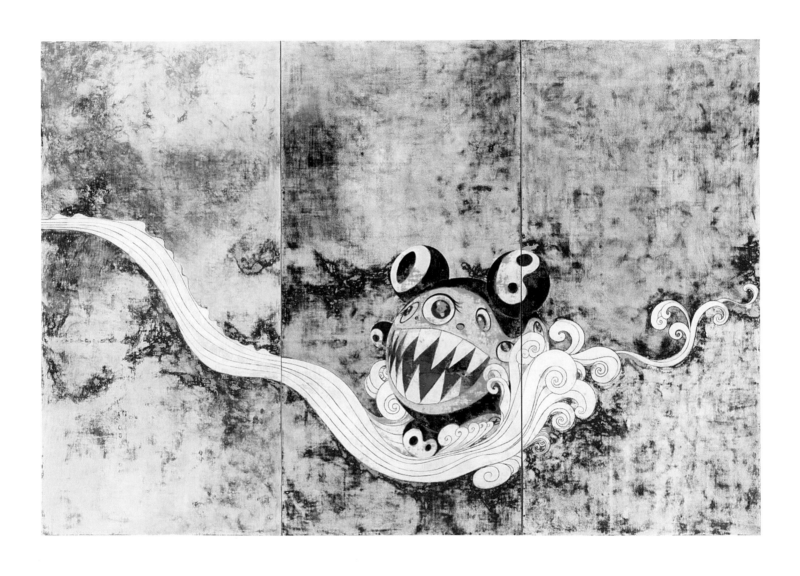

plate 41. **Takashi Murakami**
727. 1996
Synthetic polymer paint on canvas mounted on board,
9' 10" x 14' 9" x 2 ¾" (299.7 x 449.6 x 7 cm)
The Museum of Modern Art, New York. Fractional
and promised gift of David Teiger, 2003

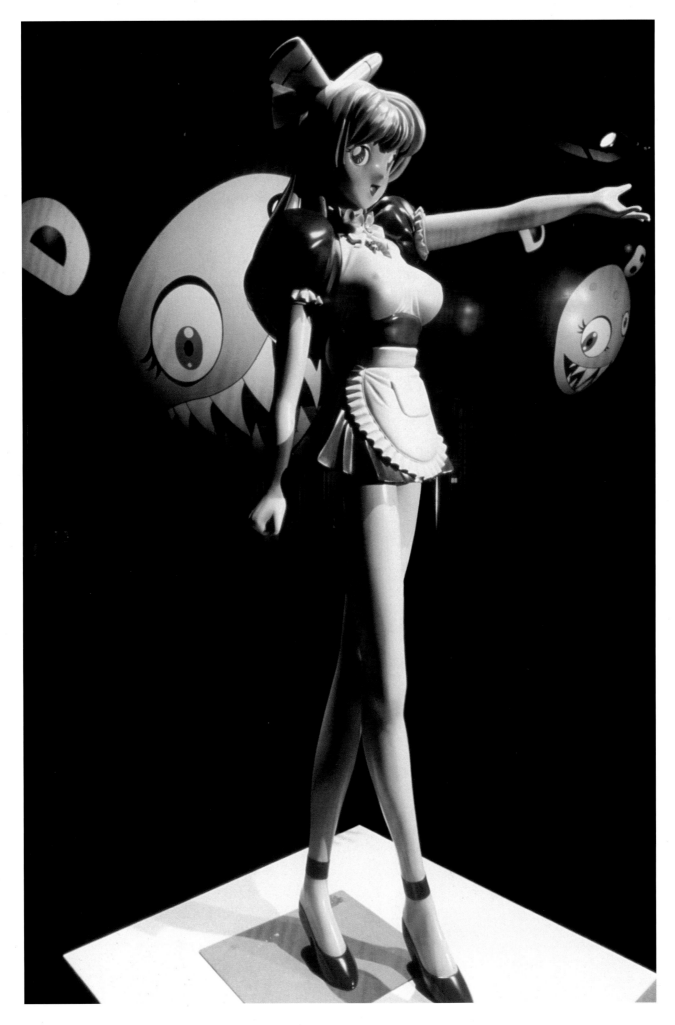

plate 42. **Takashi Murakami**
Miss Ko². 1997
Oil, synthetic polymer paint, fiberglass, and iron,
6' x 26 ¾" x 25 ⅝" (186 x 68 x 65 cm)
Vanhaerents Art Collection, Brussels

plate 43. **Takashi Murakami**
Cream. 1998
Synthetic polymer paint on canvas mounted on board,
four panels, overall 8' 10 ¼" x 17' 8 ½" x 2"
(270 x 540 x 5 cm)
Collections of Peter Norton and Eileen Harris Norton,
Santa Monica

plate 44. **Takashi Murakami**
Milk. 1998
Synthetic polymer paint on canvas mounted on board,
four panels, overall 8' 10 ¼" x 17' 8 ½" x 2"
(270 x 540 x 5 cm)
Collections of Peter Norton and Eileen Harris Norton,
Santa Monica

93

TM: My model was a production workshop for a movie. In reality, it was nothing more that an obsequious gesture by a Japanese artist who assumed that a reference to Warhol would be better accepted by the American art scene. Please disregard it as the move of a foolish Japanese artist.

RM: How many artists are employed by your art-making company Kaikai Kiki?

TM: We hire three artists as employees. The rest are simply employees. If you include the recently added animation workshop, the total staff is about one hundred people. The number of artists we represent as agents is six, including the three who work as employees.

RM: How do you see your collaboration with these artists?

TM: For one example, it was Chiho Aoshima who designed the multicolor monogram design for Louis Vuitton. It's not like I chose all of the colors by myself. The talent comes from all of us together.

RM: You have produced life-size fiberglass polychrome figurines based on your own original cartoon characters, *Hiropon* (fig. 33) and *My Lonesome Cowboy* (fig. 34). Can you talk about the names and identities of these two superhero characters?

TM: These characters were created after a previous figurative sculpture, *Project Ko²*. This groundbreaking work had been the first time a character had been blown up and reproduced in full,

life-size detail. It literally paved the way for toy manufacturers and the manga industry to make their own models, which they did after my lead. For me, these figures began to form the crucial connections between *otaku* culture and contemporary artistic dialogue. They occupy a strange place in my heart because they both alienated me from my *otaku* compatriots because of their overt sexuality but also made me realize that I could not survive without *otaku* in my work. They represent my need to expose, to shock, to be loud and make something new.

Their births were influenced by several factors. I was inspired to make *Hiropon* from a girl on the cover of a 1992 issue of *Comike* magazine. Her name comes from a nickname for a form of speed that was popular in postwar Japan. The name of *My Lonesome Cowboy* was my own invention, and his image was inspired by pop cultural sources, such as *Dragon Ball Z* and *Final Fantasy*.

RM: The abstract color-coded turquoise and pink paintings *Cream* (plate 43) and *Milk* (plate 44), both from 1998, are related to the characters *Hiropon* and *My Lonesome Cowboy*. I am interested to know more about the connection between comics and abstraction in your work.

TM: They are a combination of Kano Sansetsu and Jackson Pollock, plus animator Yoshinori Kanada and Warhol.

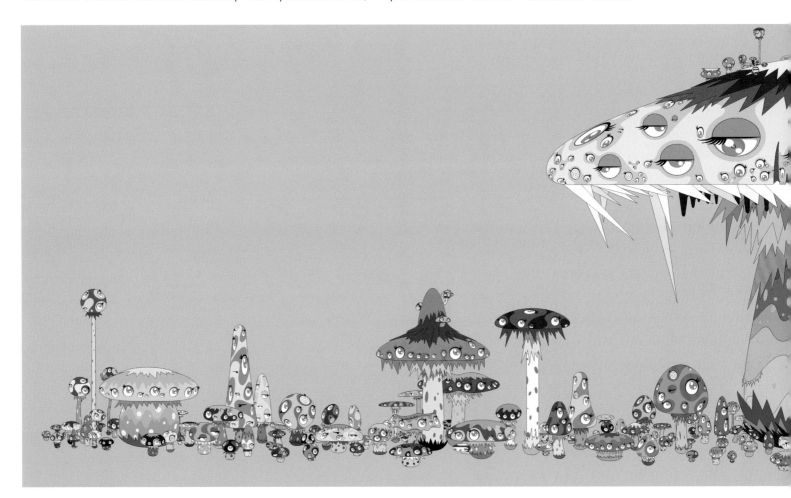

plate 45. **Takashi Murakami**
Super Nova. 1999
Synthetic polymer paint on canvas mounted on board, seven
panels, overall 9' 10" x 34' 5 ⅜" x 2 ¾" (299.7 x 1,050 x 7 cm)
Collection of Vicki and Kent Logan; fractional and promised
gift to the San Francisco Museum of Modern Art

RM: In the exhibition *Little Boy: The Arts of Japan's Exploding Subculture* that you organized in 2005 at the Japan Society in New York, you showed that Japan's trauma with World War II, Hiroshima and Nagasaki, and the postwar occupation period was relinquished to the imagination of manga comic books and anime films. Do you think that there is no rapport with historical reality outside of the fantasy-fueled world of cartoon culture in contemporary Japan?

TM: To a certain extent, people's ability to deal with reality has been lessened through the intensity of their engagement with subculture. However, that subculture was a highly cathartic and necessary means of channeling the anger and trauma from the war. While I don't think that it is completely fair to say that there is no rapport with historical reality, it is certainly true that our relationship to history has been somewhat artificialized. History and its interpretation are always on the verge of becoming a big problem in Japan, but are never quite recognized as problems. This is because of the obscurantist policy imposed by America. It further evolved from a Japanese obscurantist mentality that basically created an environment where, above all, every day should be "fun" and everyone should be "equal." Of course, a big problem is a problem that must be erased.

RM: What is the gist of your "Superflat Manifesto" (2000)?

TM: There is a previously undiscussed, unifying aesthetic—a philosophy of flatness and two-dimensionality—in Japanese art and culture that distinguishes it, even while it endlessly incorporates and processes new external information.

RM: Which Western artists do you consider to be Superflat?

TM: In the movie *The Da Vinci Code*, the computer graphics in the scene explaining [Leonardo da Vinci's] *The Last Supper* were truly Superflat. I also think that the multitude of logics and layers that existed within the brain of Leonardo himself as he created that painting were of a Superflat quality. Even if the painting itself uses single-point perspective, the basic tenet of painting is the layering of multiple painting implements on a surface.

RM: Among the many roles you have played as artist, curator, theorist, designer, and entrepreneur, is there one that you enjoy best?

TM: The operation of a company requires the highest creativity. I think that this is because a company is made of many human beings. All of the egos and desires and conflicts come together, they harmonize and clash and go forward undaunted toward a single goal. I handle my work in a way that follows this logic.

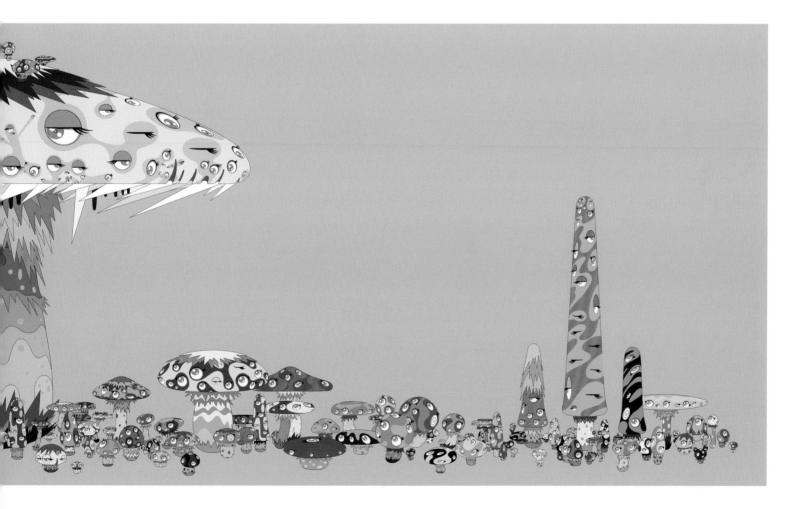

RIVANE NEUENSCHWANDER

Roxana Marcoci: In 1941, Walt Disney visited Brazil with the aim of conceiving a new character that would support American-Brazilian relations during World War II. His trip led to the development of the animated figure Zé Carioca, a soccer-playing parrot whose name loosely translates as "Joe from Rio." What motivated you to look into this comic book series and produce the 2004 cycle of drawings known as *Zé Carioca*?

Rivane Neuenschwander: First of all, Zé Carioca has a special place in my heart because he is a character from my youth. But unlike other characters that belong to a collective memory, Zé Carioca has a unique trajectory and personality. As you observed, he was created by Walt Disney after a strategic visit to Rio de Janeiro in the 1940s. For editorial and ideological reasons, Zé Carioca had a fragmented history: at times he replaced Mickey Mouse as a detective, at other times he acted as protagonist in stories with nationalistic overtones. He started off living in Duckland, then moved to a shantytown in Rio de Janeiro.

His character was based on a stereotypical cliché of the Brazilian, or more precisely, the *Carioca* (someone born in Rio de Janeiro): street-smart, lazy, a lover of soccer and samba, a flirt and a swindler. The cliché of the cliché, he ended up helping to crystallize the national image of the *malandro* (rascal).

Brazilian literature has other characters who dealt with the "jeitinho brazileiro" ("Brazilian workaround"), the most significant being the character created by Mario de Andrade: "Macunaíma, the hero without principles." These are characters of questionable ethics and morality, but with an undeniable charisma and a touch of naiveté.

RM: In your view, was Disney's representation of the Brazilian character a way of showing off American superiority?

RN: It's hard to judge Disney's motivations, especially during a time of war. Without passing judgment, I believe that the United States was at the time making an effort to develop closer ties with Brazil, rather than to assert any superiority. This was not only because of the war, but because Brazil had an expanding economy.

It is worthwhile to remember that during this period, Walt Disney also created a Mexican rooster, Panchito. Unlike Zé Carioca, however, Panchito apparently always lived in Duckland, and never developed a clearly defined nationality, as was the case with Joe from Rio.

RM: You mentioned that you like to experiment "with speech that is not quite articulated in a word or a phrase but is rather a breath, a sneeze, or a gesture."[1] This aspect is relevant to many of your projects from *Starving Letters* (2000) and *Eatable Alphabet* (2001) to *Love Lettering* (2002). From where does the idea of garbled communication originate, and how does it relate to your choice of whiting out the speech balloons in Zé Carioca, thereby short-circuiting the likelihood of dialogue?

RN: I think this originally stems from my great difficulty in communicating with people. I have attempted to explore language on various levels, ranging from something as basic as the alphabet to nonverbal communications. I like misunderstandings, the between-the-lines, the gestures and murmurs, which are at once universal and particular.

I recall a trip to Japan, where I had the impression that people had great difficulty in saying "no." They would instead contort themselves, clear their throats, or swallow their words, in such a way that I would interpret their communication as "maybe." But who knows whether, in spite of all the gesticulating and the non-spoken words, the meaning in fact had been "yes" all along.

I made a film with Cao Guimarães in which the protagonist was a gigantic soap bubble that floated through a tropical landscape without ever popping. The film was called *Sopro* (Breath), which for me is like a silent, contained utterance. Whiting out the balloons of comic books stems a bit from that idea.

RM: You take the original Zé Carioca comic books, erase the characters and narratives, and white out the words, thus turning each page into an abstraction. Can you talk about the relevance of iconoclasm in your work?

RN: I have no special interest in iconoclasm. I must emphasize that these paintings of Zé Carioca are part of a trilogy about the character. In this first series, I repaint the original comic books. The stories become abstractions, but the titles and the dates remain, which opens them up to narrative, interpretation, and context.

In *Zé Carioca and Friends no. 2* (fig. 26), the abstract painting is transposed onto a wall. The scale becomes much larger, and the balloons are painted black. Each panel becomes a large blackboard, where people are invited to draw or write their own stories, thereby erasing or altering other people's narratives. This creates the possibility of multiple dialogues, in which the images and texts interfere with each other and with the empty geometrical image on the wall.

The last work pertaining to the trilogy is a cartoon called *Joe Carioca*. At the invitation of the Saint Louis Art Museum, I conducted a workshop for kids and adolescents at some local schools. Without

plate 46. **Rivane Neuenschwander**
Zé Carioca no. 4, A Volta de Zé Carioca
[The Return of Zé Carioca] (1960). Edição Histórica,
Ed. Abril (detail). 2004 (see plate 48)

telling the students that Zé Carioca is a parrot, I asked them to recreate the character by drawing a humanized animal that, for them, might represent present-day Brazil. The responses ranged from a peacock with Nike tennis shoes to a polar bear, as well as an anteater, a much-loved animal in Brazil.

So if the initial reaction was one of complete annihilation of the image, it was soon followed by a profusion of new images, and even an attempt to reinvent our (anti)hero.

RM: There is a theory that New York "stole the idea of modern art" (as expressed in the title of Serge Guilbaut's 1983 book *How New York Stole the Idea of Modern Art: Abstract Expressionism, Freedom and the Cold War*) in an artistic war waged by the Central Intelligence Agency against the Soviet Union after World War II. Jeffrey Hughes points out that by erasing the pages of Zé Carioca comic books, you engage in a process of abstraction that precisely parodies the United States' export of abstract art as part of its foreign policy during the Cold War period.[2] Does this theory of 1950s American cultural hegemony play a role in the series *Zé Carioca*?

RN: I really liked Jeffrey Hughes's observation, and for me it adds to the reading of the work. However, I must confess that I was unaware of the details of the theory of American cultural hegemony while producing the work. On the other hand, Concretism took hold in Brazil during the postwar period with the founding of Brasília, the explosion of the urban centers, the presence of multinationals, etc.

At least for Brazilians, the character of Zé Carioca has great emotional significance. To an extent, this subverts the attempt at abstract impartiality. He is also, in my opinion, an ideologically contradictory character, given his questionable ethics and his aversion to work.

While working on this series, I thought of a painting by Tarsila do Amaral from the 1920s called *A Negra*. Behind the figure there is a strange and beautiful geometric composition. In the Zé Carioca series, it is precisely the background color that becomes superimposed on the character. The color palette is not an accident.

Other references include the comic books of Raymundo Colares, done during the 1970s, and Philippe Parreno's *Speech Bubbles* (1997; plate 53).

RM: You delve into the dark side of Disney, changing the world of comics as we know it. Can you talk about your own exploration of the language of humor and how you use it to rework stereotypical perceptions of national identity?

RN: It is not exactly humor that interests me, but playfulness. Perhaps like in comic books or cartoons, you can be distracted and miss the political implications of what you are reading, seeing, or interacting with in a work. But the political implications are there, between the lines.

RM: To close, can you say a few words about your links to the Brazilian Neo-Concretist and Tropicalist traditions?

RN: I would prefer to leave this analysis to a critic. When I think about Hélio Oiticica's *Environmental Program, with Its Nuclei, Penetrables, Bolides and Parangolés*, his slide projections and installations of the 1970s, the sensory objects of Lygia Clark, or the complex Brazilianness of Tom Zé, I feel that any approximation of mine to this legacy is somewhat superficial. On the other hand, it's who I am, right?

1. Rivane Neuenschwander, interview with Jens Hoffmann, in *Powerful Circles* (New York: The Americas Society, 2001), n.p.

2. Jeffrey Hughes, "Rivane Neuenschwander: Saint Louis Art Museum," *Art Papers* 29, no. 2 (March–April 2005): 53.

(top)
plate 47. **Rivane Neuenschwander**
Zé Carioca no. 3, Campeão de Futebol [Soccer Champion] (1955). Edição Histórica, Ed. Abril. 2004
Synthetic polymer paint on comic book pages, ten images, each 6 ¼ x 4" (15.9 x 10.2 cm)
Collection of Igor DaCosta

(middle)
plate 48. **Rivane Neuenschwander**
Zé Carioca no. 4, A Volta de Zé Carioca [The Return of Zé Carioca] (1960). Edição Histórica, Ed. Abril. 2004
Synthetic polymer paint on comic book pages, thirteen images, each 6 ¼ x 4" (15.9 x 10.2 cm)
The Museum of Modern Art, New York. Fund for the Twenty-First Century, 2005

(bottom)
plate 49. **Rivane Neuenschwander**
Zé Carioca no. 6, Um Festival Embananado [The Festival Went Bananas] (1968). Edição Histórica, Ed. Abril. 2004
Synthetic polymer paint on comic book pages, seven images, each 6 ⅜ x 4 ⅛" (16.2 x 10.4 cm)
Private collection, New York

(top)
plate 50. **Rivane Neuenschwander**
Zé Carioca no. 10, Vinte Anos de Sossego
[Twenty Years of Tranquility] (1981). Edição
Histórica, Ed. Abril. 2004
Synthetic polymer paint on comic book pages,
fourteen images, each 6 ⅜ x 4 ⅛" (16.2 x 10.4 cm)
Collection of Lisa Ivorian Gray and Hunter Gray,
New York

(middle)
plate 51. **Rivane Neuenschwander**
Zé Carioca no. 13, Nestor, o Destatuador
[Nestor, the Tattoo Remover] (2003). Edição
Histórica, Ed. Abril. 2004
Synthetic polymer paint on comic book pages,
ten images, each 6 ⅜ x 4 ⅛" (16.2 x 10.4 cm)
Collection of Linda and James Gansman

(bottom)
plate 52. **Rivane Neuenschwander**
Zé Carioca no. 7, O Leão que Espirrava [The Lion That
Sneezed] (1971). Edição Histórica, Ed. Abril. 2004
Synthetic polymer paint on comic book pages,
ten images, each 6 ¼ x 4" (15.9 x 10.2 cm)
Collection of Mari and Peter Shaw, Philadelphia

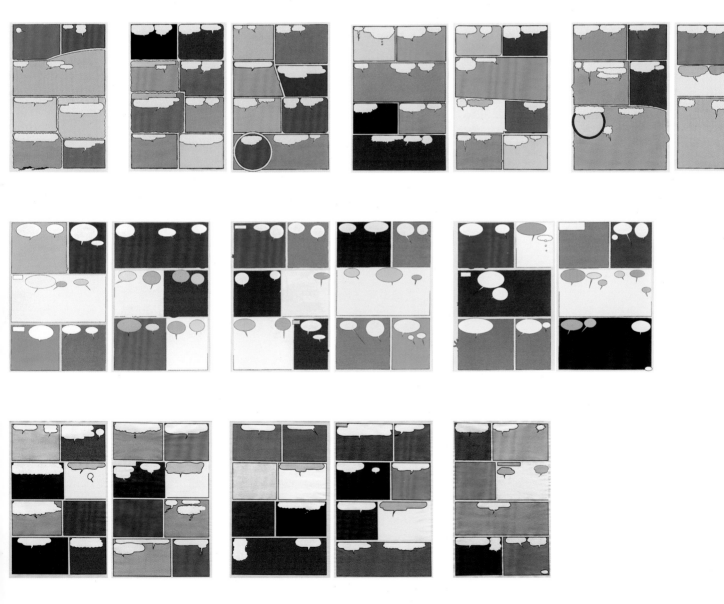

PHILIPPE PARRENO

Roxana Marcoci: Can we begin by discussing the conceptual underpinnings of what constitutes a good image? You have said that "a good image is always a social moment,"[1] which implies that an image is shaped less as an image open for interpretation and more as an interpretation of a social act.

Philippe Parreno: Precisely. An image is that moment when you are ready to negotiate and sign a social contract. In the short series *Vicinato* (1995/1999), I wanted to see how we [Carsten Höller, Philippe Parreno, and Rirkrit Tiravanija] could share the same picture. The same question recurred in the project *No Ghost Just a Shell* (1999–2002).

RM: You refer to the idea that you and Pierre Huyghe had bought in 1999 the rights to a prototype cartoon character named Annlee from a Japanese agency that specializes in figures designed for use in anime films and manga comic books. Through the project *No Ghost Just a Shell*, you made her available to other artists. The idea was to create a character with no fixed identity, who would be as real as she was fictional. Can you talk about the significance of humanizing a cartoon image?

PP: This is a collective project and a series of independent artworks. Over the course of the project, an image was circulated among a group of people. Giving a picture away is a form of exhibition. Before hanging a picture on a wall, you can also give it to somebody. The science fiction author Philip K. Dick said that reality is what doesn't go away when you are not here to look at it. From film to film, different aspects of the same object are revealed. As in three-dimensional graphics, *No Ghost Just a Shell* followed a process of faceting. In order to build three-dimensional geometric surfaces, you need a certain amount of meshes. In a way, each of the films sets up the coordinates of a mesh.

The first film I made established the idea of a fictional character who is not driven by any fictional dynamics. Does a character exist without narrative structures, without stories? I like the moment when Annlee smiles after she has been completely silent for a minute. As a viewer you are embarrassed, but you don't know why. Well, maybe that's why: Annlee is not a representative of typical human emotions. In Huyghe's version, a young girl speaks through Annlee to describe a painting. This scene really grapples with these questions. Then Dominique Gonzalez-Foerster evokes the double figure. The spectacle of doubling up is a theme often evoked in horror fiction. We thought about dealing with a monster, but in

fact, Annlee is her own double. The original character suddenly appears in the film and laughs. This scene expresses the anxiety or profound terror of not being what one thought oneself to be. Hence, one suspects that perhaps one is not something at all, but only nothing. In Liam Gillick's film, he defines Annlee as a place that is semiprivate and semipublic, a place that must be constantly reassessed. The films deal with the relationship we all have with an imaginary world and set up a zone of osmosis.

RM: Would you say that Annlee is an image that conducts a self-conscious inquiry into the life of images and the mechanisms through which images circulate in the media?

PP: Cultural objects can be seen as the sum of so many interests—a sum that busily pedals about the marketplace in search of its reception. More often than not, the cultural object is the work of a team of authors; it exhibits the tensions and struggles of collaboration. Texts, images, stars, directors, and producers all have different degrees of power, different investments in the piece, and different roles to play within the work itself. By dissecting the authorial parts of a work, it is possible to cut into the illusion of seamlessness, so powerfully structured in the rhetoric of new technologies. In our project, a group of people joined each other in order to revisit and redefine a community through a picture. It is at this point that a picture could become a sign.

RM: To reform an image, artists are involved in an act of creative destruction. The destruction of an image, like the dismantling of a scenario, results in the production of another image or scenario—but different. I am curious to know what you think of iconoclasm.

PP: Not much, really. Maybe this project has more to do with Samuel Beckett and his story of two seemingly homeless men waiting for someone named Godot. Beckett attempted to deconstruct not only text, but also the creational act. In the radio drama *Cascando* (1963), a narrator named Voice struggles to create the ultimate story. The narrator eventually fails to capture "the right one" and decides to restart. Beckett's characters attempt to complete their speeches, whereas their stories should never be fulfilled. We can interpret these characters as a writer who is in the throes of creating texts. This idea of a character who has a persistent desire for the ultimate story seems to be derived from Beckett.

RM: *Speech Bubbles* (1997; plate 53) was an installation made of blank helium-filled balloons in the shape of comic book bubbles that float in space. In light of this project, you said, "Everyone can

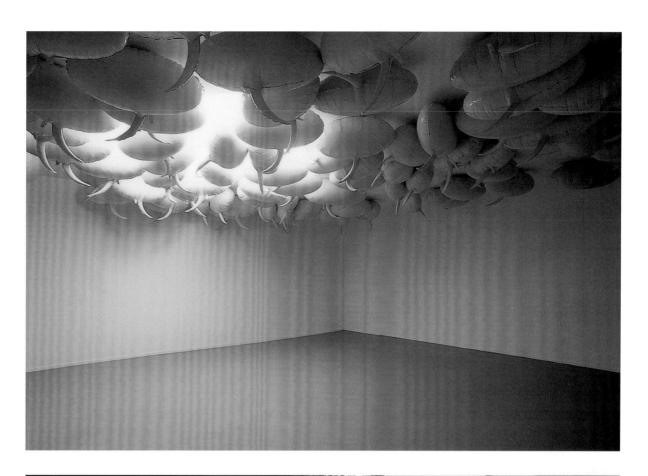

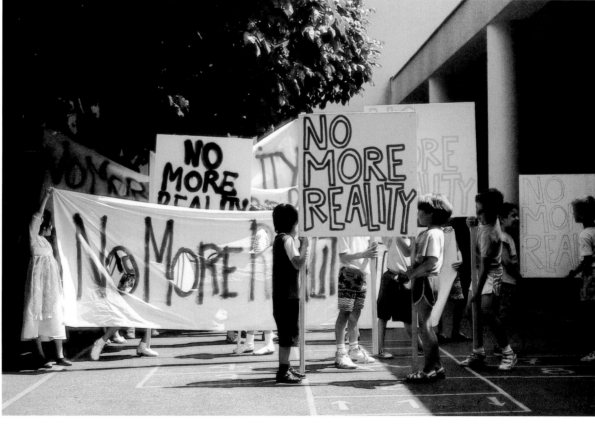

plate 53. **Philippe Parreno**
Speech Bubbles. 1997
Mylar and helium, each 42 ⅛ x 46 x 15 ¾"
(107 x 117 x 40 cm) (installation view at the Musée
d'Art Moderne de la Ville de Paris, 2002)
Frac Nord-Pas de Calais, Dunkirk, France

plate 54. **Philippe Parreno**
*No More Reality: Children Demonstrate
in Schoolyard*. 1991
Demonstration in Nice

mark in their own demand, while still participating in the same image."[2] Can you give some background about this work? Was it put to use in an actual demonstration?

PP: I did these balloons for a union demonstration. It was meant to be a protest tool that allowed you to write your own demands while still being part of the same group and the same image. The project had to do with multitude, with an infinite amount of singularities that cannot be reduced. There was an actual demonstration where these balloons were used, but I don't have any documentation of it. I thought it would have been in some newspapers, but I did not see anything published about it.

RM: In one of your first works, *No More Reality: Children Demonstrate in Schoolyard* (1991; plate 54), you organized a workshop on demonstrations at a primary school in Nice. The demands made by the students—for example, to have snow in summer—were of less consequence than the fact that the group was engaged in a form of organized protest. What is the function of protest in art?

PP: June 1991: Reality was negotiated. Jaron Lanier invented "virtual reality"; the synthesized image generated by the computer attempted to sever the umbilical cord that always kept the image tied to reality. In this era, Timothy Leary launched the computer software called Mind Mirror that invites you to play with your cultural conditioning, your imprints. On the radio, Stevie Wonder sings about his Reality. Some students demonstrated in the streets of France, yelling, "Money, we want money for better education." Whereas other kids sought to profit from the situation by looting the stores for Chevignon jackets and Burberry scarves so that they would have the appearance of being serious about their studies. In a certain way, current events can be read as a scenario. We can imagine the production of an event that prolongs these images of news like the demonstration of children on the playground of a primary school. Demonstrations are intrinsically a format for producing images. The children from Nice with whom I worked did not know what a demonstration was, as they had not had civic studies. We had to elicit from them what they wanted. They invoked all sorts of images and called upon another reality. They wanted a slogan that sounded like "Just do it," which ended up being "No More Reality."[3]

RM: Can you explain what you mean by "an aesthetic of alliances"?[4]

PP: Conversations, dialogues, and polyphonies could lead to an aesthetic of alliances.

RM: *Speech Bubbles* also appears as the title of a collection of essays you published with Les Presses du réel in 2001. A number of your texts are about artists with whom you have collaborated. Why are collaborative processes significant to your practice?

PP: Collaboration has always been part of how I work. I am surprised that there are not more collaborations. Rirkrit Tiravanija, Carsten Höller, and I were invited by the gallery Guenzani, in Milan, for a group show. We decided to make a film of our discussions, which were edited into a script. The film projection became part of a group show.

Most collaborative projects start from a series of conversations. I don't want to make any theory out of it. I just don't like playing tennis against a wall. There is a common understanding of what an author is. That notion does not have much to do with copyright issues and what is celebrated during the numerous TV award ceremonies.

1. Philippe Parreno, interview by Tom Morton, "Team Spirit," *Frieze*, no. 81 (March 2004): 85.

2. Philippe Parreno, *Alien Affection* (Paris: Musée d'Art Moderne de la Ville de Paris, 2002), n.p.

3. Parreno's response in the original French reads as: Juin 1991 . . . Le réel se négocie; Jaron Lanier invente la "réalité virtuelle"; l'image de synthèse générée à partir d'un programme calculé par ordinateur a tenté de rompre le cordon ombilical que l'image a toujours entretenu avec le réel; Timothy Leary lançait à cette époque un logiciel qui s'appellait Mind Mimesis [sic] qui vous invite à jouer avec votre conditionnement culturel, vos imprints; à la radio Stevie Wonder chantait sa Reality; les étudiants manifestaient dans la rue en France en criant "de l'argent, nous voulons de l'argent pour mieux étudier"; d'autres ados profitent des manifs pour braquer dans les magasins de prêt-à-porter des vestes Chevignon et des écharpes Burberry puisqu'à l'allure du défilé de leurs camarades se sont les gages d'une assiduité scolaire. D'une certaine manière l'actualité peut se lire comme un scénario. On peut imaginer produire un évènement qui prolonge ces images d'actualité comme une manifestation d'enfants dans la cours d'une école primaire. La manifestation est en soit un format de production d'images. Les enfants de Nice avec qui j'ai travaillé ne savaient pas ce qu'était une manifestation, on fait un peu d'éducation civique. On a cherché à savoir quelles étaient leurs revendications. Ils invoquaient tous des images et en appellaient à une autre réalité. Ils voulaient un slogan qui sonne comme *Just do it*, ça a donné *No More Reality*.

4. Philippe Parreno, "Speech Bubbles," *Art Press*, no. 264 (January 2001): 22.

plate 55. **Philippe Parreno**
No More Reality, 75 Frames from Batman Returns. 1993
Synthetic polymer paint on PVC balloon, 8' 2 ½"
(250 cm) diam. (installation view at Villa Arson, Nice, 1993)
Collection of Michael Trier

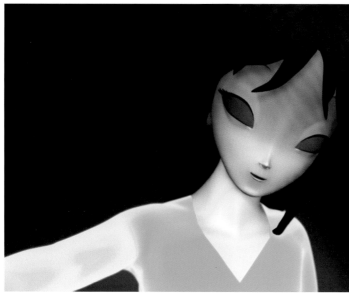
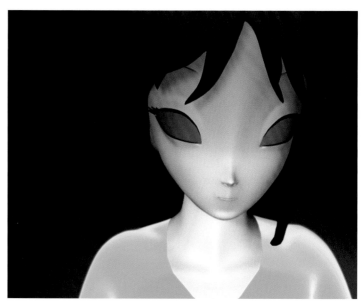

plate 56. **Philippe Parreno**
Anywhere Out of the World. 2000
Stills from video projection from the series
No Ghost Just a Shell (1999–2002)
Walker Art Center, Minneapolis

plate 57. **Philippe Parreno and Pierre Huyghe**
*Smile Without a Cat (Celebration of Annlee's
Vanishing).* 2002
Fireworks (installation view at Art Basel Miami
Beach, 2002)

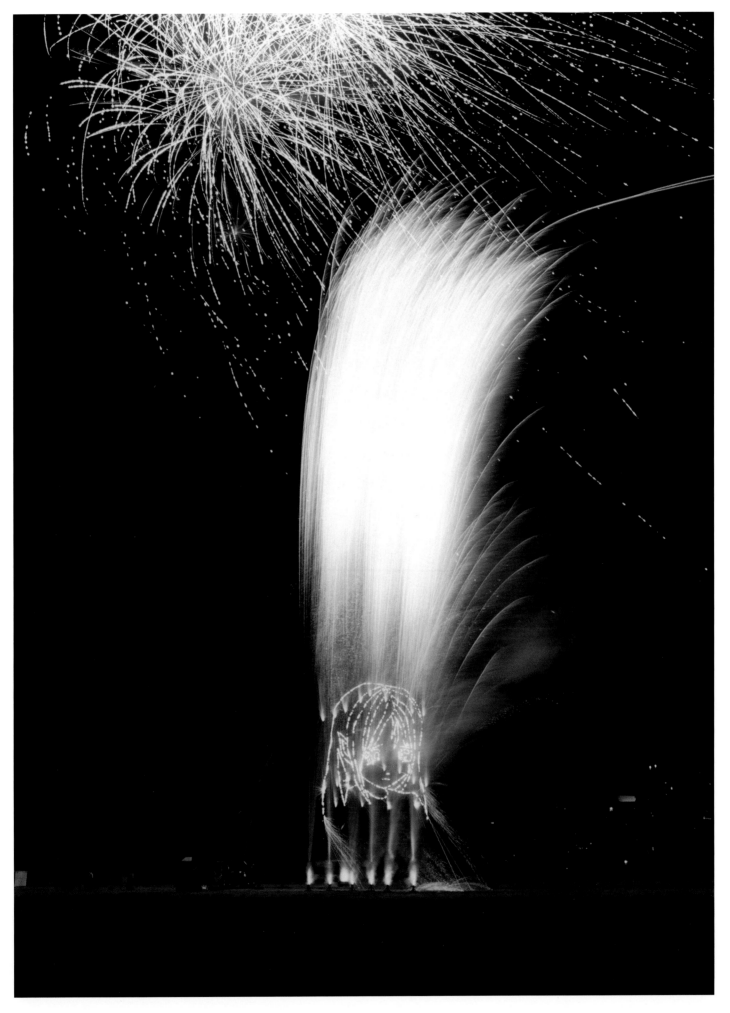

GARY SIMMONS

Roxana Marcoci: In the 1980s you studied at the School of Visual Arts (SVA) in New York and then at California Institute of the Arts (CalArts). Who were the people who had an impact on your thinking at the time?

Gary Simmons: I would say Jackie Windsor played a big role, looking at my work. Lynda Benglis and Joseph Kosuth were also influential.

RM: Did you study with them?

GS: Yes, I did, and then there were a lot of critics who informed my way of thinking, like Craig Owens, Rosalind Krauss, and Rosalyn Deutsche.

RM: Were Krauss and Deutsche teaching at SVA?

GS: Krauss was not at SVA at the time, but Deutsche was there and I took her courses. Donald Kuspit was big. We really had a good balance between artists and critics, so you understood how critique was thought and written about. Then, I went on to California. It was funny that people at SVA would come to my studio and say: "You seem to be working in a way a lot of the Californian Conceptualists would embrace." I didn't know how to take that.

RM: Did you know who they were talking about?

GS: Not completely. I knew Michael Asher and Douglas Huebler. Then there were artists with whom I did not study with but who were influential, like Adrian Piper and David Hammons. Jack Whitten turned me on to Hammons's work and that became an influence on how to put objects together and how meaning is constructed through the object.

RM: How did you start using scenes from cartoons in your drawings? Who are the protagonists in the *Erasure* series?

GS: After graduating from SVA I worked in a studio in New York, which was an old vocational school filled with all these chalkboards. I was interested in Minimalism and Conceptualism but could not find my own placement within that tradition. I really wanted to inject a kind of personal discourse into the reserve and distance imposed by Conceptualism. I thought, well, how am I going to do that? I need a material or an object to carry forth the ideas that concerned me. The chalkboard is a surface for learning and unlearning, teaching and unteaching, and thus a great object to work with because it plays such a powerful role in the way our formative memories are constructed. Early on I thought about making a film and started watching educational movies. Looking at *Dumbo* or *Snow White and the Seven Dwarfs*—all those great Disney films— I began thinking critically about them. *Dumbo* stuck out the most

because of the crows. I found that when I talked about these crows there was a division along racial lines in memory and that struck me. A lot of black folks remembered them because they identified with the stereotypical shucking and jiving crows, and a lot of people who were not of color did not remember them at all. The irony of the film is that the crows actually teach Dumbo to fly. So I started to do some drawings with them on the chalkboard surface and what I realized was that as much as I tried to erase or eradicate the image, it always stayed. There was a ghost, a trail, a trace, and that's really how these cartoons came about. Then I started to research a lot of other race cartoons, wartime cartoons that dealt with Nazism, and a lot of propaganda films and things like that. There were always these comic figures that softened the way you received the image and yet there was a commonality in the types of cartoon figures that were used in all these different camps. In other words, the crows and the frogs became almost like icons for black figures. The mouths, the teeth, the smiling eyes of frogs and crows became very symbolic in a lot of the images I used early on.

RM: So you never thought, for instance, that the crows were presented as sympathetic characters next to Dumbo? After all, they were teaching Dumbo how to fly. It is interesting what you just said about the way these figures would be softened, not made blatantly racist in a way. I recall reading at one point that they would use African-Americans to impersonate the voices of the crows, which is also interesting because then the intention was there.

GS: This speaks loudly that they specifically used black voices for these cartoon figures. I think that it is possible they would want the crows to appear sympathetic, and yet there is this comedic element to them. You know, they are very stereotypical lazy crows that don't want to fly or do any kind of work, and yet they end up through their mannerisms and all the rest of it teaching Dumbo how to deal with what he thinks to be his shortcoming. So I think the outcome has a positive bent, but how they get there is very different.

RM: So basically your selection of films was meant to expose the racial stereotyping of the 1930s and 1940s.

GS: There were a lot of animated classics from the 1930s on, like *Little Ol' Bosko and the Pirates,* that used stereotypical scenes such as a frog tap-dancing or singing in a black voice as he gets lynched. *Speedy Gonzales* is another one where you have a little Mexican mouse who is a troublemaker and all of his friends are these lazy, fat mice that don't do any work and Speedy Gonzales

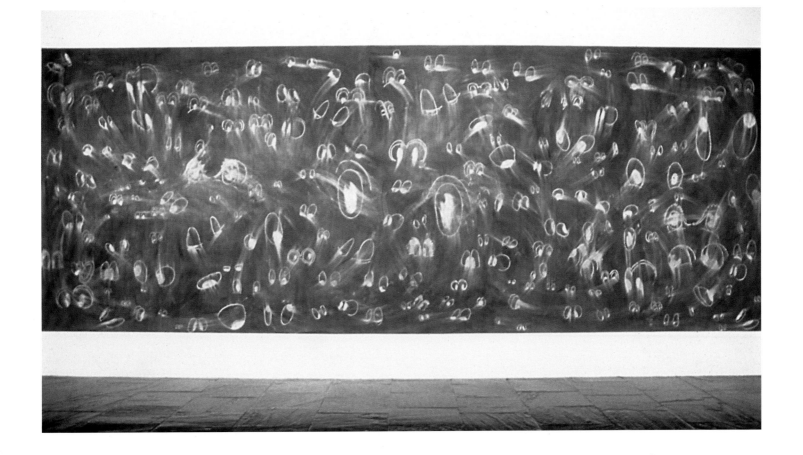

plate 58. **Gary Simmons**
Wall of Eyes. 1993
Chalk and slate paint on wall, dimensions variable
(installation view at the 1993 Biennial at the Whitney
Museum of American Art, New York)

plate 59. **Gary Simmons**
The King from the series *Green Chalkboards*. 1993
Chalk and fixative on slate-painted fiberboard
with oak frame, 48 x 60" (122 x 152.4 cm)
Collection of the artist

plate 60. **Gary Simmons**
Three Falling Bags of Cookies with a Pair of Shoes
from the series *Green Chalkboards*. 1993
Chalk and fixative on slate-painted fiberboard with
oak frame, 48 x 60" (122 x 152.4 cm)
Collection of Rachel and Jean-Pierre Lehmann

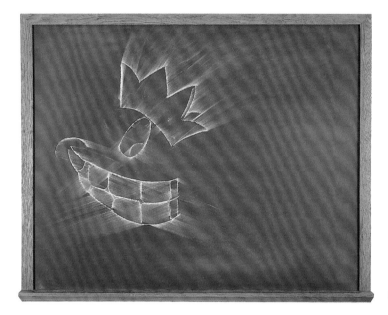

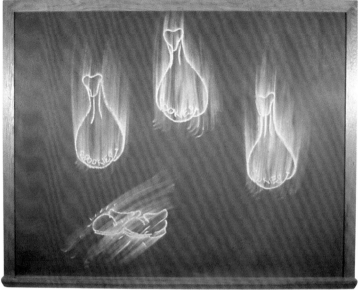

is the one that runs around doing all the chores. These cartoons were very funny and popular so that a great many people saw them. Yet there is a kind of slippage between what people actually saw and what they remember. This is how the erasure drawings actually work; there is the image and then through the act of erasure the image gets blurred and abstracted. There is information that is taken away and information that is left. The way you reconstruct what is taken away is exactly the way your memory acts. The act of reconstruction within the memory of your childhood is the function of some of these drawings.

RM: Sometimes you just extrapolate a detail from the cartoon figures, such as the mouths or eyes, as in *Wall of Eyes* (1993; plate 58). Why do you focus on these anatomical parts?

GS: At a certain point, I realized that the bodies of these figures were not as important and I started to fragment their iconography. I would pull out just the eyes, those big wide-eyed grins, or the teeth. You know, there are those old jokes: "Open your eyes or smile, so I can see you in the dark" or "Don't shoot until you see the whites of their eyes," and that kind of a thing.

RM: Erasure plays a central role in your work. Does it act as a gesture of iconoclasm, protest, critique, sabotage, resistance, remembrance?

GS: I think it is probably all these at once, since the act of erasure is a kind of reflection on black history. There are histories that are completely lost and not charted. So there is the need and desire to retrace or reclaim these histories. When these histories get reconstructed, there is empowerment.

RM: Paradoxically, erasure is double-linked to the idea of invisibility. Thinking of the Ku Klux Klan, invisibility is a covert form of organized hatred. Thinking of Ralph Ellison's novel *Invisible Man* (1952), invisibility relates to the deletion of a race. Is erasure then

also a meditation on modern social structures?

GS: To link this observation to your previous question, I think that the act of erasure *is* an act of protest. For me personally, to actually take a violent or offensive image and physically try to erase it is an act of empowerment. You violently take away something that is inherently violent in itself.

RM: Do you continue to probe issues of race, education, and popular youth culture in the erased text drawings?

GS: Yeah. A lot of the text drawings come out of slang because slang is cyclical and recyclable. Words from the 1920s are used now with a new meaning. How they are used and how they are reclaimed is a very interesting thing because they leave traces; slang is a very fluid form of communication.

RM: Can you give me an example?

GS: Take a word like "fresh." Fresh has had so many different meanings over the course of fifty years. Hip-hop picked up that term and fresh became interchangeable with cool. Let's go back. Cool came first, then it turned into fresh, fresh turned into sweet, sweet turned into something else, and this is a term that just keeps changing back and forth. Cool will probably come back around and then suddenly cool is cool! I've always loved the way communication operates. There is a kind of unspoken or invisible meaning that is assumed between two folks who are exchanging information and you sort of just know it. Music is a big vehicle for the way this happens.

RM: Talking about music, *boom* (1996; plate 63), which is in MoMA's collection, depicts an exploding cloud that hints at uneasy associations with images of war. The piece is related to a series of drawings you made in the same year titled *Reign of the Tec* (after Tec-Nine, an automatic weapon). The study for *boom* is *Boombastic*, a work that takes its title from a popular song reliant on a piercing, heavy

plate 61. **Gary Simmons**
Toothy Grin from the series *Green Chalkboards*. 1993
Chalk and fixative on slate-painted fiberboard with oak
frame, 48 x 60" (122 x 152.4 cm)
Collection of The Studio Museum in Harlem,
Gift of Zoë and Joel Dictrow, New York

plate 62. **Gary Simmons**
Crazy Conductor from the series *Green Chalkboards*. 1993
Chalk and fixative on slate-painted fiberboard with oak
frame, 48 x 60" (122 x 152.4 cm)
Collection of John Goodwin and Michael-Jay Robinson

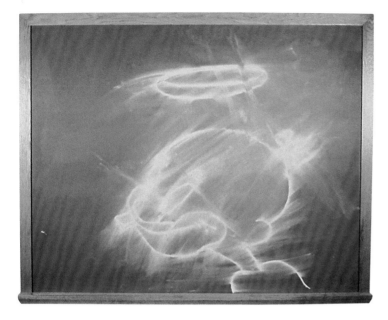

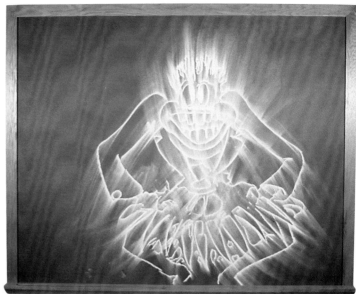

bass sound. Is your intention here to present American history through the lens of hip-hop culture?

GS: *Boom* is like the scenario where you watch two figures in a cartoon and they are either in a fight or some kind of a violent exchange. Instead of seeing their bodies clash, you see a cloud and stars and little pieces flying off from behind this cloud curtain. It is a comedic trope for violence. I always think about how explosions in wartime are used for their entertainment value. There is that old joke: "If someone falls in a hole, it is comedy; but if I fall in a hole, it is tragedy." It is fascinating the way violence entertains people. Cartoons are the first and earliest form of getting pleasure from a violent act. This explains why *boom* is such an important piece.

RM: And how does it relate to *Boombastic* and to hip-hop?

GS: A lot of my titles come out of music. The way I go about putting together images or constructing an installation is visually similar to what a DJ does when sampling sounds from different sources. *Boombastic* is one of the driving parts of hip-hop and reggae music. If you think of cars going down the street, the first thing you hear is that big boom, a sound that shakes the ground, so it's also almost hidden.

RM: Can you talk about the performance-based aspect of your practice, the actual physical and emotional investment?

GS: One of the things I always said is that the drawings, particularly the wall drawings, are the evidence of a performance that you never see. I am more interested in the traces that are left behind. In a way, it is at once an action drawing and a hidden performance.

RM: Speaking about this hidden aspect, why is it that the indelible trace of the erased image lingers in memory even more persistently than the original source?

GS: This is such a great question. I think because any memory

you have is something that haunts you. You tailor the way you want to remember things and these traces or ghosts are what you hold on to. The actual does not exist anymore. The biggest strength of the erasure drawings is their haunting quality.

RM: Is the act of image-breaking critical to image-making?

GS: How do you mean?

RM: We talked about iconoclasm at one point: the act of erasing something, of breaking the image. What does it mean to create a new image out of erasure?

GS: Someone said, "You have to destroy to create." I think it was Brancusi. You have to destroy to create because you have to break down certain perceptions. What makes great art is when you take something that exists, something familiar, and twist it, turn it, distort it, and create something new with it. So yeah, you do have to kind of fuck it up a bit to get it to someplace else. I really like that term, it's pretty great—image-breaking, image-making. What I am "making," to use your turn of phrase, is giving form to these ghosts that haunt us in the way we define certain racial constructions and stereotypes.

RM: I see your work as a zone of contamination, expanding from small chalkboards to mural-scale environments. What are the possibilities for the practice of political wall drawing?

GS: This is a very tough question. When I do a wall drawing, I actually draw on the institution itself and include the museum within the terms of my critique, so this is inherently a political act. This is how graffiti also works. There is a demarking of territories. Whether you draw in the white cube or out on the streets, what you include in that dialogue is a sense of placement. To actually work within the walls of MoMA, the architecture becomes part of the wall drawing, and the legacy of that institution becomes part of the work.

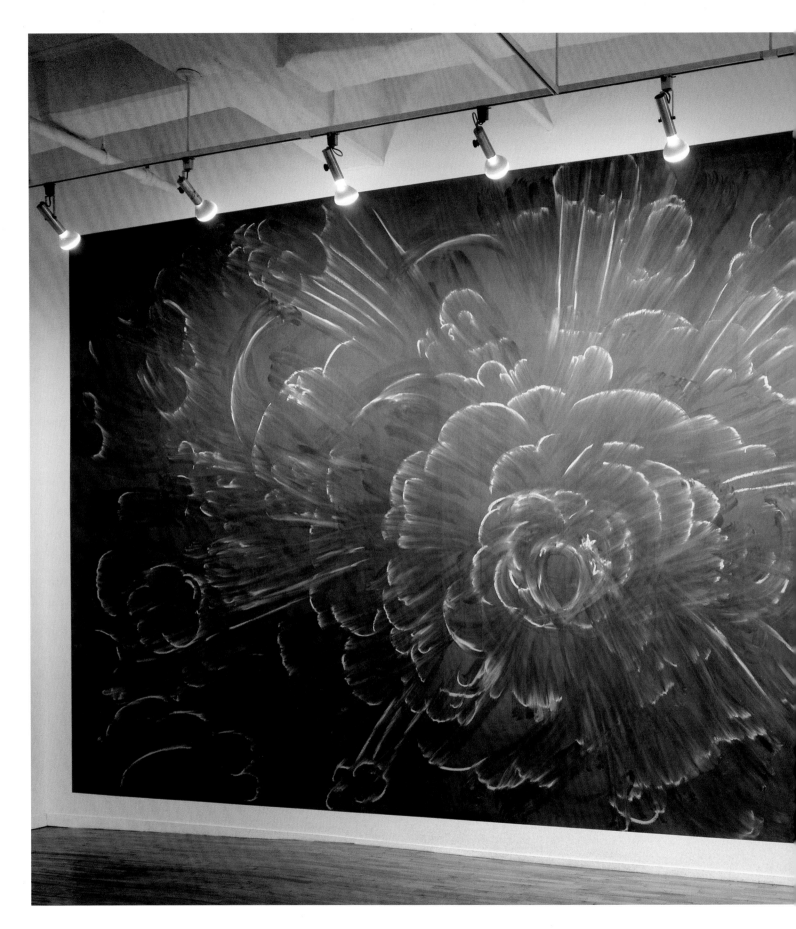

plate 63. **Gary Simmons**
boom. 1996
Slate paint and chalk on wall, 13 x 26' (396.2 x 792.5 cm)
(installation view at Metro Pictures, New York, 1996)
The Museum of Modern Art, New York. Gift of the Friends
of Contemporary Drawing and of the Friends of Education of
The Museum of Modern Art, 1999

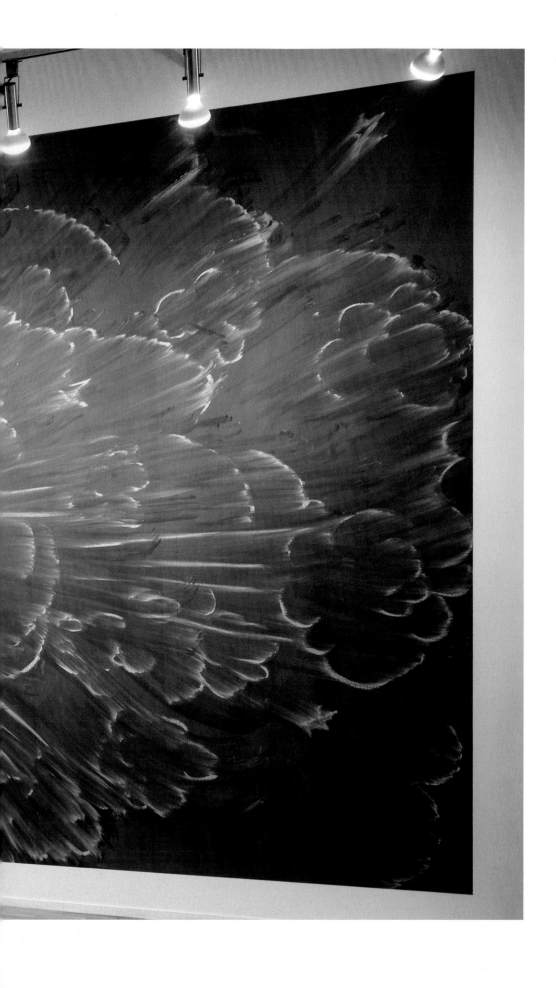

FRANZ WEST

Roxana Marcoci: What was your relationship with Bruno Gironcoli, your instructor at the Academy of Fine Arts in Vienna? How did your experience there impact the production of your early works from the 1970s?

Franz West: I think my time at the Academy had no impact on my early work. Gironcoli did not instruct at all. There were almost no students in the sculpture building where I was; the place was nearly empty. I had a big, beautiful studio that I could use alone. (Now four people work there.) My work was influenced by Dan Flavin and Bruce Nauman, in particular Flavin's fluorescent tubes and Nauman's performative photographs like *Self-Portrait as a Fountain* from *Eleven Color Photographs* (1966–67/70) that construct a set of physical and linguistic situations.

RM: You have said that students at the Academy did not use the word "sculpture," but rather "object." Was this terminology related to Donald Judd's use of "specific objects" or did it have a different significance?

FW: I don't know the roots of the word "object," but it was understood that "object" is the name for abstract forms, whereas "sculpture" denoted figuration.

RM: What is the meaning of *Passtücke* (Adaptives)? Did you come up with this word, or was it Reinhard Priessnitz, who attributed it to your pieces when they were first exhibited?

FW: *Passtück* is the German word for "Adapter," as I learned at my first and only lecture in London.[1] At that time, Reinhard Priessnitz began to translate Oswald Wiener's novel *Die Verbesserung von Mitteleuropa* (The Improvement of Central Europe) (1969), which caused quite a stir in the postwar period in the German-speaking part of Austria.[2] The book centered around a cybernetic "bio-adapter": when a person stepped into this device, the outside world was simulated by electrical impulses. Bodily extremities and bowels were severed until only the brain lay in a life-nourishing liquid, thinking that it was experiencing the world. This corresponded to philosopher Hilary Putnam's argument known as the "brain in a vat."[3] The whole thing has nothing to do with my attempts, only the name is adequate.

RM: Social interaction is critical to the makeup of your work. I love the early black-and-white photographs showing people posturing with your Adaptives. How did you make the first pieces, and how were they used by the public?

FW: There was no public—it was just private. But at that time I looked at Ludwig Wittgenstein's *Philosophical Investigations* (1953), in which he compared the use of language to the use of tools such as hammers and nails. He maintained that the meaning of a word is its use and advanced the idea of language games. If these tools were abstract (i.e., they had no use in the household), then they were understood as art. It was a logical speculation in light of Immanuel Kant's "uninterested (compulsory) liking."

RM: You often mention African art as an inspiration. Are you interested in the ritual function of art?

FW: I am not interested in the ritual aspect, but rather in the African objects themselves, which are used in everyday life. I had thought that African art would have a steady point of reference in the everyday; in that way, art would have a bigger presence in daily life. This was my thinking in the 1970s. Now it is different—cultural industry and art education give us similar constellations.

RM: An important aspect of the Adaptives is that they can be handled and thus relate to the user's body. Their role as "adapters" disrupts normal behavior, invariably leading to comical situations. When I observe people interacting with them, I think of Harold Lloyd or Buster Keaton (fig. 17), the great slapstick comedians of the silent film era. At the same time, I think of Egon Schiele's contorted gestures and the birth of modern psychoanalysis. Can one say that Sigmund Freud, comic films, and the early-twentieth-century Viennese painting tradition are overlapping influences in your work?

FW: Yes, among other things.

RM: I recall reading that the Adaptives are informed by the theatrical gestures of your half brother Otto Kobalek. How did that happen?

FW: He gesticulated a lot, maybe a bit like the bohemian character in Denis Diderot's philosophical novel *Rameau's Nephew* (1762). Since I was mostly an observer, I thought the Adaptives could be participatory. It was a similar idea to Happenings, where the spectators became actively involved. It was not like later performances in which the theatrical elements were left to actors. In the 1970s, my work was thought to be a departure from this direction. Whereas the word "ritual" always refers to something religious or mystical, I thought along more emancipative lines. I took seriously slogans like Joseph Beuys's famous comment that "every human being is an artist."

For instance, I once saw this gestural marking on canvas by Cy Twombly in a museum. It had some circular forms. At that time,

plates 64 and 65. **Franz West**
Mirror in a Cabin with Adaptives. 1996
Four Adaptives, floorboard, cubicle, mirror by
Michelangelo Pistoletto, video recorder, monitor,
and pedestal, cabin: 7' 2 ⅝" x 8' 6 ⅜" x 11' 9 ¾"
(220 x 260 x 360 cm); mirror: 6' 6 ¾" x 55 ⅛"
(200 x 140 cm) (installation view at
Les Abbatoirs, Toulouse, 2000)
Collection of the artist

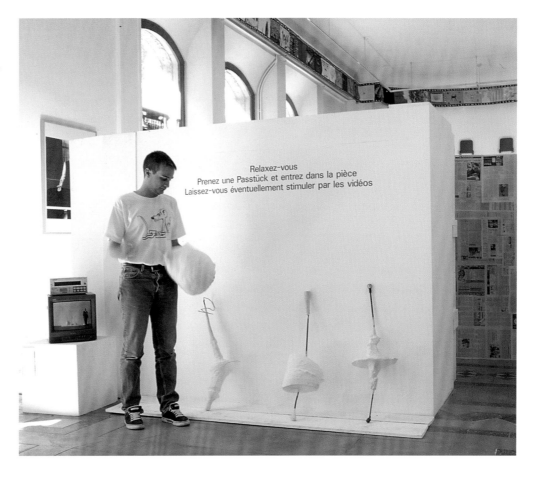

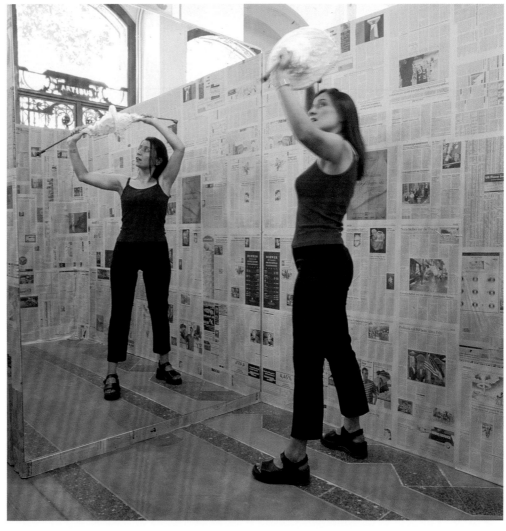

I was involved with Wittgenstein, who reckoned that music could be described through gestures. I had the idea to interpret Twombly's work into a quasi-concrete object by making a similar circular form. The experience of the work would not be internalized. Rather, it would be like an unchoreographed dance without music, like a pantomime or Chinese shadowboxing.

RM: This is an interesting observation. The improvisatory spirit of the walking-stick-like versions of Adaptives brings to mind Andre Cadere. Was the idea of portable sculpture something you both shared?

FW: Yes.

RM: The Adaptives have been called fetishistic objects. Are they based on a notational system of gestures, or are their forms arbitrary?

FW: They are arbitrary. Fetishism would be too intense.

RM: Vienna has a strong performance-based tradition rooted in Dada and the Cabaret Voltaire. There were also the Vienna Actionists, who dominated the Austrian avant-garde from the late 1950s through the 1970s. The performance-based quality of your work is actually quite different from that of the Actionists. What was your relation to this group?

FW: On the one hand, Actionism expressed a strong impulse. On the other hand, I did not want to become an imitator. Therefore, I switched into adjacent practices, maybe because of my half-Semitic ancestry. I was strongly traumatized by the blood and soil actions of the non-Semitic Actionists.

RM: Can you tell me about your collaboration with Michelangelo Pistoletto on *Mirrror in a Cabin with Adaptives* (1996; plates 64–65)?

FW: When I began to make contacts in my youth with contemporary artists, Pistoletto was a European counterpart to American art and was an impressive figure. Much later, he became more or less unknown and got a professorship in Vienna. I met him at some parties. It was a very strange feeling to become acquainted with an idol of my youth. I could not use a mirror in my installations without feeling that I plagiarized him, so I asked him to make a mirror for Adaptive users, which he agreed to do.

RM: Each time you reinstall this piece, you plaster current newspapers on the walls of the cabin. Why is that?

FW: I use the newspapers in order to incorporate the presence of outer reality.

RM: Have you collaborated with other *Arte Povera* artists? In earlier interviews, you have mentioned Jannis Kounellis and Emilio Prini.

FW: I became friendly with them and we exchanged works. I have them in my studio, which is also where I live and sleep. But our collaboration did not go any further.

RM: Your notion of participatory sculpture has evolved over the years to include furniture and whole environments. Are you trying to make sculpture go away, to make it at once more abstract and more social by shuffling it around until it becomes indivisible from all things around us?

FW: Yes. For instance, a chair or a table is indeed an Adaptive in the common sense. In the beginning, I found an illustration of a chair or table charming, but later on it became difficult and complicated to design such objects. This fit with my requirements, which is unmistakably an artistic problem.

1. The term *Passtücke* was coined in reference to West's work for the first time by poet Reinhard Priessnitz and was originally translated as "fitting pieces," an expression West disliked. In 1994, West consulted a dictionary in the British Library in London, where he found the translation "adapter," which he adopted, not least because of the affinity of this concept to that of the "bio-adapter" developed by Oswald Wiener in his novel *Die Verbesserung von Mitteleuropa* (The Improvement of Central Europe) (1969).

2. Wiener was from 1952 to 1959 one of the central figures of the experimental Vienna Group, a circle of five authors interested in the transformation of the written word into action and music. Akin to the Situationist International in Paris and the Independent Group in London, the activities of the Vienna Group fused the poetic legacies of Dada and Russian formalism with new cybernetic models that emerged in the postwar period and in the philosophical texts of Ludwig Wittgenstein.

3. In philosophy, "brain in a vat" refers to a thought experiment involving the relationship between knowledge, reality, truth, and mind. It is drawn from the idea, common in science fiction, that a mad scientist removes a person's brain and suspends it in a vat of life-sustaining liquid, connecting its neurons by wires to a supercomputer that provides it with electrical impulses identical to those that occur naturally. The computer simulates a virtual reality and the person with the disembodied brain continues to have perfectly normal conscious experiences without these being related to events in the real world.

plate 66. **Franz West**
Adaptives. 1996
Metal and epoxy, each approx. 34" (86.4 cm) tall
Collection of the artist

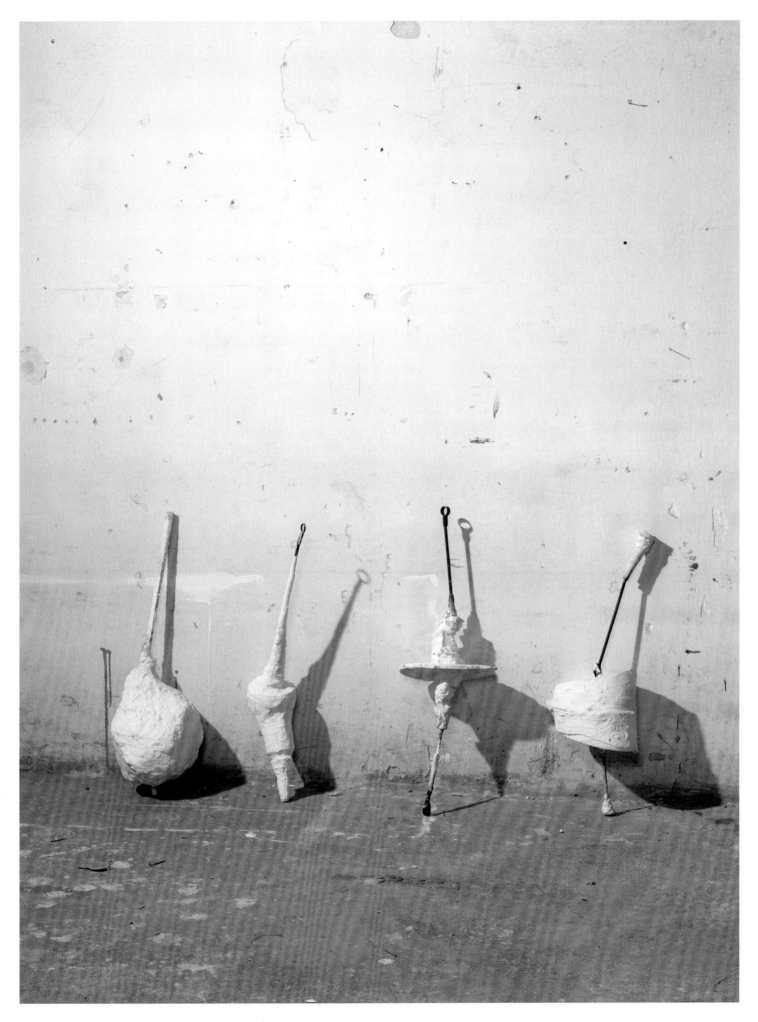

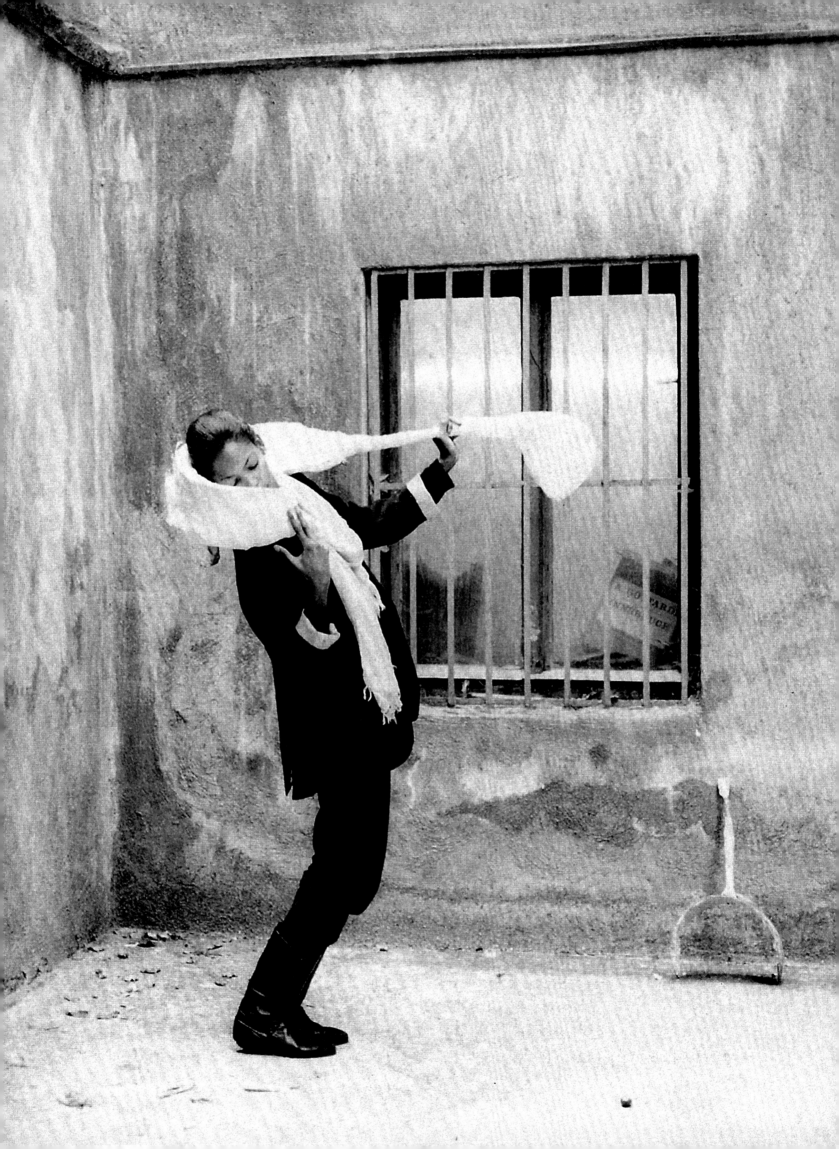

plates 67 and 68. **Franz West**
Lisa de Cohen with Adaptives, Vienna, c. 1983
Wood, papier-mâché, and wall paint,
left approx. 28 ⅜ x 17 ¾" (72 x 45 cm);
right 8 ⅝ x 14 ⅛ x 37 ½" (22 x 36 x 95 cm)

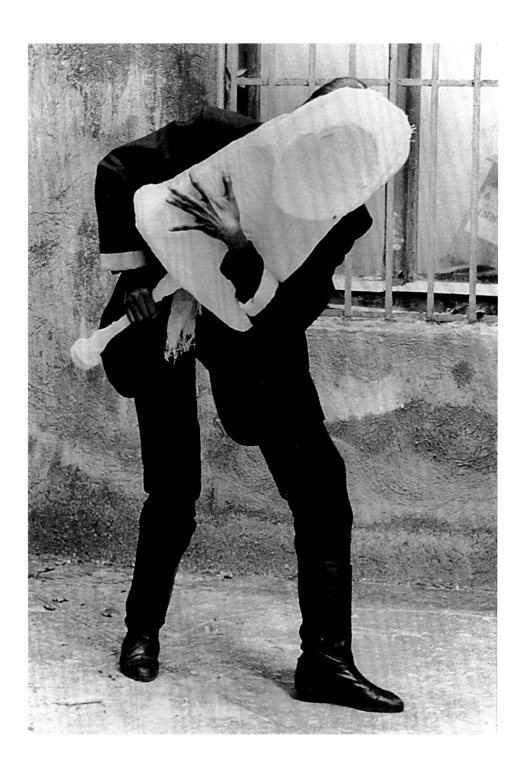

SUE WILLIAMS

Roxana Marcoci: In the mid-1970s, you moved from Chicago to Los Angeles to attend California Institute of the Arts (CalArts), where you were exposed to the teachings of John Baldessari and Elizabeth Murray and made friends with Mike Kelley and Tony Oursler. Can you talk about your experience at that time and how it impacted your practice?

Sue Williams: I went to CalArts in 1972 after high school in the Midwest. I hated it. It was barren and snobby. I had dreamed of going to the Art Institute of Chicago. Southern California didn't make any sense. Maybe it does now. I was unable to leave California because of my parents. I wanted to learn to paint. John Baldessari had just made a tall stack of his paintings and set them on fire. Everything was a little dry and judgmental. The school was really a big cement motel on a cow pasture above a really bland spread of big tract homes. Lately, it has spread over the cow pasture altogether. Everyone was from a real place somewhere else and was supposed to make stuff there. But as I was eighteen and lived there too, without a car and no public transportation available, I went mad. I slowly learned about Conceptual art and Duchamp and how not to make art.

I actually didn't have Elizabeth Murray as a teacher at CalArts, but she came to my studio at Times Square in the early 1980s and gave me some great advice. She said I could draw on the canvas and that the work could still be a painting, too. I had been struggling with areas of color and brushstroke dimension. It looked rank.

At CalArts, Baldessari taught a class for graduate students, which was called "Post-Studio Art." I was able to sit in on the course. He was very supportive of my work and still continues to be. Mike Kelley and Tony Oursler came the last year I was there. They were both very refreshing. Once we made a noise band with Jim Shaw. Mike's art was more of an influence later when he started showing at Metro Pictures in SoHo.

RM: Is it true that you began doodling in an act of rebellion, since drawing, which involved studio skills, was anathema to the cerebral milieu of CalArts? Did you do this by scrawling on the walls of the film and video editing rooms?

SW: I always doodled in private. The doodling began to emerge as lines between points, like Agnes Martin. They made a fence, then a stick figure like a cow.

Regarding the drawings on the walls, Jon McEvers and I worked late into the night editing our videos in a small, windowless room on the sublevel of the film school. I was bored.

RM: What triggered your change from the raw, cartoonlike images of the late 1980s to the more abstract and analytical work of the last decade?

SW: I usually paint what I feel compelled to paint. In the late 1980s and early 1990s, I was compelled to also write. Then I wasn't.

RM: In fact, your early comics-based scenes featured satirical writing about social brutality and emotional cruelty, while the post-1995 freewheeling sexual abstractions centered more on visual associations. Whether the mode of address is literal or abstract, there is no doubt that your work is instilled with critique.

SW: It came from personal experience and a strong feeling of terrible injustice to women that I wanted to get out. It went with my obnoxious, crummy looking painting style. This was fun, but as I played with the paint, I was also interested in what you can do with it.

RM: I am curious to learn more about your work in MoMA's collection, *Mom's Foot Blue and Orange* (1997; plate 69). The motifs of the foot and of the big toe are recurrent in your work. You have mentioned the influence of "Don Martin Steps Out!" from *Mad* magazine.[1] Can you talk about the significance of this image?

SW: My painting style changed. I wanted to check out colors and brushes and try lines without relating them to an image. After a while, I felt compelled to sit down and doodle, so I returned to appendages and what not. Out of *Mom's Foot Blue and Orange* emerged lines, a long skirt, and a giant foot with long toes like a mom. Some of the feet I occasionally made reminded me of Don Martin's "Don Martin Steps Out!" from *Mad* magazine, which I greatly admired when I was growing up.

RM: Bridging the rift between the abstract and the social in ways that are both critical and playful, you have addressed, in a wrenchingly witty tone, a wide range of issues about abuse in our society. In light of your critical perspectives, what is the most challenging aspect when you are working in the studio?

SW: I try not to think. This is key. Actually, I think about stopping the corporate killers in our government as we terrorize the world, but I end up painting toes and poop.

1. Williams, quoted in Grady T. Turner, "Sue Williams: Spinning Figures," *Flash Art*, no. 208 (October 1999): 89.

plate 69. **Sue Williams**
Mom's Foot Blue and Orange. 1997
Oil and synthetic polymer paint on canvas,
8' 2" x 9' (248.9 x 274.3 cm)
The Museum of Modern Art, New York.
Carlos and Alison Spear Gómez Fund, Marcia Riklis
Fund, and an anonymous fund, 1997

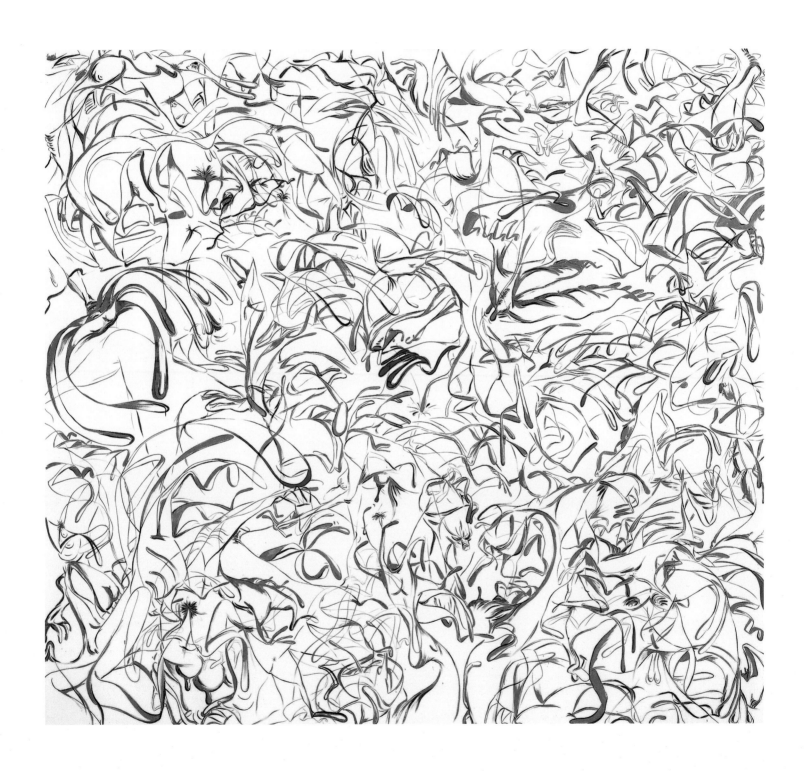

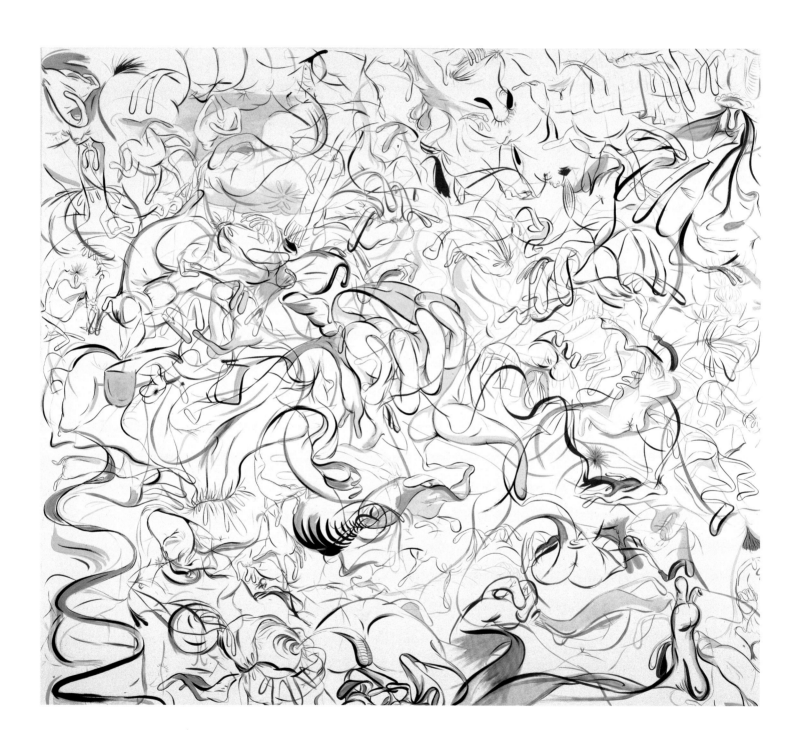

plate 71. **Sue Williams**
Large Blue Gold and Itchy. 1996
Oil and synthetic polymer paint on canvas, 8 x 9'
(243.8 x 274.3 cm)
Whitney Museum of American Art, New York.
Purchase, with funds from the Contemporary Painting
and Sculpture Committee

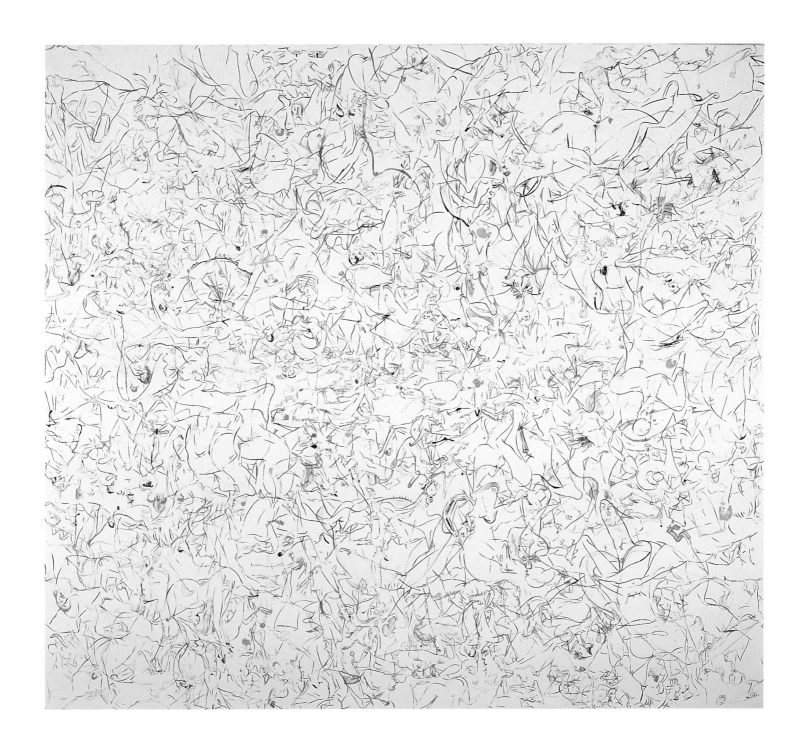

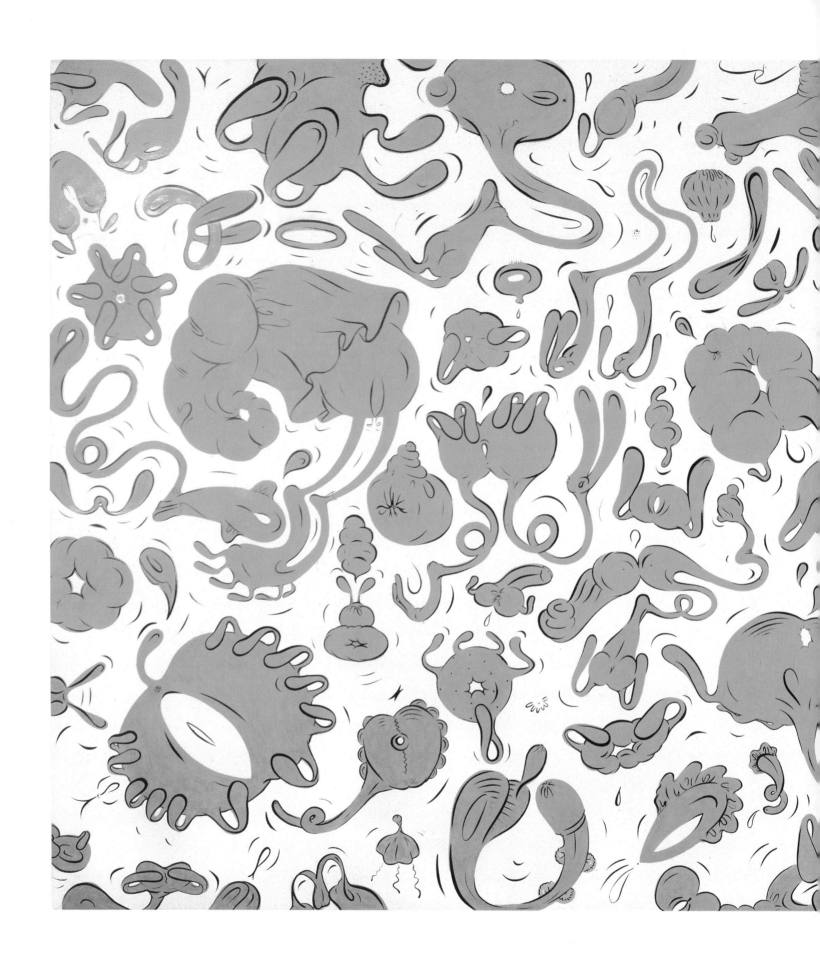

plate 72. **Sue Williams**
Bubbles. 2003
Oil and synthetic polymer paint on canvas,
6' 10" x 11' 2" (208.3 x 340.4 cm)
Collection of Erling Kagge

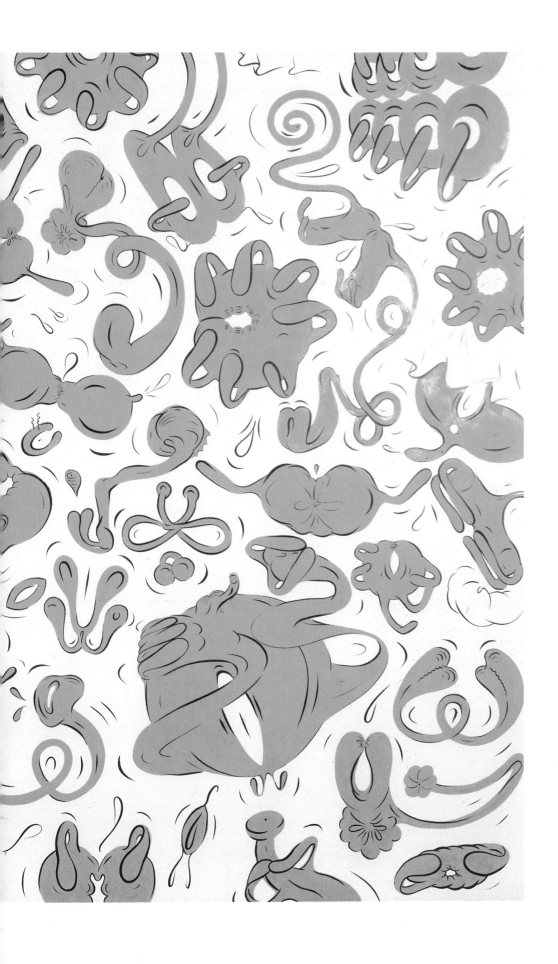

SELECTED EXHIBITION HISTORIES AND BIBLIOGRAPHIES

Exhibition history entries are listed chronologically within each year. For traveling exhibitions, dates are included with subsequent venues if they extend beyond the original year.

POLLY APFELBAUM
Born 1955 in Abington, Pennsylvania.
Lives and works in New York.

SELECTED EXHIBITIONS
Solo Exhibitions
2006
Flags of Revolt and Defiance. The Leroy Nieman Center for Print Studies, Columbia University, New York, in conjunction with Barbara Krakow Gallery, Boston
2005
Good and Plenty. Galerie Nächst St. Stephan/Rosemarie Schwarzwälder, Vienna
Cartoon Garden. D'Amelio Terras, New York
2004
Crazy Love, Love Crazy. Contemporary Art Museum St. Louis
2003
Institute of Contemporary Art, University of Pennsylvania, Philadelphia. Traveled to: Contemporary Arts Center, Cincinnati (December 6, 2003–February 29, 2004); Kemper Museum of Contemporary Art, Kansas City (June 4–September 5, 2004)
Today I Love Everybody. Triple Candie, New York
What Does Love Have to Do with It. Massachusetts College of Art, Boston
2002
Gun Club. Karyn Lovegrove Gallery, Los Angeles
2000
Skin and Bones. Bowdoin College Museum of Art, Brunswick, Maine
Powerpuff. D'Amelio Terras, New York
1998
Polly Apfelbaum: Studio K. Museum of Contemporary Art Kiasma, Helsinki
1997
The Night. Walter/McBean Gallery, San Francisco Art Institute
Realismusstudio der NGBK, Künstlerhaus am Acker, Berlin
1996
Boesky & Callery Fine Arts, New York

Group Exhibitions
2006
Resonance. Frith Street Gallery, London
Contemporary Masterworks: St. Louis Collects. Contemporary Art Museum St. Louis
The Big Picture in the Small Gallery. Peggy Phelps Gallery, Claremont Graduate University, Claremont, California
2005
Polly Apfelbaum, Katharina Grosse, Karin Sander, Jessica Stockholder. Galerie Nächst St. Stephan/Rosemarie Schwarzwälder, Vienna
The Shape of Colour: Excursions in Colour Field Art, 1950–2005. Art Gallery of Ontario, Toronto
POPulence. Blaffer Gallery, University of Houston. Traveled to: Museum of Contemporary Art, Cleveland; Southeastern Center for Contemporary Art, Winston-Salem (January 21–April 2, 2006)
Extreme Abstraction. Albright-Knox Art Gallery, Buffalo, New York
Frontiers: Collecting the Art of Our Time. Worcester Art Museum, Massachusetts (November 13, 2005–February 12, 2006)
2004
Flowers Observed, Flowers Transformed. The Andy Warhol Museum, Pittsburgh
Settlements. Musée d'Art Moderne de Saint-Étienne Métropole, France
Soft Edge. Museum of Contemporary Art, Chicago
Lodz Biennial

2003
Splat Boom Pow! The Influence of Cartoons in Contemporary Art. Contemporary Arts Museum, Houston. Traveled to: Institute of Contemporary Art, Boston (September 17, 2003–January 4, 2004); Wexner Center for the Arts, Columbus (January 31–April 30, 2004)
Valencia Bienal
Plingeling. Magasin 3 Stockholm Konsthall
Celebrating Sculpture: Modern and Contemporary Works from Dallas Collections. Dallas Museum of Art
2002
The Eye of the Beholder. Dundee Contemporary Arts Center, Scotland
Sprawl. Contemporary Arts Center, Cincinnati
2001
Making the Making. Apexart, New York
As Painting: Division and Displacement. Wexner Center for the Arts, Columbus
Waterworks: U.S. Akvarell 2001. Nordiska Akvarellmuseet, Skärhamn, Sweden
Max 2001: All About Paint. Art Museum of the University of Memphis
The Return of the Real: A Selection from the Daniel Hechter Art Collection. Tel Aviv Museum of Art
Skulptur als Feld. Kunstverein Göttingen, Germany
Operativo. Museo Rufino Tamayo, Mexico City
Patterns: Between Object and Arabesque. Kunsthallen Brandts Klædefabrick, Odense, Denmark. Traveled to: Pori Art Museum, Finland (January 12–March 10, 2002)
Best of Season. The Aldrich Contemporary Art Museum, Ridgefield, Connecticut
2000
Painting Pushed to Extremes. Worcester Art Museum, Massachusetts
1999
Postmark: An Abstract Effect. SITE Santa Fe
Hindsight. Whitney Museum of American Art, New York
The Body in Question: Tracing, Displacing and Remaking the Human Figure in Contemporary Art. The Speed Art Museum, Louisville
1998
Sydney Biennale
Abstract Painting, Once Removed. Contemporary Arts Museum, Houston. Traveled to: Kemper Museum of Contemporary Art, Kansas City (April 23–July 18, 1999)
1997
Biennale d'Art Contemporain de Lyon
Women's Work: Examining the Feminine in Contemporary Painting. Southeastern Center for Contemporary Art, Winston-Salem
Divergent Models. Nassauischer Kunstverein, Wiesbaden
1996
Painting: The Extended Field. Magasin 3 Stockholm Konsthall
1995
Pittura Immedia: Malerei der 90er Jahre aus den USA und Europa. Neue Galerie am Landesmuseum Joanneum, Graz
Tampering: Artists and Abstraction Today. High Museum of Art, Atlanta
Biennial Exhibition of Contemporary American Painting. The Corcoran Gallery of Art, Washington, D.C.

SELECTED BIBLIOGRAPHY
Books and Exhibition Catalogues

Armstrong, Philip, Laura Lisbon, and Stephen Melville. *As Painting: Division and Displacement*. Columbus: Wexner Center for the Arts, The Ohio State University; Cambridge, Mass.: The MIT Press, 2001. Text by Laura Lisbon, "Polly Apfelbaum," pp. 59–63.

Block, Holly, Leslie Luebbers, and James K. Patterson. *MAX 2001: All About Painting*. Memphis: The University of Memphis Art Museum, 2001.

Burkard, Lene. *Patterns: Between Object and Arabesque*. Odense, Denmark: Kunsthallen Brandts Klædefabrick, 2001.

Cameron, Dan. *Future Perfect*. Vienna: Heiligenkreuzerhof, 1993.

Cassel, Valerie, et al. *Splat Boom Pow! The Influence of Cartoons in Contemporary Art*. Houston: Contemporary Arts Museum, 2003.

Colpitt, Frances, ed. *Abstract Art in the Late Twentieth Century*. Cambridge: Cambridge University Press, 2002. Text by David Pagel, "Once Removed from What?" pp. 141–49.

Ferguson, Bruce W., and Louis Grauchos. *Postmark: An Abstract Effect*. Santa Fe: SITE Santa Fe, 1999.

Ferris, Alison, and Katy Kline. *Polly Apfelbaum: Installations 1996–2000*. Brunswick, Maine: Bowdoin College Museum of Art, 2000.

French, Christopher C., and Kate Norment, eds. *Painting Outside Painting: 44th Biennial Exhibition of Contemporary American Painting*. Washington, D.C.: The Corcoran Gallery of Art, 1995. Text by David Pagel, "Polly Apfelbaum," p. 34.

Friis-Hansen, Dana. *Abstract Painting, Once Removed*. Houston: Contemporary Arts Museum, 1998.

Goldman, Charles. *Making the Making*. New York: Apexart, 2001.

Gould, Claudia, Tim Griffin, Irving Sandler, and Ingrid Schaffner. *Polly Apfelbaum*. Philadelphia: Institute of Contemporary Art, University of Pennsylvania, 2003.

Keough, Jeffrey, Libby Lumpkin, and Lane Relyea. *Polly Apfelbaum: What Does Love Have to Do with It*. Boston: Massachusetts College of Art, 2003.

Levin, Kim. *Waterworks: U.S. Akvarell 2001*. Skärhamn, Sweden: Nordiska Akvarellmuseet, 2001.

Lumpkin, Libby. *Polly Apfelbaum: Studio K*. Helsinki: Museum of Contemporary Art Kiasma, 1998.

Ostrow, Saul. *Filling in the Gap*. Chicago: Feigen, 1989.

Otto, Julia. *Skulptur Als Feld*. Göttingen, Germany: Kuntsverein Göttingen, 2001. Interview with Polly Apfelbaum by Nina Zimmer, "I think of myself as irreverent," pp. 32–34.

Szeemann, Harald. *4e Biennale d'art contemporain de Lyon: l'Autre*. Lyon: Réunion des Musées Nationaux, 1997.

Zelevansky, Lynn. *Sense and Sensibility: Women Artists and Minimalism in the Nineties*. New York: The Museum of Modern Art, 1994.

Articles

Alstatt, Roseanne. "Polly Apfelbaum: Karyn Lovegrove Gallery, Los Angeles." *Art/Text*, no. 70 (August–October 2000): 86.

Bell, Tiffany. "Polly Apfelbaum's Medley of Signs." *Art in America* 84, no. 2 (February 1996): 78–81.

Demos, T. J. "Polly Apfelbaum." *Artforum* 42, no. 2 (October 2003): 176.

De Santis, Maria. "Polly Apfelbaum: Institute of Contemporary Art, University of Pennsylvania." *Surface Design Journal* 28, no. 2 (Winter 2004): 48–49.

Gibson, Wesley. "Polly Apfelbaum: D'Amelio Terras." *New Art Examiner* 28, no. 6 (March 2001): 54.

Greben, Deidre Stein. "Stain Power." *Art News* 100, no. 6 (June 2001): 102–05.

Herbert, Martin. "How Much Paint Does It Take to Make a Painting?" *Modern Painters* 17, no. 3 (Fall 2004): 82–85.

Higgie, Jennifer. "Spookie Knowledge." *Frieze*, no. 67 (May 2002): 87.

Hirsch, Faye. "Working Proof." *Art on Paper* 7, no. 4 (January–February 2003): 66–69.

Jana, Reena. "Polly Apfelbaum: Triple Candie." *Art News* 102, no. 7 (Summer 2003): 158.

Lloyd, Ann Wilson. "Seamstress of 'Splats' and 7,000 Asterisks: For Polly Apfelbaum, Tedium Is Liberating." *New York Times*, sec. 2, May 11, 2003.

Myers, Terry R. "Polly Apfelbaum." *Art/Text*, no. 70 (August–October 2000): 86.

Newhall, Edith. "Polly Apfelbaum: Institute of Contemporary Art." *Art News* 102, no. 9 (October 2003): 138.

Pagel, David. "Polly Apfelbaum: Ring-a-ring-a-roses." *Art/Text*, no. 53 (January 1996): 48–53.

Porges, Maria. "Polly Apfelbaum." *Artforum* 36, no. 3 (November 1997): 120–21.

Siegel, Jeanne. "Eva Hesse's Influence Today? Conversations with Three Contemporary Artists." *Art Journal* 63, no. 2 (Summer 2004): 72–88.

Varnedoe, Kirk. "New Acquisitions in Painting and Sculpture." *Magazine of The Museum of Modern Art* 4, no. 6 (July–August 2001): 2–5.

Westfall, Stephen. "Formalism's Poetic Frontier." *Art in America* 92, no. 1 (January 2004): 70–75.

White, Jan. "A Kind of Bliss: The Drawing Room, London." *Art Monthly*, no. 275 (April 2004): 32–33.

Williams, Alena. "Polly Apfelbaum at Karyn Lovegrove." *Art Issues*, no. 63 (Summer 2000): 46.

Znamierowski, Nell. "Polly Apfelbaum: Fallen Paintings." *Fiberarts* 30, no. 3 (November–December 2003): 60–61.

INKA ESSENHIGH

Born 1969 in Belfonte, Pennsylvania.
Lives and works in New York.

SELECTED EXHIBITIONS
Solo Exhibitions
2006
303 Gallery, New York
2005
Inka Essenhigh: Private View. Victoria Miro Gallery, London
Inka Essenhigh: Estados Unidos. Domus Artium 2002, Salamanca, Spain
2004
Saint-Lukas Galerie, Brussels
2003
The Fruitmarket Gallery, Edinburgh
Museum of Contemporary Art, North Miami
2002
303 Gallery, New York
Victoria Miro Gallery, London
2001
Works on Paper. Mary Boone Gallery, New York
2000
Victoria Miro Gallery, London
Mary Boone Gallery, New York
1999
New Paintings. Deitch Projects, New York
American Landscapes: Recent Paintings by Inka Essenhigh. Albright-Knox Art
 Gallery, Buffalo, New York
1998
Recent Paintings. Stefan Stux Gallery, New York

Group Exhibitions
2006
The Compulsive Line: Etching 1900 to Now. The Museum of Modern Art, New York
Imagination Becomes Reality, Part III. Talking Pictures. Sammlung Goetz, Munich
USA Today. Royal Academy of Arts, Burlington Gardens, London
2005
Life and Limb. Feigen Contemporary, New York
Baroque and Neobaroque: The Hell of the Beautiful. Domus Artium 2002,
 Salamanca, Spain
2004
SITE Santa Fe Biennial
São Paulo Bienal
Perspectives@25: A Quarter Century of New Art in Houston. Contemporary Arts
 Museum, Houston
Funny Cuts: Cartoons und Comics in der zeitgenössischen Kunst. Staatsgalerie
 Stuttgart

2003
Comic Release: Negotiating Identity for a New Generation. Carnegie Mellon
 University, Pittsburgh. Traveled to: Contemporary Arts Center, New Orleans;
 The University of North Texas Gallery, Denton; Western Washington University,
 Bellingham (January 12–March 13, 2004)
Painting Pictures: Malerei und Medien im Digitalen Zeitalter. Kunstmuseum
 Wolfsburg, Germany
Reverie: Works from the Collection of Douglas S. Cramer. The Speed Art Museum,
 Louisville
The New VMFA Collecting for the Future. Virginia Museum of Fine Arts, Richmond
Supernova: Art of the 1990s from the Logan Collection. San Francisco Museum of
 Modern Art
2002
La Part de l'autre. Carré d'Art–Musée d'Art Contemporain, Nîmes
Pertaining to Painting. Contemporary Arts Museum, Houston. Traveled to: Austin
 Museum of Art (November 23, 2002–February 2, 2003)
Art in the 'Toon Age. Kresge Art Museum, Michigan State University, East Lansing.
 Traveled to: Ball State University, Muncie, Indiana (July 18–October 29, 2005);
 Art and Culture Center of Hollywood, Florida (November 18, 2005–January 15,
 2006); Bryan Art Gallery, Coastal Carolina University, Conway, South Carolina
 (February 6–March 10, 2006)
2001
Hybrids: International Contemporary Painting. Tate Liverpool
Berlin Biennale
My Reality: Contemporary Art and the Culture of Japanese Animation. Des Moines
 Art Center. Traveled to: Brooklyn Museum of Art; Contemporary Arts Center,
 Cincinnati (January 24–March 31, 2002); Tampa Museum of Art (April 21–
 June 23, 2002); Chicago Cultural Center (July 13–September 8, 2002); Akron
 Art Museum (September 21, 2002–January 5, 2003); Norton Museum of Art,
 West Palm Beach (April 12–June 15, 2003); Huntsville Museum of Art, Alabama
 (October 13, 2003–January 4, 2004)
Casino 2001. Stedelijk Museum voor Actuele Kunst, Ghent
2000
Greater New York: New Art in New York Now. P.S.1 Contemporary Art Center,
 Long Island City, New York
The Figure: Another Side of Modernism. Newhouse Center for Contemporary Art,
 New York
Emotional Rescue: Contemporary Art Project Collection. Center for Contemporary
 Art, Seattle
1999
A Room with a View. Sixth@Prince Fine Art, New York
1998
Pop Surrealism. The Aldrich Museum of Contemporary Art, Ridgefield, Connecticut
1996
Night of 1,000 Drawings. Artists Space, New York

SELECTED BIBLIOGRAPHY

Books and Exhibition Catalogues

Birnbaum, Daniel, Nicolas Bourriaud, and Charles Esche. *2. Berlin Biennale 2001*. Cologne: Oktagon, 2001.

Breuvart, Valérie, ed. *Vitamin P: New Perspectives in Painting*. London: Phaidon, 2002. Text by Jane Harris, "Inka Essenhigh," p. 106.

Clark, Vicky A., and Barbara Bloemink. *Comic Release: Negotiating Identity for a New Generation*. New York: Distributed Art Publishers, 2002.

Clearwater, Bonnie. *Inka Essenhigh: Recent Paintings*. North Miami: Museum of Contemporary Art, 2003.

Cornwall-Jones, Imogen. *Inka Essenhigh*. London: Victoria Miro Gallery; New York: 303 Gallery, 2002.

Dreishpoon, Douglas. *American Landscapes: Recent Paintings by Inka Essenhigh*. Buffalo, N.Y.: Albright-Knox Art Gallery, 1999.

Fleming, Jeff, Susan Lubowsky Talbott, and Takashi Murakami. *My Reality: Contemporary Art and the Culture of Japanese Animation*. Des Moines: Des Moines Art Center; New York: Independent Curators International, 2001.

Greater New York: New Art in New York Now. Long Island City, New York: P.S.1 Contemporary Art Center, 2000.

Klein, Richard, Dominique Nahas, and Ingrid Schaffner. *Pop Surrealism*. Ridgefield, Conn.: The Aldrich Museum of Contemporary Art, 1998.

Lütgens, Annelie, and Gijs van Tuyl, eds. *Painting Pictures: Painting and Media in the Digital Age*. Wolfsburg, Germany: Kunstmuseum Wolfsburg; Bielefeld, Germany: Kerber Verlag, 2003. Text by Sarah Frost, "Inka Essenhigh," p. 199.

Morsiani, Paola. *Inka Essenhigh*. London: Victoria Miro Gallery, 2002.

———. *Pertaining to Painting*. Houston: Contemporary Arts Museum, 2002.

Nakas, Kassandra. *Funny Cuts: Cartoons and Comics in Contemporary Art*. Stuttgart: Staatsgalerie Stuttgart, and Kerber Verlag, 2004. Texts by Nakas, "Funny Cuts," pp. 10–79, and Andreas Schalhorn, "Superman's Big Sister," pp. 80–103.

La Part de l'autre. Nîmes: Actes Sud, and Carré d'Art-Musée d'Art Contemporain, 2002.

Robson, Julien. *Reverie: Works from the Collection of Douglas S. Cramer*. Louisville: The Speed Art Museum, 2003.

Rohatyn, Jeanne Greenberg. *Casino 2001: 1st Quadriënnale voor Hedendaagse Kunst*. Ghent: Stedelijk Museum voor Actuele Kunst, 2001. Text by Saul Anton and Andrea Scott, "Inka Essenhigh," p. 223.

Wallis, David. *Hybrids: International Contemporary Painting*. Liverpool: Tate Liverpool, 2001.

Articles

Buck, Louisa. "The World Is Big and Time Is Short." *Art Newspaper* 13, no. 130 (November 2002): 39.

Exley, Roy. "Inka Essenhigh: Victoria Miro." *Art Press*, no. 287 (February 2003): 74–76.

Glover, Michael. "Inka Essenhigh: Victoria Miro." *Art News* 99, no. 7 (Summer 2000): 218–19.

Holmes, Pernilla. "Inka Essenhigh: Victoria Miro Exhibition." *Art News* 102, no. 1 (January 2003): 132.

Hoptman, Laura. "Nothing Natural: Laura Hoptman on Inka Essenhigh." *Frieze*, no. 47 (July–August 1999): 74–75.

Humphrey, David. "New York: E-mail." *Art Issues*, no. 57 (March–April 1999): 34–35.

Hunt, David. "A New Grammar of Motion." *Flash Art* 33, no. 214 (October 2000): 74–77.

Kimmelman, Michael. "Inka Essenhigh, Artist: A Painter with Pop." *New York Times Magazine*, November 17, 2002, pp. 37–38.

Levine, Cary. "Inka Essenhigh at 303." *Art in America* 91, no. 4 (April 2003): 131.

Lovelace, Carey. "Inka Essenhigh at Mary Boone." *Art in America* 89, no. 12 (December 2001): 113.

Madoff, Steven Henry. "Pop Surrealism: Aldrich Museum of Contemporary Art." *Artforum* 37, no. 2 (October 1998): 120.

Saltz, Jerry. "Heat Seekers." *Village Voice*, February 9, 1999.

Schwabsky, Barry. "Inka Essenhigh: Deitch Projects." *Artforum* 37, no. 8 (April 1999): 123–24.

———. "Inka Essenhigh: Stefan Stux Gallery." *Art/Text*, no. 62 (August–October 1998): 85–86.

Sheets, Hilarie M. "Swirls, Whirls, and Mermaid Girls." *Art News* 103, no. 5 (May 2004): 136–39.

Smith, Roberta. "Inka Essenhigh: Mary Boone Gallery." *New York Times*, sec. E, June 23, 2000.

Turner, Grady T. "Abstracted Flesh." *Flash Art* 32, no. 204 (January–February 1999): 66–69.

———. "Inka Essenhigh." *Flash Art* 32, no. 205 (March–April 1999): 106.

Valdez, Sarah. "New York: Inka Essenhigh at Deitch Projects." *Art in America* 87, no. 5 (May 1999): 157–58.

Vincent, Stephen. "Boone Shows Essenhigh." *Art & Auction* 22, no. 7 (May 2000): 99.

———. "A New Gloss on Essenhigh." *Art & Auction* 24, no. 10 (November 2002): 135–36.

Williams, Eliza. "Inka Essenhigh." *Flash Art*, no. 243 (July–September 2005): 125.

ELLEN GALLAGHER
Born 1965 in Providence, Rhode Island.
Lives and works in New York and Rotterdam.

SELECTED EXHIBITIONS
Solo Exhibitions
2006
Ellen Gallagher: Salt Eaters. Hauser & Wirth, London
2005
Ellen Gallagher: DeLuxe. Whitney Museum of American Art, New York
Ellen Gallagher: Murmur and DeLuxe. Museum of Contemporary Art, North Miami
Ellen Gallagher: Ichthyosaurus. Freud Museum, London
2004
Ellen Gallagher: Preserve/Murmur. Henry Art Gallery, University of Washington, Seattle
Galerie im Taxispalais, Innsbruck
Orbus. The Fruitmarket Gallery, Edinburgh
2003
Currents 88: Ellen Gallagher. Saint Louis Art Museum
Murmur. Galerie Max Hetzler, Berlin
2001
Blubber. Gagosian Gallery, New York
Ellen Gallagher: Preserve. Des Moines Art Center. Traveled to: Yerba Buena Center for the Arts, San Francisco (November 17, 2001–January 27, 2002); The Drawing Center, New York (March 2–April 6, 2002)
Watery Ecstatic. Institute of Contemporary Art, Boston. Traveled to: Museum of Contemporary Art, Sydney (March 13–May 1, 2002)
2000
Anthony d'Offay Gallery, London
1999
Galerie Max Hetzler, Berlin
1998
Gagosian Gallery, New York
Ikon Gallery, Birmingham, England

Group Exhibitions
2006
Skin Is a Language. Whitney Museum of American Art, New York
Having New Eyes. Aspen Art Museum
Black Panther Rank and File. Yerba Buena Center for the Arts, San Francisco
Contemporary Masterworks: St. Louis Collects. Contemporary Art Museum, St. Louis
Infinite Painting: Contemporary Painting and Global Realism. Villa Manin Centre for Contemporary Art, Codroipo, Italy
The Secret Theory of Drawing. The Drawing Room, London
Heart of Darkness. Walker Art Center, Minneapolis
Alien Nation. Institute of Contemporary Arts, London
2005
Sets, Series, and Suites: Contemporary Prints. Museum of Fine Arts, Boston
Double Consciousness: Black Conceptual Art Since 1970. Contemporary Arts Museum, Houston
Artists & Prints: Part 3. The Museum of Modern Art, New York
Drawing from the Modern, 1975–2005. The Museum of Modern Art, New York
Classified Materials: Accumulations, Archives, Artists. Vancouver Art Gallery
The Fluidity of Time. Museum of Contemporary Art, Chicago

2004
Silvia Bächli, Jana Sterbak, Ellen Gallagher. Barbara Gross Galerie, Munich
Fabulism. Joslyn Art Museum, Omaha
2003
Venice Biennale
2002
Cartoon Noir: Four Contemporary Investigations. The Jack S. Blanton Museum of Art, The University of Texas at Austin
2001
The Americans: New Art. Barbican Art Gallery, London
The Mystery of Painting. Sammlung Goetz, Munich
2000
Half Dust. Irish Museum of Modern Art, Dublin
Greater New York: New Art in New York Now. P.S.1 Contemporary Art Center, Long Island City, New York
Strength and Diversity: A Celebration of African American Artists. Carpenter Center for the Visual Arts, Harvard University, Cambridge, Massachusetts
Making Sense: Ellen Gallagher, Christian Marclay, and Liliana Porter. Contemporary Museum, Baltimore
Kin. The Kerlin Gallery, Dublin
1999
Negotiating Small Truths. The Jack S. Blanton Museum of Art, The University of Texas at Austin
(Corps) social. École Nationale Supérieure des Beaux-Arts de Paris
1998
More Pieces for the Puzzle: Recent Additions to the Collection. The Museum of Modern Art, New York
Cinco Continentes y una Ciudad. Museo de la Ciudad de Mexico, Mexico City
1997
Projects. Irish Museum of Modern Art, Dublin
1996
Inside the Visible. Institute of Contemporary Art, Boston. Traveled to: National Museum of Women in Arts, Washington, D.C.; Whitechapel Art Gallery, London; Art Gallery of Western Australia, Perth (January 30–May 12, 1997)
Art at the End of the Twentieth Century: Selections from the Whitney Museum of American Art. National Gallery, Alexandros Soutzos Museum, Athens. Traveled to: Museu d'Art Contemporani de Barcelona (December 18, 1996–April 6, 1997); Kunstmuseum Bonn (June 1–September 1, 1997); Castello di Rivoli, Museo d'Arte Contemporanea, Turin (October 20, 1997–January 18, 1998)
1995
Whitney Biennial. Whitney Museum of American Art, New York
Degrees of Abstraction: From Morris Louis to Mapplethorpe. Museum of Fine Arts, Boston

SELECTED BIBLIOGRAPHY
Books and Exhibition Catalogues

Bell, Cynthia Hymes, et al. *African American Perspectives*. Waltham, Mass.: Rose Art Museum, Brandeis University, 1993.

Bonami, Francesco. *Non Toccare la Donna Bianca/Don't Touch the White Woman*. Turin: Fondazione Sandretto Re Rebaudengo, 2004.

Breuvart, Valérie, ed. *Vitamin P: New Perspectives in Painting*. London: Phaidon, 2002. Text by Eric de Chassey, "Ellen Gallagher," p. 116.

Cleijne, Edgar, and Ellen Gallagher. *Watery Ecstatic; Blizzard of White; Orbus; Monster; Super Boo*. Edinburgh: The Fruitmarket Gallery, 2005.

Currents 88: Ellen Gallagher. St. Louis: Saint Louis Art Museum, 2003.

Ellen Gallagher. Birmingham, England: Ikon Gallery, 1998. Texts by Claire Doherty, "Infection in the Sentence," pp. 9–13, and Thyrza Nichols Goodeve, "This Theater Where You Are Not There: A Conversation with Ellen Gallagher," pp. 17–23.

Ellen Gallagher: eXelento. New York: Gagosian Gallery, 2004.

Ellen Gallagher: Pickling. Berlin: Galerie Max Hetzler, 1999.

Fleming, Jeff, Robin D. G. Kelley, and Catherine de Zegher. *Ellen Gallagher: Preserve*. Des Moines: Des Moines Art Center, 2001.

Goodeve, Thyrza Nichols. *Ellen Gallagher*. London: Anthony d'Offay Gallery, 2001.

Greater New York: New Art in New York Now. Long Island City, New York: P.S.1 Contemporary Art Center, 2000.

Grosenick, Uta, ed. *Women Artists in the 20th and 21st Century*. Cologne: Taschen, 2001. Text by Raimar Stange, "Ellen Gallagher," pp. 144–49.

Grosenick, Uta, and Burkhard Riemschneider, ed. *Art Now: 137 Artists at the Rise of the New Millennium*. Cologne: Taschen, 2002.

Kim, Lisa, ed. *Ellen Gallagher: Blubber*. New York: Gagosian Gallery, 2001. Text by Beth Coleman, "Unmoored Beauty," n.p.

Lerner, Adam. *Making Sense: Ellen Gallagher, Christian Marclay, and Liliana Porter*. Baltimore: Contemporary Museum, 2000.

Morgan, Jessica, Greg Tate, and Robert Storr. *Ellen Gallagher*. Boston: Institute for Contemporary Art, Boston, and Distributed Art Publishers, 2001.

Schumacher, Rainald, ed. *The Mystery of Painting*. Munich: Kunstverlag Ingvild Goetz and Sammlung Goetz, 2001. Text by Jessica Morgan, "Ellen Gallagher in Conversation," pp. 92–99.

Wingate, Ealan, ed. *Ellen Gallagher*. New York: Gagosian Gallery, 1998.

Articles

Ammirati, Domenick. "Black Belt." *ArtUS*, no. 1 (January–February 2004): 42.

Avgikos, Jan. "Ellen Gallagher." *Artforum* 40, no. 10 (Summer 2002): 173.

Bird, Nicky. "Ellen Gallagher: Fruitmarket Gallery, Edinburgh." *Art Monthly*, no. 283 (February 2005): 24–25.

Canning, Susan. "You Can't Always Get What You Want: Sifting through the Whitney Biennial 2000; Home Sweet Home: 'Greater New York' Bucks the Biennial." *Art Papers* 24, no. 4 (July–August 2000): 20–25.

Cliff, Michelle. "Oblique Brilliance." *Parkett*, no. 73 (2005): 18–31.

Coomer, Martin. "Ellen Gallagher." *Flash Art*, no. 192 (January–February 1997): 100.

Corris, Michael. "The Americans: New Art." *Art Monthly*, no. 252 (December 2001–January 2002): 30–33.

Cotter, Holland. "Ellen Gallagher: Blubber." *New York Times*, sec. E, April 13, 2001.

———. "New York Contemporary, Defined 150 Ways." *New York Times*, sec. E, March 6, 2000.

de Chassey, Eric. "Painting Is Alive: 10 Artists under 40 Years of Age." *L'Oeil*, no. 489 (October 1997): 52–61.

Decker, Andrew. "Conjuring Consensus." *Art News* (Special edition, 1996): 58–59, 64.

Edwards, Charlotte. "Hidden Depths." *Art Review* 2, no. 9 (December 2004–January 2005): 23.

Ermen, Reinhard. "The Mystery of Painting." *Kunstforum International*, no. 158 (January–March 2002): 348–49.

Farquharson, Alex. "The Americans: New Art." *Artforum* 40, no. 7 (March 2002): 136.

Goodeve, Thyrza Nichols. "The History Lesson: Flesh Is a Texture as Much as a Color." *Parkett*, no. 73 (2005): 39–53.

Herbert, Martin. "The State of the Arts." *Art Review*, no. 53 (October 2001): 48–51.

Hudson, Suzanne P. "1,000 Words: Ellen Gallagher." *Artforum* 42, no. 10 (April 2004): 128–31.

Hughes, Jeffrey. "Ellen Gallagher: St. Louis, Missouri." *Art Papers* 27, no. 4 (July–August 2003): 45.

Hunt, Ron. "Ellen Gallagher." *Modern Painters* 11, no. 4 (Winter 1998): 98.

Lewine, Edward. "60 Ways of Looking at a Black Woman." *New York Times*, sec. 2, January 23, 2005.

Okri, Ben. "The Racial Colorist." *Parkett*, no. 73 (2005): 32–38.

Princenthal, Nancy. "Artist's Book Beat." *Art on Paper* 6, no. 2 (November–December 2001): 108–09.

Raverty, Dennis. "Des Moines." *Art Papers* 25, no. 6 (November–December 2001): 77

Richard, Frances. "Ellen Gallagher." *Artforum* 39, no. 10 (Summer 2001): 182.

Rondeau, James. "50th Venice Biennale." *Frieze*, no. 77 (September 2003): 96–97.

Schmerler, Sarah. "Ellen Gallagher." *Art News* 97, no. 7 (Summer 1998): 159.

Sirmans, Franklin. "Spotlight: Ellen Gallagher." *Flash Art* 31, no. 201 (Summer 1998): 136.

Van de Walle, Mark. "Ellen Gallagher." *Artforum* 34, no. 6 (February 1996): 76–77.

Vezin, Luc. "(Corps) Social: l'art dans tous ses états." *Beaux-Arts Magazine*, no. 185 (October 1999): 34.

Wulffen, Thomas. "Delays and Revolutions." *Kunstforum International*, no. 166 (August–October 2003): 62–89.

ARTURO HERRERA

Born 1959 in Caracas, Venezuela.
Lives and works in New York and Berlin.

SELECTED EXHIBITIONS

Solo Exhibitions

2006
Sikkema Jenkins & Co., New York

2005
Centro Galego de Arte Contemporánea, Santiago de Compostela
Arturo Herrera: zusammen aber getrennt. Galerie Max Hetzler, Berlin

2002
Present Tense 21: Arturo Herrera. Art Gallery of Ontario, Toronto
You Go First. Institute of Contemporary Art, University of Pennsylvania, Philadelphia
Brent Sikkema, New York

2001
Hammer Projects: Arturo Herrera. Hammer Museum, University of California, Los Angeles
Before We Leave. Whitney Museum of American Art, New York

2000
Artpace, San Antonio
Arturo Herrera: Felt Installation and Collages. Centre d'Art Contemporain, Geneva
Vertical Painting: Arturo Herrera: Party for Torn. P.S.1 Contemporary Art Center, Long Island City, New York

1999
Zeno X Gallery, Antwerp

1998
The Renaissance Society at the University of Chicago
Wall Project. Worcester Art Museum, Massachusetts
(Un)Conscious Articulations: Fifty Drawings by Arturo Herrera. The Art Institute of Chicago
Artist's Web Projects: Arturo Herrera: Almost Home. Dia Center for the Arts, New York

1995
Museum of Contemporary Art, Chicago

1994
Arturo Herrera: Sculptures. P.S.1 Contemporary Art Center, Long Island City, New York

1993
Center for Contemporary Arts, Santa Fe

Group Exhibitions

2006
Transforming Chronologies: An Atlas of Drawings. Part Two. The Museum of Modern Art, New York
The New Collage. Pavel Zoubok Gallery, New York
Big Juicy Paintings (and More): Highlights from the Permanent Collection. Miami Art Museum
Anstoss Berlin. Haus am Waldsee, Berlin

2005
Works on Paper. Galerie Max Hetzler, Berlin
Extreme Abstraction. Albright-Knox Art Gallery, Buffalo, New York
Drawing from the Modern, 1975–2005. The Museum of Modern Art, New York

2004
MoMA at El Museo. Latin American and Caribbean Art from the Collection of The Museum of Modern Art. El Museo del Barrio, New York
Stalemate. Museum of Contemporary Art, Chicago
São Paulo Bienal
Arturo Herrera, Jac Leirner, Thomas Nozkowski. Brent Sikkema, New York
Funny Cuts: Cartoons und Comics in der zeitgenössischen Kunst. Staatsgalerie Stuttgart

2003
Comic Release: Negotiating Identity for a New Generation. Carnegie Mellon University, Pittsburgh. Traveled to: Contemporary Arts Center, New Orleans; The University of North Texas Gallery, Denton; Western Washington University, Bellingham (January 12–March 13, 2004)
Splat Boom Pow! The Influence of Cartoons in Contemporary Art. Contemporary Arts Museum, Houston. Traveled to: Institute of Contemporary Art, Boston (September 17, 2003–January 4, 2004); Wexner Center for the Arts, Columbus (January 31–April 30, 2004)
I Moderni/The Moderns. Castello di Rivoli, Museo d'Arte Contemporanea, Turin
Mercosul Biennial, Porto Alegre, Brazil
Tony Feher, Arturo Herrera, Nancy Shaver, and Richard Tuttle. Brent Sikkema, New York

2002
Urgent Painting. Musée d'Art Moderne de la Ville de Paris
The Photogenic: Photography through Its Metaphors in Contemporary Art. Institute of Contemporary Art, University of Pennsylvania, Philadelphia
Whitney Biennial. Whitney Museum of American Art, New York
Cartoon Noir: Four Contemporary Investigations. The Jack S. Blanton Museum of Art, The University of Texas at Austin
ForwArt: A Choice. BBL Cultural Centre, Brussels
Life, Death, Love, Hate, Pleasure, Pain: Selected Works from the Museum of Contemporary Art, Chicago, Collection. Museum of Contemporary Art, Chicago

2001
Painting at the Edge of the World. Walker Art Center, Minneapolis
The Americans: New Art. Barbican Art Gallery, London

2000
Greater New York: New Art in New York Now. P.S.1 Contemporary Art Center, Long Island City, New York
Drawing on the Figure: Works on Paper of the 1990s from the Manilow Collection. Museum of Contemporary Art, Chicago
From a Distance: Landscape in Contemporary Art. Institute of Contemporary Art, Boston

1999
Collectors Collect Contemporary: 1990–99. The Institute of Contemporary Art, Boston
Trouble Spot: Painting. MUHKA–Museum van Hedendaagse Kunst Antwerpen, Antwerp
Istanbul Biennial
Colour Me Blind! Malerei in Zeiten von Computergame und Comic. Württembergischer Kunstverein, Stuttgart. Traveled to: Städtische Ausstellungshalle Am Hawerkamp, Munster (February 13–March 26, 2000); Dundee Contemporary Arts Center, Scotland (May 31–July 22, 2000)

1997
Plane Speak. Chicago Cultural Center

SELECTED BIBLIOGRAPHY
Books and Exhibition Catalogues
Arturo Herrera: Keep in Touch. Santiago de Compostela: Centro Galego de Arte Contemporánea, 2005. Text by Diane Williams, n.p.

Arturo Herrera: Photographs. Turin: Galeria Franco Noero, and New York: Sikkema Jenkins & Co., 2004. Text by Ralf Christofori, "On Arturo Herrera's Photographs," n.p.

Block, Holly, Leslie Luebbers, and James K. Patterson. *MAX 2001: All About Painting*. Memphis: The University of Memphis Art Museum, 2001.

Boris, Staci. *Drawing on the Figure: Works on Paper of the 1990s from the Manilow Collection*. Chicago: Museum of Contemporary Art, 2000.

Bradley, Jessica. *Present Tense: Contemporary Project Series No. 21*. Toronto: Art Gallery of Ontario, 2002.

Breuvart, Valérie, ed. *Vitamin P: New Perspectives in Painting*. London: Phaidon, 2002. Text by Dominic Molon, "Arturo Herrera," p. 142.

Cassel, Valerie, et al. *Splat Boom Pow! The Influence of Cartoons in Contemporary Art*. Houston: Contemporary Arts Museum, 2003.

Christofori, Ralf, ed. *Colour Me Blind! Malerei in Zeiten von Computergame und Comic*. Stuttgart: Verlag der Buchhandlung Walther König and Württembergischer Kunstverein, 1999.

Christov-Bakargiev, Carolyn. *Arturo Herrera*. Los Angeles: Hammer Museum, University of California, 2001.

——, ed. *I Moderni/The Moderns*. Milan: Skira; Turin: Castello di Rivoli, Museo d'Arte Contemporanea, 2003. Text by Hamza Walker, "Arturo Herrera," pp. 108–09.

Clark, Vicky A., and Barbara Bloemink. *Comic Release: Negotiating Identity for a New Generation*. New York: Distributed Art Publishers, 2003.

Fogle, Douglas, et al. *Painting at the Edge of the World*. Minneapolis: Walker Art Center, 2001.

Fresh Cream: Contemporary Art in Culture. London: Phaidon, 2000. Text by Amada Cruz, "Arturo Herrera," p. 328.

Greater New York: New Art in New York Now. Long Island City, New York: P.S.1 Contemporary Art Center, 2000.

Nakas, Kassandra. *Funny Cuts: Cartoons and Comics in Contemporary Art*. Stuttgart: Staatsgalerie Stuttgart, and Kerber Verlag, 2004. Texts by Kassandra Nakas, "Funny Cuts," pp. 10–79; Andreas Schalhorn, "Superman's Big Sister," pp. 80–103; and Ulrich Pfarr, "Comics as Mythology of the Modern Age," pp. 104–29.

Neri, Louise, and Friedrich Meschede. *Arturo Herrera: You Go First*. New York: Distributed Art Publishers, 2004.

Rinder, Lawrence R., Chrissie Iles, Christiane Paul, and Debra Singer. *2002 Biennial Exhibition*. New York: Whitney Museum of American Art, 2002.

Singer, Debra. *Arturo Herrera: Before We Leave*. New York: Whitney Museum of American Art, 2001.

Sladen, Mark. *The Americans: New Art*. London: Booth-Clibborn Editions and Barbican Art Gallery, 2001. Text by John Slyce, "Arturo Herrera," p. 36.

Smith, Elizabeth A. T., Alison Pearlman, Julie Rodrigues Widholm, and Robert Fitzpatrick. *Life, Death, Love, Hate, Pleasure, Pain: Selected Works from the Museum of Contemporary Art, Chicago, Collection*. Chicago: Museum of Contemporary Art, 2002.

Wakefield, Neville, and Maria Tatar. *Arturo Herrera*. Chicago: The Renaissance Society at the University of Chicago, 1998.

Articles
"Art Listings." *New York Times*, January 2, 2004.

Briggs, Patricia. "Painting at the Edge of the World." *Artforum* 36, no. 10 (Summer 2001): 185–86.

Caniglia, Julie. "Arturo Herrera: Brent Sikkema." *Artforum* 39, no. 5 (January 2001): 139.

Deitcher, David. "Tony Feher, Arturo Herrera, Nancy Shaver and Richard Tuttle." *Time Out New York*, January 8–15, 2004.

Ermen, Reinhard. "Colour Me Blind! Malerei in Zeiten von Computergame und Comic." *Kunstforum International*, no. 149 (January–March 2000): 392–94.

Estep, Jan. "Arturo Herrera." *New Art Examiner* 25 (March 1998): 50–51.

Farquharson, Alex. "The Americans: New Art." *Artforum* 40, no. 7 (March 2002): 136.

Gioni, Massimiliano. "Painting the Edge of the World." *Flash Art* 34, no. 218 (May–June 2001): 147.

Grabner, Michelle. "Arturo Herrera." *Art Press*, no. 234 (April 1998): 80–81.

Helguera, Pablo. "Arturo Herrera: The Edges of the Invisible." *Art Nexus*, no. 33 (August–October 1999): 48–52.

Herbert, Martin. "The States of Art." *Art Review*, no. 53 (October 2001): 48–51.

Katzenstein, Inés. "Arturo Herrera: Brent Sikkema." *Art Nexus*, no. 39 (February–April 2001): 150–51.

Lai, Adrianne. "The Moderns." *Parachute*, no. 113 (January–March 2004): 7–8.

Lambrecht, Luk. "ForwArt." *Flash Art* 35, no. 227 (November–December 2002): 41, 50.

Lefkowitz, David. "Edgy: Painting at the Edge of the World at Walker Art Center." *New Art Examiner* 29, no. 1 (September–October 2001): 66–71.

McElheny, Josiah. "Arturo Herrera." *Bomb*, no. 93 (Fall 2005): 68–75.

Montreuil, Gregory. "Arturo Herrera: Brent Sikkema." *Flash Art* 34, no. 225 (July–September 2002): 117–18.

Phillips, Christopher. "Report from Istanbul: Band of Outsiders." *Art in America* 88, no. 4 (April 2000): 71–73.

Smith, Roberta. "Art in Review: Arturo Herrera." *New York Times*, sec. E, May 17, 2002.

Wei, Lilly. "Arturo Herrera at Brent Sikkema." *Art in America* 91, no. 2 (February 2003): 119–20.

MICHEL MAJERUS

Born 1967 in Esch, Luxembourg; died 2002.
Lived and worked in Berlin.

SELECTED EXHIBITIONS
Solo Exhibitions
2005

Michel Majerus: Installationen 92–02. Kunsthaus Graz am Landesmuseum Joanneum, Graz. Traveled to: Stedelijk Museum, Amsterdam, under the title *Michel Majerus: What Looks Good Today May Not Look Good Tomorrow*; Deichtorhallen, Hamburg, under the title *Michel Majerus: Demand the Best Don't Accept Excuses* (November 25, 2005–February 5, 2006); Kestnergesellschaft, Hannover, under the title *Michel Majerus: What Looks Good Today May Not Look Good Tomorrow* (November 26, 2005–February 26, 2006); Musée d'Art Moderne Grand-Duc Jean, Luxembourg, under the title *Michel Majerus* (December 13, 2006–April 16, 2007)

Michel Majerus: "progressive aesthetics." neugerriemschneider, Berlin

2003

Michel Majerus: Pop Reloaded. Hamburger Bahnhof, Berlin. Traveled to: Tate Liverpool (January 24–April 18, 2004)

2002

Controlling the Moonlight Maze. neugerriemschneider, Berlin

Michel Majerus: Leuchtland. Friedrich Petzel Gallery, New York

2001

Eleni Koroneou Gallery, Athens

2000

Delfina, London

If We Are Dead . . . So It Is. Kölnischer Kunstverein, Cologne

1999

Sein Lieblingsthema war Sicherheit, seine These-es gibt sie nicht. neugerriemschneider, Berlin

Die Shiva-Matrix. In collaboration with Björn Dahlem. Schnitt Ausstellungsraum, Cologne

1998

Never Trip Alone. Always Use 2 Player Mode. Eleni Koroneou Gallery, Athens

1997

Produce-Reduce-Reuse. Galerie Karlheinz Meyer, Karlsruhe

1996

Kunsthalle Basel

Aesthetic Standard. Grazer Kunstverein, Graz

Group Exhibitions
2006

Sellout. Bard College Center for Curatorial Studies, Annandale-on-Hudson, New York

Infinite Painting: Contemporary Painting and Global Realism. Villa Manin Centre for Contemporary Art, Codroipo, Italy

"Where are we going?" Selections from the François Pinault Collection. Palazzo Grassi, Venice

Surprise, Surprise. Institute of Contemporary Arts, London

Spank the Monkey. Baltic Centre for Contemporary Art, Gateshead, England

Off the Shelf: New Forms in Contemporary Artists' Books. Frances Lehman Loeb Art Center, Vassar College, Poughkeepsie, New York

Get Ready, Land of the Rising Sun! Contemporary Japanese Art from Taikan Yokoyama to the Present. Osaka Municipal Museum of Art

2005

Exit: Ausstieg aus dem Bild. Museum für Neue Kunst, Zentrum für Kunst- und Medientechnologie (ZKM), Karlsruhe

Just Do It: The Subversion of Signs from Marcel Duchamp to Prada Meinhof. Lentos Kunstmuseum, Linz

La Nouvelle peinture Allemande. Carré d'Art-Musée d'Art Contemporain, Nîmes

Berliner Zimmer: Neuerwerbungen der Nationalgalerie. Hamburger Bahnhof, Berlin

2004

Kunst, ein Kinderspiel. Schirn Kunsthalle, Frankfurt

Support: Die Neue Galerie als Sammlung. Neue Galerie Graz am Landesmuseum Joanneum, Graz

Flirts: Kunst und Werbung/Arte e pubblicità. Museion–Museo d'Arte Moderna e Contemporanea, Bolzano, Italy

Direkte Malerei/Direct Painting. Kunsthalle Mannheim

Strips & Characters: Kunst unter dem Einfluss von Comics. Kunstverein Wolfsburg, Germany

2003

Painting Pictures: Malerei und Medien im digitalen Zeitalter. Kunstmuseum Wolfsburg, Germany

Actionbutton. Hamburger Bahnhof, Berlin. Traveled to: The State Russian Museum, St. Petersburg (September 17–November 16, 2004)

Heißkalt: Aktuelle Malerei aus der Sammlung Scharpff. Hamburger Kunsthalle, Hamburg. Traveled to: Staatsgalerie Stuttgart (March 20–June 13, 2004)

Sitings: Installation Art 1969–2002. Museum of Contemporary Art, Los Angeles

Supernova: Art of the 1990s from the Logan Collection. San Francisco Museum of Modern Art

2002

Palais de Tokyo, Paris

The Starting Line. Pinakothek der Moderne, Munich

Reality Check: Painting in the Exploded Field. CCA Wattis Institute for Contemporary Arts, San Francisco

Keine Kleinigkeit. Kunsthalle Basel

2001

Freestyle: Werke aus der Sammlung Boros. Museum Morsbroich, Leverkusen, Germany

Les Années Pop. Musée National d'Art Moderne, Centre Georges Pompidou, Paris

Viel Spass. Espace Paul Ricard, Paris

Casino 2001. Stedelijk Museum voor Actuele Kunst, Ghent

2000

HausSchau: das Haus in der Kunst. Deichtorhallen, Hamburg

Négociations. Centre Régional d'Art Contemporain, Languedoc-Roussillon

Taipei Biennial

Malkunst. Fondazione Mudima, Milan

1999

Colour Me Blind! Malerei in Zeiten von Computergame und Comic. Württembergischer Kunstverein, Stuttgart. Traveled to: Städtische Ausstellungshalle Am Hawerkamp, Munster (February 13–March 26, 2000); Dundee Contemporary Arts Center, Scotland (May 31–July 22, 2000)

Expanded Design. Salzburger Kunstverein, Salzburg

Nach-Bild. Kunsthalle Basel

Venice Biennale

Le Capital: Tableaux, diagrammes, bureaux d'études. Centre Régional d'Art Contemporain, Languedoc-Roussillon

Originale echt/falsch. Neues Museum Weserburg Bremen, Germany
Kraftwerk Berlin. Århus Kunstmuseum, Denmark
German Open. Kunstmuseum Wolfsburg, Germany
1998
Raconte-moi une histoire: La Narration dans la peinture et la photographie contemporaines. Centre National d'Art Contemporain, Grenoble
Manifesta 2. Luxembourg
Made in Berlin: Eine Neue Kunstlergeneration. Rethymnon Centre for Contemporary Art, Crete. Traveled to: The House of Cyprus, Athens (January 12–January 30, 1999)
1997
Topping Out. Städtische Galerie Nordhorn, Germany
1996
Wunderbar. Hamburger Kunstverein, Hamburg

SELECTED BIBLIOGRAPHY
Books and Exhibition Catalogues

Breuvart, Valérie, ed. *Vitamin P: New Perspectives in Painting*. London: Phaidon, 2002. Text by Alison M. Gingeras, "Michel Majerus," p. 196.

Christofori, Ralf, ed. *Colour Me Blind! Malerei in Zeiten von Computergame und Comic*. Stuttgart: Verlag der Buchhandlung Walther König and Württembergischer Kunstverein, 1999.

Deecke, Thomas, Christian Köhler, and Mike Bidlo. *Originale echt/falsch: Nachahmung, Kopie, Zitat, Aneignung, Fälsung in der Gegenwartskunst*. Bremen, Germany: Neues Museum Weserburg Bremen, 1999.

Gorner, Veit, et al. *German Open: Contemporary Art in Germany*. Wolfsburg, Germany: Kunstmuseum, 2000. Text by Robert Fleck, "Michel Majerus," n.p.

Grosenick, Uta, and Burkhard Riemschneider, eds. *Art Now: 137 Artists at the Rise of the New Millennium*. Cologne: Taschen, 2002.

Grosenick, Uta, Burkhard Riemschneider, and Lars Bang Larsen. *Art at the Turn of the Millennium*. Cologne, New York: Taschen, 1999. Text by Susanne Titz, "Michel Majerus," pp. 330–33.

Hapkemeyer, Andreas, ed. *Flirts: Kunst und Werbung/Arte e pubblicità*. Bolzano, Italy: Museion–Museo d'Arte Moderna e Contemporanea, 2004.

Heinrich, Christoph, and Nina Zimmer, ed. *Heißkalt: Aktuelle Malerei aus der Sammlung Scharpff/Ice Hot: Recent Paintings from the Scharpff Collection*. Hamburg: Hamburger Kunsthalle; Ostfildern-Ruit, Germany: Hatje Cantz, 2003. Text by Kassandra Nakas, "Michel Majerus," pp. 58–60.

Higgs, Matthew, and Michael Roth. *Reality Check: Painting in the Exploded Field*. San Francisco: California College of Arts and Crafts, 2002.

Immenga, Silke, and Ralph Melcher. *Werke aus der Sammlung Boros*. Ostfildern-Ruit, Germany: Hatje Cantz; Karlsruhe: Museum für Neue Kunst, Zentrum für Kunst- und Medientechnologie (ZKM), 2004.

Jäger, Joachim. *Michel Majerus: Los Angeles*. Cologne: Verlag der Buchhandlung Walther König, 2005.

Kunsthalle Basel: Nach Bild. Basel: Schwabe & Co., 1999. Interview with Michel Majerus by Susanne Küper, pp. 60–65.

Lütgens, Annelie, and Gijs van Tuyl, eds. *Painting Pictures: Painting and Media in the Digital Age*. Wolfsburg, Germany: Kunstmuseum Wolfsburg; Bielefeld, Germany: Kerber Verlag, 2003. Text by Raimar Stange, "Michel Majerus," pp. 209–10.

Michel Majerus. Basel: Kunsthalle Basel and Schwabe & Co., 1996.

Pakesch, Peter, et al. *Michel Majerus: Installationen 92–02/Michel Majerus: Installations 92–02*. Cologne: Verlag der Buchhandlung Walther König, 2005.

Rohatyn, Jeanne Greenberg. *Casino 2001: 1st Quadriënnale voor Hedendaagse Kunst*. Ghent: Stedelijk Museum voor Actuele Kunst, 2001. Text by Saul Anton and Andrea Scott, "Michel Majerus," p. 233.

Szeemann, Harald, ed. *D'APERTutto/Aperto Over All: 48a Esposizione Internazionale d'Arte, la Biennale di Venezia*. Venice: Biennale di Venezia, 1999. Text by Christine Standfest, "Human Skills as Opposed to Nature," p. 282.

Articles

Allen, Jennifer. "Michel Majerus." *Artforum* 38, no. 4 (December 1999): 156.

Birnbaum, Daniel. "All Together Now." *Frieze*, no. 42 (September–October 1998): 58–61.

——. "Michel Majerus 1967–2002." *Frieze*, no. 72 (January–February 2003): 60–61.

——. "The Power of Now." *Frieze*, no. 34 (May 1997): 54–55.

——. "Search Engine: The Art of Michel Majerus." *Artforum* 44, no. 6 (February 2006): 168–73.

Frangenberg, Frank. "If We Are Dead . . . So It Is." *Kunstforum International*, no. 153 (January–March 2001): 356–57.

Funken, Peter. "Objects in the Rear View Window May Appear Closer Than They Are." *Kunstforum International*, no. 147 (September–November 1999): 361–62.

Heidenreich, Stefan. "Genug, genug, genug. Paradox: Michel Majerus in der Galerie neugerriemschneider." *Frankfurter Allgemeine Zeitung*, September 11, 1999.

Hohmeyer, Boris. "Kandinsky trifft auf Omo-Reklame." *Art*, no. 7 (July 2003): 96–97.

Le Thorel, Pascale. "Pop Never Dies." *Art Press*, no. 266 (March 2001): 72–75.

Levine, Cary. "Michel Majerus at Friedrich Petzel." *Art in America* 90, no. 12 (December 2002): 109.

Lütticken, Sven. "Casino 2001." *Artforum* 40, no. 8 (April 2002): 145.

Pollack, Maika. "Michel Majerus." *Flash Art* 34, no. 226 (October 2002): 101–02.

Richter, Peter. "Welten aus Malerei." *Frankfurter Allgemeine Zeitung*, November 8, 2002.

Ruyter, Thibault de. "Michel Majerus: Kunsthaus Graz." *Art Press*, no. 313 (June 2005): 78–79.

Ryan, David. "Berlin." *Art Papers* 26, no. 5 (September–October 2002): 52.

Smith, Roberta. "The Armory Show, Grown Up and in Love with Color." *New York Times*, sec. E, February 22, 2002.

Smolik, Noemi. "Die Absichten des Künstlers werden überbewertet." *Frankfurter Allgemeine Zeitung*, November 3, 2000.

——. "Michel Majerus." *Artforum* 35, no. 8 (April 1997): 102.

——. "Michel Majerus." *Kunstforum International*, no. 148 (December 1999–January 2000): 316–17.

Stange, Raimar. "Adventures of Uncertainty." *Modern Painters* 15, no. 4 (Winter 2002): 98–101.

——. "Never Trip Alone." *Kunstbulletin*, no. 11 (November 1999): 12–17.

Thiel, Wolf Günter. "Michel Majerus." *Flash Art* 35, no. 228 (January–February 2003): 46.

Zamet, Kate. "On the Verge of World Domination." *Blueprint*, no. 218 (April 2004): 123.

JULIE MEHRETU

Born 1970 in Addis Ababa, Ethiopia.
Lives and works in New York.

SELECTED EXHIBITIONS

Solo Exhibitions

2006

Julie Mehretu: Heavy Weather. Crown Point Press Gallery, San Francisco
Museo de Arte Contemporáneo de Castilla y León

2005

Julie Mehretu: Drawings. Projectile Gallery, New York
Currents 95: Julie Mehretu. Saint Louis Art Museum

2004

Julie Mehretu/Matrix 211: Manifestation. Berkeley Art Museum, University of California

2003

Julie Mehretu: Drawing into Painting. Walker Art Center, Minneapolis. Traveled to:
 Palm Beach Institute of Contemporary Art, Lake Worth, Florida; Albright-Knox
 Art Gallery, Buffalo, New York (January 24–March 28, 2004); CalArts Gallery
 at Redcat, Valencia (May 27–July 18, 2004)

2002

White Cube, London

2001

Artpace, San Antonio
The Project, New York

1999

Module. In collaboration with Amy Brock. Project Row Houses, Houston

1998

Barbara Davis Gallery, Houston

1996

Paintings. Sol Kofler Graduate Student Gallery, Rhode Island School of Design,
 Providence

Group Exhibitions

2006

Sydney Biennale
Belief and Doubt. Aspen Art Museum
The Unhomely: Phantom Scenes in Global Society. 2nd Seville International
 Biennial of Contemporary Art

2005

Firewall. Württembergischer Kunstverein Stuttgart
Mythologies. Walker Art Center, Minneapolis
Fünfundzwanzig Jahre Sammlung Deutsche Bank. Deutsche Guggenheim, Berlin
Remote Viewing: Invented Worlds in Recent Painting and Drawing. Whitney
 Museum of American Art, New York. Traveled to: Saint Louis Art Museum
 (June 18–August 27, 2006)
This storm is what we call progress. Arnolfini, Bristol
Baroque and Neobaroque: The Hell of the Beautiful. Domus Artium 2002,
 Salamanca, Spain
On Line. Louisiana Museum for Moderne Kunst, Humlebæk, Denmark
Swarm. The Fabric Workshop and Museum, Philadelphia

2004

Whitney Biennial. Whitney Museum of American Art, New York
São Paulo Bienal
Carnegie International. Carnegie Museum of Art, Pittsburgh

2003

Social Strategies: Redefining Social Realism. University Art Museum, University
 of California, Santa Barbara. Traveled to: Illinois State University, Normal;
 DePauw University Art Gallery, Greencastle, Indiana (November 15, 2003–
 February 15, 2004)
Splat Boom Pow! The Influence of Cartoons in Contemporary Art. Contemporary
 Arts Museum, Houston. Traveled to: Institute of Contemporary Art, Boston
 (September 17, 2003–January 4, 2004); Wexner Center for the Arts,
 Columbus (January 31–April 30, 2004)
I Moderni/The Moderns. Castello di Rivoli, Museo d'Arte Contemporanea, Turin
Ethiopian Passages: Dialogues in the Diaspora. National Museum for African Art,
 Smithsonian Institution, Washington, D.C.
GNS: Global Navigation System. Palais de Tokyo, Paris
Prague Biennial
Istanbul Biennial

2002

Project 244: MetaScape. Museum of Contemporary Art, Cleveland
*Terra Incognita. Contemporary Artists' Maps and Other Visual Organizing
 Systems*. Contemporary Art Museum, St. Louis
Out of Site. New Museum of Contemporary Art, New York
Baltic Triennial of International Art, Vilnius
Busan Biennale, Busan Metropolitan Art Museum, South Korea
Drawing Now: Eight Propositions. The Museum of Modern Art, New York
Stalder-Solakov-Mehretu. Kunstmuseum Thun, Switzerland

2001

Urgent Painting. Musée d'Art Moderne de la Ville de Paris
Painting at the Edge of the World. Walker Art Center, Minneapolis
Freestyle. The Studio Museum in Harlem, New York
Casino 2001. Stedelijk Museum voor Actuele Kunst, Ghent

2000

Greater New York: New Art in New York Now. P.S.1 Contemporary Art Center, Long
 Island City, New York
Cinco Continentes y una Ciudad. Museo de la Ciudad de Mexico, Mexico City

1999

Material, Process, Memory. Jones Center for Contemporary Art, Austin
Core 1998. The Glassell School of Art, The Museum of Fine Arts, Houston
Sheer Abstraction. Barbara Davis Gallery, Houston

1998

Text and Territory: Navigating through Immigration and Dislocation. Illinois State
 University, Normal

SELECTED BIBLIOGRAPHY
Books and Exhibition Catalogues
Bourriaud, Nicolas, et al. *GNS: Global Navigation System*. Paris: Palais de Tokyo and Cercle d'art, 2003.

Breuvart, Valérie, ed. *Vitamin P: New Perspectives in Painting*. London: Phaidon, 2002. Text by Meghan Dailey, "Julie Mehretu," p. 214.

Cassel, Valerie, et al. *Splat Boom Pow! The Influence of Cartoons in Contemporary Art*. Houston: Contemporary Arts Museum, 2003.

Christov-Bakargiev, Carolyn, ed. *I Moderni/The Moderns*. Milan: Skira; Turin: Castello di Rivoli, Museo d'Arte Contemporanea, 2003. Text by David Hunt, "Julie Mehretu," pp. 144–45.

Currents 95: Julie Mehretu. St. Louis: Saint Louis Art Museum, 2005.

Fogle, Douglas, ed. *Painting at the Edge of the World*. Minneapolis: Walker Art Center, 2001.

Fogle, Douglas, Julie Mehretu, and Olukemi Ilesanmi. *Julie Mehretu: Drawing into Painting*. Minneapolis: Walker Art Center, 2003.

Greater New York: New Art in New York Now. Long Island City, New York: P.S.1 Contemporary Art Center, 2000.

Hoptman, Laura. *54th Carnegie International*. Pittsburgh: Carnegie Museum of Art, 2004. Text by Elizabeth Thomas, "Julie Mehretu," p. 188.

——. *Drawing Now: Eight Propositions*. New York: The Museum of Modern Art, 2002.

Iles, Chrissie, Shamim M. Momin, and Debra Singer. *Whitney Biennial 2004*. New York: Whitney Museum of American Art, 2004.

Jacobson, Heidi Zuckerman. *Julie Mehretu/Matrix 211: Manifestation*. Berkeley: Berkeley Art Museum, University of California, 2004.

Kim, Christine Y., and Franklin Sirmans. *Freestyle*. New York: The Studio Museum in Harlem, 2001. Text by David Hunt, "Julie Mehretu," p. 59.

Ottmann, Klaus. *Social Strategies: Redefining Social Realism*. New York: Pamela Auchincloss/Arts Management, 2003.

Rohatyn, Jeanne Greenberg. *Casino 2001: 1st Quadriënnale voor Hedendaagse Kunst*. Ghent: Stedelijk Museum voor Actuele Kunst, 2001. Text by Saul Anton and Andrea Scott, "Julie Mehretu," pp. 235–36.

Sussman, Elisabeth, Caroline A. Jones, and Katy Siegel. *Remote Viewing: Invented Worlds in Recent Painting and Drawing*. New York: Whitney Museum of American Art. Text by Tina Kukielski, "Julie Mehretu: Ferocious Speed, Nebulous, Explosions," pp. 49–54.

Articles
Albani, Chris. "Layer Me This." *Parkett*, no. 76 (2006): 38–51.

Berwick, Carly. "Excavating Runes." *Art News* 101, no. 3 (March 2002): 95.

Chua, Lawrence. "Julie Mehretu." *Bomb*, no. 91 (Spring 2005): 24–31.

Dumbadze, Alexander. "Julie Mehretu and Amy Brock: Project Row Houses." *New Art Examiner* 27, no. 1 (September 1999): 62.

Firstenberg, Lauri. "Painting Platform in NY." *Flash Art* 34, no. 227 (November–December 2002): 70–75.

Gaines, Malik. "Aftershocks." *Art/Text*, no. 77 (Summer 2002): 36–37.

Griffin, Tim. "Exploded View." *Time Out New York*, December 6–13, 2001.

Harris, Susan. "Julie Mehretu at The Project." *Art in America* 90, no. 3 (March 2002): 122.

Hirsch, Faye. "Full-Throttle Abstract." *Art in America* 92, no. 6 (June–July 2004): 170–71, 193.

Holmes, Pernilla. "Julie Mehretu: White Cube." *Art News* 101, no. 10 (November 2002): 282–83.

Hoptman, Laura. "Crosstown Traffic." *Frieze*, no. 54 (September–October 2000): 104–07.

Jacobson, Heidi Zuckerman. "Found Rumblings of the Divine." *Parkett*, no. 76 (2006): 26–37.

Lefkowitz, David. "Edgy Painting at the Edge of the World at Walker Art Center." *New Art Examiner* 29, no. 1 (September–October 2001): 66–71, 103.

Martens, Anne. "Julie Mehretu: Redcat." *Flash Art* 37, no. 238 (October 2004): 125–26.

Schuppli, Madeleine. "Files in Amber." *Parkett*, no. 76 (2006): 52–61.

Sirmans, Franklin. "Mapping a New, and Urgent, History of the World." *New York Times*, sec. 2, December 9, 2001.

Valdez, Sarah. "Freestyling." *Art in America* 89, no. 9 (September 2001): 134–39.

Worth, Alexi. "Julie Mehretu: The Project." *Artforum* 40, no. 6 (February 2002): 129–30.

JUAN MUÑOZ

Born 1953 in Madrid; died 2001.
Lived and worked in Madrid and Rome.

SELECTED EXHIBITIONS

Solo Exhibitions

2006
Juan Muñoz: Rooms of My Mind. K21 Kunstsammlung im Ständehaus, Düsseldorf

2004
Marian Goodman Gallery, Paris

2001
Hirshhorn Museum and Sculpture Garden, Smithsonian Institution, Washington, D.C. Traveled to: The Art Institute of Chicago (September 14–December 8, 2002); Contemporary Arts Museum, Houston (February 1–March 30, 2003); The Museum of Contemporary Art, Los Angeles (May 4–July 27, 2003)
The Unilever Series: Juan Muñoz. Tate Modern, London

2000
Juan Muñoz: The Nature of Visual Illusion. Louisiana Museum for Moderne Kunst, Humlebæk, Denmark

1999
Dia Center for the Arts, New York

1998
Juan Muñoz. Certain Drawings in Oil and Ink 1996–1998. Sala Robayera, Miengo, Spain

1997
Directions: Juan Muñoz. Hirshhorn Museum and Sculpture Garden, Smithsonian Institution, Washington, D.C.

1996
A Place Called Abroad. Dia Center for the Arts, New York. Traveled to: SITE Santa Fe under the title *Streetwise* (June 6–August 2, 1998)
Juan Muñoz: Monólogos y diálogos. Museo Nacional Centro de Arte Reina Sofía, Madrid

1995
Juan Muñoz: A Portrait of a Turkish Man Drawing. Isabella Stewart Gardner Museum, Boston

Group Exhibitions

2005
Obras entorno a la ciudad. Sala de Exposiciones de la Fundación "la Caixa", Madrid
Venice Biennale
Occupying Space: The Generali Collection. Witte de With, Rotterdam
Baroque and Neobaroque: The Hell of the Beautiful. Domus Artium 2002, Salamanca, Spain

2004
Continental Drift: Installations by Joan Jonas, Ilya & Emilia Kabakov, Juan Muñoz, and Yinka Shonibare. Norton Museum of Art, West Palm Beach
WOW: The Work of the Work. Henry Art Gallery, University of Washington, Seattle

2003
Images of Society. Kunstmuseum Thun, Switzerland
Potential Images of the World. The Speed Art Museum, Louisville

2001
Collaborations with Parkett: 1984 to Now. The Museum of Modern Art, New York
Dialogue Ininterrompu. Musée des Beaux-Arts de Nantes
Animations. P.S.1 Contemporary Art Center, Long Island City, New York. Traveled to: Kunst-Werke-Institute for Contemporary Art, Berlin (February 8–April 6, 2003)

2000
Sydney Biennale
Over the Edges. Stedelijk Museum voor Actuele Kunst, Ghent
Between Cinema and a Hard Place. Tate Modern, London
Around 1984: A Look at Art in the Eighties. P.S.1 Contemporary Art Center, Long Island City, New York

1999
Collectors Collect Contemporary: 1990–1999. Institute of Contemporary Art, Boston
Nye Konstellationer/New Constellations. Louisiana Museum for Moderne Kunst, Humlebæk, Denmark
Istanbul Biennial
Liverpool Biennial of Contemporary Art
Vergiss den Ball und spiel' weiter. Kunsthalle Nürnberg, Nuremberg
Zeitwenden: Ausblick. Kunstmuseum Bonn. Traveled to: Museum moderner Kunst Stiftung Ludwig Wien and Künstlerhaus, Vienna (July 5–October 1, 2000)

1998
Wounds: Between Democracy and Redemption in Contemporary Art. Moderna Museet, Stockholm
René Magritte en de hedendaagse kunst/René Magritte and the Contemporary Art. Museum voor Moderne Kunst, Ostend, Belgium
Arterias. Malmö Konsthall, Sweden
Louisiana at 40: The Collection Today. Louisiana Museum for Moderne Kunst, Humlebæk, Denmark

1997
Venice Biennale
Biennale d'Art Contemporain de Lyon
Hip. Museum für Gegenwartskunst Zürich
La Collection de la Fondation Cartier pour l'Art Contemporain. Fondation Cartier pour l'Art Contemporain, Paris

1996
Die Sammlung. Museum für Gegenwartskunst Zürich
Marks: Artists Work Throughout Jerusalem. The Israel Museum, Jerusalem

1995
Sculpturen uit de Colectie var Marlies en Jo Eyck. Bonnefantenmuseum, Maastricht
Ripple Across the Water. The Watari Museum of Contemporary Art, Tokyo
L'Escultura, Creacions Paral-Leles: Metáfores del Real. Museu d'Art Contemporani de Barcelona

SELECTED BIBLIOGRAPHY
Books and Exhibition Catalogues

4e Biennale d'art contemporain de Lyon. Lyon: Réunion des Musées Nationaux, 1997.

Benezra, Neal. *Directions: Juan Muñoz*. Washington, D.C.: Hirshhorn Museum and Sculpture Garden, Smithsonian Institution, 1997. Text by Benezra, n.p.

Benezra, Neal, Olga M. Viso, Michael Brenson, and Paul Schimmel. *Juan Muñoz*. Chicago: The Art Institute of Chicago; Washington, D.C: Hirshhorn Museum and Sculpture Garden, Smithsonian Institution, 2001.

Biesenbach, Klaus, ed. *Animations*. Berlin: Kunst-Werke-Institute for Contemporary Art, 2002. Text by Juan Muñoz, "Artist's Statement," p. 174.

Blazwick, Iwona, James Lingwood, and Andrea Schlieker. *Possible Worlds: Sculpture from Europe*. London: Institute for Contemporary Arts, and Serpentine Gallery, 1990. Text by Blazwick, Lingwood, and Schlieker, "Juan Muñoz," pp. 57–61.

Cooke, Lynne. *Juan Muñoz*. New York: Dia Center for the Arts, 1999.

Cooke, Lynne, Karen Kelly, and Bettina Funcke. *Robert Lehman Lectures on Contemporary Art*. New York: Dia Art Foundation, 2004. Text by Marina Warner, "Here Comes the Bogeyman: Goya, the Late Grotesque, and Juan Muñoz," pp. 99–121.

Debbaut, Jan. *Juan Muñoz: Ultimos Trabajos*. Madrid: Galería Fernando Vijande, 1984.

Heynen, Julian. *Juan Muñoz: Arbeiten 1988 bis 1990*. Krefeld, Germany: Krefelder Kunstmuseen, 1991.

Lingwood, James, and Rebecca Dimling-Cochran. *Juan Muñoz: Monólogos y Diálogos*. Madrid: Museo Nacional Centro de Arte Reina Sofía, 1996.

May, Susan. *Juan Muñoz: Double Bind at Tate Modern*. London: Tate Publishing, 2001.

Medvedow, Jill S. *Portrait of a Turkish Man Drawing*. Boston: Isabella Stewart Gardner Museum, 1995. Text by Medvedow, "Juan Muñoz: Looking Inside and Out," n.p.

Muñoz, Juan. *Segment*. Geneva: Centre d'Art Contemporain de Genève; Chicago: The Renaissance Society at the University of Chicago, 1990.

Muñoz, Juan, Louise Neri, and James Lingwood. *Silence Please! Stories after the Works of Juan Muñoz*. Dublin: The Irish Museum of Modern Art; Zurich: Scalo, 1996.

Nacking, Åsa, Lise Kaiser, and Steingrim Laursen. *Juan Muñoz: The Nature of Visual Illusion*. Humlebæk, Denmark: Louisiana Museum for Moderne Kunst, 2000.

Neri, Louise. *Juan Muñoz: Selected Works*. New York: Zwirner & Wirth, 2004. Text by Neri, "The Murder of Simple Art," n.p.

Poinsot, Jean-Marc. *Juan Muñoz: Sculptures de 1985 à 1987*. Bordeaux: CAPC–Musée d'Art Contemporain, 1987.

Tosatto, Guy. *Juan Muñoz*. Nîmes: Carré d'Art-Musée d'Art Contemporain, 1994. Text by Guy Tosatto, "I Remember, One Sunday. . . ," pp. 15–19.

Articles

Bryars, Gavin. "A Man in a Room, Gambling." *Parkett*, no. 43 (1995): 52–55.

Canning, Susan M. "Juan Muñoz." *Sculpture* 16 (March 1997): 58–59.

Chong, Alan. "The Page Boy and the Empty Page." *Art News* 104, no. 11 (December 2005): 108–09.

Cochran, Rebecca Dimling. "Juan Muñoz." *Art Papers* 21 (March–April 1997): 81.

Cooke, Lynne. "Juan Muñoz." *Burlington Magazine* 144, no. 1186 (January 2002): 56–58.

———. "Juan Muñoz and the Specularity of the Divided Self." *Parkett*, no. 43 (1995): 20–27.

Cruz, Juan. "Gavin Bryars and Juan Muñoz." *Art Monthly*, no. 211 (November 1997): 30–31.

Drathen, Doris von. "Juan Muñoz: Rauminstallation 'Double Bind.' " *Kunstforum International*, no. 157 (November–December 2001): 397–99.

Ebony, David. "Fact and Fable: Juan Muñoz." *Art in America* 90, no. 10 (October 2002): 116–23, 191.

Eccles, Tom. "Juan Muñoz at Dia." *Art in America* 85, no. 5 (May 1997): 121.

Harris, Jane. "Juan Muñoz." *Art Papers* 21, no. 2 (March–April 1997): 64.

Howell, George. "Juan Muñoz: Figurative Metaphors on the Washington Mall." *Sculpture* 16, no. 1 (January 1997): 8–9.

———. "Washington." *Art Papers* 26, no. 3 (May–June 2002): 43.

Jimenez, Carlos. "Juan Muñoz: Staging of Anonymity." *Art Nexus* 1, no. 47 (January–March 2003): 66–70.

Lingwood, James. "Juan Muñoz: A Conversation." *Parkett*, no. 43 (1995): 42–51.

Llorca, Pablo. "Juan Muñoz." *Artforum* 35, no. 6 (February 1997): 95–96.

Lloyd, Ann Wilson. "Empty Hands, Silent Mouths." *Art in America* 84, no. 3 (March 1996): 50–51.

Melo, Alexandre. "The Art of Conversation." *Parkett*, no. 43 (1995): 36–41.

Tanguy, Sarah. "Juan Muñoz: Negotiating Disbelief." *Sculpture* 21, no. 4 (May 2002): 28–33.

Tosatto, Guy. "Juan Muñoz." *L'Oeil*, no. 492 (January 1998): 56–59.

Unger, Miles. "Juan Muñoz." *New Art Examiner* 23 (December 1995): 37–38.

TAKASHI MURAKAMI
Born 1962 in Tokyo.
Lives and works in Tokyo and New York.

SELECTED EXHIBITIONS
Solo Exhibitions
2006
Takashi Murakami: "The Pressure Point of Painting." Galerie Emmanuel Perrotin, Paris
2005
T1: Takashi Murakami. Fondazione Sandretto Re Rebaudengo, Turin
2004
Inochi. Blum & Poe, Los Angeles
Satoeri Ko² Chan. Tomio Koyama Gallery, Tokyo
2003
Superflat Monogram. Marianne Boesky Gallery, New York
Takashi Murakami at Rockefeller Center: Reversed Double Helix. Rockefeller
 Center, New York
2002
Takashi Murakami: Kaikai Kiki. Fondation Cartier pour l'Art Contemporain, Paris.
 Traveled to: Serpentine Gallery, London (November 12, 2002–January 26, 2003)
2001
Takashi Murakami: Made in Japan. Museum of Fine Arts, Boston
Takashi Murakami: Summon Monsters? Open the Door? Heal? Or Die? Museum of
 Contemporary Art, Tokyo
2000
727. Blum & Poe, Los Angeles
Takashi Murakami: Second Mission Project Ko². P.S.1 Contemporary Art Center,
 Long Island City, New York
1999
Takashi Murakami: The Meaning of the Nonsense of the Meaning. Center for
 Curatorial Studies Museum, Bard College, Annandale-on-Hudson, New York
1998
Takashi Murakami: Hiropon, Project Koko-Pity, Sakuraku Jet Airplane Nos. 1–6.
 Feature Inc., New York
1997
Takashi Murakami: 7272 – To Dream of Bombay. Art Space HAP, Hiroshima
1996
Konnichiwa, Mr. DOB! Kirin Plaza Osaka
Takashi Murakami: A Very Merry Unbirthday, to You, to Me! Ginza Komatsu, Tokyo
1995
Galerie Emmanuel Perrotin, Paris
Takashi Murakami: Crazy Z. SCAI The Bathhouse, Tokyo

Group Exhibitions
2006
Infinite Painting: Contemporary Painting and Global Realism. Villa Manin
Centre for Contemporary Art, Codroipo, Italy
2005
POPulence. Blaffer Gallery, University of Houston. Traveled to: Museum of
 Contemporary Art, Cleveland; Southeastern Center for Contemporary Art,
 Winston-Salem (January 21–April 2, 2006)
Japan Pop: Manga and Contemporary Art. Helsinki City Art Museum
Ecstasy: In and About Altered States. The Geffen Contemporary at The Museum of
 Contemporary Art, Los Angeles

2004
Monument to Now. Deste Foundation, Athens
Liverpool Biennial of Contemporary Art
Funny Cuts: Cartoons und Comics in der zeitgenössischen Kunst. Staatsgalerie
 Stuttgart
2003
Comic Release: Negotiating Identity for a New Generation. Carnegie Mellon
 University, Pittsburgh. Traveled to: Contemporary Arts Center, New Orleans;
 The University of North Texas Gallery, Denton; Western Washington University,
 Bellingham (January 12–March 13, 2004)
Painting Pictures: Painting and Media in the Digital Age. Kunstmuseum Wolfsburg,
 Germany
Splat Boom Pow! The Influence of Cartoons in Contemporary Art. Contemporary
 Arts Museum, Houston. Traveled to: Institute of Contemporary Art, Boston
 (September 17, 2003–January 4, 2004); Wexner Center for the Arts,
 Columbus (January 31–May 2, 2004)
Pulp Art: Vamps, Villains, and Victors from the Robert Lesser Collection. Brooklyn
 Museum of Art
Venice Biennale
2002
POPjack: Warhol to Murakami. Museum of Contemporary Art, Denver
Reality Check: Painting in the Exploded Field. CCA Wattis Institute for
 Contemporary Arts, San Francisco
Drawing Now: Eight Propositions. The Museum of Modern Art, New York
2001
Under Pressure. Swiss Institute, New York. Traveled to: Museum of Contemporary
 Art, Tucson
Painting at the Edge of the World. Walker Art Center, Minneapolis
My Reality: Contemporary Art and the Culture of Japanese Animation. Des Moines
 Art Center. Traveled to: Brooklyn Museum of Art; Contemporary Arts Center,
 Cincinnati (January 24–March 31, 2002); Tampa Museum of Art (April 21–
 June 23, 2002); Chicago Cultural Center (July 13–September 8, 2002); Akron
 Art Museum (September 21, 2002–January 5, 2003); Norton Museum of Art,
 West Palm Beach (April 12–June 15, 2003); Huntsville Museum of Art,
 Alabama (October 13, 2003–January 4, 2004)
Public Offerings. The Geffen Contemporary at The Museum of Contemporary Art,
 Los Angeles
SITE Santa Fe
Casino 2001. Stedelijk Museum voor Actuele Kunst, Ghent
JAM: Tokyo London. Barbican Art Gallery, London. Traveled to: Tokyo Opera City Art
Gallery (February 8–May 6, 2002)
2000
Let's Entertain: Life's Guilty Pleasures. Walker Art Center, Minneapolis. Traveled to:
 Portland Art Museum, Oregon; Musée National d'Art Moderne, Centre Georges
 Pompidou, Paris, under the title Au-delà du spectacle (November 22,
 2000–January 8, 2001); Museo Rufino Tamayo, Mexico City (June 6–August 8,
 2001); Miami Art Museum (September 12–November 25, 2001)
Superflat. Parco Gallery, Tokyo. Traveled to: Parco Gallery, Nagoya; The Museum
 of Contemporary Art Pacific Design Center, Los Angeles (January 14–May 27,
 2001); Walker Art Center, Minneapolis (July 15–October 14, 2001); Henry Art
 Gallery Art, Seattle (November 10, 2001–March 3, 2002)
Biennale d'Art Contemporain de Lyon

1999

Almost Warm and Fuzzy: Childhood and Contemporary Art. Des Moines Art
Center. Traveled to: Tacoma Art Museum (July 7–September 17, 2000);
Scottsdale Museum of Contemporary Art (October 6, 2000–January 14,
2001); P.S.1 Contemporary Art Center, Long Island City, New York (February
4–April 8, 2001); Fundacio "la Caixa", Barcelona (April 26–July 8, 2001);
Crocker Art Museum, Sacramento (August 30–November 4, 2001); Art Gallery
of Hamilton, Ontario (November 24, 2001–January 20, 2002); Memphis
Brooks Museum of Art (June 2–July 28, 2002); Cleveland Center for
Contemporary Art (September 13–November 17, 2002)

Carnegie International 1999/2000. Carnegie Museum of Art, Pittsburgh

Colour Me Blind! Malerei in Zeiten von Computergame und Comic.
Württembergischer Kunstverein, Stuttgart. Traveled to: Städtische
Ausstellungshalle Am Hawerkamp, Munster (February 13–March 26, 2000);
Dundee Contemporary Arts Center, Scotland (May 31–July 22, 2000)

1998

Pop Surrealism. The Aldrich Contemporary Art Museum, Ridgefield, Connecticut

Abstract Painting, Once Removed. Contemporary Arts Museum, Houston. Traveled
to: Kemper Museum of Contemporary Art, Kansas City (April 23–July 18, 1999)

The MANGA Age. The Museum of Contemporary Art, Tokyo. Traveled to:
Hiroshima City Museum of Contemporary Art

1997

Japan Today: Kunst, Fotografie, Design. MAK, Vienna

Cities on the Move: Contemporary Asian Art on the Turn of the 21st Century.
Wiener Secession, Vienna. Traveled to: CAPC-Musée d'Art Contemporain,
Bordeaux (June 4–August 30, 1998); P.S.1 Contemporary Art Center, Long
Island City, New York (October 18, 1998–January 3, 1999); Louisiana Museum
for Moderne Kunst, Humlebæk, Denmark (January 29–April 21, 1999);
Hayward Gallery, London (May 13–June 27, 1999)

1996

Asia-Pacific Triennial. Queensland Art Gallery, Brisbane

1995

Japan Today. Louisiana Museum for Moderne Kunst, Humlebæk, Denmark

SELECTED BIBLIOGRAPHY

Books and Exhibition Catalogues

Cassel, Valerie, et al. *Splat Boom Pow! The Influence of Cartoons in
Contemporary Art*. Houston: Contemporary Arts Museum, 2003.

Christofori, Ralf, ed. *Colour Me Blind! Malerei in Zeiten von Computergame und
Comic*. Stuttgart: Verlag der Buchhandlung Walther König and Württembergischer
Kunstverein, 1999.

Clark, Vicky A., and Barbara Bloemink. *Comic Release: Negotiating Identity for a
New Generation*. New York: Distributed Art Publishers, 2002.

Cruz, Amada, Midori Matsui, and Dana Friis-Hansen. *Takashi Murakami: The
Meaning of the Nonsense of the Meaning*. New York: Harry N. Abrams, 1999.

Fogle, Douglas, et al. *Painting at the Edge of the World*. Minneapolis: Walker Art
Center, 2001.

Fleming, Jeff, Susan Lubowsky Talbott, and Takashi Murakami. *My Reality:
Contemporary Art and the Culture of Japanese Animation*. Des Moines: Des
Moines Art Center; New York: Independent Curators International, 2001.

Friis-Hansen, Dana. *Abstract Painting, Once Removed*. Houston: Contemporary Arts
Museum, 1998.

Murakami, Takashi, ed. *Little Boy: The Arts of Japan's Exploding Subculture*. New York:
Japan Society; New Haven, Conn., and London: Yale University Press, 2005.

——. *Superflat*. Tokyo: MADRA Publishing Co., 2000.

——. *Takashi Murakami: Summon Monsters? Open the Door? Heal? Or Die?*
Tokyo: Museum of Contemporary Art and Kaikai Kiki Co., 2001.

Nakas, Kassandra. *Funny Cuts: Cartoons and Comics in Contemporary Art*.
Stuttgart: Staatsgalerie Stuttgart, and Kerber Verlag, 2004. Text by Nakas,
"Funny Cuts," pp. 10–79.

Articles

Baralhe, Antoine. "Takashi Murakami: Kawaii! Vacances d'Eté." *Modern Painters*
15, no. 4 (Winter 2002): 146–47.

Cooper, Jacqueline. "Superflat." *New Art Examiner* 29, no. 1 (September–October
2001): 58–65.

Darling, Michael. "Plumbing the Depths of Superflatness." *Art Journal* 60, no. 3
(Fall 2001): 76–89.

Ermen, Reinhard. "Colour Me Blind! Malerei in Zeiten von Computergame und
Comic." *Kunstforum International*, no. 149 (January–March 2000): 392–94.

——. "Takashi Murakami: 'Summon Monsters? Open the Door? Heal? Or Die?' "
Kunstforum International, no. 157 (November–December 2001): 407–08.

Hauser, Kitty. "Superflat." *Artforum* 43, no. 2 (October 2004): 129, 286.

Hettig, Frank-Alexander. "Superflat." *Kunstforum International*, no. 154 (April–May
2001): 458–59.

Itoi, Kay. "The Wizard of DOB." *Art News* 100, no. 3 (March 2001): 134–37.

Kaplan, Cheryl. "Takashi Murakami: Lite Hapiness + The Super Flat." *Flash Art* 34,
no. 219 (July–September 2001): 94–97.

Mattick, Paul. "Takashi Murakami at Marianne Boesky." *Art in America* 92, no. 1
(January 2004): 107–08.

Molinari, Guido. "Takashi Murakami." *Flash Art* 31, no. 199 (March–April 1998): 106.

Murakami, Takashi. "On the Level." *Artforum* 43, no. 2 (October 2004): 155.

Richard, Frances. "Takashi Murakami." *Artforum* 40, no. 1 (September 2001): 192.

Rimanelli, David. "Takashi Murakami." *Artforum* 38, no. 3 (November 1999): 134–35.

Roberts, James. "Magic Mushrooms." *Frieze*, no. 70 (October 2002): 66–71.

Rubinstein, Raphael. "In the Realm of the *Superflat*." *Art in America* 89, no. 6
(June 2001): 110–15.

Siegel, Katy. "Planet Murakami." *Art Review*, no. 54 (November 2003): 46–53.

——. "Takashi Murakami." *Artforum* 41, no. 10 (Summer 2003): 185–86.

Smith, Roberta. "From a Mushroom Cloud, a Burst of Art Reflecting Japan's
Psyche." *New York Times*, sec. E, April 8, 2005.

Steinberg, Marc. "Characterizing a New Seriality: Murakami Takashi's DOB Project."
Parachute, no. 110 (April–June 2003): 90–109.

Vogel, Carol. "The Murakami Influence; A New Exhibition Offers the Childlike and
Dark Sides of Japanese Art." *New York Times*, sec. E, April 6, 2005.

RIVANE NEUENSCHWANDER

Born 1967 in Belo Horizonte, Brazil.
Lives and works in Belo Horizonte.

SELECTED EXHIBITIONS
Solo Exhibitions
2006
Tanya Bonakdar Gallery, New York
2005
Klosterfelde Galerie, Berlin
2004
Currents 93: Rivane Neuenschwander. Saint Louis Art Museum
2003
Superficial Resemblance. Palais de Tokyo, Paris
Museu de Arte Moderna Aloísio Magalhães, Recife, Brazil
2002
Stephen Friedman Gallery, London
Institute of Visual Arts, University of Wisconsin, Milwaukee
To/From: Rivane Neuenschwander. Walker Art Center, Minneapolis
Museu de Arte da Pampulha, Belo Horizonte, Brazil
2001
Artpace San Antonio
The Americas Society, New York
Rivane Neuenschwander: Spell. Portikus, Frankfurt
2000
Galeria Camargo Vilaça, São Paulo
Syndrome. IASPIS, International Artists Studio Program, Stockholm
1999
Stephen Friedman Gallery, London

Group Exhibitions
2006
Stopover. FRI-ART, Centre d'Art Contemporain, Fribourg
Havana Bienal
2005
Rampa: Signaling New Latin American Art Initiatives. Arizona State University Art Museum, Tempe
Urban Cocktail. Walker Art Center, Minneapolis
Venice Biennale
New Work/New Acquisitions. The Museum of Modern Art, New York
Old News. Los Angeles Contemporary Exhibitions
Here Comes the Sun. Magasin 3 Stockholm Konsthall
Biennale d'Art Contemporain de Lyon
Deseos fluidos: Brazilian and Cuban Perspectives between Reality and Fantasy. Thyssen-Bornemisza Art Contemporary, Vienna
Tropicália: A Revolution in Brazilian Culture. Museum of Contemporary Art, Chicago. Traveled to: Barbican Art Centre, London (February 15–May 21, 2006); Haus der Kulturen der Welt, Berlin (June 10–July 9, 2006); Bronx Museum of the Arts, New York (October 14, 2006–January 28, 2007)

2004
Novas Aquisições 2003: Coleção Gilberto Chateaubriand. Museu de Arte Moderna, Rio de Janeiro
Brazil: Body Nostalgia. The National Museum of Modern Art, Tokyo. Traveled to: The National Museum of Modern Art, Kyoto
2003
Land, Land! Helen Mirra, Rivane Neuenschwander, Katja Strunz. Kunsthalle Basel
Visual Poetics: Art and the World. Miami Art Museum
Venice Biennale
10 x Minas. Museu de Arte da Pampulha, Belo Horizonte, Brazil
Happiness: A Survival Guide for Art and Life. Mori Art Museum, Tokyo
From Dust to Dusk. International Exhibition of Contemporary Art. Charlottenborg Udstillingsbygning, Copenhagen
Plunder: Culture as Material. Dundee Contemporary Arts Center, Scotland
2002
The Eye of the Beholder. Dundee Contemporary Arts Center, Scotland
Liverpool Biennial of Contemporary Art
Haunted by Detail. De Appel Foundation, Amsterdam
2001
Panorama de Arte Brasileira. Museu de Arte Moderna de São Paulo
Trans Sexual Express: A Classic for the Third Millennium. Centro de Arte Santa Mònica, Barcelona. Traveled to: Műcsarnok, Budapest (January 18–February 28, 2002)
2000
Brasil + 500: Mostra do Redescobrimento. Pavilhão Ciccillo Matarazzo, Fundação Bienal de São Paulo
Space Experiences: Homage to The National Museum of Art. The National Museum of Art, Osaka
A Quietude da Terra/Quiet in the Land. Museu de Arte Moderna da Bahia, Salvador de Bahia, Brazil
No Es Sólo Lo Que Ves: Pervirtiendo El Minimalismo. Museo Nacional Centro de Arte Reina Sofía, Madrid
1999
Powder. Aspen Art Museum
SITE Santa Fe Biennial
Liverpool Biennial of Contemporary Art
1998
Bili Bidjocka, Los Carpinteros, and Rivane Neuenschwander. New Museum of Contemporary Art, New York
São Paulo Bienal
1997
Material/Immaterial. Art Gallery of New South Wales, Sydney
Istanbul Biennial
Johannesburg Biennale

SELECTED BIBLIOGRAPHY

Books and Exhibition Catalogues

5th International Istanbul Biennial. Istanbul: Istanbul Foundation for Culture and Arts, 1998.

Clark, Robin. *Currents 93: Rivane Neuenschwander*. St. Louis: Saint Louis Art Museum, 2004.

Cream: Contemporary Art in Culture. Ten Curators, Ten Writers, One Hundred Artists. London: Phaidon, 1998. Text by Rosa Martínez, "Rivane Neuenschwander," p. 300.

Dreams and Conflict: The Dictatorship of the Viewer. La Biennale di Venezia: 50th International Art Exhibition. Venice: Biennale di Venezia, 2003.

Genocchio, Benjamin. *Material/Immaterial: The Guinness Contemporary Art Project*. Sydney: Art Galley of New South Wales, 1997.

Hoffman, Jens, and Rivane Neuenschwander. *Rivane Neuenschwander*. New York: The Americas Society, 2001.

Hugo Boss Prize 2004. New York: Solomon R. Guggenheim Museum, 2004. Text by Rosa Martínez, "A Letter for You," pp. 48–51.

Ilesanmi, Olukemi. *To/From: Rivane Neuenschwander*. Minneapolis: Walker Art Center, 2002.

Martínez, Rosa. *Rivane Neuenschwander. XXIV Bienal de São Paulo*. São Paulo: Galeria Camargo Vilaça; London: Stephen Friedman Gallery, 1998.

Morin, France. *A Quietude da Terra/Quiet in the Land*. Bahia, Brazil: Museu de Arte Moderna da Bahia and France Morin, 2000.

Mosquera, Gerardo. *No Es Sólo Lo Que Ves: Pervirtiendo El Minimalismo*. Madrid: Museo Nacional Centro de Arte Reina Sofía, Madrid. Text by Lisette Lagnado, "Rivane Neuenschwander," pp. 118–19.

Mostra do Redescobrimento: Arte Contemporânea/Contemporary Art. São Paulo: Associção Brasil 500 Anos Artes Visualis and Fundação Bienal de São Paulo, 2000. Text by Nelson Aguilar, "Brazilian Art in the 90s," pp. 212–17.

Stjernstedt, Mats, Lisette Lagnado, and Rivane Neuenschwander. *Rivane Neuenschwander*. São Paulo: Galeria Camargo Vilaça; London: Stephen Friedman Gallery; Dublin: The Douglas Hyde Gallery, 2000.

Végh, Christina, and Gregor Hens. *Land, Land! Helen Mirra, Rivane Neuenschwander, and Katja Strunz*. Basel: Schwabe & Co. and Kunsthalle Basel, 2003.

Volz, Jochen. *Rivane Neuenschwander: Spell*. Frankfurt: Portikus, 2002. Text by Adam Szymczyk, "The Sensorium of Sense, the Empire of the Senses," pp. 30–33.

Articles

Abbe, Mary. "Rivane Neuenschwander: Walker Art Center." *Art News* 101, no. 10 (November 2002): 280–81.

Birnbaum, Daniel. "Feast for the Eyes: The Art of Rivane Neuenschwander." *Artforum* 41, no. 9 (May 2003): 142–46.

Cordeiro, Veronica. "Rivane Neuenschwander: Galeria Camargo Vilaça." *Art Nexus*, no. 40 (May–July 2001): 125–26.

———. "Rivane Neuenschwander: Museu de Arte da Pampulha Belo Horizonte." *Art Nexus*, no. 47 (January–March 2003): 100–02.

Ewing, John. "Rivane Neuenschwander, Shahzia Sikander, Tony Villejo: ArtPace." *Sculpture* 20, no. 8 (October 2001): 77–78.

Hansson, Annika. "Rivane Neuenschwander: IASPIS, Stockholm." *Make*, no. 90 (December 2000–February 2001): 36–37.

Hoffmann, Jens. "Rivane Neuenschwander: Ethereal Materialism." *Flash Art* 34, no. 226 (October 2002): 90–92.

Hughes, Jeffrey. "Rivane Neuenschwander: Saint Louis Art Museum." *Art Papers* 29, no. 2 (March–April 2005): 53.

Pollack, Barbara. "Report from Tokyo: Art Above the City." *Art in America* 92, no. 5 (May 2004): 99–103.

Schwabsky, Barry. "Rivane Neuenschwander." *Artforum* 40, no. 8 (April 2002): 147.

PHILIPPE PARRENO
Born 1964 in Oran, Algeria.
Lives and works in Paris.

SELECTED EXHIBITIONS
Solo Exhibitions
2005
Philippe Parreno: The Boy from Mars. Friedrich Petzel Gallery, New York
Media Series: Philippe Parreno, the Boy from Mars. Saint Louis Art Museum
Liam Gillick and Philippe Parreno: Briannnnnn & Ferryyyyyy. Vamiali, Athens.
 Traveled to: Kunsthalle Zürich (January 20–March 26, 2006)
2004
Fade Away. Kunstverein München, Munich
Welcome to Reality Park. Air de Paris, Paris
(Rider) Law and creativity. In collaboration with Liam Gillick. Lunds Konsthall, Sweden
2003
The Sky of the Seven Colors. Center for Contemporary Art Kitakyushu, Japan
2002
Philippe Parreno: Alien Seasons. Musée d'Art Moderne de la Ville de Paris.
 Traveled to: Friedrich Petzel Gallery, New York (April 26–May 24, 2003)
No Ghost Just a Shell. Kunsthalle Zürich. Traveled to: Institute of Visual Culture,
 The Fitzwilliam Museum, Cambridge (December 2, 2002–January 19, 2003);
 San Francisco Museum of Modern Art (December 14, 2002–March 16, 2003);
 Van Abbemuseum, Eindhoven, The Netherlands (January 19–August 24, 2003)
2001
Anywhere Out of the World. Institute of Visual Culture, The Fitzwilliam Museum,
 Cambridge. Traveled to: Kunstverein München, Munich (April 26–June 2, 2002)
El Sueño de una cosa. Museet Project, Moderna Museet, Stockholm. Traveled to:
 Portikus, Frankfurt (February 2–March 10, 2002)
2000
Philippe Parreno. One Thousand Pictures from One Thousand Walls. Musée d'Art
 Moderne et Contemporain, Geneva
Anna Sanders. The Story of a Feeling. Scene 3. In collaboration with Pierre
 Huyghe. San Francisco Art Institute
1998
Institute of Visual Arts, University of Wisconsin, Milwaukee
Le Procès de Pol Pot. In collaboration with Liam Gillick. Centre National d'Art
 Contemporain, Grenoble
1995
Snow Dancing. Le Consortium, Dijon
While. . . Hamburger Kunstverein, Hamburg

Group Exhibitions
2006
Winterausstellung. Esther Schipper, Berlin
Again for Tomorrow. Royal College of Art Galleries, London
Melancholia. Sommer Contemporary Art, Tel Aviv
The Expanded Eye: Stalking the Unseen. Kunsthalle Zürich
2005
Present Perfect. Friedrich Petzel Gallery, New York
Universal Experience: Art, Life, and the Tourist's Eye. Museum of Contemporary
 Art, Chicago
Projet Cône Sud. Fonds Régional d'Art Contemporain (Frac), Poitou-Charentes,
 France. Traveled to: Museo de Arte Moderno de la Ciudad de Buenos Aires
Shadowland: An Exhibition as a Film. Walker Art Center, Minneapolis
Bidibidobidiboo. Fondazione Sandretto Re Rebaudengo, Turin

Philippe Parreno, Atlas of Clouds. 1301PE, Los Angeles
Biennale d'Art Contemporain de Lyon
Baltic Triennial of International Art, Vilnius
Guangzhou Triennial
Pierre Huyghe, Philippe Parreno, Dominique Gonzalez-Foerster: "Ann Lee."
 Les Abattoirs de Toulouse
Lichtkunst aus Kunstlicht. Museum für Neue Kunst, Zentrum für Kunst- und
 Medientechnologie (ZKM), Karlsruhe
2004
The Big Nothing. Institute of Contemporary Art, University of Pennsylvania,
 Philadelphia
3'. Schirn Kunsthalle, Frankfurt
Gelegenheit und Reue. Grazer Kunstverein, Graz
Utopia Station: Auf dem Weg nach Porto Alegre. Haus der Kunst, Munich
Funny Cuts. Cartoons und Comics in der zeitgenössischen Kunst. Staatsgalerie
 Stuttgart
2003
Coollustre. Collection Lambert, Avignon
Venice Biennale
Sodium Dreams. Center for Curatorial Studies Museum, Bard College,
 Annandale-on-Hudson, New York
Biennale d'Art Contemporain de Lyon
2002
Sydney Biennale
Touch: Relational Art from the 1990s to Now. San Francisco Art Institute
2001
Double Life: Identität und Transformation in der zeitgenössischen Kunst. Generali
 Foundation, Vienna
Neue Welt. Frankfurter Kunstverein, Frankfurt
Istanbul Biennial
Animations. P.S.1 Contemporary Art Center, Long Island City, New York. Traveled to:
 Kunst-Werke-Institute for Contemporary Art, Berlin (February 8–April 6, 2003)
Televisions-Kunst sieht fern. Kunsthalle Wien, Vienna
2000
Let's Entertain: Life's Guilty Pleasures. Walker Art Center, Minneapolis. Traveled to:
 Portland Art Museum, Oregon; Musée National d'Art Moderne, Centre Georges
 Pompidou, Paris, under the title *Au-delà du spectacle* (November 22, 2000–
 January 8, 2001); Museo Rufino Tamayo, Mexico City (June 6–August 8, 2001);
 Miami Art Museum (September 12–November 25, 2001)
What If: Art on the Verge of Architecture and Design. Moderna Museet, Stockholm
I love you too, but... Positionen zwischen Comic-Ästhetik und Narration. Galerie
 für Zeitgenössische Kunst, Leipzig
Présumés innocents. Musée d'Art Contemporain, Bordeaux
Ich-Maschine. Dominique Gonzalez-Foerster, Philippe Parreno, Pierre Huyghe.
 Hamburger Kunstverein, Hamburg
1999
Venice Biennale
Culbutes: Œuvre d'impertinence. Musée d'Art Contemporain de Montréal
1998
Weather Everything. Galerie für Zeitgenössische Kunst, Leipzig
Dominique Gonzalez-Foerster, Pierre Huyghe, Philippe Parreno. Musée d'Art
 Moderne de la Ville de Paris

1997
Enter: Artist/Audience/Institution. Kunstmuseum Luzern
Biennale d'Art Contemporain de Lyon
1996
Traffic. Musée d'Art Contemporain, Bordeaux
More Time, Less History. Fundação de Serralves, Porto
1995
Johannesburg Biennale
Venice Biennale
Passions Privées. Musée d'Art Moderne de la Ville de Paris
Biennale d'Art Contemporain de Lyon

SELECTED BIBLIOGRAPHY
Books and Exhibition Catalogues

Biesenbach, Klaus, ed. *Animations.* Berlin: Kunst–Werke–Institute for Contemporary Art, 2002. Text by Philippe Parreno, "Artist Statement," p. 176.

Bonami, Francesco. *Campo 6: Il Villaggio a Spirale/The Spiral Village.* Milan: Skira and Fondazione Sandretto Re Rebaudengo per l'Arte, 1996.

Bonami, Francesco, Julie Rodrigues Widholm, and Tricia Van Eck. *Universal Experience: Art, Life, and the Tourist's Eye.* Chicago: Museum of Contemporary Art, 2005.

Bony, Anne, ed. *Les années 90.* Paris: Editions du Regard, 2000.

Bourriaud, Nicolas. *Postproduction; Culture as Screenplay: How Art Reprograms the World.* New York: Lukas & Sternberg, 2002.

Breitwieser, Sabine. *Double Life: Identität und Transformation in der zeitgenössischen Kunst/Identity and Transformation in Contemporary Arts.* Vienna: Generali Foundation; Cologne: Verlag der Buchhandlung Walther König, 2001.

Dominique Gonzalez-Foerster, Pierre Huyghe, Philippe Parreno. Paris: Musée d'Art Moderne de la Ville de Paris, 1998.

Grosenick, Uta, and Burkhard Riemschneider, eds. *Art at the Turn of the Millennium.* Cologne: Taschen, 1999. Text by Grosenick, "Philippe Parreno," pp. 378–81.

Huyghe, Pierre, and Philippe Parreno. *No Ghost Just a Shell.* Cologne: Verlag der Buchhandlung Walther König/Oktagon, 2003.

Let's Entertain. Minneapolis: Walker Art Center, 2000. Text by Susan G. Davis, "R & D for Social Life: Entertainment Retail and the City," pp. 133–60.

Lind, Maria. *Fade Away.* Munich: Kunstverein München, 2004.

Nakas, Kassandra. *Funny Cuts: Cartoons and Comics in Contemporary Art.* Stuttgart: Staatsgalerie Stuttgart, and Kerber Verlag, 2004.

Obrist, Hans Ulrich. *Interviews.* Florence: Fondazione Pitti Immagine Discovery, 2003. Text by Obrist, "Philippe, Parreno," pp. 701–21.

Parreno, Philippe. *Speech Bubbles.* Dijon: Les Presses du réel, 2001.

Parreno, Philippe, Maria Lind, and Peio Aguirre. *Philippe Parreno. Moderna Museet Projekt.* Stockholm: Moderna Museet, 2002.

Parreno, Philippe, Laurence Bossé, and Doug Aitken. *Philippe Parreno: Alien Affection.* Paris: Paris Musées and Les Presses du réel, 2002.

Szeemann, Harald. *4e Biennale d'art contemporain de Lyon: L'Autre.* Lyon: Réunion des Musées Nationaux, 1997.

———, ed. *D'APERTutto/Aperto Over All: 48a Esposizione Internationale d'Arte, la Biennale di Venezia.* Venice: Biennale di Venezia, 1999. Text by Nicolas Bourriaud, "Philippe Parreno," p. 232.

Articles

Allen, Jennifer. "1,000 Words: Liam Gillick and Philippe Parreno." *Artforum* 43, no. 6 (February 2005): 144–45.

Bourriaud, Nicolas. "Correspondence: Nicolas Bourriaud, Philippe Parreno." *Paletten,* no. 4 (1995): 26–36.

———. "Philippe Parreno: Real Virtuality." *Art Press,* no. 208 (December 1995): 41–44.

Corvi-Mora, Tommaso. "Philippe Parreno at le Consortium." *Art in America* 83, no. 5 (May 1995): 126–27.

Cotter, Holland. "Philippe Parreno." *New York Times,* sec. E, April 27, 2001.

Dailey, Meghan. "Philippe Parreno." *Artforum* 42, no. 2 (October 2003): 170.

Davis, Ben. "Philippe Parreno." *Art Review,* no. 56 (June 2005): 107.

Demir, Anaid. "Portrait d'artiste: Philippe Parreno." *L'Œil,* no. 537 (June 2002): 26–27.

Drolet, Owen. "Philippe Parreno: Friedrich Petzel." *Flash Art* 36, no. 231 (July–September 2003): 117–18.

Francblin, Catherine. "D. Gonzalez-Foerster, Pierre Huyghe, Philippe Parreno." *Art Press,* no. 242 (January 1999): 84–86.

Mahoney, Robert. "Philippe Parreno at Friedrich Petzel." *Art in America* 89, no. 9 (September 2001): 151.

Morton, Tom. "Team Spirit." *Frieze,* no. 81 (March 2004): 80–85.

Nabakowski, Gislind. "Philippe Parreno." *Art Press,* no. 278 (April 2002): 72–73.

Nobel, Philip. "Sign of the Times." *Artforum* 41, no. 5 (January 2003): 104–09.

Obrist, Hans Ulrich. "Philippe Parreno: Post-Apocalyptic Now." *Flash Art* 37, no. 238 (October 2004): 110–12.

Perret, Mai-Thu. "Philippe Parreno." *Frieze,* no. 57 (March 2001): 110–11.

Sterling, Bruce. "The Boy from Paris." *Domus,* no. 870 (May 2004): 48–49.

———. "Thailandia/Thailand: Hybrid Muscle." *Domus,* no. 870 (May 2004): 42–47.

Troncy, Eric. "La Fabrique du réel." *Beaux-Arts Magazine,* no. 174 (November 1998): 46–51.

———. "No Ghost Just a Shell." *Art Press,* no. 260 (September 2000): 82–84.

van den Boogert, Kate. "'Alien' Philippe Parreno." *Tate International Arts and Culture,* no. 3 (January–February 2003): 48–53.

Vergne, Philippe. "Philippe Parreno, la représentation en question: Speech Bubbles." *Art Press,* no. 264 (January 2001): 22–28.

Wellington, Darryl Lorenzo. "Pierre Huyghe, Philippe Parreno, Dominique Gonzalez-Foerster." *Art Papers* 23, no. 3 (May–June 1999): 62.

Wetterwald, Élisabeth. "Philippe Parreno: L'exposition comme pratique de liberté." *Parachute,* no. 102 (April–June 2001): 32–43.

Wilsher, Mark. "In Many Ways the Exhibition Already Happened." *Art Monthly,* no. 253 (February 2002): 32–34.

Wulffen, Thomas. "Philippe Parreno: 'Listen to the Picture.'" *Kunstforum International,* no. 141 (July–September 1998): 348.

GARY SIMMONS

Born 1964 in New York.
Lives and works in New York and Los Angeles.

SELECTED EXHIBITIONS
Solo Exhibitions
2006
1964. Bohen Foundation, New York
2005
Diggin' in the Crates. Margo Leavin Gallery, Los Angeles
2004
Criminal Slang. Metro Pictures, New York
2003
Anthony Meier Fine Arts, San Francisco
Wishing. Margo Leavin Gallery, Los Angeles
Gary Simmons: Unique Drawings. Jan Weiner Gallery, Kansas City
2002
Museum of Contemporary Art, Chicago. Traveled to: SITE Santa Fe (June 22–
 September 8, 2002); The Studio Museum in Harlem, New York (October 9,
 2002–January 5, 2003)
2001
Ghost House. SITE Santa Fe
Wishful Drinking. Metro Pictures, New York
Desert Blizzard. Philadelphia Museum of Art
2000
Wake. Dia Center for the Arts, New York
Bench Markers. Musée d'Art Américain, Giverny
Country Grammar. Margo Leavin Gallery, Los Angeles
1999
Currents 80: Gary Simmons. Saint Louis Art Museum
1998
Dana Arts Center, Colgate University, Hamilton, New York
1997
Gary Simmons: Gazebo. Museum of Contemporary Art, San Diego
Wandzeichnungen/Wall Drawings. Kunsthaus Zürich
1996
Museum of Contemporary Art, Chicago
1995
Gary Simmons: Erasure Drawings. Lannan Foundation, Los Angeles

Group Exhibitions
2005
Double Consciousness: Black Conceptual Art Since 1970. Contemporary Arts
 Museum, Houston
Monuments for the USA. CCA Wattis Institute for Contemporary Arts, San Francisco.
 Traveled to: White Columns, New York (December 15, 2005–January 28, 2006)
*Mike Kelley, Martin Kippenberger, Louise Lawler, Robert Longo, John Miller, Jim Shaw,
 Cindy Sherman, Gary Simmons*. Metro Pictures, New York
Past Presence: Childhood and Memory. Whitney Museum of American Art at
 Altria, New York
2004
White: Whiteness and Race in Contemporary Art. International Center of
 Photography, New York
Social Studies: Eight Artists Address Brown v. Board of Education. Krannert Art
 Museum, University of Illinois, Urbana-Champaign

African American Artists in Los Angeles. A Survey Exhibition: Fade (1990–2003).
 Luckman Gallery and Fine Arts Gallery, California State University, Los Angeles
One Hundred Artists See God. Institute of Contemporary Arts, London. Traveled to:
 Contemporary Art Center of Virginia, Virginia Beach (June 9–September 4, 2005)
2003
Whiteness: A Wayward Construction. Laguna Art Museum, Laguna Beach
Supernova: Art of the 1990s from the Logan Collection. San Francisco Museum of
 Modern Art
2002
New York Renaissance: Masterworks from the Whitney Museum of American Art.
 Palazzo Reale, Milan
2001
I'm Thinking of a Place. Hammer Museum, University of California, Los Angeles
One Planet under a Groove: Hip Hop and Contemporary Art. Bronx Museum of the Arts,
 New York. Traveled to: Spelman College Museum of Fine Art, Atlanta (March 21–
 May 17, 2003); Walker Art Center, Minneapolis (July 13–October 13, 2003)
Audible Imagery: Sound and Photography. Museum of Contemporary Photography,
 Columbia College, Chicago
2000
Point of Reference. Addison Gallery of American Art, Andover, Massachusetts
1999
Sightgags: Humor, Satire and Grotesque in Modern and Contemporary Drawing.
 The Museum of Modern Art, New York
Heaven. Kunsthalle Düsseldorf
At Century's End: The John P. Morrissey Collection of Nineties Art. Museum of
 Contemporary Art, Lake Worth, Florida
Billboard. MASS MoCA, North Adams, Massachusetts
American Century. Whitney Museum of American Art, New York
Videodrome. New Museum of Contemporary Art, New York
1998
Cut on the Bias. The Fabric Workshop and Museum, Philadelphia
1997
New York: Drawings Today. San Francisco Museum of Modern Art
no place (like home). Walker Art Center, Minneapolis
Gothic: Transmutations of Horror in Late Twentieth-Century Art. The Institute of
 Contemporary Art, Boston
Johannesburg Biennale
Heart, Mind, Body, Soul: American Art in the 1990s. Whitney Museum of
 American Art, New York
1996
Defining the Nineties: Consensus-Making in New York, Miami, and Los Angeles.
 Museum of Contemporary Art, Miami
The World Over. Under Capricorn: Art in the Age of Globalisation. Stedelijk
 Museum, Amsterdam. Traveled to: City Gallery Wellington, New Zealand
Fragments. Museu d'Art Contemporani de Barcelona
*Inklusion, Exklusion: Kunst im Zeitalter von Postkolonialismus und globaler
 Migration*. Reininghaus and Künstlerhaus Graz
1995
Gary Simmons: Step in the Arena. The Fabric Workshop and Museum,
 Philadelphia, in collaboration with Beaver College Art Gallery, Philadelphia

SELECTED BIBLIOGRAPHY

Books and Exhibition Catalogues

Brunenberg, Christoph. *Gothic: Transmutations of Horror in Late Twentieth Century Art*. Boston: The Institute of Contemporary Art; Cambridge, Mass.: The MIT Press, 1997.

Cruz, Amada. *Directions: Gary Simmons*. Washington, D.C.: Hirshhorn Museum and Sculpture Garden, Smithsonian Institution, 1994.

Curnow, Wystan, and Dorine Mignot, ed. *The World Over. Under Capricorn: Art in the Age of Globalisation*. Amsterdam: Stedelijk Museum; Wellington, New Zealand: City Gallery Wellington, 1996. Text by Gregory Burke, "Points of Departure: Three Buoys and a Lighthouse," p. 79.

Fibicher, Bernhard. *Wandzeichnungen/Wall drawings: Simon Patterson, Maria Eichhorn, Gary Simmons*. Zurich: Kunsthaus Zürich, Graphisches Kabinett, 1997. Text by Fibicher, "Gary Simmons: Interview," pp. 34–35.

Flood, Richard, et al. *No Place (Like Home)*. Minneapolis: Walker Art Center, 1997. Text by Siri Engberg, "Gary Simmons," pp. 78–89.

Golden, Thelma. *Gary Simmons*. Chicago: Museum of Contemporary Art; New York: The Studio Museum in Harlem, 2002.

———. *Gary Simmons: The Garden of Hate*. New York: Whitney Museum of American Art, 1992.

Gordon, Avery, and Louis Grachos. *Gary Simmons: Ghost House*. Sante Fe: SITE Santa Fe, 2001.

Kanjo, Kathryn. *Songs of Innocence, Songs of Experience*. New York: Whitney Museum of American Art, 1992.

Lyons, Lisa. *Gary Simmons: Erasure Drawings*. Los Angeles: Lannan Foundation, 1995.

Princenthal, Nancy. *Gary Simmons*. Hamilton, N.Y.: Gallery of the Department of Art and Art History, Dana Arts Center, Colgate University, 1998.

Steiner, Rochelle. *Currents 80: Gary Simmons*. St. Louis: Saint Louis Art Museum, 1999.

Articles

Albertini, Rosanna. "Gary Simmons: Lannan Foundation." *Art Press*, no. 208 (December 1995): 76.

Baker, George. "Gary Simmons: Metro Pictures." *Artforum* 37, no. 7 (March 1999): 113.

Carron, Natacha. "Gary Simmons: Philippe Rizzo." *Flash Art*, no. 190 (October 1996): 118.

Clifford, Katie. "Gary Simmons: Metro Pictures." *Art News* 98, no. 3 (March 1999): 134.

Ebony, David. "Gary Simmons at The Studio Museum in Harlem." *Art in America* 91, no. 6 (June 2003): 116.

Eccles, Tom. "Gary Simmons at The Contemporary and Metro Pictures." *Art in America* 83, no. 7 (July 1995): 83–84.

Howel, George. "Gary Simmons: Erasures." *Art Papers* 19, no. 2 (March–April 1995): 39–40.

Indyke, Dottie. "Southwest Sizzle." *Art News* 101, no. 7 (Summer 2002): 100–05.

Isé, Claudine. "Gary Simmons at Margo Leavin." *Art Issues*, no. 54 (September–October 1998): 44.

Kerr, Merrily. "Gary Simmons: If These Walls Could Talk." *Flash Art* 36, no. 228 (January–February 2003): 98–100.

Kirshner, Judith Russi. "Gary Simmons: Museum of Contemporary Art, Chicago." *Artforum* 40, no. 10 (Summer 2002): 170.

LaBelle, Charles. "Gary Simmons: Lannan Foundation, Los Angeles." *Art/Text*, no. 53 (January 1996): 78–79.

Perchuk, Andrew. "Gary Simmons: Lannan Foundation." *Artforum* 34, no. 4 (December 1995): 94–95.

Pollack, Barbara. "Gary Simmons." *Art News* 101, no. 11 (December 2002): 116.

Princenthal, Nancy. "Gary Simmons: Disappearing Acts." *Art/Text*, no. 57 (May–July 1997): 52–57.

Smith, Roberta. "Finding Art in the Artifacts of the Masses." *New York Times*, sec. H, December 1, 1996.

Veneciano, Jorge Daniel. "Invisible Men: Race, Representation and Exhibition(ism)." *Afterimage* 23, no. 2 (September–October 1995): 12–15.

Volk, Gregory. "Gary Simmons at Metro Pictures." *Art in America* 84, no. 10 (October 1996): 114.

Zellen, Jody. "Los Angeles." *Art Papers* 25, no. 2 (March–April 2001): 52–53.

FRANZ WEST

Born 1947 in Vienna.
Lives and works in Vienna.

SELECTED EXHIBITIONS
Solo Exhibitions
2006
Galerie Gisela Capitain, Cologne
Galerie Eva Presenhuber, Zurich
Franz West: Displacement and Condensation. Gagosian Gallery, London
Sit In. Galerie Ghislaine Hussenot, Paris
2005
Franz West. Vancouver Art Gallery
2004
Franz West: Recent Sculptures. Lincoln Center and Doris C. Freedman Plaza, New York
Franz West: Early Work. Zwirner & Wirth, New York
2003
We'll not carry coals. Kunsthaus Bregenz, Austria
Franzwestite. Franz West: Works 1973–2003. Whitechapel Art Gallery, London
2002
Burning. Musée d'Art Contemporain de Marseille
2001
Appartement. Deichtorhallen, Hamburg
Sammlung: Ich sammle mich. Kunstverein Braunschweig, Germany
Gnadenlos/Merciless. Museum für angewandte Kunst, Vienna. Traveled to: MASS MoCA, North Adams, Massachusetts
Franz West: 2TOPIA. Wexner Center for the Arts, Columbus
2000
Pre-Semblance and the Everyday. The Renaissance Society at the University of Chicago
Franz West: In & Out. Museum für Neue Kunst, Zentrum für Kunst- und Medientechnologie (ZKM), Karlsruhe. Traveled to: Museu Nacional Centro de Arte Reina Sofía, Madrid (April 19–June 26, 2001)
1999
Rooseum Center for Contemporary Art, Malmö, Sweden
1998
Functional Objects and Related Works. A/D Gallery, New York
Franz West. Openluchtmuseum voor Beeldhouwkunst Middelheim, Antwerp
1997
Fundação de Serralves, Porto
Projects 61. Franz West. The Museum of Modern Art, New York
1996
Kombi. Künstlerhaus Bregenz, Austria
Proforma. Museum moderner Kunst Stiftung Ludwig Wien, Vienna. Traveled to: Kunsthalle Basel; Kröller-Müller Museum, Otterlo, The Netherlands (October 5, 1996–January 20, 1997)
Gelegentliches–zu einer anderen Rezeption. Städtisches Museum Abteiberg, Mönchengladbach, Germany
1995
Franz West: Retrospective. Museum Moderne Kunst, Vienna

Group Exhibitions
2006
Carnets du Sous-Sol. Galerie Michel Rein, Paris
Broken Surface. Galerie Sabine Knust, Munich
Mozart. Enlightenment: An Experiment. Albertina, Vienna
Der Ficker, No. 2. Wittgensteinhaus, Vienna

2005
Occupying Space: Sammlung Generali Foundation. Haus der Kunst, Munich. Traveled to: Witte de With, Center for Contemporary Art, Rotterdam; Nederlands Fotomuseum, Rotterdam; TENT, Rotterdam
Kunst in Schokolade. Museum Ludwig Köln, Cologne
Exit: Ausstieg aus dem Bild. Museum für Neue Kunst, Zentrum für Kunst- und Medientechnologie (ZKM), Karlsruhe
La Collection en trois temps et quatre actes: Acte I, l'art, la vie, le corps. Musée d'Art Contemporain de Marseille
Modèles modèles. Musée d'Art Moderne et Contemporain, Geneva
Les Grands Spectacles: 120 Jahre Kunst und Massenkultur. Museum der Moderne Salzburg
Extreme Abstraction. Albright-Knox Art Gallery, Buffalo, New York
Entdecken und Besitzen. Museum moderner Kunst Stiftung Ludwig Wien, Vienna
Flashback: Revisiting the Art of the Eighties. Museum für Gegenwartskunst, Basel
Lichtkunst aus Kunstlicht. Museum für Neue Kunst, Zentrum für Kunst- und Medientechnologie (ZKM), Karlsruhe
2004
Funky Lessons. Büro Friedrich, Berlin
Flirts. Kunst und Werbung/Arte e pubblicità. Museion–Museo d'Arte Moderna e Contemporanea, Bolzano, Italy
Support. Die Neue Galerie als Sammlung. Neue Galerie Graz am Landesmuseum Joanneum, Graz
One Hundred Artists See God. Institute of Contemporary Arts, London. Traveled to: Contemporary Art Center of Virginia, Virginia Beach (June 9–September 4, 2005)
2003
Biennale d'Art Contemporain de Lyon
Venice Biennale
Grotesque! 130 Jahre Kunst der Frechheit. Schirn Kunsthalle, Frankfurt
2002
Meeting Points. Edinburgh Festival
Dak'Art. Biennial of Contemporary African Art, Dakar
Keine Kleinigkeit. Kunsthalle Basel
Zeitmaschine. Kunstmuseum Bern
2001
Valencia Biennial
Unter freiem Himmel. Schlosspark Ambras, Innsbruck
Yokohama Triennial
Collaborations with Parkett: 1984 to Now. The Museum of Modern Art, New York
2000
Project Facade. Wiener Secession, Vienna
Sydney Biennale
In between. EXPO 2000, Hannover
Abstract Art. Neues Museum, Nuremberg
Around 1984: A Look at Art in the Eighties. P.S.1 Contemporary Art Center, Long Island City, New York
1999
Zeitwenden. Kunstmuseum Bonn
Space Place. Salzlager Hall/Kunsthalle Tirol, Austria
Melbourne International Biennial

1998

São Paulo Bienal

Life Style. Kunsthaus Bregenz, Austria

Blunt Object. David and Alfred Smart Museum, University of Chicago

Ethno-Antics. Nordiska Museet, Stockholm

Mai 98. Positionen zeitgenössischer Kunst seit den sechziger Jahren. Kunsthalle Köln, Cologne

Eight Artists from Europe. Museum of Modern Art Gunma, Takasaki, Japan

Secession: Das Jahrhundert der künstlerischen Freiheit. Wiener Secession, Vienna

Wounds: Between Democracy and Redemption in Contemporary Art. Moderna Museet, Stockholm

Out of Actions: Between Performance and the Object, 1949–1979. Museum of Contemporary Art, Los Angeles. Traveled to: Museum für angewandte Kunst, Vienna; Museu d'Art Barcelona; Museum of Contemporary Art, Tokyo; National Museum of Art, Osaka

1997

Venice Biennale

Biennale d'Art Contemporain de Lyon

Documenta X. Kassel, Germany

Home Sweet Home. Deichtorhallen, Hamburg

Engel, Engel. Kunsthalle Wien, Vienna. Traveled to: Galerie Rudolfinum, Prague

Sculpture Projects. Westfälisches Landesmuseum, Munster

1996

Die Schrift des Raumes: Kunst Architektur Kunst. Kunsthalle Wien, Vienna

Model Home. P.S.1 Contemporary Art Center, Long Island City, New York

1995

Carnegie International. Carnegie Museum of Art, Pittsburgh

Corpus Delicti. Museum van Hedendaagse Kunst, Ghent

SELECTED BIBLIOGRAPHY

Books and Exhibition Catalogues

4e Biennale d'art contemporain de Lyon. Lyon: Réunion des Musées Nationaux, 1997.

Archer, Michael. *Art since 1960*. London: Thames & Hudson, 1997.

Badura-Triska, Eva, Robert Fleck, Peter Gorson, and Lóránd Hegyi. *Franz West. Proforma*. Vienna: Museum moderner Kunst Stiftung Ludwig Wien, 1996.

Beil, Ralph, ed. *Zeitmaschine. Oder: Das Museum in Bewegung*. Osfildern-Ruit, Germany: Hatje Cantz in association with Kunstmuseum Bern, 2002.

Blazwick, Iwona, James Lingwood, and Andrea Schlieker. *Possible Worlds: Sculpture from Europe*. London: Institute for Contemporary Arts, and Serpentine Gallery, 1990. Text by Blazwick, Lingwood, and Schlieker, "Franz West," pp. 82–85.

Blazwick, Iwona, Anthony Spira, and Rebecca Morrill, eds. *Franz West: 'I read art like a magazine at the barber's'*. London: Whitechapel Art Gallery, 2003.

Cooke, Lynne, Joao Fernandes, and Vincente Todoli. *Franz West*. Porto: Fundação de Serralves, 1997.

Edelbert, Kob, Hildegund Amanshauser, Ferdinand Schmatz, and Georg Schollhammer. *Franz West. Ansicht*. Vienna: Wiener Secession, 1987.

Falckenberg, Harald von, et al. *Grotesque! 130 Years of Witty Art*. Munich: Haus der Kunst; Frankfurt: Schirn Kunsthalle, 2003.

Fleck, Robert, Bice Curiger, and Neal Benezra. *Franz West*. London: Phaidon, 1999.

Franz West: Displacement and Condensation. With a conversation between West and Sarah Lucas and an interview with West by Benedikt Ledebur. London: Gagosian Gallery, 2006.

Grässlin, Karola, and Rudolf Schmitz. *Franz West. Sammlung: Ich sammle mich*. Braunschweig: Kunstverein Braunschweig, 2001.

Hapkemeyer, Andreas, ed. *Flirts: Kunst und Werbung/Arte e pubblicità*. Bolzano, Italy: Museion–Museo d'Arte Moderna e Contemporanea, 2004.

Noever, Peter, ed. *GnadenlosFranzWestMerciless*. Vienna: MAK, 2001.

Obrist, Hans Ulrich. *Interviews*. Florence: Fondazione Pitti Immagine Discovery, 2003. Text by Obrist, "West, Franz," pp. 925–38.

Rian, Jeffrey. *Franz West: Possibilities*. Long Island City, New York: P.S.1 Contemporary Art Center, 1986.

Schneider, Eckhard, ed. *Franz West. We'll not carry coals*. Cologne: Verlag der Buchhandlung Walther König and Kunsthaus Bregenz, 2003.

Storr, Robert. *Projects 61. Franz West*. New York: The Museum of Modern Art, 1997.

Thoman, Klaus. *Die Aluskulptur: Franz West*. Cologne: Verlag der Buchhandlung Walther König, 2000.

Unterdorfer, Michaela, ed. *The House of Fiction*. Nuremberg: Sammlung Haus und Wirthin der Lokremise, St. Gallen, 2002.

Von Zdenek, Felix, and Ludwig Seyfarth. *Franz West: Appartement*. Hamburg: Deichtorhallen, 2002.

West, Franz, Enrico Comi, and Hans Hollein. *Franz West*. Austria: Biennale di Venezia, 1990.

West, Franz, and Kasper König. *Franz West: Investigations of American Art*. Warsaw: Galeria Foksal; New York: David Zwirner Gallery, 1992–93.

Zbikowski, Dorte. *Franz West*. Munich: Verlag Silke Schreiber, 2002.

Articles

Cooke, Lynne. "Vienna and Basel: Franz West." *Burlington Magazine* 138, no. 1121 (August 1996): 32.

Draxler, Helmut. "Franz West: The Antibody to Anti-body." *Artforum* 27, no. 7 (March 1989): 98–101.

Falconer, Morgan. "Franzwestite: Franz West, Works 1973–2003: Whitechapel Art Gallery." *Art on Paper* 8, no. 2 (November–December 2003): 70.

Felderer, Herbert, and Herbert Lachmayer. "Potentially Inaccessible, Factually Accessible: Franz West." *Parkett*, no. 24 (1990): 88–96.

Glover, Michael. "Franz West." *Art News* 100, no. 10 (November 2001): 184.

Gustafson, John. "Franz West: The Renaissance Society." *New Art Examiner* 28, no. 1 (September 2000): 52.

Kravagna, Christian. "Franz West." *Artforum* 35, no. 3 (November 1996): 109.

Schlebrugge, Elisabeth. "Pelops' Meal for Franz West." *Parkett*, no. 37 (1993): 66–73.

Storr, Robert. "West's Corporeal Comedy." *Art in America* 91, no. 10 (October 2003): 96–99.

Szeemann, Harald. "Conversation for Franz West (Indirectly)." *Parkett*, no. 37 (September 1993): 74–79.

———. "Franz West, ou le baroque de l'âme et de l'esprit en fragments séchés." *Art Press*, no. 133 (February 1989): 28–30.

Thorne, Matt. "Franzwestite: Franz West–Works 1973–2003: Whitechapel Art Gallery." *Modern Painters* 16, no. 4 (Winter 2003): 116–18.

Verhagen, Marcus. "Franz West." *Art Monthly*, no. 270 (October 2003): 37–38.

Verwoert, Jan. "Adaptation: Jan Verwoert on Franz West." *Frieze*, no. 76 (June–August 2003): 98–101.

Wege, Astrid. "Franz West." *Artforum* 39, no. 9 (May 2001): 186.

West, Franz. "A Thousand Words: Franz West Talks about His *Passtücke*." *Artforum* 37, no. 6 (February 1999): 84–85.

Wilscher, Mark. "Franz West." *Art Monthly*, no. 250 (October 2001): 30–31.

SUE WILLIAMS

Born 1954 in Chicago Heights, Illinois.
Lives and works in New York.

SELECTED EXHIBITIONS

Solo Exhibitions

2006
Galerie Eva Presenhuber, Zurich
Regen Projects, Los Angeles

2005
303 Gallery, New York

2004
Addison Gallery of American Art, Andover, Massachusetts
Bernier/Eliades Gallery, Athens

2003
Sue Williams: On the Surface. Carpenter Center for the Visual Arts, Harvard
 University, Cambridge, Massachusetts
Regen Projects, Los Angeles

2002
303 Gallery, New York
Sue Williams: A Fine Line. Palm Beach Institute of Contemporary Art, Lake Worth, Florida
Galerie Hauser & Wirth & Presenhuber, Zurich
Art for the Institution and the Home. Wiener Secession, Vienna. Traveled to: IVAM
 Centre Julio González, Valencia (May 15–July 6, 2003)

2001
Bernier/Eliades Gallery, Athens
Gallery Side 2, Tokyo

2000
303 Gallery, New York

1999
Galerie Hauser & Wirth & Presenhuber, Zurich

1998
Neue Galerie am Landesmuseum Joanneum, Graz
Sadie Coles HQ, London
303 Gallery, New York

1997
Johnen & Schöttle, Cologne
Centre d'Art Contemporain, Geneva

1996
303 Gallery, New York
Sue Williams: Heavy and Thin Lines. Galerie Ghislaine Hussenot, Paris
Regen Projects, Los Angeles

1995
Jack Hanley Gallery, San Francisco

Group Exhibitions

2006
Lara Schnitger, Lilly Van Der Stokker, Sue Williams. Stuart Shave/Modern Art, London
Webs, Loops, and Skeins in Modern and Contemporary Art. Rhode Island School
 of Design Museum, Providence

2005
Obras entorno a la ciudad. Sala de Exposiciones de la Fundación "la Caixa", Madrid
KISS KISS. c/o – Atle Gerhardsen, Berlin

2004
Ghada Amer, Shirazeh Houshiary, Sue Williams. Kukje Gallery, Seoul
North Fork/South Fork: East End Art Now. The Parrish Art Museum,
 Southampton, New York
Funny Cuts: Cartoons und Comics in der zeitgenössischen Kunst. Staatsgalerie Stuttgart

2003
Comic Release: Negotiating Identity for a New Generation. Carnegie Mellon
 University, Pittsburgh. Traveled to: Contemporary Arts Center, New Orleans;
 The University of North Texas Gallery, Denton; Western Washington University,
 Bellingham (January 12–March 13, 2004)
Social Strategies: Redefining Social Realism. University Art Museum, University of
 California, Santa Barbara. Traveled to: Illinois State University, Normal;
 DePauw University Art Gallery, Greencastle, Indiana (November 15,
 2003–February 15, 2004)

2002
Culture of Violence. University of Massachusetts, Amherst. Traveled to: Bowdoin
 College Museum of Art, Brunswick, Maine
Art in the 'Toon Age. Kresge Art Museum, Michigan State University, East Lansing.
 Traveled to: Ball State University, Muncie, Indiana (July 18–October 29, 2005);
 Art and Culture Center of Hollywood, Florida (November 18, 2005–January 15,
 2006); Bryan Art Gallery, Coastal Carolina University, Conway, South Carolina
 (February 6–March 10, 2006)
Die Wohltat der Kunst. Post/Feministische Positionen der 90er. Staatliche Kunsthalle
 Baden-Baden. Traveled to: Sammlung Goetz, Munich (December 2–March 15,
 2003); Bergen Kunstmuseum, Bergen, Norway (August 23–October 26, 2003)
Contemporary Art Project. Seattle Art Museum

2001
Collaborations with Parkett: 1984 to Now. The Museum of Modern Art, New York
Works on Paper: From Acconci to Zittel. Victoria Miro Gallery, London
Brooklyn! Palm Beach Institute of Contemporary Art, Lake Worth, Florida

2000
Open Ends. The Museum of Modern Art, New York

1999
Negotiating Small Truths. The Jack S. Blanton Museum of Art, The University of
 Texas at Austin
The American Century: Art and Culture 1900–2000. Whitney Museum of
 American Art, New York

1998
Franz Graf, Renée Green, Peter Kogler, Eva Schlegel, Hubert Schmalix, Sue Williams.
 Kunsthalle Krems, Austria
Skulptur Figur Weiblich. Landesgalerie Oberösterreich, Linz
Pop Surrealism. The Aldrich Contemporary Art Museum, Ridgefield, Connecticut
Painting: Now and Forever. Pat Hearn and Matthew Marks Gallery, New York
Connections, Contradictions. Emory University, Atlanta
Fast Forward: Body Check. Hamburger Kunstverein, Hamburg

1997
Birth of the Cool. Deichtorhallen, Hamburg. Traveled to: Kunsthaus Zürich
Whitney Biennial. Whitney Museum of American Art, New York
Multiple Identity: Works from the Whitney Museum of American Art. Museu d'Art
 Contemporani de Barcelona

1996

Art at Home: Ideal Standard Life. Spiral/Wacoal Art Center, Tokyo

The Comic Depiction of Sex in American Art. Galerie Andreas Binder, Munich

1995

Imperfect. Herter Art Gallery, University of Massachusetts, Amherst

Whitney Biennial. Whitney Museum of American Art, New York

25 Americans: Painting in the 90s. Milwaukee Art Museum

Fémininmasculin: Le Sexe de l'art. Musée National d'Art Moderne, Centre Georges Pompidou, Paris

SELECTED BIBLIOGRAPHY

Books and Exhibition Catalogues

Bad Girls. London: Institute of Contemporary Arts; Glasgow: Centre for Contemporary Arts, 1993. Texts by Laura Cottingham, "What's So Bad About 'Em," pp. 54–59, and Cherry Smith, "Bad Girls," pp. 6–12.

Bernadac, Marie-Laure, and Bernard Marcadé. *Fémininmasculin: Le Sexe de l'art*. Paris: Gallimard/Electa and Musée National d'Art Moderne, Centre Georges Pompidou, 1995.

Cameron, Dan, and Juan Carlos Román. *Sue Williams: Art for the Institution and the Home*. Vienna: Secession; Valencia: IVAM Centre Julio González, 2002.

Clark, Vicky A., and Barbara Bloemink. *Comic Release: Negotiating Identity for a New Generation*. New York: Distributed Art Publishers, 2003.

Curiger, Bice. *Birth of the Cool. Amerikanische Malerei: von Georgia O'Keeffe bis Christopher Wool*. Zurich: Kunsthaus Zürich; Hamburg: Deichtorhallen, 1997.

Klein, Richard, Dominique Nahas, and Ingrid Schaffner. *Pop Surrealism*. Ridgefield, Conn.: The Aldrich Contemporary Art Museum, 1998.

Louis, Eleonora, and Toni Stooss. *Die Sprache der Kunst: die Beziehung von Bild und Text in der Kunst des 20. Jahrhunderts*. Vienna: Kunsthalle Wien, 1993.

Nakas, Kassandra. *Funny Cuts: Cartoons and Comics in Contemporary Art*. Stuttgart: Staatsgalerie Stuttgart, and Kerber Verlag, 2004. Texts by Nakas, "Funny Cuts," pp. 10–79, and Andreas Schalhorn, "Superman's Big Sister," pp. 80–103.

Ottmann, Klaus. *Social Strategies: Redefining Social Realism*. New York: Pamela Auchincloss/Arts Management, 2003.

Schwabsky, Barry, and Michael Rush. *Sue Williams: A Fine Line*. Lake Worth, Florida: Palm Beach Institute of Contemporary Art, 2002.

The Subject of Rape. New York: Whitney Museum of American Art, 1993. Text by Hannah J. L. Feldman, "More Than Confessional: Testimonial and the Subject of Rape," pp. 13–41.

Sue Williams. New York: 303 Gallery, 2000.

Sue Williams. Seoul: Kukje Gallery, 2004. Text by Barry Schwabsky, "Second Chances and More," n.p.

Sue Williams. Barcelona: Galeria Joan Prats, 2000. Text by Dan Cameron, "Sue Williams," n.p.

Williams, Sue, and Jean-Edith Weiffenbach. *They Eat Shit: Sue Williams*. San Francisco: Walter/McBean Gallery, San Francisco Art Institute, 1993.

Articles

Barden, Lane. "Body Language: Stuart Regen Gallery, Los Angeles." *Artweek* 24 (January 7, 1993): 23.

Bonami, Francesco. "Sue Williams." *Flash Art*, no. 171 (Summer 1993): 101.

Cameron, Dan. "Reverse Backlash: Sue Williams' Black Comedy of Manners." *Artforum* 31, no. 3 (November 1992): 70–73.

Camhi, Leslie. "Domestic Horrors." *Parkett*, nos. 50–51 (1997): 200–08.

Dannatt, Adrian. "Sweet Williams." *Parkett*, nos. 50–51 (1997): 186–90.

Hapgood, Susan. "Sue Williams at 303." *Art in America* 83 (January 1995): 98.

Hess, Elizabeth. "Spiritual America: Sue Williams Taps a Vein of Female Anger." *Village Voice*, May 19, 1992.

Hudson, Suzanne. "Sue Williams." *Artforum* 44, no. 4 (December 2005): 276.

Kimmelman, Michael. "In the Studio with Sue Williams: In a Cheerful Groove, with a Plan and Serendipity." *New York Times*, December 28, 2001.

Meinhardt, Johannes. "Die Wohltat der Kunst: Post/Feministische Positionen der Neunziger Jahre aus der Sammlung Goetz." *Kunstforum International*, no. 162 (November–December 2002): 352–53.

Nesbit, Molly. "Touched." *Parkett*, nos. 50–51 (1997): 176–85.

Reilly, Maura. "New York: Sue Williams at 303." *Art in America* 87, no. 2 (February 1999): 115.

Schjeldahl, Peter. "Shock of the Good." *Village Voice*, December 31, 1996.

Schwabsky, Barry. "Abjection by Other Means. Exhibition at 303 Gallery." *Art in America* 90, no. 1 (January 2002): 92–97.

———. "Sue Williams: 303 Gallery." *Artforum* 33, no. 5 (January 1995): 85.

Schwendener, Martha. "Sue Williams." *Flash Art*, no. 193 (March–April 1997): 120.

Smith, Roberta. "An Angry Young Woman Draws a Bean on Men." *New York Times*, May 24, 1992.

Todd, Stephen. "Sue Williams." *Art/Text*, no. 57 (May–July 1997): 98–99.

Turner, Grady T. "Abstracted Flesh." *Flash Art* 32, no. 204 (January–February 1999): 66–69.

———. "Sue Williams: 303." *Art News* 98, no. 2 (February 1999): 113–14.

———. "Sue Williams: Spinning Figures." *Flash Art* 32, no. 208 (October 1999): 88–89.

Weissman, Benjamin. "Sue Williams: Regen Projects, Los Angeles." *Artforum* 35, no. 3 (November 1996): 104.

INDEX

Asterisks denote works included in the exhibition.
Numbers in italics refer to illustrations.

ACKNOWLEDGMENTS

This publication and the exhibition it accompanies have come about thanks to the hard work of a multitude of people. First and foremost, however, I owe my deepest gratitude to the thirteen remarkable artists brought together here: Polly Apfelbaum, Inka Essenhigh, Ellen Gallagher, Arturo Herrera, Michel Majerus, Julie Mehretu, Juan Muñoz, Takashi Murakami, Rivane Neuenschwander, Philippe Parreno, Gary Simmons, Franz West, and Sue Williams. From the exhibition's inception to its realization, I thank them for the generosity of their collaboration.

At the Museum, my heartfelt appreciation is extended to Glenn D. Lowry, Director, who has been exceptionally supportive of this project from its outset. Once again, he has demonstrated his continued commitment to an institutional environment that both values the experimental and promotes the very highest standard of contemporary art.

I am most indebted to Peter Galassi, Chief Curator of the Department of Photography, for his intellectual rigor and unflagging support of my work. I am especially grateful to John Elderfield, Chief Curator of Painting and Sculpture, and Connie Butler, Chief Curator of Drawings, for generously lending works from their departments to the show.

Very warm thanks are due to Kelly Sidley, Project Curatorial Assistant, for her exceptional professional assistance with the exhibition. Furthermore, her scholarly attention to detail informs every aspect of this publication. My sincere thanks go to my friends and colleagues Nicholas Cullinan, Claire Gilman, Béatrice Gros, Pepe Karmel, and John Tain for the acumen of their suggestions and their ongoing critical support. Appreciation is also extended to the invaluable research assistance of Joy Kim, Curatorial Intern, as well as the contributions of Katie Latona, Photography Department Assistant.

In the Department of Publications, the thoughtful and expert direction of Christopher Hudson, Publisher, and Kara Kirk, Associate Publisher, merits the most worthy attention, as does the guidance of David Frankel, Managing Editor, and the editorial skills of Libby Hruska, Editor. Marc Sapir, Production Director, and Elisa Frohlich, Associate Production Manager, supervised the production of the book with unmatched professionalism. Thanks to Rebecca Roberts, Assistant Editor, for her work on the related exhibition materials. Intern Whitney Wilson deserves recognition for her able assistance. In Imaging Services, I am grateful to Erik Landsberg, Head of Collections Imaging; Robert Kastler, Production Manager; and Roberto Rivera, Production Assistant, who met our photography needs under extremely tight deadlines. My praise also goes to Naomi Mizusaki of Supermarket, who arrived at a highly imaginative design for this book.

The organization of an exhibition requires the professional help of many people. Always at the forefront of this effort is Jennifer Russell, Senior Deputy Director for Exhibitions, Collections, and Programs. In addition, Maria DeMarco Beardsley, Coordinator of Exhibitions, and Randolph Black, Associate Coordinator of Exhibitions, oversaw its logistics. Senior Registrar Assistant Sacha Eaton handled the transport and registration of the exhibition with great expertise. Jerome Neuner, Director of Exhibition Design and Production, and Lana Hum, Exhibition Designer/Production Manager, conceived a superb exhibition design. Scott Gerson, Assistant Paper Conservator, attended to the condition of the artists' works with utmost care. I salute Pete Omlor, Manager of Art Preparation and Handling, and all of the preparators, with whom I share the joy of the show's physical implementation.

This exhibition is accompanied by an artists' panel, audio guide, and Web site. The organization of these programs would not have been possible without the expertise of many individuals. In the Department of Education, I am indebted to David Little, Director of Adult and Academic Programs; Laura Beiles, Associate Educator, Adult and Academic Programs; and Sara Bodinson, Associate Educator, Educational Resources. In the Department of Graphic Design, I thank Claire Corey, Production Manager, and Burns Magruder, Senior Graphic Designer, who gave a signature style to the exhibition. K Mita, Director of Audio-Visual and e-Commerce Technology, and Allegra Burnette, Creative Director of Digital Media, expertly translated the exhibition beyond the physical boundaries of the Museum.

The Department of Marketing and Communications has skillfully disseminated information about the exhibition. I am especially grateful to Kim Mitchell, Director of Communications; Peter Foley, Director of Marketing; Daniela Stigh, Communications Manager; and Meg Blackburn, Senior Publicist.

There are many others in the Museum whom I want to acknowledge for their efforts. Stephen Clark, Associate General Counsel, provided sound advice regarding the reproduction of artwork. Jenny Tobias, Librarian; Philip Parente, Senior Library Assistant; and David Senior, Acquisitions Assistant, gave expert research assistance.

Not least, I would like to express my profound appreciation for the strong support given by Michael Margitich, Senior Deputy Director, External Affairs; Todd Bishop, Director of Exhibition Funding; and Mary Hannah, Assistant Director of Exhibition Funding.

Assistance has come from many quarters outside the Museum. I would like to credit and offer special thanks to: Blum & Poe, Los Angeles; Tanya Bonakdar Gallery, New York; Galeria Fortes Vilaça, São Paulo; Stephen Friedman Gallery, London; Gagosian Gallery, New York; Marian Goodman Gallery, New York; Hauser & Wirth, London and Zurich; Metro Pictures, New York; neugerriemschneider, Berlin; Friedrich Petzel Gallery, New York; The Project, New York; Regen Projects, Los Angeles; Sikkema Jenkins & Co., New York; 303 Gallery, New York; and David Zwirner Gallery, New York. These galleries and their staffs have provided much-needed assistance throughout the development of this project.

Comic Abstraction: Image-Breaking, Image-Making would not have been possible without the generosity of the lenders to this exhibition. I would like to express my deepest gratitude to each of them for their willingness to make such notable works available to a larger viewing public.

Roxana Marcoci
Curator, Department of Photography

CREDITS

LENDERS TO THE EXHIBITION

Boros Collection, Germany

Collection of Igor DaCosta

Dimitris Daskalopoulos Collection, Greece

Frac Nord-Pas de Calais, Dunkirk, France

Collection of Linda and James Gansman

Collection of John Goodwin and Michael-Jay Robinson

Collection of Lisa Ivorian Gray and Hunter Gray, New York

Hauser & Wirth, Zurich and London

Estate of Michel Majerus

Estate of Juan Muñoz

The Museum of Modern Art, New York

Collections of Peter Norton and Eileen Harris Norton, Santa Monica

Private collection, New York

Collection of Michael and Joan Salke, Naples, Florida

The Schorr Family Collection

Collection of Mari and Peter Shaw, Philadelphia

The Studio Museum in Harlem, New York

Tate

Collection of David Teiger

Collection of Franz West

Whitney Museum of American Art, New York